GW00501927

The Art and Ideology of the Trade Union Emblem, 1850–1925

The Art and Ideology of the Trade Union Emblem, 1850–1925

Annie Ravenhill-Johnson
Edited by Paula James

ANTHEM PRESS
LONDON · NEW YORK · DELHI

Anthem Press
An imprint of Wimbledon Publishing Company
www.anthempress.com

This edition first published in UK and USA 2013
by ANTHEM PRESS
75–76 Blackfriars Road, London SE1 8HA, UK
or PO Box 9779, London SW19 7ZG, UK
and
244 Madison Ave. #116, New York, NY 10016, USA

Copyright © Annie Ravenhill-Johnson and Paula James 2013

The moral right of the authors has been asserted.

All rights reserved. Without limiting the rights under copyright reserved above,
no part of this publication may be reproduced, stored or introduced into
a retrieval system, or transmitted, in any form or by any means
(electronic, mechanical, photocopying, recording or otherwise),
without the prior written permission of both the copyright
owner and the above publisher of this book.

British Library Cataloguing-in-Publication Data
A catalogue record for this book is available from the British Library.

Library of Congress Cataloging-in-Publication Data
Ravenhill-Johnson, Annie, 1942–
The art and ideology of the trade union emblem, 1850–1925 /
Annie Ravenhill-Johnson ; edited by Paula James.
pages cm
Includes bibliographical references and index.
ISBN 978-0-85728-530-0 (hardback : alk. paper)
1. Labor union emblems–Great Britain–History. I. James, Paula. II. Title.
HD6664.R29 2013
331.880941'09034–dc23
2013009634

ISBN-13: 978 0 85738 530 0 (Hbk)
ISBN-10: 0 85728 530 0 (Hbk)

Cover image: Emblem of the Brass Founders, Turners, Fitters, Finishers and Coppersmiths
Association, designed and printed by Blades, East & Blades, 1890s. Working Class Movement
Library, Salford; and Plate 50 of this volume.

This title is also available as an eBook.

To John Gorman and R. A. Leeson,
pioneers in the study of trade union art

CONTENTS

PREFACE

Paula James

How This Book Came About

This book has been a labour of love and would not have been accomplished without the dedication and expertise of Dr Annie Ravenhill-Johnson who began her study of trade union emblems in her prize-winning undergraduate thesis, *Gender Issues in Trade Union Imagery 1850–1925*, followed by an MA dissertation covering the same historical period on *Themes and Influences in Trade Union Imagery, 1850–1925*. Annie Ravenhill-Johnson's chapters, which form the bulk of the book, build upon her earlier research to reveal the array of cultural influences that gave the emblems their form and meaning.

A classicist by profession, I became intrigued by the Greco-Roman iconography of the New Unions when teaching mid-Victorian Britain at an Open University residential school in the 1990s. I was put in touch with Annie by the Manchester People's History Museum and a friendship and collaboration began, which has never wavered despite the obstacles of distance and the usual pressures of life and work making plans for a sustained project a real challenge in recent years.

Annie contributed a fascinating lecture on the Bricklayers' banner to the Open University DVD, *Four Faces of Rome*, part of the Classical Studies Department's course Experiencing Rome: Culture, Identity and Power in the Roman Empire (presented 2000–2010), introducing thousands of part-time students to the rich iconography of this surviving emblem housed in the Manchester museum. We have given joint and solo presentations on aspects of emblems at seminars and conferences run by classicists, the Society for Emblem Studies, art history departments, spoken to audiences at galleries and museums and at Open University day schools to students of the Roman Empire and classical myth. The images of labour always surprise and delight audiences whatever their discipline or ideological standpoint.

I am proud to have facilitated and encouraged Annie's research, which has culminated in ten chapters of detailed analysis of key banners and certificates. Very little editing has been required and my contribution to *Art and Ideology* has developed into a dialogue with Annie's findings as her research raises a number of issues for classicists and for those of us wrestling with the conundrum of cultural hegemony

past and present. Figures, forms and mottoes from antiquity have filtered through the visual motifs of medieval guilds, Renaissance art and architecture, and the emblems of Freemasonry and friendly societies permeate trade union banners and certificates. These artefacts were newly forged for a recently industrialized world; the message of modernity was carefully couched within an artistic template that suggested continuity and tradition.

It seems as if the working-class leaders who commissioned the banners and the membership 'plates' (miniature works of art for their proud owners) had not just appropriated Greek and Roman culture from purely decorative considerations but also understood its potential (as did the British ruling classes) for symbolizing the strength, power and ingenuity associated with an empire-building nation. However, the use of classical figures and features to enhance the prestige of a trade and its toilers was not a new phenomenon. The prevalence of allusions to the ancient world is a complex and challenging aspect of the emblems.

ACKNOWLEDGEMENTS

The Open University Arts Faculty has been particularly generous in financing short-term consultancies for Annie Ravenhill-Johnson and helping out with the costs of conference attendance and visits to museums and archives. The Arts Faculty research team has also awarded £850 from the additional funding budget towards the copyright costs of plates and paintings and provided a short-term consultancy for image searching; indeed this book has only been possible because of their consistent and generous support. We are grateful to Dr Amanda Sandiford who located a number of images and started negotiations for their use. The Lipman-Miliband Trust contributed £500 towards image payments and the Lancashire and Cheshire Historical Society donated £400. We very much appreciate these contributions as the book has been enriched by the inclusion of 90 illustrations across a range of visual media. We are indebted to our indexer, Dave Cradduck. We would also like to thank conference and seminar audiences, friends, colleagues and comrades who have commented upon work in progress and especially our peer reviewers whose input has enhanced our understanding and improved this volume's critical edge. We were lucky to have the patience and support of long-suffering spouses, Brian Johnson and John James. Any infelicities are the responsibility of the authors.

ABOUT THE AUTHORS

Annie Ravenhill-Johnson (neé Curtis) comes from a working-class family of Channel Island refugees who left Jersey two days before the arrival of the German occupying forces and who returned to Jersey in 1945 as soon as the island was liberated. She was not able to pursue her grammar school education beyond the age of 16, due to family pressures, and was required to find paid work as a secretary and clerk. When she embarked upon an Open University degree in 1989, aged 47, her day job was at a slate mine in North Wales. She eventually managed to complete her studies as a full-time BA (Hons) art history student at Warwick University (1993–96). Her undergraduate dissertation was awarded the Association of Art Historians' annual prize for the best BA or MA thesis from a British university. She gained a distinction for her MA taken at Birmingham City University whilst she worked full-time as a clerk for Lunn Poly. Annie completed a PhD (part-time) at the age of 62 on the metamorphoses of Vulcan/Hephaistos in Renaissance and Baroque art. Annie chose Vulcan because he was a working-class god, labouring away in the soot of the forge whilst the rest of the gods were having a jolly good time. She has acquired a well-deserved reputation in academic circles for her knowledge of British banner and certificate history and has published in the *Journal of the Social History Curators' Group*.

Paula James (neé Deahl) was born in 1950, the youngest of five children, on what was then the largest council estate in Britain (Millbrook, Southampton). She benefited from a culturally stimulating environment as her father (one of ten children and forced to leave school at 14) was widely read, had taken night schools in art and architecture and had also been a violinist by profession (taught by his father whose own family were musicians originally from Bavaria). Paula thrived in an intellectual household as her dad, a lifelong socialist and a loyal union man, was determined that all his children would receive the formal education he had been denied. However, she abandoned her degree when her mother became terminally ill and returned to higher education at age 27 with two daughters of 7 and 3 in tow. After gaining a degree in 1977 in Latin with Greek and a PhD (on Apuleius' Latin novel, *The Golden Ass*), Paula had a variety of teaching and lecturing posts before joining the Open University Classical Studies Department in 1993. She has taught, researched and written widely on Latin literature and the refashioning of mythical narratives in film and television.

As mature students with family commitments, neither Annie nor Paula could ever have contemplated college on credit and they both support and where possible participate in the current protests against the privatization of education.

LIST OF PLATES

Note: Whilst every effort has been made to locate original certificates, in some instances those reproduced are of a later reprint or issue, but to the original design.

The majority of banner and certificate images were obtained from the People's History Museum (PHM), Manchester and the Working Class Movement Library (WCML), Salford. We are especially grateful to Phil Dunn (PHM) and Tara Sutton (WCML) for their assistance and for reducing costs. Fine art and sculpture reproductions owned by art galleries and museums were also purchased by the authors.

1. Photograph, late Roman mosaic floor, room of the ship owners and merchants of Cagliari, Sardinia, in the Forum of the Corporations, Ostia. Courtesy of Professor Mary Sullivan, Bluffton University, Ohio.
2. Certificate of the Amalgamated Society of Carpenters and Joiners, 1866, A. J. Waudby. Working Class Movement Library, Salford.
3. Banner of the Friendly Society of Sawyers, Whitehaven, 1838. Courtesy of the Beacon Collections, Copeland Borough Council.
4. Renaissance drawing from a medieval copy of a title page of codex, circa 354 CE. Featured in H. Stern, *Le Calendrier de 354*, Paris, 1953, plate 1.2.
5. Cremorne Gardens playbill advertisement, c. 1850. Courtesy of Kensington Central Library, photograph by John W. Rogers.
6. Print of the Confraternity of Farm Labourers, woodcut, 1771, Raynaud Sc. Musée National des Arts & Traditions Populaires, Paris.
7. Banner, Transport and General Workers' Union, Export A.12.C. Branch, post-1922. People's History Museum, Manchester.
8. Frontispiece, Workes of Beniamin Jonson, engraving, 1616. William Hole.
9. Certificate of the Order of Friendly Boiler Makers, 1844. Featured in J. E. Mortimer, *History of the Boilermakers Society, Volume 1, 1834–1906*, 48.
10. Certificate of the Stone Masons' Friendly Society, 1868, A. J. Waudby. Working Class Movement Library, Salford.
11. *Penrhyn Quarry in 1832*, oil, 1832, Henry Hawkins. National Trust.
12. *Work*, oil, 1852–63, Ford Madox Brown. Manchester City Art Gallery.
13. *The Forge*, oil, 1844–47, James Sharples. Blackburn City Art Gallery, courtesy of the Sharples family.
14. Certificate of the United Society of Boiler Makers and Iron and Steel Ship Builders. Working Class Movement Library, Salford.
15. Certificate of the London Society of Compositors, 1894, Alexander Gow. Featured in Leeson, *United We Stand*, 67.
16. Certificate of the United Machine Workers' Association, 1880s, Blades, East & Blades. Working Class Movement Library, Salford.

65. Banner of the National Union of General Workers, Tottenham Branch, c. 1919. Featured in Gorman, *Banner Bright*, 125.

66. Banner of the Durham Miners' Association, Witton Lodge, c. 1915. Courtesy of Kate Reeder, The Beamish Museum, The Living Museum of the North, Durham.

67. Advertisement, National Union of Women's Suffrage Societies' Procession, 13 June 1908, Caroline Watts, published by the Artists' Suffrage League. Courtesy of Diana Carey at the Schlesinger Library, Radcliffe Institute, Harvard University.

68. 'Cartoon to celebrate May Day', Walter Crane, *The Sun*, 1903. People's History Museum, Manchester.

69. Suffrage poster, 1912, Louise Jacobs. Courtesy of Jenna Collins, Museum of London.

70. Anti-Suffragette poster, 1912, Harold Bird. Museum of London.

71. *Triumph of Labour*, 1891, Walter Crane, engraved by Henry Scheu. People's History Museum, Manchester.

72. Banner of the National Union of General and Municipal Workers, Plymouth Branch, c. 1915. People's History Museum, Manchester.

73. *A Garland for May Day*, 1895, Walter Crane, engraved by Carl Hentschel (*Clarion*). People's History Museum, Manchester.

74. Banner of the National Union of General Workers, Chelmsford Branch, c. 1915. People's History Museum, Manchester.

75. May Day poster, *Socialist Reconstruction versus Capitalist Constriction*, 1909, Walter Crane. People's History Museum, Manchester.

76. Banner of the Dockers' Union, Export Branch, early 1890s. People's History Museum, Manchester.

77. *La Marseillaise, The Departure of the Volunteers of 1792*, Arc de Triomphe, Paris, 1836, François Rude.

78. Banner of the Electrical Trades Union, 1899, Walter Crane. People's History Museum, Manchester.

79. *Icarus*, 'Transport' frieze, 1896–97, Walter Crane. Courtesy of Worth Abbey. www.worthabbey.net

80. Banner of the Electrical Trades Union, 1899, Walter Crane. People's History Museum, Manchester.

81. Emblem of the United Pattern Makers' Association, 1897, Blades, East & Blades, Walter Crane and G. Twist. Working Class Movement Library, Salford.

82. Banner of the National Union of Gas Workers and General Labourers, Bristol District No. 1 Branch, after Walter Crane, 1893. People's History Museum, Manchester.

83. Banner of the National Builders', Labourers' and Construction Workers' Society, Shamrock Branch, c. 1915, George Tutill. People's History Museum, Manchester.

84. Emblem commemorating the opening in 1830 of the Steam Engine Makers' Society, Rochdale Branch No. 3, c. 1865. Working Class Movement Library, Salford.

85. Banner of the Workers' Union, Witney Branch, c. 1920. Featured in Gorman, *Banner Bright*, 134.

86. Banner of the National Union of Railwaymen, Stockton Branch, 1914. Courtesy of Stockton Museums.

87. *A Distinguished Member of the Humane Society*, oil, 1838. Sir Edwin Henry Landseer. British Museum.

INTRODUCTION

Paula James

This is the first comprehensive analysis of trade union emblems to address the genre, the designers and the social history at the heart of the images. These banners and certificates are very much part of an industrial and union heritage, as the emblems were the art of and for the toiling masses. *Art and Ideology* celebrates working-class culture and shows how it could be both innovative and derivative. Annie Ravenhill-Johnson's exploration of the artistry of the emblems sets these images of labour in their historical, cultural and ideological context. Practically and intellectually this has not been an easy task. John Gorman did wonderful work promoting research into the banners, and then writing about them in his volumes *Banner Bright* and *Images of Labour* in the 1970s. R. A. Leeson produced a marvellous and succinct book on the certificates in 1971. However, these visual records present significant challenges for historians of working-class culture.

Nick Mansfield (2004) argued cogently for the value of these emblems as insights into the material conditions and political movements of the Victorian working class. His chapter 'Radical Banners as Sites of Memory' in *Contested Sites: Commemorative, Memorial and Popular Politics in Nineteenth-Century Britain* describes the documenting of surviving emblems in the National Banner Survey held at the People's History Museum. Yet Katy Layton-Jones (2008) notes in *Visual Resources* (vol. 24) that such artistic resources are still underused for the purposes of historical research. In the introduction to her 2008 article 'Visual Collections as Historical Evidence', she writes of the many practical obstacles to locating and using artefacts of this type.

Layton-Jones (2008) also argues that categorizing them under the heading of 'cultural history' tends to detach them from mainstream historical research and to reinforce the notion that 'visual history is fundamentally more fictionalized, and therefore less credible, than the written word' (106). Annie Ravenhill-Johnson's synthesized methodological approach to the artistic and ideological layers of the nineteenth- and earlier twentieth-century trade union iconography should dispel any lingering doubts about the value of the banners and certificates for cultural and historical studies. The compass of her chapters is broad and yet there is still painstaking but exciting research to be done, as the conclusion to this book, 'Reprise and Review', indicates.

The Historical Narrative

In her introductory chapter, 'The Genre', Annie Ravenhill-Johnson explores the resignification of Greco-Roman, medieval and Renaissance architecture, figures and symbols in the emblem tradition, and analyses how these images served the representation and developing self-awareness of the growing industrial workforces during the nineteenth and early twentieth centuries. Freemasonry and friendly societies had adopted and adapted classical, biblical and medieval depictions of crafts and craftsmen to illustrate the antiquity of their trade and to lend solemnity and legitimacy to the tradition of forming associations for protection and benefits.

The essay is a summary of the strategies employed by the trade clubs or corporations of the ancient world, the medieval guilds and, later in the seventeenth century, the friendly societies (representing a cross-section of professions) to promote their existence in pictures as well as in words. (The visual representations espoused by the friendly societies have inspired a good deal of literature and Daniel Weinbren produced useful reviews of these in his 2006 articles for *Social History* and *Cultural and Social History*.)

In short, there is a wide cultural and chronological range of artefacts depicting manual crafts, from mosaics, stained glass windows and sculptural reliefs, to (with the advent of printing) moralizing Books of Trade. The emblems of organized labour followed these traditions. Renaissance art, architecture and sculpture, the conventions of landscape painting and the more prestigious genres of mythical and biblical subjects all provided settings and structures that sanitized working conditions and idealized the workers themselves. A detailed account of the emblem's origins is given in the following chapter, 'The Emblem within the Emblem'. Many of the vignettes within the banners and certificates of the nineteenth century were inspired by classical, biblical and contemporary scenes of men plying their trade.

However, as Annie Ravenhill-Johnson demonstrates in these first two essays, the history of influences and trends is by no means straightforward. Gorman (1986) assumed that fairground canvasses had a direct influence upon the large pictorial designs of the banners produced by George Tutill (48). It seems likely that the traditions of trade association imagery and the visual delights of travelling shows, fairs and carnivals were intertwined and harked back to a common provenance. Trade bodies had a long history of enacting biblical and mythical scenes loosely connected with their crafts at public processions, pageants and festive occasions in general. Certainly, classical legends and legendary figures did not spring fully fledged into nineteenth-century emblems but were part of the artistic fabric of labour associations and popular culture throughout the centuries. Aspects of the staging and scenery of such performances as well as the stories they told were preserved in artefacts associated with both leisure and labour, and a commonality of themes blurred the boundaries between 'high' and 'low' art.

Fairground artists are not well documented but their banners shared an agenda with the trade union emblem, being forms of communication that Gorman (1986) saw as uniting the familiar and the elevated for general consumption (48–50). The National Fairground Archive based at the University of Sheffield has a companion

website tracing the colourful history of the travelling show, where it is noted that the academies and salons of Europe did not have the monopoly on 'heroic, monumental, passionate and often violent subject matter' (2009).

At the fairground, large-scale representations of historical and mythological scenes were intended to stir up interest and excitement in the casual viewer and entice them into a wondrous world of *trompe l'oeil* (the National Fairground Archive has a fascinating survey of its changing fashions and aesthetics). The art and architecture of the fairground continued to reflect the shifting shapes and technologies of town and country and marry up such features as classical carving with the contemporary and even the avant-garde.

The banners of organized labour aimed to invite the viewer into mythological and biblical scenes as players in a distant past. It reinforced a sense of belonging, a personal identification with a collective and its history. The notion of purposeful art is 'predicated upon skills of looking and interpreting', writes Kim Woods in her 2012 introduction to the Open University art history module. She observes that 'medieval thinkers seem to have assumed that ordinary people too were capable of thoughtful looking' (2). This is an important point because although the context of this statement is the dissemination of religious art of the sixteenth century, we should not dismiss the communicative power of the emblems however culturally complex their motifs and messages may have been.

The expectation that mythological figures and motifs might be familiar, even if their full import and 'back stories' were grasped only by the cognoscenti, is an issue underlying Chapter 3, 'Depicting the Worker' and will be revisited in the conclusion with a discussion of the Hercules (Greek: Herakles) figure. In this chapter, Annie Ravenhill-Johnson discusses the artistic ingenuity involved in constructing a positive visual narrative around industrial toil through the use of classical figures and motifs, recalling Marx's recognition that the Industrial Revolution called upon workers to manage machines of terrifying power and to tame the technological forces of factory production in his 1856 speech on the fourth anniversary of *The People's Paper*.

In his 1840s painting *The Forge*, James Sharples ennobled the toilers and altered the perception of the workplace as a fiery furnace, a purgatorial place or a gateway to hell, by portraying the white heat of the factory as a bright and heavenly portal. Sharples, a Bury blacksmith working in the Phoenix forge, played a seminal role in emblem iconography. His design for the newly formed Amalgamated Society of Engineers, Machinists, Millwrights, Smiths and Pattern Makers won the union competition for an official certificate of membership.

Sharples's *The Forge* featured in Jeremy Paxman's informative 2009 series for the BBC, *The Victorians*, along with other illustrations that celebrated the craft of ironworking such as Godfrey Sykes's *Sheffield Scythe Tilters*, painted a decade later. Paxman's book of the series (2009) summarizes Sharples's remarkable life (88–91), but the blacksmith's winning design and indeed the whole area of trade union art are not mentioned – and yet the Sharples certificate clearly influenced a number of middle-class artists who were commissioned to design new emblems for trade union executives and local branches.

Sharples followed an established tradition in high art with his positive portrayal of the blacksmith as a lofty hero albeit dressed in his workaday clothes. James Sharples elevated the worker in the forge by placing him high on the celestial ziggurat structure. His imaginative use of the flattened pyramid was taken up for subsequent banners and certificates across a sustained period of certificate production and the ziggurat as well as other aspects of the Sharples design influenced the Iron Founders, the Bakers and Confectioners and the Locomotive Engineers, whose colourful imagery is reproduced in the plates accompanying Chapter 4.

Annie Ravenhill-Johnson persuasively argues that this visual medium, the art of the certificate, which Sharples used to affirm the presence, power and identity of organized labour, took on its own cultural momentum. The foregrounding of the worker may even have found reflection in the composition of Ford Madox Brown's painting *Work*. It would not be surprising to discover that the art of the people, like their literature and music, contributed to and inspired middle-class cultural forms that might then reconfigure the collective identity of labour to their own purpose.

Annie Ravenhill-Johnson illustrates the monumental influences at work in the designs in Chapter 5, 'The Development of the Architecture of the Emblem'. The triumphal arch and the tomb façade, particularly the capitals and colonnades that framed Renaissance altarpieces, clearly inspired the impressive structures A. J. Waudby designed for the Bricklayers, Carpenters and Stone Masons. The classical tripartite arch formed a backdrop to allegorical tableaux during the medieval and Renaissance periods. Another important architectural structure was the portal, a secret and solemn gateway that kept the unskilled at bay. The depiction of the commemorative tomb also persisted in trade union emblems, a clear indication of a core aspect of these combinations, namely that they provided for working people in sickness and in health. The banners provided backdrops at burials as well as branch meetings. In this respect, Gwyn A. Williams's phrase 'cathedrals to labour' (Gorman 1986, 20) for the more splendid banners is perhaps more appropriate to their figurative content than to their structural form.

Annie Ravenhill-Johnson's unravelling of these significant strands in the artistic history of the emblems is important for classicists because banners and certificates reveal a cultural continuum in which Greek and Roman motifs stand out in the representation of the toiling classes. She demonstrates how frequently the principles of Roman monumental structures were referenced in the design of the banners and certificates although Gothic architecture also featured in the emblems. Their coexistence (sometimes within the same emblem) is a complicating factor, as the religious and political timbres of these opposing cultural trends cannot always be neatly aligned to particular trades and associations.

What appears on the nineteenth-century flattened canvas or the framed membership card reaches back across the centuries to a time when heroic figures of pagan and Christian iconography gave the gravitas of antiquity to a whole collective. Chapter 6 focuses upon the artist Arthur J. Waudby and the symbols of Freemasonry, and the decorative fancy of the visual narratives in such emblems is treated to a detailed exegesis. The pictorial allusions range across the historical, the classical, the biblical and the mythological.

As Annie Ravenhill-Johnson demonstrates in Chapter 7, 'Men, Myth and Machines', Waudby and like-minded emblem designers were operating within a common cultural framework as Sharples had done before them. The emblems display a sacred centre (the worker, or the patron saint of his trade, sometimes its legendary founder) that is the fulcrum of a master fiction about the continuity of labour across the centuries. Eventually machines became the central 'figures', and female abstractions, whilst human in form, could be viewed as statements about the alienation of labour in an age of industrial technology.

The Greeks and Romans provided the inspiration for deified abstracts such as Virtue, Justice and Truth. Female figures, when they do appear in the emblems, are predominantly classically garbed and sometimes scantily clad statues embodying these noble qualities. These finely robed 'classical women' lend nobility to the emblems but also could spice up their visual sermons on the benefits of unity, transparency and truth in the labouring classes' collectives. The moral high ground was left intact in much the same way as provocatively garbed girls were sanctioned in Victorian high art because they were semi-mythological creatures of a distant past.

In her following chapter, 'The Classical Woman', Annie Ravenhill-Johnson offers a more detailed discussion of the presence of the idealized female form to proclaim the eternally noble ethics of the working classes, and to express classical continuity sitting side by side with the newfangled men and their newfangled machinery. The emblems could transform the toilers into the modern heroes and gods of an industrial (and vulcanized) world. Just occasionally women at work are incorporated into the iconography but more usually they are shown as ideal and anonymous or appear in a variety of scenes as passive wives in receipt of union benefits.

European artists depicted women side by side with men as workers in industry and toilers in the fields. With the birth of the Soviet state and the emergence of a conscious and orchestrated revolutionary art (the banners and posters of nascent socialism), the regular portrayal of women as equal in labour entered the proletarian art form. Walter Crane, whose emblem designs (and related works in the traditions of agitational art) are analysed in Chapter 9, seems to celebrate the female figure as a socialist icon paving the way for a future of equality and plenty with an end to oppression and exploitation. However, she is invariably a saintly creature handing down liberty and benefits from on high. Annie Ravenhill-Johnson produces a trenchant critique of Crane's utopian vision and the part women play within his romantic aesthetics, but his images of rural merry England – very much at odds with 'its bleak industrial reality' (Spencer 1975, 157) – persisted in trade union emblems well into the twentieth century.

The final chapter, 'The Art of Copying', deals with the creative imitation that characterizes the designs of trade union banners and certificates, which are masterclasses in the art of copying for the discerning viewer. Victorian artists were trained to copy before being allowed to draw from life and working-class artists were given art primers, engravings and books as their resources. Those commissioned by the unions to design new banners developed formulaic frameworks for the emblems. Middle-class and

working-class artists copied freely from each other as well as from famous painters to produce a completely new hybrid genre in the history of visualization.

This brief navigation through the ten chapters does not do justice to the interpretative layers Annie Ravenhill-Johnson has incorporated into her detailed descriptions of the rich imagery that characterizes the emblems in all their variety. Her analysis of persistent motifs, messages, forms and themes certainly strengthen Gorman's promotion of the banners and certificates of organized labour as a genre well worthy of study for its political as well as its aesthetic implications.

Art and Ideology

We may find that we are battling with a many-headed hydra of issues that have so far resisted intellectual and theoretical conquest. In the conclusion, I rather rashly take on the role of 'respondent' to this research, not just as a classical commentator on the iconography but with the goal of deepening my own understanding of Marxist (and Leninist) views on art and revolution, although art in the service of socialism may seem a far cry from the predominantly reassuring discourse Annie Ravenhill-Johnson reveals in the Victorian and Edwardian images of labour.

In the Open University Art Foundation course, Joan Bellamy (1986) writes:

> Trade union certificates have an obvious utilitarian function: they are also rich in cultural significance. Through them, different sections of the working-class movement expressed a view of their role in society, their claim on it and their contribution to it. They created the means of expressing and reinforcing their own identity even if the forms of expression carried uncritically elements of the dominant culture of the time. (58)

The classical symbolism the working-class leaders adopted in the banners and the certificates certainly played its part in enhancing the image of the new unions. The creative and imaginative, sometimes humorous, borrowing from the artistic output of Greece and Rome, not to mention the use of Latin *sententiae* in the emblems, was a flattering imitation of the culture of the ruling classes. Reid argues in his 1992 book, *Social Classes and Social Relations in Britain 1850–1914*, that these ruling classes were, even well into the industrial nineteenth century, predominantly composed of the landed aristocracy. The bankers and merchants played their part but the manufacturers were quite parochial in their political activity and both sectors became stakeholders in the existing culture. The early emblems of unionism were not confrontational. However, Bellamy is surely right to view skilled labour's proclamation of presence and strength through references to the classical past as a statement of power and a claim to the familiar cultural insignia of that power.

Annie Ravenhill-Johnson identifies the persistence of a nonthreatening and accommodating message in the emblems and this seems to characterize Sharples's influential ASE design, but she also acknowledges that the ASE certificate ennobled

the worker by means of classical iconography. However, the very same structure (the flattened pyramid or ziggurat) that elevated him also leaves us a visual record of his gradual demotion. Whilst the worker continued to find a niche in the architecture of the banner, he could be ousted from the highest places by the founders of the craft (historical, biblical and mythical) and the leaders of the union. This was not necessarily a universal trend within the more elaborate banner and certificate designs but it is an indication that the union branches that commissioned emblems from middle-class artists were comfortable with their representation of working men's associations as bastions of tradition and conservatism.

Both Adam Smith in his *Wealth of the Nations* (1776) and Karl Marx in *Capital* (1867) recognized that the division of labour reduced the status of skilled workers and that they would be engaged in regular battles (in the march of capital towards mechanization and modernization) to retain and regain the dignity, respectability and independence their tools bestowed upon them. The role of Greek and Roman features and figures in the banners and certificates of the period is an aspect of the conservatism that characterized the unions of the skilled, but we should not downplay the potential of classical culture to empower the working classes generally.

When a new wave of union organization embraced the manual labourers, the Dockers' strike banner displayed a Herculean hero strangling the snake of capitalism. The figure of Hercules has a long history in pagan iconography and the culture of Christian nations. His proletarianization during the French Revolution was by no means straightforward (more of which in the final pages). For this reason, the shifting attributes of mythical and legendary figures that appear on the Victorian emblems deserve more attention from classicists working in the reception of the ancient world. Bradley (2009) explores representations of Roman rule in popular culture as well as treading the more familiar ground of the high culture of academic scholarship and political commentary; but here as elsewhere the genre of trade union art seems to have slipped out of sight.

Marx, Engels and, later, Lenin all championed the role of education and access to the totality of human culture as a part of the revolutionary development of the oppressed. However, the creative artistry of the emblem could simultaneously reflect and reinforce the ideological colonization of working-class consciousness. Other banners during the Great Strike for the Dockers' tanner proclaimed that workers and employers should labour together to make the British Empire as great as the Roman Empire.

This identification sends a rather bleak message to left-wing classicists: even in the later and more militant trade unions of the unskilled and the skilled, the acquisition of Greek and Roman culture by organized labour ultimately served the interests of capitalism. In short, classics corrupts, or did in this historical context; but, of course, this intentionally provocative statement is bound to be a simplification of both the aesthetics and the politics of the emblems under study. Certain key classical figures become multifaceted signifiers. Symbols can never stand alone. Any symbol can and should be extracted and examined for its cultural properties; but then these existing

properties have to be reappraised in the context of the artefact in which it appears and the historic circumstances of that artefact's production. According to Mansfield (in Pickering and Tyrell 2004, 32–3) during discussions amongst labour historians from 1999 to 2000 Dorothy Thompson suggested that Union Jacks and crowns on radical banners should be seen as 'icons of contested loyalty in a fluid political discourse'. Linda Colley observes, 'Crudely, but also fundamentally, class and nation in Britain at this time were not antithetical but two sides of the same historical process' (1986, 100). This approach may offer a less ideologically stark way of interpreting the allusions to the Roman Empire in the agitational banners born out of bitter struggles with the bourgeoisie.

In the *Eighteenth Brumaire of Louis Bonaparte*, Marx writes,

> Men make their own history, but they do not make it just as they please; they do not make it under circumstances chosen by themselves, but under circumstances directly encountered, given and transmitted from the past. The tradition of all the dead generations weighs like a nightmare on the brain of the living. And just when they seem engaged in revolutionizing themselves and things, in creating something that has never yet existed, precisely in such periods of revolutionary crisis they anxiously conjure up the spirits of the past to their service and borrow from them names, battle cries and costumes in order to present the new scene of world history in this time-honored disguise and this borrowed language. (Padover 1971, 245–6)

In his judgement on the revolutionary struggle in France of 1789 and its brief resurrection in 1848, Marx goes on to comment in this same section on the way in which the artistic expressions of the conflict could cloud the fact that the real winners were the bourgeoisie:

> But unheroic as bourgeois society is, it nevertheless took heroism, sacrifice, terror, civil war and battles of peoples to bring it into being. And in the classically austere traditions of the Roman republic its gladiators found the ideals and the art forms, the self-deceptions that they needed in order to conceal from themselves the bourgeois limitations of the content of their struggles and to keep their enthusiasm on the high plane of the great historical tragedy. (244–6)

Marx contrasts these classical symbols with 'speech, passion and illusions from the Old Testament' employed by the much earlier English bourgeois revolution of the seventeenth century spearheaded by Oliver Cromwell (246). He concludes that the social revolutionary movement of the nineteenth century could not draw its poetry from the past but only from the future. We should not be surprised if the aesthetics of the organizations of labour in Victorian Britain that did not constitute a social revolution continued to draw their visual poetry from the past, combining biblical and classical symbols and signifiers to claim their right to recognition. The banners and

other emblems are beset by a trade union consciousness and this is expressed in the iconography they adopted, even in times of great militancy.

In Britain, as Annie Ravenhill-Johnson observes, socialism and trade unionism were never happy bedfellows. Her chapter on Walter Crane highlights his ultimately revisionist message of utopian socialism sold to the working classes through the deceptive filter of agitational art. Crane transformed Marx and Engels's vision of a future communist society with a socially integrated and nonalienated workforce in full possession of technologically advanced forces of production into an idealized medieval age with happy toilers sporting peasant garb – and once again classical images kick in. The male workforce is disempowered and, as previously noted, a feminine Liberty does not so much lead the people (as she did in the imagery of postrevolutionary France) as hover over them like a classical deity (Nike or Victory) or as a remote and beneficent angel.

Of course, we have to recognize the pitfalls of viewing the emblems as a social barometer as they cannot capture the various ideological moods of the labouring masses in the rich range of all their manifestations. Their lives and attitudes emerge from reports and surveys, for instance the nineteenth-century investigations of Henry Mayhew and then Charles Booth (see Englander and O'Day (1998) for a sound and informative critique of Mayhew's and Booth's research and its historical and sociological significance). Friedrich Engels's *Conditions of the English Working Classes* (1844) remains essential reading for scholars of the first half of the century and has been cited in Annie Ravenhill-Johnson's essays.

There were plenty of pamphlets and pictures in circulation in which satire and social comment would provide an antidote to the more conciliatory discourse of many trade union emblems. As for militancy in the factories, at one end of the spectrum there might be small individual acts of defiance and, at the other (particularly among women workers), walkouts, spontaneous strikes and threats of violence towards strike breakers, which indicated a keen understanding of capitalist society as one of irreconcilable differences.

Important research is being done by Catherine Feeny at the University of Manchester on the dissemination of Marx's *Capital* in the British Isles from 1881 to 1940. Although this bulky and difficult treatise had a limited impact on socialist theory in the labour movement, Marx's shorter and more accessible writings did reach and influence portions of the working classes; in times of economic crisis they looked back to agitational works, especially *The Communist Manifesto* (1848). Even without exposure to communist ideology, there were those ready to reject the royalist attitudes and patriotic poses of trade union iconography and to counterpose the pride in empire and commonwealth it might display.

There have been two distinct schools of thought among historians (the Mackenzie and Porter divide), one of which claims that images of empire steeped in notions of the racial superiority of the colonizers permeated children's books, popular entertainments and education at all levels, whilst the alternative picture is of an empire that belonged to the middle and upper class, at least up until the 1880s, with a working class largely

indifferent to its rhetoric and reality. Frank, Horner and Stewart's 2010 collection, *The British Labour Movement and Imperialism*, comprises essays on the key issues of the interaction of the working classes with empire and popular imperial culture. On the overarching conundrum of the class-consciousness of the British workforce, it is worth revisiting Gorman's comments about the radical leaders of the new unions who were contemptuous of the older corporate craft unions as 'coffin clubs for cowardly and constipated "labour aristocrats"':

> In many ways these 'new model' unionists were in fact more coherently class conscious than their predecessors; at the crunch their class commitment was apparent – as the occasional sharp and swinging banner broke the general pattern of resolute 'good intent'. But it was a class-consciousness which was essentially corporate, integrated into the system which they largely accepted and tried to work to the benefit of their class. (1986, 18)

By the end of this volume, the reader may with some justification conclude that, although the British banner and certificate genre as developed through the nineteenth century was the first visual representation of the working people as a class *in* itself under capitalism, the creators (and many of the consumers) of this distinct art for organized labour in Victorian Britain were not developing the necessary consciousness (identified by Marx in *The Communist Manifesto* as a prerequisite of revolutionary change), i.e. that of the class *for* itself. This question will be revisited in the concluding chapter.

Chapter 1

THE GENRE

Annie Ravenhill-Johnson

There are many excellent books in existence dedicated to trade unions, their histories and their outward form of display – banners, certificates, posters, regalia, medals, pottery and ephemera. The intention of this book is to cover a previously neglected field – how the artists who devised the emblems of the Victorian and Edwardian eras conceived their ideas. Our inspiration lies with the groundbreaking work of Joan Bellamy, who opened up this field of exploration in the Open University Art Foundation course.[1]

Little exists on the commissioning of banners and certificates. Minute books and monthly records of the unions and friendly societies, if they record the matter at all, often merely state that a particular artist has been contracted to perform the work for a given amount of money. In some cases, the printers themselves (who also produced commercial advertising posters) designed the certificates. Sometimes the certificates were issued with a 'key' in order to explain the intricacies of the iconography to the union members. The key was a separate sheet of paper on which was reproduced a scaled down version of the emblem and an explanation beneath. Sometimes the explanation described the scenes above and why they were included, but others printed a number beside certain figures or scenes with a list of the numbers beneath and a very basic identification or explanation of what was portrayed.[2] Keys also appear in trade journals of the period. However, it is often only by studying the emblems embodied in the certificates and banners that we are able to deduce from the iconography what the union set out to portray about itself, the identity that the artist (often of the middle classes) chose to confer upon on it or the unwitting testimony it reveals about prevailing social conditions.

The purchase of a certificate by a union member would often be a major outlay, to be framed and proudly displayed in the home as proof of the wage earner's standing within the family, the workplace and the community. The more intricate and detailed the certificate, the more prestigious it would seem, the more value for money it would appear to embody and the more time and attention could be given in perusing and examining it. Similarly, the larger, the more colourful, the more elaborate the banner,

with its gilded poles, fringing, ropes and tassels, the greater the importance it would achieve in a march, the greater would be the pride of those bearing it and marching with it and the greater would be the impact on the viewing audience. Some banners were so huge that they were too large to be carried and were mounted on specially designed wheeled frameworks that were pushed along. Size really mattered! So banners, great painted silken sails, formed a major focus moving through a choreographed procession. But, unlike certificates, they needed to be easily read and understood from a distance, so their designs are frequently less complex, bolder and more striking.

The roots of trade union membership are embedded deep in social history. In ancient Greece and Rome, trade clubs existed into which members paid subscriptions and from which they received hardship benefits. Plutarch mentions the *collegia opificum* instituted by Numa Pompilius, which included guilds of tradesmen.[3] Usually associated with the goddess Minerva/Athena, her temple in Rome on the Aventine Hill was both a religious space and a business meeting place,[4] and throughout the Roman Empire tradesmen met in their *schola* in towns, for trade protection, socializing and for funerary grants to cover the costs of burial in the *collegium* or in a public *columbarium*. Elected officials administered the finances.

In second-century Ostia, grain was imported from Roman colonies and stored in warehouses for onward distribution. The Forum of the Corporations was a large, colonnaded square containing the offices of some seventy merchants and ship owners who conducted their business in the forum. Each room was paved with a floor mosaic identifying the particular type of business carried out there. The room of the ship owners and merchants of Cagliari, Sardinia, for example, was paved with a black-and-white tesserae mosaic depicting a merchant sailing vessel flanked by two *rutellae* or grain measures (Plate 1), and from this type of trade emblem we see the origins of later trade union emblems.

During the Middle Ages, guilds – either religious fraternities or trade fraternities – provided sickness benefits and financial assistance for widows and orphans. The growing power of the medieval guilds resulted in the depiction in high art of the urban craftsmen. Forty-seven of the stained glass windows of the twelfth-century Chartres Cathedral were donated by the guilds and illustrate the occupations of their donors. Vincent of Beauvais, the great Dominican theologian who died circa 1262, author of the *Speculum Maius* (the 'Great Mirror'), an encyclopaedia and history of the world, believed that the *artes* were a means of mitigating Adam's Original Sin, the consequence of which was manual labour. Crafts became symbols of the *arts mécaniques* and appear, for example, in reliefs by Andrea Pisano and his workshop on the campanile of Florence Cathedral. With the advent of printing, moralizing Books of Trade were published in Britain until the middle of the nineteenth century, offshoots of this tradition.[5]

From the seventeenth century, friendly societies were founded. Victoria Solt Dennis, in her excellent book *Discovering Friendly and Fraternal Societies: Their Badges and Regalia*, relates how members, drawn from a cross-section of trades and professions, paid into a fund that provided sickness benefit, superannuation benefit and burial monies and how, after 1793, friendly societies were legalized under the Rose Act as corporate

bodies. She describes how these societies adopted the outer forms of ritual and secrecy of Freemasonry with initiation ordeals, sworn oaths, passwords and gestures of recognition, and how each meeting ended in dining and drinking. They covered a variety of interests from serious debating clubs to riotous drinking clubs and, by the nineteenth century, women were forming their own societies.[6]

Workers in a particular trade also joined together in trade clubs to air grievances, to make demands such as shorter working hours, to protect their interests by controlling admission to their trade and to protect ancient privileges guaranteed by Parliament. Prior to the nineteenth century, the movement was limited to a very few skilled workers in the larger conurbations, meeting usually in public houses, some of which still bear their names today, for example, 'The Bricklayers' Arms'.

The Enclosure Acts (1770–1820) ended traditional rights such as the collecting of wood for fuel, the grazing of livestock and the mowing of hay on common land. These were major blows that, together with the loss of the few acres villagers farmed for themselves, resulted in whole communities being forced off the land. The result was the creation of a new landless class now entirely dependent upon wages. They moved in to swell the labour forces of the growing industrial cities where they were confronted with long hours, low wages and appalling housing conditions.

The journeyman craftsman found himself working with many others of his own kind in the large industrial complexes, where the chances now of his ever becoming a master himself had become minimal. It is at this time that trade unionism really took hold. It begins in groups of workers banding together to protect their interests, to restrict admission to their trade or to fight against a particular injustice. However, the activities of these trade clubs and societies became illegal under the Unlawful Oaths Act of 1797, the Unlawful Societies Act of 1799 (not repealed until 1967) and the Combination Acts of 1799 and 1800, when it was feared that revolutionary influences in France and republican ideas from America (promoted in popular books by authors such as Tom Paine)[7] could cause the British working classes to rise in a revolution for democracy and political reform. The acts also applied, of course, to trade combinations by employers but were not enforced in that regard. Freemasonry was also exempt, due to its large number of aristocratic and royal members but, even so, every lodge was forced to register with a magistrate, pay a fee and produce a list of members.

Peace with France had coincided with widespread unemployment, not only for the many thousands of out-of-work fighting men but, due to the expansion of factory mechanization, for domestic hand loom weavers as well. The power loom, the steam hammer and the spinning machine took away work from the individual working at home, and relocated this work in the factory or mill. This new organization of labour brought with it the division of labour in order to speed up production and turn out cheaper goods.

Before the acts, any 'conspiracy to raise wages' was already punishable in law.[8] However, during the first two decades of the nineteenth century, the Luddite Movement of 1812–15, led by the mythical 'Ned Ludd', revealed that these acts were not effective in preventing the joining together of workers who saw their livelihoods threatened

by the new steam-driven machines. In Nottingham, for example, in March 1811, the riots there resulted in the destruction of 60 of the new mechanized stocking frames. Reprisals against the Luddites were harsh, with transportation, imprisonment and even the death penalty. In Manchester, workers meeting at St Peter's Fields in 1819 were cut down in the 'Peterloo Massacre'. In 1815, employers such as the Lancashire firm of Butterworth, Brooks and Co., were able to advertise employment for boys and women as journeymen who were 'independent of combination'.[9] But in reducing workers to starvation wages, capitalism ruined its own home market and became reliant upon export markets.

The restrictions imposed by the Combination Acts resulted in the growth of friendly societies, which remained legal because they existed ostensibly not for the improvement of wages or working conditions, but for insurance purposes and for the provision of social gatherings such as annual family outings and dinners. However, in defiance of the Unlawful Oaths Act of 1797, which could inflict seven years' transportation on anyone convicted, some of these societies, such as the Agricultural Friendly Society set up by the Tolpuddle Martyrs, still defiantly employed sworn oaths of secrecy in their ritualistic admission, initiation or 'making of members' ceremonies, with the threats of severe injury or even death to anyone who revealed them. It was dangerous for any trade union records to be kept so we know little of the unions during these years. The Iron Founders, for example, met on dark nights out on lonely moors and kept their records buried in the ground. Postgate describes the rituals of the Stone Masons in which the lodge was opened by the singing of an anthem, followed by a prayer. The Inside Tyler brought in the new recruits, the Doxology was sung[10] and the new recruits were told to kneel and read the Ninetieth Psalm,[11] after which the President addressed them and a further hymn was sung. In darkness, the President requested that they be given light, then pointed to a skeleton and delivered a sermon on how death was every man's destiny. Candidates were then sworn in on the Bible, and swore on their own lives to keep all rituals secret.[12]

In 1824, the Combination Acts were repealed (largely due to the efforts of Joseph Hume and Francis Place, and also the negligence of MPs in reading the actual wording), making trade union membership legal. Employers were outraged, and lobbied for the restoration of the acts. However, even half a century after the repeal of the Combination Acts, the records of the unions still reflected those years of fear of discovery and trade protection. In 1873, the *September Monthly Report of the United Society of Boiler Makers and Iron Ship Builders* records that the Secretary had difficulty each quarter sending out 'the pass-words'. As some lodges received many reports, the one containing the quarterly password was falling into the hands of 'private members' (i.e. ordinary members), with the result that the lodge officers were not receiving them. To overcome the problem, a key to the passwords would thenceforth be printed in the Initiation Book, with a copy sent to all lodges, featuring the 'Hebrew alphabet' with the 'English alphabet' printed directly above it. A key, of course, is itself symbolic of the unlocking of something such as a door that has been locked to keep people out or secrets in. In future, the password printed 'in Hebrew'

would be sent out each quarter in the *Monthly Reports*, and by comparing the letters to the 'English alphabet', the new password would be revealed.[13]

The union, with its social strata and hierarchy, was a class system in itself within the broader class system of Victorian society. Much of its new imagery referred to the secrecy of its clandestine years and its links with Freemasonry, which had also evolved from a medieval craft guild to a society of brothers engaged not in manual labour, but in philosophical work. Trade unions organized themselves along lines of the infrastructure of Freemasonry, with passwords, officers, regalia, rituals, lodges and grand lodges. In their lodges, the skilled craftsman and the factory worker alike bonded together for mutual protection, but almost as a by-product of membership they also learned organizational and leadership skills that would eventually lead to the formation by the working classes of their own political party. The history of the developments of trade unions after the repeal of the Combination Acts is well documented and no purpose is served by reproducing it here. Suffice to say that by the middle of the nineteenth century, new membership certificates for the home and banners for public display were being produced, the large majority of which were formed in terms of the classical, which, from the 1820s, had been undergoing an immensely popular revival in architecture, art and sculpture. The classical speaks of rationality, Roman Republican values and democracy. However, there was also a minority of unions and friendly societies who employed the Gothic as their way of representing themselves, influenced by the Gothic Revival. The great Victorian architect Pugin saw the Gothic as the expression of religious values embodied in British medieval architecture, but of course its roots are French, originating in the Church of St Denis of Abbot Suger.

Chartism entered the political field in 1837, originating in the London Working Men's Association. It proposed a radical charter of 'universal' suffrage (by 'universal', however, it meant for men only), annual parliaments, secret ballots, no property qualifications for Members of Parliament, salaries for MPs and equal electoral districts. The movement was divided into those who wished to achieve these aims by force and those who merely advocated moral reform. These internal rifts, along with stiff government repressive measures, eventually resulted in the demise of Chartism in the 1850s, but not before London had been so intimidated by a Chartist rally held there in 1848 that the city was fortified and armed, anticipating rioting and revolution that did not happen.

Benefits first offered by the savings clubs of friendly societies became more and more important in the nineteenth century when the Poor Law Amendment Act of 1834 abolished parish relief for paupers in their homes and brought in the cruel conditions of the workhouse. The Anatomy Act of 1822 allowed the bodies of those who died in the workhouse to be collected by medical schools for dissection, saving the cost to the parish of burial. Under their 1839 Rule Book, when a member of the Order of Friendly Boiler Makers was thrown out of work, every man in his branch was required to claim an extra shilling a day from their employer to donate to him. If an employer refused, members in other workshops or yards were informed and expected not to take up any future employment there. Men also charged employers double

rates for night and Sunday work, not for their own benefit but in order to discourage overtime working so that employers would give jobs to the unemployed.[14] Many later trade union and friendly society banners and certificates, such as the 1866 certificate of the Amalgamated Society of Carpenters and Joiners by Arthur John Waudby (Plate 2), contain reassuring depictions of their insurance benefits. In this emblem, flanking scenes of working men, four small vignettes set between the two incised Corinthian pilasters on each side of the arch show the reverse side of the coin – what happens to those unable to work. They depict the accident at work, the £100 benefit payment, superannuation payment and relief of the widow, scenes which recur in so many emblems of the period. Union officials (sometimes holding conspicuously large bags of money) are pictured visiting the sick, the injured or the widowed, and old people sitting happily outside rose-covered cottages or at a cosy fireside – images designed to comfort and allay the fear of the workhouse. Later, under Lloyd George's National Insurance Act of 1911, all wage earners were required to belong to a legal institution such as a trade union or friendly society for unemployment and sickness benefit. When this was replaced after the Second World War by state-controlled National Insurance and the National Health Service, the need for friendly societies within the United Kingdom dwindled.

The designs of the certificates and banners of Victorian and Edwardian trade unions frequently have their roots in the ancient coats of arms of the guilds of their trades. The new certificates are the successors of the 'blank book', 'clearance' or 'document', a type of passport given by eighteenth-century trade clubs and sometimes friendly societies to their members when they were forced to move from place to place looking for employment. In the towns he visited, an unemployed member would present this document, printed with his trade emblem and stamped up with paid contributions, at the lodge or 'house of call' of his society (usually a public house) where employers came to seek out workers. This document entitled him to receive board and lodgings and a tramping allowance. A 'call book' would be kept there, as a record. If there was no work to be had, he would tramp on to the next town that had a branch.[15] Henry Broadhurst, a stonemason and later a Member of Parliament, describes in his autobiography how he, in common with many other working men, had been itinerant, moving from place to place as work became available.[16] R. A. Leeson's excellent book *Travelling Brothers* gives a comprehensive account of the tramping system.[17]

According to the first Rule Book drawn up by their General Council in 1839, members of the Order of Friendly Boiler Makers were required to have been members for 12 months and to be up to date with their contributions before being eligible for tramping, and were required to obtain a certificate from their Branch Secretary to present to the Branch Secretaries in the towns they visited. If they had been in the union for over two years they could also claim (in addition to supper, a pint and a bed for the night) 1d. for every mile travelled by land or water since the last benefit payment received. Crossing the waters between England and Ireland, or vice versa, entitled them to receive 5s. However, they could not visit the same branch twice within 6 months to claim benefit.[18]

When members of a particular trade united in 'mutual understanding' with members of other towns, a united society was formed and an emblem conceived.[19] The design of these early trade union emblems and banners, based on coats of arms or armorial bearings of the medieval craft guild, tend to be very balanced, with a figure each side supporting the coat of arms. The 1838 banner of the Friendly Society of Sawyers, Whitehaven Branch (Plate 3), is as example of this early type of emblem, in which a central motif is flanked by two associated symbols, and an identifying description of the trade. This banner demonstrates the close links between sawyers and shipbuilders. It illustrates two types of saw for cutting timber into planks and, to the bottom left, a sawyer and sawpit. On each side of a central roundel containing a sailing ship, sawyers hold aloft tools of the trade – the plumb line and the carpenter's rule. We can trace this type of emblem back to Roman trade mosaics in commercial buildings such as that in the Forum of the Corporations, Ostia (Plate 1) and to monograms, such as that of a title page from a now lost illustrated codex of circa 354 (Plate 4), with this balance between two figures supporting a central panel, repeated so often in early trade union imagery. This arrangement of a central motif flanked by associated symbols to form a trade emblem is also common to eighteenth-century memorial hatchments.

Gorman, in his iconic and groundbreaking book, *Banner Bright*, believes that the format of the design of many Victorian trade union emblems can be traced back to the banner maker George Tutill, born in Howden, Yorkshire in 1817 and believed to have set up in business in 1837 at the age of 20.[20] Certainly by the age of 21 he was defining himself as 'artist', as evidenced by his occupation on his marriage certificate.[21] Gorman writes that Charles Henry Caffyn, whose parents worked for Tutill in the 1880s, believed that Tutill began life as a travelling fairground showman and from there took on commissions to paint banners for unions.[22] However, as Roger Logan writes in his excellent and comprehensive biography of Tutill, 'There is no available evidence to confirm or refute the contention that during his youthful years he was involved with travelling fairs or shows.'[23] Gorman's theory is that Tutill copied the format for his banners from painted fairground canvasses, and he illustrates his theory with photographs of fairground canvasses dating from the 1890s. These have a tripartite structure with a central arch surrounded by roundels, cameo inserts surmounted by large pictorial canvasses with corner roundels and ornate decorations. However, as is shown in a later chapter herein, this type of structure is present in trade union imagery from a far earlier period. The Sheffield Typographical Society, for example, used an elaborately decorated arch format in an 1832 commemorative poster celebrating the passing of the 1832 Reform Act.[24] Indeed, sheet music covers, handbills and all manner of advertising materials of the nineteenth century, such as a playbill of the 1850s advertising the delights of the Cremorne Gardens, are also in this ubiquitous format. In some ways it can be seen as mimicking the theatre or music hall with a central 'stage' and tiers of 'boxes' on each side for the audience. In the 1850s Cremorne Gardens playbill advertisement (Plate 5), which predates Gorman's 1895 examples by 40 years, there is a tripartite division effected by classical arches, supported each side by allegorical women on plinths, large central scenes, vignettes in decorative frames, all given explanatory labels beneath, very

much in the manner of trade union emblems, such as that of Waudby's 1866 certificate of the Amalgamated Society of Carpenters and Joiners (Plate 2).

In medieval and Renaissance times, allegorical tableaux, descendants of medieval mystery plays, were presented in honour of the procession of a hero on a roadside stage in the form of a triumphal arch.[25] These freestanding arches, which were designed by leading architects and artists of the city, featured flanking columns supporting a cornice and pediment. A tableau or play would be performed on them, with the actors dressed as classical gods, heroes and personifications. They were placed along the route of the procession, elevated to maximize the viewing experience. Vasari gives an excellent description of Sansovino's wooden triumphal arch for the festivities of 1514:

> Then in the year 1514, a very lavish display had to be mounted in Florence, for the visit of Pope Leo X, and orders came from the Signoria and from Giuliano de'Medici that many triumphal arches should be erected, in wood, in various parts of the city; and so Sansovino not only made the designs for many of them, but also undertook in company with Andrea del Sarto to make himself the facade of Santa Maria del Fiore all in wood, with statues, and scenes, and architectural orders, exactly as one would like it to be in order to remove all its Gothic order and composition. [...] Sansovino had constructed the facade in the Corinthian order giving it the appearance of a triumphal arch, and that he had placed, on an immense base, double columns on each side with some huge niches between them, complete with figures in the round representing the Apostles; and over this were some large scenes in half-relief made to look like bronze with episodes from the Old Testament. [...] Above came the architraves, friezes, and cornices, projecting outward and then varied and very beautiful frontispieces. Then in the angles between the arches, on the broad parts and below, were scenes painted in chiaroscuro.[26]

This description conjures up an image very similar in overall design to that in Waudby's Carpenters and Joiners emblem (Plate 2).

Corneille de Schryver calls such a stage a *pegma* in his account of the entry of Philip of Spain into Antwerp in 1549.[27] And, as McGrath has shown, pegma and trade bodies have a long and close connection, guild arches of the trades having formed part of these parades, pageants and civic festivals.[28] They constituted an ideal opportunity for trades to advertise their profession publicly and enhance their prestige. The Shipwrights and Fishmongers might enact a biblical story such as that of Noah with his ark on their pegma, Jonah being swallowed by a great whale, or the classical myth of Arion and his dolphin; the Skinners might depict Orpheus charming animals; the Drapers might enact the story of Jason and the Golden Fleece; the Bakers and Vintners, parables of bread and wine or Bacchic feasts; the Goldsmiths, gifts of the Magi; the Grocers, the story of Adam and Eve and the apple in the Garden of Eden; the Blacksmiths and Ironmongers, Vulcan and his forge; the Painters, St Luke painting the Virgin, and so on. In London, the Lord Mayor's show had a new decorative

programme each year devised by the particular company to which the new Lord Mayor belonged – an unmissable opportunity to promote his trade.[29] The trade signs of the Tudor period hung outside Britain's shops also display this tripartite division of the architectural space, the classical pillars and capitals, and depictions in small scenes of the work of the trade, all arranged around a central 'portal'. In the French print of the Confraternity of Farm Labourers (1771, Plate 6) there is a classicized architectural framework containing an Annunciation, saints and members of the guild. In a *praedella* below, farmers plough, dig and prune, their implements depicted in the blazon above. Engravers also provided the confraternities with *cartas* (diplomas).[30] So the links between the old guilds and confraternities with the type of fictive architectural setting of Victorian and Edwardian trade union emblems, such as that of the certificate of the Amalgamated Society of Carpenters and Joiners by Arthur John Waudby (1866, Plate 2), can be traced back in art to the Renaissance, many centuries before George Tutill and the fairground canvases of the 1890s that Gorman cites. Many banners of the Victorian period such as Tutill's feature elaborate scrolling foliate decoration surrounding the central image, a design frequently found in Renaissance tapestries, so this tradition of reproducing images on fabric must also be taken into account.

Pegma have remained popular right through to the present day. In London, Temple Bar, a permanent arch built in 1670 to designs by Christopher Wren, was also a site of ritual and pageantry. Constructed right on the border between the City of London and the City of Westminster, its gates were barred to the monarch. The Lord Mayor granted entry to the monarch only upon his relinquishing a ceremonial sword, which was returned to him on the way back through. Temple Bar was draped in black mourning cloth for the funeral of the Duke of Wellington in 1852 and decorated with brilliant illuminations for the wedding of the Prince of Wales in 1863.[31] Two temporary triumphal arches, covered in laurel and various greenery and flowers, marked the procession of the royal family through central London in 1872 to the thanksgiving service at St Paul's for the recovery from illness of the Prince of Wales. To mark Queen Victoria's visit to Wolverhampton in 1866, an arch was constructed from local coal; in Swansea, in 1881, an arch made of wool and gilded iron bars was erected by the Wool Staplers, whilst in 1897 an arch made out of blocks of salt was built to mark the opening of a new technical school in Northwich. And when the Duke and Duchess of York visited Toronto in 1905, an arch was built over the route of the procession by the Independent Order of Foresters, and members of the order actually stood along the top of it, dressed in full regalia. So the pegma tradition continued well into the twentieth century. Indeed, we still see vestiges of the tradition on our streets today, for example marking the end of marathons, car and cycle races.

The certificates of the Victorian era follow in the tradition of these temporary trade arches. Many of the artist Arthur John Waudby's designs for the Victorian unions (see Plate 2) feature a classical entablature, a large central space flanked by two smaller ones marked off by pilasters, surrounded by classical figures and complex classical swags and ornate decoration, in an outdoor setting. Waudby's designs for the unions have merited a chapter to themselves.

Arches, portals and doorways are symbolic of the transformative properties of rights of passage, something to be journeyed through to the other side. They stand between what is now and what will be. In wall tomb sculpture, open doors both invite yet repel because of the attraction and the fear of the unknown on the other side. In banners and certificates of the New Model Unions, these arches and portals speak of the transformation of the self by means of apprenticeship, the state of 'becoming' by passing through them, the ancient symbolism of passing over the threshold as a rite of passage. In the same way that the monarch was barred from passing through Temple Bar until given leave, the workman was barred from entry to the trade until he had passed through the appropriate apprenticeship.

The connections between the trade union emblem and the frontispiece of books are discussed in the following chapter, 'The Emblem within the Emblem'. The frontispiece is an emblematical title page of a book, made up of visual symbols that sum up the meaning of the entire work, and Corbett and Lightbown theorize that the frontispiece may have its origins in the pegma.[32] Figures, allegorical, biblical or modern, standing in niches or perching on the top of classicized structures with inset plaques of dedication or explanation, are common features in frontispieces, as with the pegma tradition. The frontispiece acts as a formal 'entrance' to the work within, a visual introduction, and pattern books of their designs were in constant use by engravers. This concept of 'entry' is, of course, highly relevant in trade union certificates. With the restrictive closed-shop practices that unions imposed to prevent the dilution of the trade by unqualified men, and in trade union certificates and banners of the 1860s, the arch represents the apprenticeship system, the only means by which 'entry' might be obtained through education to the class of master craftsman.

One of the problems with the study of trade union art is that we have little knowledge of what has been lost. Of the artists and draftsmen who formed the designs of the emblems we know little, in many cases not even their names. Many old certificates were discarded by later generations, the recipient having been long since dead and no longer remembered. Much of our heritage was lost in the bombing raids of the Second World War. Some banners, for example, may be seen only in tantalizing glimpses from old photographs or illustrations of parades. High winds were a constant hazard to these great, silken sails and many were ripped apart in this way during marches, or attacked by police and destroyed. Insufficient drying out after rain and poor storage resulted in mould and rot eating away banners. In addition, banners were never meant to be suspended for long periods of time, yet were regularly displayed as a backdrop in meeting halls. Such prolonged hanging results in the weakening of the fabric, which eventually is pulled apart by its own weight. Changes in temperature and humidity combined with pollution from coal fires, oil stoves and cigarette smoke cause warping, fading, discolouration and general disintegration. Unions were not usually required to keep records of the location or condition of their banners and so, when amalgamating, moving premises, commissioning new banners or when closing down altogether, old or outmoded banners were often discarded and destroyed. After the failure of the national strike in 1926, many of the

old banners were lost forever but the style of the Victorian banners sometimes lives on in newer ones.

It is mainly due to the work of the late John Gorman and his wife, Pamela, who travelled the country during the 1970s and 1980s to find, record and write about the banners of the trade union movement, that interest in them has been rekindled. In recent years, the People's History Museum, Manchester has spearheaded a National Banner Initiative to locate and record existing historic banners.

Originally, banners were made by local signwriters or coachmakers, or by branch members or their wives. Early nineteenth-century flags, unlike banners, were mounted on a single pole and were embroidered or painted, often by the members themselves, and typically depicted heraldry copied from the livery companies, tools of the trade and even puns, and often they were hastily prepared because they carried demands for immediate action.[33] With the Victorian era came commercial manufacturers who often took the designs of the union's amateur artists and painted them onto the silks.[34]

The great banner maker, George Tutill, was an artist in his own right, specializing in landscapes and exhibiting at the Royal Academy – his oil painting *Scarborough Castle* being shown in 1846. At the British Institution he exhibited *Douglas Bay* in 1850, *Laxey* and *Holy Island Castle* in 1851, *Tare Mountain, Killarney* and *Glengareff* in 1852.[35] He is also listed as having exhibited *Bantry Bay, Hungry Mountain in the Distance* (on sale for £15 15s.) in 1855 and *Mouth of the Humber* (sale price £21) in 1858.[36] In 1842, Tutill became a member of Court 'Uriah', No. 1416 of the Ancient Order of Foresters, a friendly society, rising to the rank of City of London District Chief Ranger (Court No. 1810) in 1845 and serving on Final Appeals committees at the 1847, 1849, 1856 and 1861 High Court meetings as Chairman.[37] 'Brother Tutill' was thus well placed to supply the burgeoning market for banners and regalia.

His banner-making company at 83 City Road, London, was purpose-built, with three galleries lit by natural light emanating from a glass roof. From here, it is estimated that he manufactured more than three-quarters of all banners produced from 1837 onwards and also cornered the export market to the colonies. His advertisement of 1895 proudly proclaims that he exports to India, Australia, New Zealand, West Indies, Canada, United States, Newfoundland, the Orkneys, Gibraltar and 'the most extreme points of the civilized world'. In 1879 he won a silver medal at the Sydney Exhibition. During the 1880s, shortly before his death in 1887, he travelled to his markets in Australia, New Zealand and America, where he visited New York, Hawaii, San Francisco, Salt Lake City and Chicago.

His factory handled the entire process, from the dying and weaving of the raw silk to the cutting, painting and trimming of the banners, and the front cover of his catalogue depicts many of these processes. His silk banners had painted scrolls and foliage, but during the 1880s, he imported a Jacquard loom reputed to be the largest in the world, which produced a two-colour, woven silk ground, and was programmed with punchcards, like a pianola, repeating a pattern every nine feet, leaving a central area free for the emblem. His team of artists then painted these central panels, the cameos and the lettering, using oils. Some specialized in the copying from photographs

of machinery or buildings, others in portraiture or in lettering. From his catalogues, we can see that he produced not only regalia and banners for the unions and friendly societies, but also for Sunday schools, churches and chapels and he invited prospective customers to come into his London factory to view the banners being made.[38] Because of Tutill's monopoly of the banner-making trade, designs became standardized and frozen into a 'type', mechanized and easy to reproduce, with a painted medallion or roundel in the centre and woven foliage around it filling in the rest of the banner. The banner of the Transport and General Workers' Union, Export A. 12. C. Branch, dated post-1922 (Plate 7), shows this style surviving well into the first quarter of the twentieth century, and the designs in the catalogue of 1930 of the banner makers, Bridgett Bros, 19 Pakenham Street, Dublin Road, Belfast, are based entirely on the same style.

The Tutill factory was destroyed during the London Blitz. The archives were lost in the fire and no museum had been kept, so sadly we know nothing of the artists who worked for him during the early years, although photographs exist of later artists at work. The factory was rebuilt, continuing in manufacture until the 1960s, when it closed, and the great Jacquard loom smashed and sold for scrap. Its successor, 'George Tutill', based in Chesham, manufactures banners and regalia, and Toye, Kenning & Spencer also continue in business.

The earliest banners in the collection of the People's History Museum (which houses the largest collection of trade union banners in the country) date from about 1820. Traditionally, banners are made from silk, but some were made in other fabrics, such as linen, with appliqué work and embroidery. Early banners are painted in oils, sometimes directly onto the fabric.[39] Some have ground layers, but even museums specializing in the conservation of antique banners, such as the People's History Museum, have limited facilities to analyse them. However, according to Vivian Lochhead, Senior Conservator at the People's History Museum, these grounds are of a type of chalk. Unfortunately, many of Tutill's dyes were the new synthetic dyes of the Industrial Revolution, such as aniline dyes, and they have tended to bleed badly. He developed a rubberized treatment for the silk, which he patented in July 1861.[40] Again, according to Vivian Lochhead, there is insufficient evidence to be able to state categorically whether these treated banners survive in any better condition than untreated ones, as of course other factors such as the circumstances of their use and how they were stored also affect their condition. From her work in cleaning and conserving the banners, she believes that Tutill artificially aged his oils, using a siccative process to speed up the drying period of the painted areas.

As with a painting or other work of art, banners are often signed, either by the manufacturer or by the artist. Tutill usually printed his name clearly either on the central painted panel or, in the case of his Jacquard banners, woven into the lower right-hand corner. As a result, where a banner is made of just a single piece of silk rather than being double-sided, his name appears in reverse on the back.

Newspaper accounts of the nineteenth century report that on special occasions, such as the Shrove Tuesday March in Derby and the laying of the first stone of the Operative Builders' Guildhall, Birmingham, that temperance societies (which included juvenile branches aimed at persuading the young to eschew the temptations of alcohol),

Foresters, Oddfellows and other friendly societies, Freemasons and trade unions all marched together in one great procession in their uniforms and regalia, with their banners and their bands.[41] Even still, in relatively recent times, we read of banners being blessed in church.[42] Banner makers manufactured for unions, friendly societies, Sunday schools and churches, so it is not therefore surprising that on the backs of trade union banners, artists simply depicted favourite biblical stories, with scenes often relating to the patron saint of the old guild or with relevance to the work or materials of the union. Alongside these religious symbols and figures of the Judaic/Christian tradition, however, are the old pagan gods and goddesses.

Erasmus Darwin had revived the process of the deification of nature and natural phenomena embodied in classical myth in order to extol the latest scientific theories and inventions. His didactic poems, especially *The Botanic Garden* (published towards the end of the eighteenth century),[43] use the classical convention of eighteenth-century didactic poems to describe graceful nymphs who metamorphose into modern machinery.[44] His mixture of mythology, machinery and poetry expressed the intellectual attraction of the desired union between the sciences and the arts, and it is this same blending which is expressed in so many of the new emblems of the unions.

In 1857, Karl Marx wrote,

> Is the view of nature and of social relations which shaped Greek imagination and thus Greek [mythology] possible in the age of automatic machinery and railways and locomotives and electric telegraphs? Where does Vulcan come in as against Roberts & Co., Jupiter as against the lightning rod, and Hermes as against the Crédit Mobilier? All mythology masters and dominates and shapes the forces of nature in and through the imagination; hence it disappears as soon as man gains mastery over the forces of nature. What becomes of the Goddess Fame side by side with Printing House Square? Greek art presupposes the existence of Greek mythology, i.e., that nature and even the forms of society itself are worked up in the popular imagination in an unconsciously artistic fashion. [...] Is Achilles possible where there are powder and lead? Or is the *Iliad* at all possible in a time of the hand-operated or the later steam press? Are not singing and reciting and the muse necessarily put out of existence by the printer's bar; and do not necessary prerequisites of epic poetry accordingly vanish? But the difficulty does not lie in understanding that the Greek art and epos are bound up with certain forms of social development. It rather lies in understanding why they still afford us aesthetic enjoyment and in certain respects prevail as the standard and model beyond attainment.[45]

The gods and goddesses of the ancients, however, rather than vanishing from sight, buried beneath the foundations of the mills and factories, the canals and railways of the Industrial Revolution, lived on and flourished in the emblems of the unions. In fact, as Chapter 2 will reveal, the Goddess of Fame herself appears in pride of place at the very top of the emblem in Plate 45.

Chapter 2

THE EMBLEM WITHIN THE EMBLEM

Annie Ravenhill-Johnson

The tradition inherited by artists who created the new Victorian trade union emblems is both long and venerable. As we have seen, the arrangement of a central motif flanked by associated symbols to form a trade emblem, seen so frequently in emblems from the beginning of the nineteenth century, can be traced back to Roman floor mosaics. This chapter considers the history of the emblem tradition itself, how it is reflected in the new emblems designed in the nineteenth century for the working classes, and what this reveals about working-class consciousness.

The Greek word for emblem implies any sort of inserted part, but the Latin *emblema* was a technical term for inlaid works of art, especially mosaics – such as the floor mosaics in the Forum of the Corporations, Ostia (Plate 1) – and ornamental reliefs. The Roman rhetoricians Lucilius, Quintilian and Cicero used the term *emblema* in an ironical way to characterize a speech, composed of interwoven points.[1]

Emblems also have their origin in the Latin *symbolum*, Italian *impresa* (the 'device' – a chivalric symbol chosen to depict a personal preoccupation, aspiration or vow). They were not only displayed on shields, banners and surcoats, but also on jewellery, medals, buildings, furniture and books. The literature on devices dates from Florence in 1555 with Paolo Giovio's *Dialogo dell'Imprese amorose e militare*,[2] but an *impresa* or device has only two parts, a title and an image, as opposed to the tripartite emblem, which comprises a motto, an illustration and an epigram containing a moral.

Whereas the device was primarily a chivalric, courtly symbol, the emblem was the province of the learned man. The *Emblemata* (1522) by Andrea Alciati, a Milanese lawyer and humanist, is considered to be the first emblem book.[3] According to Moffitt, Alciati's main literary source was the *Anthologia Graeca*, a collection of Greek epigrams edited by the Byzantine scholar, Maximus Planudes (circa 1255–1305), published in 1484. Alciati was one of three translators of a new edition, *Selecta Epigrammata Graeca Latine Versa*, published Basel in 1529, and a quarter of Alciati's emblems were direct translations or paraphrases of it.[4]

The Greek word for epigram denotes an inscription and most were written in elegiac couplets, a verse form developed circa 500 BCE. They were designed to

commemorate special occasions. Typically, they describe something in a way that also signifies something else, and Alciati's epigrams, now called *emblema*, verbally describe something in such a way as to give an alternative meaning, usually moral.[5] In this, he follows in the tradition of Aesop (sixth century BCE). Aesop's book of fables concerns animals, but these stories also offer a moral interpretation, with the underlying message that God reveals himself to mankind through his entire creation.[6] Alciati was further influenced by his friend Erasmus's moralized interpretations of proverbs, *Adagia*,[7] and by Sebastian Brandt's illustrated moralizing stories, *Das Narrenschiff* (Ship of Fools).[8]

Alciati's book was published in Augsburg, 1531. His publisher, Steyner, added little engravings to his epigrams commissioned from Jörg Bren in order to make the meaning clearer.[9] Each emblem consisted of a small allegorical picture (the icon), a motto (the lemma) and an explanatory verse (the epigram). In these early emblems, it was the verse or epigram which was important. Modelled on the ancient Greek and Latin epigram, it contained a description of a pictorial invention. According to Moffitt, a further source for Alciati's emblems is the illustrated Greek manuscript of Horopollo's *Hieroglyphica*. This manuscript arrived in Florence in 1419 and was translated into Latin in 1517 by Filippo Fasanini, Alciati's tutor at Bologna, who describes hieroglyphics as 'short sayings [...] which can, in combination with painted or sculpted figures, wrap in shrouds the secrets of the mind'.[10] Later emblem books printed the pictures separately at the beginning so that the reader had the enjoyment of deciphering them before looking up the real explanation in the poem at the back of the book.[11] There was never a complete English translation, but 86 emblems were paraphrased in Geoffrey Whitney's *A Choice of Emblemes* (1586).[12]

According to Claude-François Ménestrier (*L'art des Emblemes*, 1662),

Images are what constitute the matter of emblems, for emblems are instructions which must enter through the eyes in order to pass through them towards the soul. The images are obtained from all perceivable objects, and from these we can represent spiritual things by using human figures. Hence, Nature, the Arts, Fables, the [Ovidian] Metamorphoses, Proverbs, Apologetics, Moral Sentences, Axioms drawn from the Sciences, examples taken from History and the fictions of the Poets are all material proper to emblems; for all these [subjects] provide images which can instruct us [...]. Images applicable to an emblem are natural figures, symbolic figures and poetic figures. Natural figures are the images of things with which we are familiar, such as an eagle, a lion, a rock, a river. Symbolic figures are the symbols or hieroglyphs denoting certain things, such as the Caduceus of Mercury, the Horns of Plenty, etc. Poetic figures are images belonging to virtues, vices, passions and other moral, civic and spiritual things which do not submit to the senses; for they only represent a moral state or a spiritual state, such as virtue, the angels, the soul, life, honor glory, etc.[13]

Designers and producers of trade union emblems of the mid-Victorian period appear to have taken Claude-François Ménestrier's advice to heart, as his words conjure up

many of the emblems of the period, peopled as they are by virtues, Nikes, angels, gods and containing horns of plenty, *fasces*, animals, mottoes and so on.[14]

Thus, when the New Model Unions commissioned their first emblems, certificates and banners in the 1850s, they chose artists such as Arthur John Waudby and Alexander Gow, trained within the rigid Victorian art school system and who would have been versed in the moralizing tradition, to fashion their identifying images. These artists devised grand new inventions based on the old trade emblems, but incorporating stock emblems known from books of emblemata, handed down from the Renaissance, and moralizing Books of Trades that lent dignity and authority to union imagery. As R. A. Leeson records, 'They followed the medieval tradition that an emblem must contain "some witty deuice [...] something obscure [...] whereby when with further consideration it is understood, it maie the greater delight the beholder."'[15]

From the emblem, the frontispiece developed – an emblematical title page comprising visual symbols that expressed the meaning of the whole book. These symbols were probably chosen by the author in order to provide him with a second 'language' in which to reinforce his message. A front or facade to a book, the frontispiece acts as a formal entrance to the work – an elaborate allegorical and emblematical visual introduction to its contents.[16]

Pattern books of emblemata and frontispieces were used by engravers. Certain types of frontispiece design were in constant use, and became traditional patterns, as books became more and more widespread. Woodcut title pages could be used over and over again for different books because they were set in movable type so that the framing border could be reused.[17] William Hole's engraving for the frontispiece of *The Workes of Beniamin Jonson* (1616, Plate 8), depicts the type of architectural frontispiece which may be the inspiration for many trade union certificates and banners. If we compare it with Arthur John Waudby's certificate of the Amalgamated Society of Carpenters and Joiners (Plate 2), we see at once that both feature a figure at the top of a classical arch, flanked by two inward-facing figures beneath, with a central feature between them (in Waudby's certificate, the old guild coat of arms). Beneath are two sets of pilasters or columns on each side flanking a central feature (in the frontispiece, the title of the book; in Waudby's, two scenes of carpenters and joiners at work). The two figures between the columns in the frontispiece become the figures of Justice and Truth in Waudby's certificate, moved to the outer edge of the structure. In the centre of the base of the structure is an oval plaque containing details of the place of publication and printer, whilst in Waudby's certificate is a round medallion or picture containing an emigration scene.

It is from these traditions, handed down from the Renaissance, that a host of available symbols came to be used by trade union artists to form emblems. When, in 1851, the Amalgamated Society of Engineers, Machinists, Millwrights, Smiths and Pattern Makers ran a competition for an emblem for their newly formed union, it was won by a design by the 26-year-old blacksmith James Sharples (Plate 45). His prize was £5 and the emblem was engraved by George Greatbach and hand-coloured. Later editions dating from 1869 were printed by Gow, Butterfield & Co., and in 1889 and in the early twentieth century by Blades, East & Blades.

Sharples employs many of these 'stock' symbols, which he may have culled from various sources (for example, books, journals and popular advertisements, as well as the emblems paraded on the banners of other trade unions). His design also relates to a long tradition of forge paintings, which mix classical mythology with depictions of the modern blacksmith. He was most probably influenced by the design of the emblem of 1834 produced under the direction of another workman, William Hughes of the Order of Friendly Boiler Makers, and the 1844 certificate deriving from it (Plate 9). The eye in Hughes's design has been replaced by a dove in Sharples's, and the compartmentalized space between the workers moved to the lower part of the structure. Hughes's choice of motto, 'Humani Nihil Alienum',[18] is replaced in Sharples's emblem with 'Be united and industrious'.

Sharples presents the viewer with scenes of manual labour in the manner of high art, and depicts his fellow workers as heroic, in the elevated manner associated with the history painting of high art. His design is very much in keeping with the new recognition of the times that the wealth of the nation rested on its industrial output, and the skills of its working men. His emblem appears to anticipate the words of Karl Marx of 1856:

> We know that to work well the new fangled forces of society, they only want to be mastered by new fangled men – such are the working men. They are as much the invention of modern times as machinery itself. The English working men are the first born sons of modern industry.[19]

The basis of the composition is a low, arched structure of wood or stone with pilasters and painted Doric capitals. Inside Sharples's structure are small 'rooms', like stage sets, containing scenes representing five branches of the iron trade and a central room housing a piston engine.[20] The representation of hot and dirty back-breaking industrial labour is idealized and depicted as clean and sanitized.[21] The rural *Georgics* tradition of processing the earth's raw materials through ploughing and harvesting is here transposed to industrial labour. In his didactic work the Latin poet Virgil had made his treatise on husbandry a metaphor for the human condition. In Sharples's design, good management of the raw materials indicates morality, continuity and good government of the country. But the viewer is barred from this inner sanctum of skilled labour, so rigidly enforced by the union, and cannot enter, but must merely view it from outside.

In the top of the structure, set into what appears to be a sheet of copper, are three portraits in oval medallions of Crompton, Arkwright and Watt, the inventors and improvers of the mule jenny, the spinning frame and the steam engine. All are copied from existing portraits, which Sharples could have seen in books, journals or newspapers. The classical toga of Watt elevates him and endows him with Roman attributes such as *gravitas* and *humanitas*. Displayed like a Trinity, they resemble ancestral portraits, and the young men above in modern dress are their heirs. Each portrait is framed in a gilded frame by a serpent devouring its own tail.

Ouroboros, the serpent that renews itself by devouring itself is, of course, a classical symbol of eternity. Alciati depicts it in his Emblem 132: 'Immortality is acquired through humanistic study.' It reads, 'Fame accompanies men of outstanding talent, demanding that their illustrious deeds be read about throughout the world.'[22] So by framing the portraits with this symbol, the implication is that the fame of these three outstandingly gifted men will live forever. However, it should be noted that the brass serpent, also known as Nehushtan, is a Freemasonry symbol signifying truth, because in its nakedness it hides nothing.[23]

Beneath the portraits is a phoenix on its nest of flames. The phoenix, a mythological fire bird, is found in many mythologies including those of the Greeks, the Romans, Persians and Egyptians, and is mentioned by Philostratus and Ovid. A bird with beautiful plumage, it is said to have a very long life cycle, up to a thousand years, at the end of which it builds itself a nest and then self-immolates until it is reduced to ashes. And from the ashes arises a new phoenix, reborn, a symbol of immortality. Placed in such a prominent place in this emblem, it reminds us that this new amalgamated union arose from the ashes of several older ones. The phoenix on its flame appears in many emblem books; for example, in Theodore de Beze's 1581 book of emblems, *Vrais Portraits*. But The Phoenix was also the name of the actual foundry, Kay's Phoenix Foundry in Bury, where Sharples worked, its very name symbolic of the transformative process of the foundry, of metals transformed through fire. The phoenix is also a Freemasonry symbol, appearing on the aprons and ornaments of the Eighteenth Degree, again with the meaning of rebirth.[24]

At the outer edges of the top section, a classical figure on the left is breaking a single stick across his knee, whilst the one on the right cannot break the fasces, the bunch of sticks bound together, demonstrating that the unity of the workforce bound together can withstand pressures that would break the single worker. The fasces as a symbol of unity also appears in Gilles Corrozet's 1540 emblem book, *Hecatomgraphie*, in 'Amytié entre les freres'. But the story itself is far older, of course, dating back to Aesop's *The Bundle of Sticks*, which tells of an old man with two sons who, by the ease with which one breaks a single stick and the failure of the other to break a fasces, demonstrates that 'unity gives strength'.

At the top of Sharples's emblem, a classicized female figure stands on a cornucopia, the charmed horn of the goat of Zeus, which he presented to Amalthea, and which filled itself with wonderful fruits. The cornucopia or 'horn of plenty' is one of the most frequently occurring symbols in trade union emblems. It forms Alciati's Emblem 118, 'Fortune as the companion of virtue'. In Freemasonry, a password of the Second Degree is 'Shibboleth' which denotes 'plenty'.[25]

The woman standing on the cornucopia appears to be Nike, goddess of victory, but the union identifies her as Fame (Klymene or Fama), despite her lack of her usual attribute, the trumpet.[26] Here, indeed, is an answer to the question posed by Marx in 1857: 'What becomes of the Goddess of Fame side by side with Printing House Square?'.[27] She stands under the direction of the dove of the Holy Spirit, as in the Renaissance tradition of painting religious subjects, with the clouds parting to reveal

them, as in a divine revelation. She is facing the viewer directly, her hair is parted in the centre and every part of her wings and clothing is entirely symmetrical and matching on each side. From this we understand that she is completely impartial, a representation of balanced reason, and she hands out wreaths of laurel to the workmen.

Apollo's unrequited love for Daphne caused her to be turned into a laurel tree to avoid his unwelcome advances, and he broke off a branch to wear on his head in her memory.[28] Laurel became sacred to the god and laurel wreaths were used to crown the victors of contests such as the Pythian games because it is evergreen, signifying immortality, and therefore that the name of the victor would never die. It appears as Emblem 210 in Alciati, which says, 'Let such garlands adorn the heads of victors'. In Sharples's emblem Nike or Fame awards wreaths of laurel to the workmen.

The men are silhouetted against the Light of Glory in an oval *mandorla*. The mandorla or *vesica piscis*'s shape is derived from the intersection of two circles, and was used extensively in Byzantine, medieval and Romanesque art to enclose Christ and the Virgin Mary in order to show transcendence over time and space. Here, it appears to be made out of smoke, possibly from the chimney of an iron foundry or from a railway engine. By enclosing the workmen with the goddess under the dove of the Holy Spirit it is implied that they are sacred, God's chosen, honoured by the laurel wreath of the victor.

On each side is a group of three figures. The success of the kneeling classical figure on the left in breaking the single stick, and the failure of the other on the right who cannot break the bunch of sticks bound together, is explained and expanded upon by the little dramas enacted by the other two figures in each grouping. On the left, Mars offers up his broken sword for repair, but the blacksmith holds up his hand in a gesture of refusal. He is quite literally refusing to fan the flames of war. Without his sword, Mars is powerless. He is like the lone worker without union support – the single stick that is easily broken. On the other side, a female personification hands up a scroll to a worker with a vice. Her cloak is attached across her back by a golden cord, and beside her the fasces that cannot be broken is also bound with ropes. Implicit are the references to the cords that bind; she resembles Concordia, who symbolizes a binding together in peace. Concordia, like Eirene (Irene) and Pax, is a peace goddess. Eirene appears on coins with a cornucopia and olive branch and burning weapons. Placed here, in opposition to Mars and his broken sword, the obvious reading is that he represents War and she represents Peace. Her scroll may contain the names of the older, smaller unions being amalgamated. And she may be asking that they be held together tightly in the grip of the vice. The strength of the vice's grip would then be explained by the kneeling figure beside her who is unable to break the bundle of sticks bound tightly together. This message of peace through the power of unity is amplified by the olive branch carried in the mouth of the dove, which is echoed in the laurel wreaths being handed out to the workers and in the laurel wreath actually worn on the head of Concordia.

Taken together, we can see that the two groupings of figures represent the rejection of war and strife contrasted with the endorsement of concord and peace.

However, according to the key issued by the union to accompany the emblem, the female figure is Clio (the muse of history whose attribute is a scroll) and she is presenting a design to an engineer.[29] Yet in nineteenth-century painting, the convention for depicting plans or designs is to show them open, not in a scroll. This union was formed through the combination of several specialized engineering unions to become a national organization, so it is possible that Sharples's original message of binding the various factions together peaceably in the grip of the vice was rejected by the union in favour of an emphasis on this historic moment. For this reason the union leaders may, perhaps, have chosen to identify the figure as Clio in the key.

Resting above the foundation stone is an arrangement of flowers – the English rose, the Scottish thistle, the Welsh daffodil and the Irish shamrock. Diagonals formed by the railway lines on the left side of the image and the timber on the shore on the right side meet at the centre of this floral arrangement. These diagonals serve as an important compositional device, counteracting the downward diagonals formed by the triangle of the figure grouping in the upper section and the clouds. The railway has a factory in the background and on the horizon behind the timber is a sailing ship. The diagonals, by meeting in the national flowers of Britain herself, also point to Britain as a focal point for exports, thus expanding the union's motto of unity and industry to include the political union of the United Kingdom (exemplified by the grouping together of the flowers) and all her industries. Such pictorial explanation of a motto is very much in keeping with traditions of emblemata.

Lettered onto a band of blue strapwork resting on the foundation stone is the motto of the new union, 'Be United and Industrious'. The motto is explained by the depiction of scenes of industry within the compartmentalized structure and the visual sermon on unity on the top of it in the traditions of emblemata.

The all-seeing eye of God appears in many friendly society and trade union emblems (for example, in the certificate of the Order of Friendly Boiler Makers of 1844 by William Hughes, Plate 9), where it not only sheds rays down onto the scene beneath but also looks straight out of the certificate at the viewer, as though assessing him. Alciati portrays the eye in Emblem 16: 'Live Soberly and do not accept beliefs heedlessly'. According to Leeson, it was known to the guilds, expressed cabalistically for alchemists and Rosicrucians as a 'blind point' in a circle, and adopted by Freemasonry. For Oddfellows, for example, for officers and brothers it meant that no act, secret or thought remains unseen, and from thence went on to symbolize the vigilance of the central executive.[30]

Another frequently occurring image in trade union imagery is the handshake. This is normally shown as two disembodied hands ending at the wrists but here in the certificate of the Order of Friendly Boiler Makers, unusually there are four, forming the shape of a cross. Illustrated editions of Horapollo have body parts hanging in the sky, and this follows that same tradition. The handshake is the symbol of concord, as for example in Whitney's *Emblemes* of 1586. Whitney's motto tells us that Concordia, through the joining of the hands of great kings and princes, knits their subjects' hearts in one, which in turn makes both lands wealthier. She hates bloody battles and Envy,

and teaches the soldier to plough, whilst his armour rusts. The handshake itself between two right hands dates back to days of weaponry when shaking hands with right hands demonstrated the fact that no weapon was being carried, most people being right-handed. One can certainly see why it is one of the most popular symbols in trade union imagery, but of course it also refers to the secret handshake of recognition.

Another frequently occurring symbol is that of compasses. George Wither, in *A Collection of Emblemes, Ancient and Moderne* (1635), illustrates them as a symbol for constancy.[31] According to Wither's text, one foot of the compasses is firmly fixed to the ground and the other moves in a constant circle. This is a metaphor for standing firm so that whatever good deed is performed, perseverance and hard work will bring it to fulfilment.

Artists such as Arthur John Waudby were familiar with the emblematic tradition from sample books and iconologies. The central vignette in his emblem for the certificate of the Amalgamated Society of Carpenters and Joiners (Plate 2) is acknowledged to have been taken from a frontispiece of Nicholson's *Practical Carpentry*. Thomas Jenner, in his 1626 emblem book *The Soules Solace or Thirtie and One Spirituall Emblems*, uses the carpenter as an emblem of reconciliation to God.[32] The carpenter finishes forms, glues them together and from the two makes one, in the way that God and man, separated, are reunited through Christ the Carpenter, who is both God and man.

The witty element of mottoes was not entirely absent from trade union emblems. In that of the Amalgamated Society of Lithographic Printers formed in 1880, the motto 'The Stones Speak' is a play on words, together with the letters ENS in the coat of arms, and the German word for 'fields', making up in heraldic rebus style the name Senefelder, the German founder of the industry's first stone in 1798, whose portrait appears on the emblem.[33] The Nantwich Shoemakers' 1834 banner, painted by Thomas Jones, includes the light-hearted motto: 'May the manufactures of the sons of St Crispin be trod upon by all the world.'[34]

Classical mottoes and symbols from Renaissance emblemata arrived in trade union emblems filtered through the armorial bearings of the ancient guilds and unions, Renaissance emblem books and through Freemasonry. They became part of a new 'language' based on metaphor, and by the Victorian era they had become an integral part of society's collective consciousness. A cultural production used by the upper classes to express morality, they are part of the dominant ideology and value systems transmitted to the lower classes that are then reflected back by them, serving to reinforce the base, or economic system, upon which the capitalistic superstructure rested.

By adopting the elevated language of the oppressor, the class tensions existing within Victorian society could be eased. Many of the new emblems contain reassuring messages to the middle and upper classes, not only in actual words (central to Arthur John Waudby's Stone Masons' Friendly Society certificate of 1868 (Plate 10) are the words 'In all labour there is profit') but in depicting the working man as proud, industrious, respectable and nonrevolutionary, labouring to make Britain great.

With the coming of the Industrial Revolution, social mobility had begun to increase, and Freemasonry provided the vehicle by which the cream of the working classes could

belong to a society whose members included the highest in the realm. Ford Madox Brown, in *Work*, for example, depicts the skilled craftsman in waistcoat and bow tie, and a carrying a copy of the *Times*, in order to distinguish him from the lowly, unskilled manual labourer who was quite possibly illiterate. Friendly societies and trade unions adopted much of the regalia and ceremony of Freemasonry.[35] It is this legacy we observe in the banners and certificates of the early Model Unions. Trade unionists were using the language of classicism and Freemasonry to reassure the middle and upper classes that they shared in their culture and moral beliefs, that they were part of the brotherhood and working for the good of society. As Rose has noted, 'working-class cultural conservatism is a real phenomenon in industrial societies [...] a cultural conservatism that often coexisted with political radicalism.'[36] Although the Reform Act of 1867 gave the vote to many skilled male workers, especially in towns, it was not until 1884 that this right was extended to male workers in rural areas, including the unskilled, providing that they were heads of households.

The earnest claims of workers for respectability and recognition expressed in these emblems through shared values and shared symbolism, may have been instrumental in helping to achieve suffrage.

On the other hand, the use of classical symbols and emblems may be seen as the higher ranks of the working classes appropriating high art and using the 'language' of capitalism to claim social and cultural equality, thus empowering themselves. By inserting these references and emblems almost as collage, they render high art a truly 'social' thing, available to all. These emblems, with the constant recycling of themes and images from past eras, appear to anticipate Postmodernism even before Modernism.

Chapter 3

DEPICTING THE WORKER

Annie Ravenhill-Johnson

One of the most intriguing features of trade union emblems is the way in which the working classes themselves, together with their places of work, chose to be represented. In this chapter, the depiction of the working man in high art by professional artists is examined, together with *The Forge*, an oil painting by the blacksmith artist James Sharples, in which he represents the world of work with which he himself was so familiar. The processes of commissioning an emblem depicting union members and their workplaces are also examined in a case study from the 1870s of the United Society of Boiler Makers and Iron Ship Builders – the executive decisions, the instructions given to the artist and the reception of the new emblem by the members.

Industrial scenes and themes first had appeared in fine art during the Reformation in genre painting. Artists such as Holbein and Hans Hesse portrayed manual labourers such as miners as dignified and self-sufficient. Later, these themes gave way to depictions of the lives of rich merchants and, whilst there was still a hierarchy in the representation of workers, the lower classes frequently became relegated to tavern scenes.

However, attitudes to the representation of labour in high art changed quite rapidly in Britain with the advent of the new industrial society, and it is necessary to consider these changes and how they might impinge on the way in which the working class came to view itself when forming its own distinct imagery. There had been a tradition of the representation of the worker in paintings of landscapes and the countryside, but not in a modern industrial setting. Joseph Wright of Derby's *The Blacksmith's Shop* (1771) depicts a family forge. Domestic life and working life were not yet divided, there was no division of labour, and the workers are portrayed as heroic and noble. It speaks of a nation being forged, domestic harmony and happiness made possible by being industrious.

The French Revolution, the turmoil in Europe and the British wars with the French made travel abroad difficult for over a quarter of a century, and the draughtsmen who had accompanied gentlemen on their Grand Tours were forced to look for other work. Artists began exploring their own islands for subjects to paint, the British landscape

being of course a patriotic subject, despite the fact that the countryside was still not entirely free of footpads and highwaymen. Many of these lesser artists of the time, and indeed some better-known ones, turned their hands to the production of topographical paintings and prints of unusual places not normally seen, for instance industrial complexes and wild and untamed nature. Some artists focused on capturing the then fashionable 'sublime', found in the high drama of the play of light and shadow in these new industrial scenes and pictured at night for maximum effect.

By the nineteenth century, comparisons between conditions in industry and hell itself were being drawn by many, including Philippe de Loutherbourg and John Martin. De Loutherbourg's *Colebrook Dale by Night* (1801) is painted in lurid reds and blacks, fire and darkness, the awesome and the ugly aestheticized for maximum impact. These paintings of the new technology of the age reveal the spectacle of vast industrial buildings like great fortresses that ran 24 hours a day by candlelight, and of roaring furnaces like volcanoes. These terrifying works of man are often pictured beneath dark and threatening skies and under a pale moon, with tiny workers overwhelmed in scale by the fearsome majesty of their surroundings. The dim moon is contrasted with the blazing furnaces to show the forces of nature overcome and harnessed by the forces of man.

John Barrell theorizes that the upper classes had deliberately set out to create a landless proletariat (and therefore a dispossessed and dependent workforce) by means of enclosures and the removal of ancient rights.[1] Edward Said declares, 'It is the first principle of imperialism that there is a clear-cut and absolute hierarchical distinction between ruler and ruled.' He defines colonization as 'an act of geographical violence through which virtually every space [is] brought under control' and involves 'the loss [...] of the local place'.[2] Were the Victorian working classes a 'colonized' people? The subjugation of the men of a colony, and the prostitution of the women, is a feature of the colonial process. The affluence of the middle- and upper-class Victorian man was secured by the labour of the working-class man, whilst the purity of the middle- and upper-class woman was secured at the expense of working-class woman who, denied a living wage by bourgeois employers, was frequently forced into prostitution.[3]

According to John Barrell, at the end of the eighteenth century:

> The threat which the workers themselves might represent as an undisciplined, collective force was recognised, as writers and artists [...] appropriated the pastoral ideal of a life of light labour, as a radical ideology, in the face of an increasing demand on the part of employers and moralists that the poor submit to labour as a moral discipline.[4]

Thus the jolly imagery of Merry England, which had replaced the artificial imagery of the classical pastoral (where the good earth, Eden, provided all that mankind needed without work), was in turn replaced by the depiction of a cheerful, sober, domestic peasantry, which then gave way to a picturesque image of the poor. When this image

could no longer serve, it was in turn replaced by

a romantic image of harmony with nature where the labourers were merged
as far as possible with their surroundings, too far away from us for the question
about how contented or how ragged they were to arise.[5]

Turner, for example, in his 1796 watercolour *Cyfarthfa Ironworks*, roughly sketches the
workers as either turned away from the viewer or with their faces obscured. Their
clothing is drab and they merge with their surroundings, merely a part of the interior,
as though they had no other separate existence in the world outside. They are simply a
force, not actual people with identities.

Barrell writes that, by 1820, Constable

reduces all labourers to serfs, but [...] in the very same act he presents them as
involved in an enviable [...] relationship with the natural world, which allowed
his nineteenth-century admirers [...] to ignore the fact that the basis of his social
harmony is social division.[6]

Lord Penrhyn purchased (and probably commissioned) from the artist Henry Hawkins
a large oil painting of his own slate quarry, *Penrhyn Quarry in 1832* (Plate 11); 1832 being
the year that Princess Victoria, later Queen, had visited the quarry. In this painting,
nature is being conquered. The workers are painted in the colours of the landscape
itself, similarly subjugated. They are in constant motion. They hang precariously from
the steep slope on ropes, the danger exemplified by a young boy picked out in white at
the bottom centre of the painting, whilst in the distance others merge with the black,
dark mountain like sheep on a hillside. And, like sheep, they are but another producer
of wealth for the landowner. Only a few workers at the bottom right of the painting
are at ease, standing with tools idle, listening deferentially to the instructions of the
overseer with his open book and his assistant, who points towards the quarry. Peter
Lord identifies this figure as possibly the artist himself, but it is unlikely.[7] Until the early
1780s, men quarried the slate in return for a small rent and a royalty on the slates they
produced. However, in 1782 the landowner Richard Pennant halted this tradition and
appointed James Greenfield as his agent, employing workers directly. The men, who
had to provide their own working tools, ropes and chains, worked in gangs on designated
areas. On the first Monday of each month, they would agree with management on the
areas allotted to them to be worked. The painting appears to be of just such a meeting
with the agent, acting as the representative of the patron, allocating these areas. Such
a painting purports to demonstrate the knowledge and planning of the quarry owner
and the discipline imposed by him upon his workers. The workers, like the land itself,
are depicted as his property. The basis on which the Victorian unified society rested
was the control and direction of the workers by the landowning and industrialist
classes. The slate being produced here was roofing London and the new industrial
cities, helping to build the great empire, being exported to build the colonies and bring

wealth back into this country. This painting then is, like Sharples's certificate, in Virgil's *Georgics* tradition of good management of the land demonstrating patriotism and good management of the nation by the ruling classes, such as Lord Penrhyn himself. The intellect of the educated landowning class is portrayed as governing, directing and controlling the uneducated labouring class. As Barrell says, the foundation of paintings that purport to show social harmony is actually social division. The workers are not necessarily represented as they actually are but how the patrons of art wanted them to be – sober, honest, industrious and, above all, respectful and deferential. Poverty was the tool by which society controlled them. Not until 1874, 40 years after the date of this painting, was the North Wales Quarrymen's Union founded.

By the 1850s, however, there was a new way of representing labour in high art. Although social divisions were still very much in evidence, artists began to demonstrate a realization that Britain's position as the leading industrial nation in the world was founded on the efforts of the British working man. In *Work* (1852–63, Plate 12), Ford Madox Brown represents the laying of a water main in Hampstead during the summer of 1852, with the labourers depicted as heroic, in the manner of history painting, the highest of the genres of painting. This work will be discussed in more detail later, but it is sufficient here to show that in high art class barriers were beginning to be broken down. In this painting, the gentry have to be carried along on horseback, whilst the labourers are described by Brown in terms of 'lusty manhood'. Similarly, in a painting of 1857 by George Elgar Hicks, *The Sinews of Old England*, a muscular workman, clean and respectable, with pick and shovel over his shoulder, stands godlike, staring fearlessly out of the painting, whilst his wife clings to him and gazes adoringly at him. Her clasped hands give the impression of being at prayer, as though before an icon. On the other side of him, his small son, still in skirts, holds a small shovel to show that his destiny is to follow in his father's footsteps. In these paintings the workman is idealized, yet there is still something unsettlingly patronizing about their depiction. They are still 'the other', not of the same class as the purchaser of fine art; their depiction acts as reassurance that workers are sober, industrious and, above all, nonthreatening.

In 1852, the blacksmith James Sharples designed the certificate of the Amalgamated Society of Engineers, Machinists, Millwrights, Smiths and Pattern Makers (Plate 45). His third oil painting, *The Forge* (Plate 13) was executed between 1844 and 1847, and he engraved it himself, entirely by needle, completing it in 1859. He could not afford to purchase a magnifying glass to use during the engraving process, so instead used his father's spectacles. *The Forge* is surprisingly different from the depiction of industrial subjects by professional, middle-class artists such as Martin and de Loutherbourg. Rather than employing the iconography of hell, it employs instead a heavenly iconography, reminiscent of the forge scenes of Joseph Wright of Derby. Sharples's scene is lit by the fire of a great furnace. The shadows are very deep and the light is far stronger than any natural light, which is beyond the windows. The furnace must have been white hot, yet the men stare stoically and directly into its depths and do not cringe from its immense heat, even though they are working in a restricted space. Their tools are carefully depicted, as are the various tasks they perform. There is no evidence of

the beer historians tell us they drank copiously to relieve the raging thirst caused by the high temperatures and the loss of body fluids in sweat. In fact, they appear cool, calm, clean and neatly presented, despite the heat and the heaviness of the work.

Their working space is Piranesi-like, resembling the nave of a church, with Romanesque windows and arches. Light emanates from an unseen source and the feeling this gives is rather like a Nativity scene with wise men and shepherds approaching the manger, bearing gifts. The men are arranged across the middle ground, blocking the viewer's way into the picture. We may not pass. We are uninitiated. This is the preserve of the skilled worker. In the same way, entrance to their trade union was closely guarded by a long apprenticeship. Confident, erect and purposeful, these men are the embodiment of engineering progress, the Victorian work ethic, and the heavy industry at the heart of empire. They may be seen as taming and controlling the awesome natural forces, which de Loutherbourg and Martin had feared capable of dwarfing mankind and bringing about its ultimate destruction. Sharples accords these labourers great dignity as they control unflinchingly these alien and terrifying forces.

Printed copies of *The Forge* were advertised at 3s., or 4s. 6d. for larger India Proof copies, and could be ordered by mail order directly from James Sharples at 44 Audley Lane, Blackburn. His advertisement is accompanied by a eulogy to smiths entitled 'King Solomon's Smith', which serves to locate the trade in biblical times and promotes the trade's supreme importance. In this tale, Solomon, having completed the Temple in Jerusalem, invites his chief architects, artificers, silver and goldsmiths, carpenters, stonemasons and ivory workers to a banquet. A grimy blacksmith hammers on the door and demands to be let in, as he considers himself to be entitled to dine with the King of Israel as one of the chief workmen of the Temple. The master tradesmen object, saying that the smith is neither sculptor, nor worker of fine metals, nor joiner, and is therefore not entitled to be present. Solomon challenges the blacksmith to explain why he should not have him scourged and stoned to death for his impudence in daring to intrude. The smith replies that he is superior to all those who have objected because without the tools that he made for them they would not have been able to ply their trades. Upon hearing this, Solomon invites him to wash the smut of the forge from his face and sit at his right hand as 'all mankind's father in art'.

'The Great Unwashed' was a derogatory term applied to the labouring classes by those who considered themselves their betters, and was still in common use in the twentieth century. First used by Edmund Burke with reference to the French, then by Edward Bulwer-Lytton in *Paul Clifford* (1830) and Thackeray in *History of Pendennis* (1850), it was employed in 1868 by Thomas Wright as the title for his book on the working classes of England. Small wonder, then, that the labouring classes fought back by representing themselves in their new emblems as upright, well dressed and, above all, clean and well groomed. It is not surprising that the working blacksmith Sharples should want to paint scenes of manual labour in the manner of high art, to extol Solomon's smith as superior to the craftsmen whose tools he forged, and to depict his own fellow workers as heroic. They were, after all, amongst the most privileged and skilled of the working class. In their new emblems and banners of the nineteenth

century, the working-class man depicts himself as confident, proud of his union status and his abilities as a craftsman or worker, but also clean and neatly dressed.

Many of the professional artists who produced emblems for the unions from the 1850s onwards were initially trained in art schools by copying from antique fragments, from antique sculpture, plaster casts and from Old Masters, before being allowed to draw from life. Such rigorous training in the classical tradition reflects strongly in their later work. Lesser artists studied at night school, in Mechanics' Institutes, and copied from art primers, pattern books and engravings. Designs for the new emblems, certificates and banners are confident, intricate and aimed to impress. Classical architecture, mythological figures, high art and portraits of union officials are all pressed into service alongside sanitized and idealized depictions of the trade and its working tools. Designed by the workers themselves (as in the case of Sharples), by competition winners, by commissioned artists, by engravers, printers or banner studios, the emblems sometimes move from certificate to banner, creating a sense of co-ordination. The familiar images from the certificate in the home are carried on high in the banner and members march proudly beneath, displaying loyalty to their trade and their fellow workers, but also to family and home. Banners bear images of home and hearth in depictions of sickness and superannuation benefits, whilst certificates in the home bear images of the workplace and the means of production, reinforcing the message of commitment, both working and social. Within this new and unstable society in which the working man found himself, these emblems served to help him forge a secure identity and a bond with his fellow workers. However, there was not always agreement or approval amongst the trades as to the wording that appeared on their banners. In the *Trade Report of the United Society of Boiler Makers and Iron Ship Builders of Great Britain and Ireland for the month ending 31 October 1859*, it is noted,

We considered the case of the 'London Lock-outs' of sufficient importance to claim our attention, we placed it before you at the solicitation of several lodges who, were anxious that support should be given to these men; among whose ranks Death has appeared, as the reward of inscribing on their banner, – 'Union among the trades, and no surrender'.

To this motto, – we venture to say, all will respond in loud acclamations; but that words without money will ever obtain the object of the *motto*, we deny. Verily, if neither the object of the motto, or the blessing it is intended to confer on the trades is never gained until words without support gains it – we may say, 'Union's cause is lost,' and that wretchedness, misery and slavery, will rise on its ruins; through the apathy, deceit, and uncharitableness of man, to man.[8]

A certificate was an item much desired, but expensive to purchase. The *Trade Report of 31 January 1861* of this same union records that their new emblems had been sent out to the lodges who had ordered them, with the instruction that members be charged 2s. 6d. each, plus carriage. The following month a further request was made for speedy payment as the union's funds were so depleted. Funeral expenses

of over £200 had been met, £70 had been paid out for the cost of the emblems and 'consequently the money we had on hand is exhausted'. Further appeals were made in April, as emblems were obviously not selling well, and it was suggested that members get together, pay 5d. per week each into a joint kitty, so that in six weeks each member could receive his emblem, paying the cost of carriage between them. Only by saving up and putting money aside each week in this way was a certificate within the grasp of many members.

The following year, in their *Trade Report for January 1862* a widows and orphans fund was proposed into which new members would pay 1s. upon joining, after which contributions would be 1d. a month. Widows would receive £6 and motherless orphans £10. This may have been why, in 1872, 11 years after a new emblem had been issued, the society was considering yet another new emblem design, most probably prompted by a desire to include new benefits.

The *Trade Report for August 1872* records that

a large number of members [...] have given their names for the new emblems, but not enough to warrant us to give the order for the plate. We would therefore, call your attention to this again, that we may get the requisite number: it will be a splendid design and well executed. Please give your orders without delay.

The September report records that they now had a thousand orders for emblems, sufficient to justify a new plate. They believed that they could clear the cost of it within two or three years 'and the Society will have a first-class steel plate to call its own'.

However, it is obvious that caution still needed to be exercised when considering the expenditure, as General Secretary Mr R. Knight's December 1872 report records that an approach had been made to Mr J. D. Prior, the General Secretary of the Amalgamated Carpenters' and Joiners' Society, to enquire what their new design had cost and what steps they had taken to obtain it.[9] Prior's reply was that they had employed an artist to produce it and it had cost £70. This amount must have been considered to be beyond their means, so a further approach was made, this time to Mr Daniel Guile of the Iron Founders' Society, who, in a letter dated 9 November 1872, replied that he agreed with Knight's own suggestion that an advertisement would be the best way to proceed, further suggesting that as their own emblem had been engraved 15 years before, and although he could supply the names of the draughtsman and engraver, there was probably now more talent and 'modern thought' in existence. Consequently an advertisement was inserted in newspapers in Liverpool, Glasgow and London, following which they received 120 applications. The advertisement read,

Particulars and regulations of a design for an emblem for the Boiler Makers' and Shipbuilders' Society. The Executive Council of the above-named Society wish the design to embody as much as possible, the principles of the Society – prominently Iron Shipbuilding and Boiler Making – and, as far as they can be shown by symbolic figures the benefits given by the Society – viz., help in

sickness, accident, superannuation, and the widow and orphan; also Industry, Justice, Truth, Art, and Science are to be represented, with representations of workmen. The design and colouring is left to the discretion of the Artist, but must be contained within the measurement of 21 inches long by 16 inches broad, *not including margin*. Space must be allowed at the bottom and included in the above dimensions, either within a Scroll or Tablet, or any other device, for the following inscription:–

THE UNITED SOCIETY OF BOILER MAKERS
AND IRON SHIPBUILDERS.

This is to certify that _____was admitted a Member of the _____ Branch of this Society on the ____day of _____ 18__

_____General Secretary.
_____Branch Secretary.

Preference will be given to such designs as may contain few colours (combined for most varied effect), and can therefore be most cheaply worked off, if combined with artistic excellence. The Council will award the prizes as soon as possible after the undermentioned date, and the designs obtaining the prizes will become the property of the Society. All others will be returned, and competitors will be notified of their success or otherwise, at the earliest moment.

The prize for the best design will be £20, for that next in order £10. Designs must be sent in (post free) not later than February 14, 1873, to the Office, 26, Russell Street, Liverpool; and any further particulars can be obtained of Mr R. Knight, General Secretary.

Despite the fact that the closing date for submissions was not until 14 February 1873, members were given the opportunity to call at head office to inspect the designs between 9 a.m. and 8 p.m. on 21 January 1873 and between 9 a.m. and 6 p.m. on 22 January, a Saturday.

The *Trade Report for March 1873* records,

There were some splendid designs sent as works of art, but neither of them represented boiler making and iron shipbuilding as we should have wished; in some boiler making was too prominent, and in others it was so with shipbuilding. What we want is that both sections shall be equally represented. We selected the two best, and wrote to the designers of one to ask him if he would make the alterations we required for the first prize, which he consented to do; but to make him thoroughly understand what we wanted he was compelled to come here, as we could not explain it to him by writing. We also wanted him to take two sketches when here, which he did. The second prize was paid over to the designer entitled to it. We intend, if possible, to get a thorough good emblem for

the society, as we feel assured, looking at it from a financial point of view, that it will be to the society's interest to spend a few pounds and get one our members would be pleased with, and then the numbers sold would very soon defray the cost.[10]

The *Trade Report for April 1873* records,

We are anxious that the emblem, when completed, shall be acceptable to you, we have made some little alteration in the design, and there is more work yet to be done, but unfortunately the gentleman who has the work in hand has been prevented, through illness, from completing it, and for your information we here publish his letter sent to the C.S.

The letter reproduced in the report is included here. It was addressed to Mr Knight, from 9 Hornsey Park Road, Hornsey, Middlesex, and dated 21 April 1873.

Sir – I am afraid that it seems long to you before you hear anything of me as regards your design, therefore I feel it my duty to give you an explanation. I congratulated myself on having Easter holidays, in which I intend doing such a lot towards the new sketches. Just on Good Friday morning I was taken ill suddenly with a very severe attack of quincy [sic] and have been ill ever since, and am not able at present to leave the house; and thus I lost my best chance.

My doctor says I ought to go into the country for a few weeks for the benefit of my health; and if I should go I intend finishing it during my stay, wherever it may be, so as not to lose any more time.

I must thank you for the kind forbearance you have evinced so far, and ask you now for a little indulgence, as I have laid all the facts before you. Will you kindly acquaint the Council of these contents, and oblige.

Yours truly,

M. Fitschen

Without the delay in completing the emblem, which resulted in his letter of apology being reproduced in the *Trade Report for April 1873*, the actual name of the winner of the competition might never have been known to us. To the union he was simply a workman, a competition winner, paid to perform a job of work.

Martin Joseph Fitschen was a naturalized British citizen of German origin who had arrived in the Port of London from Ostend on 25 September 1855, aged 14. Born in 1841, he describes himself in the Census of 1871 (two years before his submission of the emblem design) as 'Professor of Drawing and Tobacco Grower'.[11] Ten years later, in the Census of 1881 he declares himself to be 'Art Master and Stationer', so it appears that, like many other hopefuls, he was unable to live upon an income derived

from teaching or practising art, and it was a secondary income, hence his intention to complete the emblem design in the Easter holidays.[12]

Pressure appears to have been placed on the executive by members, as in the *Trade Report for July 1873* we find:

> Many of our members are very anxious to know when the New Emblems will be issued, and by the tone of the letters sent to us on the subject, they appear to think that to get a new design, also estimates for the engraving of the plate, and the time for engraving, can all be accomplished within a very short period; but we have found it to be the contrary as we have had difficulties to contend with that we did not anticipate, and no time has been lost on our part in pushing the matter forward. The engraver is now cutting the plate, which will take him four months yet to complete, and he has been engaged on it the past two months, so that you may expect them about the end of the year. If you want a thorough good steel plate, it will take a long time in cutting and if you force the work, you do it to the injury of the plate, which we decline to do.

Plate 14, although of a later date, and by then incorporating the word 'Steel' into its title, is in most respects true to the original design. It illustrates a solid, breakfront edifice with an arched centre section supported by magnificent incised, banded, coloured and decorated engaged columns with *entasis* and deep blue Corinthian capitals.[13] Justice is enthroned at the top above regional flowers, although personifications of Industry, Truth, Art and Science, as required by the advertisement, are not included. Instead, to the left and right of Justice, small putti or *spiritelli* frolic. Those to the right of the emblem, with the hive of industry above them, are working at an anvil, representing industry, whilst those to the left, with a globe above them, appear to represent science or navigation. In this way, industry, science, truth and art are still present, but not in the form of female personifications. Four pictures, attached to the structure by brass fittings, depict the required benefits – sickness, relief of the widow, accident and superannuation. A boilermaking workshop and an iron ship–building yard are given equal prominence in the central arch, an amendment that Fitschen had been required to make after his initial submission. In actual fact, the union faced stiff competition from the Shipwrights who were trying to wrest the work on iron ships away from them. Semicircular vignettes at the base represent steam-driven locomotion and, with a view of Brunel's Royal Albert Bridge at Saltash, opened in 1859, shipping. A new motto (attributable to Benjamin Franklin) proclaims, 'God helps those who help themselves' – obviously deemed a safer motto than 'Union among the trades, and no surrender', which had been so decried in the *Trade Report for October 1859*.[14] The emblem was in use for many years. Leeson writes, 'Thirty years later Cummings thought the emblem with technical adaptations would last another thirty.'[15]

In the *Trade Report for July 1872*, it is stated that Constantinople Lodge had asked for regalia for their officers to wear at lodge meetings. This is indicative that the worker himself had now become the canvas for the display of status and authority.

For a total sum of £3 they purchased five dark blue sashes five inches wide and three yards long, decorated with various lettering, tassels and designs to indicate rank.

The manufacture of regalia and banners was dominated by commercial manufacturers such as George Tutill, Henry Whaite, Henry Slingsby and George Kenning (later Toye, Kenning & Spencer). As well as producing custom-made commissions, they also held catalogues of stock designs. Often these cheaper stock images were interchangeable and could be used either for religious banners or for union banners. The Good Samaritan, for example, on the reverse of a trade union banner would reinforce the paternalistic function of the union with sickness and injury benefits. Copyists would have known high art from visits to the London galleries, from engravings and from books and the ubiquitous religious images, which these men (and later, women) produced, were frequently based on Renaissance art. The issue of the borrowing of earlier themes and traditions of Western art in order to develop the new genre of trade union art will be explored in the following chapters. In banners, there was a trend later in the period away from the formal, architectural-based image taken from the emblem to images based on narrative scenes and this coincided with the rise of the commercially produced banner. In certificates, the worker, once depicted as so proud, upstanding and clean, begins to give way in importance to the machines to which he tends. In the certificate of the London Society of Compositors by Alexander Gow, (1894, Plate 15), he is once again a small figure in the distance – sober, honest, industrious and submitting to work as a moral discipline. In the certificate of the United Machine Workers' Association of the 1880s by Blades, East & Blades, still in use in the second decade of the 1900s (Plate 16), the worker is not even pictured at all.

Chapter 4

JAMES SHARPLES AND HIS LEGACY

Annie Ravenhill-Johnson

In Chapter 2 ('The Emblem within the Emblem'), the certificate of the Amalgamated Society of Engineers, Machinists, Millwrights, Smiths and Pattern Makers by James Sharples (1852, Plate 45) was discussed. In this chapter, the various sources that influenced his design are considered, notably the *crepidoma* or *ziggurat*, together with the way in which this format came to exert a great influence over later designers of union emblems and certificates for more than half a century.

On 20 August 1834, 14 boilermakers met in Manchester with the intent of founding an Order of Friendly Boiler Makers and in October of that year a branch was established in Bolton with four present at its inaugural meeting. A General Council was formed in 1835 of 14 members with Abraham Hughes as the first Chairman, and William Hughes of Manchester the first General Secretary. To William Hughes was entrusted the task of forging the new union's identity. According to Mortimer's account of the society's history, William Hughes 'arranged for the design of the new emblem' in addition to which he drew up a book of rules, a hymn and a prayer for lodge meetings, an oath of allegiance, an opening ceremony and lectures for new, prospective members that stressed brotherhood and unity and described the functions of the branch officers. David and Jonathan were held up as examples of brotherhood, as Jonathan had saved David's life by notifying him of Saul's jealousy and evil intent. The code of conduct rigidly enforced the behaviour of members, afforded fraternal bonding and a sense of elitism through ritual and performance, and created an identity to be ostentatiously displayed and impress those outside the order. Also decided upon were 'a grip, words, signs and counter-signs'.[1] Members were expected to familiarize themselves with the forms of the rituals because they protected a lodge meeting against intruders who could be spies or informers working on behalf of employers or the authorities. A member wishing to enter the lodge gave four distinct raps on its door. From inside, a responding four knocks would be heard. The member had then to give to the outside doorkeeper the first part of the current sacred word or sign, which changed every 3 months. He would then be admitted, and after the door had closed behind him he would give the second half of the password or sign to the inner doorkeeper. After taking his seat,

and before the lodge came to order, two inspectors rose from their seats and visually examined every person to make sure there were no unknown faces.

Leeson writes that Hughes himself designed the emblem ('But in designing his emblem Hughes could not simply take a gild coat of arms').[2] It is not clear if William Hughes actually drew it himself, but certainly he decided on its form and content. It comprises a shield in four quarters, supported by two members of the craft with a scroll beneath bearing the motto 'Humani Nihil Alienum', a quotation from Publius Terentius Afer (known to us as 'Terence'), 195/185–59 BCE. The full quotation, from his play *Heauton Timoroumenos* (The Self-Tormentor) is 'Homo sum: humani nil a me alienum puto' (I am a man: I consider nothing that is human alien to me). This humanitarian quotation gives the design a touch of elevated, classical learning, but it is also poignant in that Terence had once been a slave, owned by Terentius Lucanus who educated him and eventually gave him his freedom.

A certificate of 1844 (Plate 9) based on this emblem places the two members of the craft in long aprons, waistcoats and rolled-up sleeves on a flat platform, leaning against the coat of arms, which is in an ornate frame, resting on two feet. Above is the figure of Justice, her uplifted arm (the boilermaker's 'sign') holding her scales, with the all-seeing eye of the deity above her, radiating its beams. The coat of arms contains scenes of contemporary life in four quarters, with factory, train and working and tramping boilermakers. In the bottom right quadrant is a scene wherein the union brother, with his possessions in the traditional tramping mode tied in cloth and hanging from a stick held over his shoulder, displays his certificate and is welcomed by an apron-clad boilermaker. Immediately beneath the platform is the handshake with not two but four disembodied hands joined together in a complex handshake in the form of a cross. The motto is beneath on scrolling strapwork. Those standing on the platform appear to be enclosed in a misty oval mandorla, its arching shape echoed in the curve of the words 'Unity is Strength' above it, and the answering curve of the scrolling strapwork beneath, carrying the eye of the viewer in a circle around the emblem.

Based on Moresque[3] patternwork, strapwork comprises bands or straps of metal, leather or plasterwork that appear to scroll in three dimensions, and it is used in ornamentation. Originating with the Florentine painter, Rosso, and his elaborate plaster frames of strapwork for his murals in the Galerie François I, Fontainebleau, 1535–37, Cornelis Floris and Cornelis Bos devised a lighter and more versatile variety, widely used in Northern Europe and adapted and varied by English craftsmen for many decorative purposes. More ornamentation surrounds the certificate in a pleasing foliate border.

The platform on which the coat of arms and its supporters stand cuts across the mandorla. It is obviously in an outdoor setting as there are clumps or fronds of vegetation springing up from each side and emerging at the centre beneath it. This is in the Renaissance tradition of implying new life or new beginnings by illustrating fresh new growth. And when, in 1839, J. Shury of Charterhouse Lane, London designed and engraved the emblem of the United Society of Brushmakers (Plate 17), two figures of Truth and Justice at the base of his edifice stand on little grassy rocks lapped by the sea. These outdoor settings are, of course, in the ancient tradition of the pegma.

The Brushmakers' emblem incorporates the ancient heraldic-style guild arms in a shield. Above it is a fasces, on which rests a barrel with the two-headed imperial Russian eagle perched on it, with a crown above. At the very top, two hands are joined in the handshake from which rays of light stream down. Supporting the guild arms are, to the left, a Russian hunter with a spear and, to the right, the Russian boar, with British regional flowers (rose, thistle, shamrock) at their feet. A reassuring motto 'United to Protect Not Combined to Injure' is written on red strapwork beneath.[4] This upper section is supported by a simple two-storey construction with elaborate, swirling embellishments. An oval vignette contains Britannia and the British lion on the shoreline. Britannia watches a sailing ship in the background bringing in the bristles from Russia, but the large rocks behind her and the might of her lion are a reminder of the solid defences of Britain against attack from the sea, and the vigilance with which she guards her coasts. Britannia is flanked by tall urns with what appears to be Prince of Wales feathers sprouting from their tops.

According to Leeson, the lower section depicts St Katherine's docks and wharf, where the bristles were unloaded, flanked by personifications outside the frame.[5] To the left is Truth in modern dress with her mirror, and holding the Rod of Asclepius (a single snake wrapped around a wingless staff), which is associated with medicine and healing. In 1780, William Addis invented the commercial toothbrush, which was manufactured using bone handles, and certainly a hair comb is incorporated into the guild arms. So Truth may be looking in her mirror to admire her coiffure and her brightly polished teeth! Justice, to the right, is blindfolded to show her impartiality and holds her sword and scales. Between them on the base on which they stand is the name of the society in tiny letters.

The arms of six towns forming the united society are around the framing decorative garlanded border of oak leaves, acorns, grapes and ferns, topped by the two disembodied hands joined in friendship from which beams of light cascade. At the very bottom, two Welsh dragons support a red cross on a white background, the cross of St George. This emblem is in the tradition of Flemish armorial tapestries, which typically featured a central crest with two supporters, surrounded by a border of fruit and vegetables with crests in the corners.

Only three years separate this design from that of Hughes, but whereas Hughes gives a simple, plain platform, Shury gives a two-storey construction with a raised rope embellishment separating them and sculptural decoration with the scenes of Britannia and St Katherine's dock inserted as though in picture frames. The shield, hunter and bear are perched on a narrow ledge above in a group formed from an equilateral triangle. The whole composition is elegantly framed with foliage, elaborate metalwork, draped and fringed curtaining, all of which joins together the arms of the towns, the shield and the handshake.

It is very modern for its time, when compared with the certificate of the Woolcombers' Union of a just year earlier, 1838 (Plate 18). In this, a certificate rather than an emblem, the certificate and signatures form the lower part of the page. Lettered strapwork above ('Unity Supports Society') and the ubiquitous handshake in the centre, with four lines

of poetry in the scrolls of the strapwork on each side, separate the certifying document from the upper section. Whereas Shury's emblem has a vertical tripartite division, the Woolcombers' has a horizontal tripartite division.

In the centre, on a chequered tiled floor, Bishop Blaise, an Armenian martyr and one of the Fourteen Holy Helpers, patron saint of woolcombers, holds up a Bible, and the iron wool comb with which he was said to have been flayed before his execution by beheading.[6] This deliberate reference to the traditions of the earlier guild affords a sense of continuity with the past, and to the ancient rites of Bishop Blaise processions on civic occasions. The two flanking images are joined by classical swags and garlands to which are attached shepherds' crooks, with a wool comb, shears and a suspended sheep, anchored on each side by a Corinthian column topped with a decorative urn.

The scenes on each side refer to the workings of the trade. On the left is an interior scene of aproned woolcombers at work, whilst on the right is an outdoor, pastoral scene of a shepherd seated with his dog and crook under the protection of a large, spreading tree, looking after the sheep. The pasture ends at the sea, with a sailing ship in the distance, a contraction of two distinct scenes from the earlier ticket of the Amicable Society of Woolstaplers of 1785, which has a sailing ship at sea on the left, the shepherd and his sheep on the right and a woolsack between.

The depiction on the left of the working of the trade is in the tradition of sixteenth-century moralizing Books of Trade, which illustrated and beatified professions, trades and crafts. These books followed in the tradition of painted illustrations from the medieval scriptorium in which the illustration and a didactic text taught the use of, for example, herbs. Hugo of St Victor's *Didascalicon de Studio Legendi* of 1130 describes seven mechanical arts. *Lanificium* (textile and leather work), in which human clothing is made, is revealed as the imitation of a natural process, the equivalent to a tree's outer protection of bark.[7] So in this emblem, the portrayal on the left of woolcombers at work producing wool for clothing is also shown as the imitation of the natural process of the sheep growing its own fleece, as in the scene on the right.

During the 1850s, many trade clubs and unions amalgamated in order to centralize their organization and their finances. When, in 1851, the Amalgamated Society of Engineers, Machinists, Millwrights, Smiths and Pattern Makers ran a competition for the design of their new emblem (Plate 45), it was won by one of their own workers, James Sharples, a founding member. According to his biographer, Joseph Baron, Sharples began working at the age of 10 in William Kay & Sons' Phoenix Foundry, Bury, in 1835. Both of his grandfathers were blacksmiths, as was his father (who worked at the same foundry) and five of his maternal uncles. He worked from 6 a.m. until 7 or 8 p.m., heating and carrying rivets for the boilermakers.[8] He served an apprenticeship there from approximately 1838 to 1846, beginning at the age of 12. After working a 12-hour day, in his 'spare' time he learned to read and write. It was whilst helping his foreman to chalk out designs on the workshop floor that his talent for drawing was discovered, and he was encouraged by Peter, his elder brother, to practise drawing and copying. At the age of 16 he began attending drawing classes one evening a week, for 6 months only, at the Bury Mechanics' Institute where his tutor, Billy Binns, was a barber and

signwriter. Art was taught to the working class artisan or mechanic in order to improve his technical design skills, which could then be applied to manufactured articles. At 18, Sharples began to paint, making his own easel and palette, and walking the 18 miles to (and from) Manchester to buy his brushes and paints. Bequests to the People's History Museum, Manchester, received in late 1997 and early 1998 from his great-granddaughter, Eileen Iwanicki of New Brunswick, Canada, and his granddaughter, Marion Sharples of Mellor Brook, Blackburn, include books such as *Anatomical Studies of the Bones and Muscles, for the Use of Artists, from Drawings of the Late John Flaxman, Esq., R.A.*, engraved by Henry Landseer (London, M. A. Nattali, 1833), which his father had bought for him and from which he studied.

By educating himself, Sharples eventually rose to the position of foreman and he also became a part-time teacher. In 1846, at the completion of his apprenticeship at the Phoenix Factory, Sharples devoted himself entirely to art for 15 months, painting mainly portraits but also a head of Christ, a large view of Bury, and a scene from Gray's *Elegy*.[9] At the end of this period he returned to the foundry, and was to suffer extended periods of unemployment during the 1870s and 1880s.[10] The publicity that followed the engraving of *The Forge* of 1859 (see Chapter 3)[11] had elevated Sharples to celebrity status. John Ruskin himself purchased a dozen copies[12] and Samuel Smiles included a biography of Sharples in his second edition of *Self-Help: With Illustrations of Character and Conduct*, published in June 1860. However, Sharples was exploited by the print sellers and what little he earned from the engravings was used up during prolonged periods of illness and unemployment.[13,14]

The new emblem that Sharples designed was first produced as a monochrome engraving and later available in a hand-coloured version. Like Hughes of the Boiler Makers, Sharples adopted an outdoor setting for his emblem's basic structure. Instead of a coat of arms containing four scenes of the modern workings of the trade as in Hughes's design, he dispenses with the coat of arms and places the scenes within the structure itself, as though the supporting structure were three-dimensional and the viewer could look inside it.

Like other well-paid labouring men, Sharples would probably have travelled to London to the Great Exhibition, as he appears to have been influenced in his design by the frontispiece of the catalogue of the Great Exhibition of 1851 by John Tenniel (Plate 19). For Sharples, the design would have been especially interesting due to the depiction of two smiths in the bottom right-hand corner. Following the tradition of the format for the frontispiece, for example as in Cornelis Boel's frontispiece of the King James Bible of 1611 (Plate 20), the title and the details of the work within its pages are set out in a central plaque of text within an architectural framework with a distinctly hierarchical separation between the figures in the different realms. John Tenniel's design has a similar central plaque and a hierarchical separation of the lower classes at the very base of the stepped edifice (the labourers who produced the goods on display) from the brain workers at the next level, who produced works for cultural consumption (music, poetry, literature, architecture, sculpture and painting), and who (along with shadowy figures of other races from around the globe) are in turn separated from the

nationalistic figures at the highest level – St George, Peace, Britannia and Justice – posed in the form of an equilateral triangle.

Sharples also used an equilateral triangle for the upper section of his design and, like Tenniel, adopted a stepped form, which allowed the figures to stand on three distinct levels. The upper section rests on a rectangular base containing the six small scenes of the branches of the trades. The three-level, upper-stepped structure may have been copied from a crepidoma, the three-level platform on which a Greek temple stands, the *stylobate* being the top level, or from a *rostrum*.[15] It also resembles the ziggurat, a flat-topped pyramid made with two to seven, but typically three, terraced steps or receding levels to the top, which emerged in Mesopotamia around 3,100 BCE at the time the Sumerians were building cities and inventing writing. It is thought that there was a shrine at the top, the dwelling place of gods where, because it was only accessible by the steps, rituals performed at the top could be protected from the eyes of outsiders by just a small number of guards. Indeed, the Tower of Babel on the Plain of Shinar in Southern Mesopotamia, described in Genesis 11, is thought to have been in this form of construction, as was the Mausoleum at Halikarnassus by Satyros and Pythis, described by Pliny the Elder, one of the seven wonders of the ancient world, and the probable source of inspiration for Hawkesmoor for his Church of St George, Bloomsbury, of 1731. Artists such as Maerten van Heemskerck painted interpretations of the ziggurat.[16] The ziggurat was first discovered by William Kennett Loftus, a British geologist, archaeologist and explorer, who located the ancient Sumerian city of Uruk in 1849, and he excavated there in 1850. Kings were believed to have had their names engraved on the facing surfaces of the levels of ziggurats, rather in the way that Sharples inserted portrait roundels in his facing surface. This three-stepped platform, first introduced into trade union emblems by Sharples, remained immensely influential right through to the first quarter of the twentieth century.

In the rectangular lower section, metal workers are depicted in rooms like stage sets, and here Sharples employs the English tradition of technical drawing with its ambiguities of style and of perspective.[17] The workers are in rooms having three walls only, the fourth being left open to reveal the machinery and technology within. The depiction of the piston engine is part of a tradition of technical illustration that goes back to the first printed illustrations of Vitruvius, to drawings of machinery by Leonardo, to Georg Agricola's *De Re Metallica*, published in Basle in 1556, and to Diderot's *Encyclopédie*, published 1751–65. There are huge variations in scale between these workers and the figures that stand like gods on top of the three-stepped platform. There are further ambiguities in multiple perspectives – we are able to look directly onto the toecaps of the shoes worn by the two heroic workers and we look up to the underside of the Nike's upper arms. Yet we also look straight at the workers in the upper 'rooms', down on the workers in the lower ones, whilst the piston engine also on the lower level appears as though it were also on our eye level.

We are able to make out the type of work that the men are performing – activities relating to the engineering trade – but they are too far removed from us for us to be able to see the men's expressions or to gain any idea of them as individuals. They are not

heroized like Sharples's workers in his oil painting, *The Forge* (Plate 13), or the worker 'gods' on the top of the three-stepped platform. Fictive windows in the 'rooms' on the upper level appear to look out onto a landscape and seascape behind the structure in a manner reminiscent of the early eighteenth-century topographical print, with the artificial formula for the architectural 'prospect' of estates and cities.

On the left is a factory, with a canal aqueduct and a railway train to transport its goods. Again, we need to read this scene as a technical illustration, for the train cannot have emerged from under the aqueduct because the angle of turning would have been too sharp. On the right, goods on the shore either await transportation in the paddle steamer at anchor or have just been unloaded. The latter is perhaps the more likely explanation as there does not appear to be the busy commercial dock that one would expect from a British port. Instead, the scene is more of a remote harbour, perhaps in a distant colony. The bare, seemingly uninhabited cliffs on the far shore might place the scene in Australia or Canada. Tiny human figures in the tender give scale to the scene.

The boat inside the left upper quadrant in the centre of Hughes's structure (Plate 9) is now to the right at the outside of Sharples's structure, with a visible horizon behind it, and Hughes's factory and steam train are also outside, on land to the left. In both Hughes's emblem and in Sharples's, there is a hazy, smoky mandorla surrounding the figures of the workmen. Beneath the structure, as in Hughes's emblem, the motto of the Engineers ('Be United and Industrious') is on curling metallic painted strapwork, but Sharples places it on a fictive dressed stone plaque. Later versions of the certificate bear the red seal of the union in the plaque's right-hand corner, bearing the image of a three-masted schooner – a reference to their 'craft'. Above the stone, and resting upon it, are national symbols – the Irish shamrock, the Welsh daffodil, the Scottish thistle and, in the centre, the English rose.

Unions of this period were increasingly seeking a new reputation for peaceful co-operation with employers and for respectability in order to enhance their image with government, due to their still-insecure legal status. Interestingly, one can read Sharples's certificate in the Marxist view of base and superstructure, where the 'superstructure' of the neoclassical structure containing depictions of the workforce rests upon the land and national flowers, with the capitalist 'base' of flanking factory, rail and shipping network. The interests of the dominant class are revealed as the foundation on which the entire edifice rests. And, of course, an emblem (particularly when on a painted banner in a public parade) is essentially an advertisement for the trade, furthering the interests not just of the workers but of the industry itself and the foundry owners. Branches of the Amalgamated Society of Engineers frequently displayed Sharples's emblem on the front of their banner and portraits of their regional officers on the back.[18]

Five years after Sharples's emblem for the Amalgamated Society of Engineers, James John Chant designed the certificate of the Friendly Society of Iron Founders of England, Ireland and Wales (1857, Plate 21), engraved by John Saddler. Chant was a mezzotint engraver of large sized reproductions of paintings, many of which were exhibited at the Royal Academy, and Saddler was another exhibitor at the Royal Academy. Engravers were often commissioned by publishers to produce engravings of

important paintings exhibited at the Royal Academy and elsewhere. Chant's design for the Iron Founders was also used for the front of their banners, with the local branch named on the reverse. George Tutill & Co., for example, produced banners for the Sheffield and District Branches where the handshake, surrounded by laurel and oak leaves, is entwined with scrolling strapwork reading 'United We Stand, Divided We Fall', a favourite motto of the unions, originating in Aesop's *Fables*[19] and then popularized in 'The Liberty Song' of 1786 by John Dickinson:

> [...] Then join in hand, brave Americans all
> By uniting we stand, by dividing we fall!

Chant's design is, of course, a blatant copy of Sharples, with an equilateral triangle forming the top section resting on a rectangular base. A three-stepped upper structure supports figures above a lower portico. The outdoor setting is once again made obvious by fresh growth of vegetation at the foot of the structure, with ploughing of the land taking place beside the coast, a paddle steamer against the horizon on the right, whilst on the left the factory and railway (with an added viaduct) appear again, as the products of iron founding. The floral arrangement at the foot of the structure is very similar to Sharples's English rose, Scottish thistle, Welsh daffodil and Irish shamrock, resting as they do on a fictive stone plaque, even to the top outer corners of the stone being chamfered.

Chant and Saddler place their edifice on a three-stepped temple-base crepidoma, which is then echoed and expanded in the ziggurat or crepidoma on which the figures are arranged above the portico. The four Doric pilasters in Sharples's emblem have now become four handsome marble pillars with Corinthian capitals. The three sections of the building they separate are not divided into two stories, but are to full elevation, affording added clarity to the scenes of work within. Those to the left and right contain scenes of working inside with depth and perspective. The explanatory key, engraved by Gow, Butterfield & Co., and issued with the certificate, records that the image on the left was taken from a drawing of a foundry of Messrs Mare & Co., Baw Creek, Blackwall, London, whilst that on the right from one of Messrs Bradley & Nevins, Great Guildford St, Southwark, London. In the centre is an outside scene, with sky beyond, of two blast or smelting furnaces at Oak Farm, near Dudley, where workmen converted the miner's ore into iron for manufacturing. The phoenix on its bed of flames in the centre of the top section of Sharples's edifice is here too, on a block of stone above an elaborate dentilled cornice, which, as in Sharples's certificate, fronts a flat rear panel that is recessed well back.

According to the key, in the dominant centrepiece of the emblem (in the middle of the ledge and immediately above the phoenix) is a miner of iron ore working with a pickaxe, 'the first process associated with Iron Founding'. Britain was at this time producing half the world's coal and iron. The miner is flanked by Justice (referred to in the key as 'Truth and Justice') who holds her sword and scales, from which is suspended a tiny head of Athena, goddess of wisdom and of craft. On the wall behind the left

shoulder of Justice is a coiled serpent, which, according to the key, indicates unity. Instead of Ouroboros, the serpent that renews itself by devouring itself, a classical symbol of eternity that Sharples has used to frame the portraits of Arkwright, Watt and Crompton, this serpent is coiled into the mathematical symbol for eternity, implying that Justice is eternal.

Demeter is on the right, a Greek agricultural goddess who presided over the harvest and over grains. She is referred to in the key as 'Commerce' but she also represents Agriculture, Peace, Plenty and Navigation as she has a sextant, in addition to a bale of merchandise and the hive of industry, as well as her sheaf of corn and cornucopia:

> [...] At the feet of Commerce is a Quadrant and bale of Merchandize and in her hand a Sheaf of Corn, identifying Agriculture with Manufacture Trade and Commerce, which connection is productive of Peace and Plenty as indicated by the Cornucopia or Horn of Plenty.

Beneath, on land at a cliff edge, is a small figure in an agricultural smock ploughing the land with a horse-drawn plough whilst a sailing ship sails away. Iron is used here in the tools of agriculture, and also in the ship that transports the produce abroad. Iron is a harvest from beneath the ground, like Demeter's grains.

In the section above, where Sharples places his blacksmith and engineer, Chant places two workers who, according to the key, represent 'a green sand and a loam moulder'. At the very top, Sharples's Nike or Goddess of Fame has been replaced by:

> [...] the Emblem of Art: the cup beneath the Emblem of design. The face on her knee, the Palette, Brushes and Tamborine at her feet, are the emblematical representatives of the Art of Sculpture, Painting and Music.

In actual fact, it is Thalia who is depicted, the muse of poetry and comedy. Thalia with her mask appears on the Muses Sarcophagus of the Via Ostiense, Louvre, early second century, and here in this emblem she is holding her identifying attributes of mask and stylus, with palette and brushes on one side and a drum on the other. According to Diodorus Siculus, Thalia is said to sing the praises of great men – here, of course, the Iron Founders.[20]

At the bottom of the key is a paragraph designed to boost the ego of the worker whilst reinforcing the benefits of union membership:

> The above Figures being Emblematical represent the following ideas:

> That Iron Founding as an employment is not only Mechanical but Scientific and Artistic. Therefore it is associated with Art in its highest development both of utility and beauty. That the persons engaged in this Calling are not only industrious but Wise and prudent and therefore have associated together for the purpose of assisting each other to provide for those contingencies to which

working men are subject. That the Society is powerful because it is based on the principles of Truth and Justice. That it receives without distinction men from all parts of the Kingdom as its Members, and when properly understood, it is not opposed to Free Commercial arrangements. A Society thus constituted if its Members are faithful, not withstanding all the adverse circumstances with which it has to contend, must be perpetual.

Sharples's design for a modern trade union emblem remained highly influential and was still in use as his union's emblem well into the twentieth century. His unfinished design for the emblem of the Co-operative Society (Plate 22) follows his basic design for the Amalgamated Society of Engineers, framed within a lunette (rather in the manner of Waudby) with two portrait roundels of leaders set into the upper stepped section. The four small rooms here give way to one large depiction of the co-operative ideal, with workmen producing goods in the foreground, others behind them finishing goods, with the retail store at the very back, all within the same space. A large, kneeling classical figure with fasces is centrally placed with Justice above him. The female personification of Agriculture is to the left with her cornucopia and Commerce to the right with a *caduceus*, the winged staff around which are coiled twin snakes. The caduceus originally belonged to Apollo, but he traded it with Hermes, the messenger of the gods, either for pan pipes or a lyre. Everything Hermes touched with it turned to gold, giving it associations with trade and commerce. At the feet of Commerce is a tiny Atlas figure, the globe of the world that he bears symbolizing the world market of the Co-operative Society.

In the 1890s, Sharples's design for the Amalgamated Society of Engineers, Machinists, Millwrights, Smiths and Pattern Makers was emulated again in the certificate of the Amalgamated Union of the Operative Bakers and Confectioners Association (Plate 23). Thomas Hollingworth's house in Manchester was used as a meeting place for members in the early years when it was risky to meet as a trade union, and friendly society benefits were used as a cover for their activities. The first amalgamated union was formed from local societies in London, Liverpool, Manchester, Warrington, Cheltenham, Bristol, Newcastle, Wigan and Hanley in 1861 and a code of rules was drawn up. From 1864 to 1883, Thomas H. Hodson served as Part Time General Secretary.[21]

This magnificent emblem, engraved in the late nineteenth century by J. M. Kronhein & Co., London and Manchester, again features a triangular top section above a rectangular lower section with two small 'rooms' showing members of the trade at work. The emblem is still very classical, in that it is equally balanced each side. At the very top, rather than the dove of the Holy Spirit in Sharples's emblem, the all-seeing eye of God shines golden rays down, whilst at the base of the edifice is the handshake of brotherhood under a tiny strapwork ribbon containing the motto 'Union is Strength'.

In the top section, Sharples's plain, stepped structure is reproduced in the same stone-like colour of the lower section. Sharples's central roundel, which contained a portrait of James Watt, is enlarged and extended downwards, eliminating the two

flanking portrait roundels and the central 'room' in the scenes beneath. Framed by ears of corn and wheat, it depicts an agricultural worker cutting wheat by hand with a sickle, and a windmill in the background – a scene by now anachronistic, with the advent of threshing machines and factory milling. However, it may refer to a patron saint of bakers, Albert of Bergamo, who is usually represented as a farm worker cutting a stone with a scythe. Strapwork beneath bears the motto 'By the sweat of thy brow shall thou eat bread' – a corruption of the authorized version of Genesis 3:19: 'In the sweat of thy face shalt thou eat bread.'

Agricultural workers in Britain had suffered greatly earlier in the century with years of poor harvests in the 1820s and in the 1830s and there was rioting and rick burning after the introduction of the new threshing machines, resulting in transportations and even hangings. In addition, the Great Depression of the mid-1870s, which continued into the 1880s, caused further unemployment amongst agricultural workers, with some hundred thousand moving off the land to the towns and cities to find alternative employment or emigrating to the colonies. Joseph Arch, a Warwickshire farm labourer and Methodist preacher, founded the National Agricultural Labourers' Union in 1872 in the face of great opposition from landowners and farmers, who locked out workers. So this peaceful rural scene is both nostalgic and idealized. Viewed with the piles of loaves of bread and sheaves of grain and fruit in the main areas of the emblem, it refers again to the rural *Georgics* tradition in which ploughing and harvesting and good management of the land indicates morality, continuity and good government of the country. And this, again, demonstrates the dominant ideology of the middle and upper classes being reflected back to them by the working classes. At this time there was much fear amongst the middle and upper classes that working-class children, now being bred in towns such as Birmingham and therefore alienated from the land, would be degraded and degenerate due to the immense poverty and deprivation they suffered. The Roman Empire, on which the British Empire modelled itself, had suffered a similar depopulation of the countryside and an influx into urban areas during the Late Republic. Sarah Butler has shown how the urban–rural debate in Victorian times used the experience of Rome as both a positive and negative template.[22] Baden-Powell's establishment of the Boy Scout movement was in response to his observations that army recruits from the working classes were underweight and undersized, and that British working-class children suffered from preventable deformities.

In the certificate of the Operative Bakers and Confectioners, Sharples's cornucopia above the portrait roundels is here replaced by representations of wheat, fruits and sugar. Each side, as in Sharples's design, flanking workers with aprons and rolled-up sleeves represent the two trades: baking and confectionery. The figure of the confectioner on the left is even in the same stance as the one on the left of Sharples's but reversed, a mirror image. The two are beside the stepped structure, not actually standing on it, not occupying the place of the gods, as were the workers in Sharples's. Instead, it is the produce of the land and the scales of justice, symbols of the Roman gods of Ceres and Vulcan, that occupy the place of the shrine of the gods on the crepidoma or ziggurat.

The confectioner and the baker display the many and varied tools of their trades, as well as the fruits of their labour – loaves, buns, pies, biscuits and a magnificently iced tiered cake with a small winged figure on the top – perhaps even a nod to Sharples's Nike or Fame. There were no limits then to hours worked, no overtime payments and bakers almost lived on the job. There was also little in the way of modern machinery, mixing was done by hand, and bakers worked all night.[23] The display is an advertisement for their skills, the bounties of Mother Earth transformed by their labour, a perfection to be consumed with the eyes.

Where Sharples has placed Nike or Fame with outstretched arms holding the laurel wreaths of the hero, this union has Justice, but not as a female personification – simply as weighing scales with outstretched arms holding the even balance. And scales are, of course, essential to the confectionary and baking trades, both in the weighing out of ingredients and in the giving of correct weights and measures in selling their goods – another form of justice. Enshrined in the guild codes of the Worshipful Company of Bakers in London is a thirteenth-century law, 'The Assize of Bread and Ale', under which bakers who short-changed their customers suffered severe punishments – they could be flogged, fined or put in a pillory. So baking 13 to the dozen was a safety net to ensure they erred on the safe side of the law.

The 'peel' or shovel the baker is holding is the attribute of St Honoratus of Amiens (St Honoré), the most popular of the many patron saints of bakers, born circa 600. The Seventh Bishop of Amiens, a ray of light from heaven descended on him upon his election, as here, where the all-seeing eye of God looks down and divine rays of light pour blessings on the workmen and their products. And of course bread itself becomes divine in the rite of Holy Communion. A further attribute of St Honoré is the holy oil that appeared on his forehead, and which may be referred to in the tall bottle placed next to the base of the baker's 'peel'.[24] The Guild of St Honoré was established for bakers and confectioners in Paris in 1400, and the *corquenbouche* (a sponge flan filled with vanilla custard cream and surrounded by caramelized choux pastry buns, also known as a *Gateau St Honoré*) is still popular at French weddings, which may be why the confectioner has a rather magnificent iced cake in the British tradition beside him.

The 1890s also saw another variant on Sharples's design – that of the certificate of the Amalgamated Society of General Toolmakers, Engineers and Machinists (circa 1892, Plate 24), designed and printed by Percival Jones Ltd, Birmingham. Here, it is the lower section only of Sharples's emblem that is adapted to form this new certificate. Four blue-veined, black marble engaged columns support a break-front entablature with an arching section above with the society's name in raised brass lettering. It contains not a phoenix but a scene entitled 'Donation' (the word used at the time to refer to the unemployment benefit payment that had replaced the old, out of date tramping system). The view is that of an office (the words 'Club Room' are lettered on the doors) in which a fire blazes in the grate, and an open safe is beside an official at a desk who is handing out money. This amplifies and explains the Latin motto at the feet of Nike above, which reads 'Sunt vis industriaque prosperitati ac paci' (The strength of industry exists for the purpose of prosperity and peace).

The office is above a tall rectangular view of a machine shop. It is edged by bronze animal heads with blue ribbons in their mouths from which are suspended elaborate brass and copper frames, scrolling in three dimensions, containing vignettes of the accident at work and superannuation, further monies that would be handed over from the office safe, reinforcing the motto of profit by labour. In the accident at work scene, the accident has only just occurred and the manager or supervisor is coming quickly through the door. Two colleagues are rushing over, expressions of concern on their faces. The injured man is very pale with eyes almost closed, and a suited and aproned man are supporting him. The superannuation vignette (which is replicated on their banner) is of an old couple outside a cottage door with immaculate, weed-free brick paving. The elderly gentleman is seated with his newspaper beside the door (indicating a leisurely existence and healthy, fresh air away from the city). His wife is talking to him and their cat is curled up at his feet. A climbing rose is over the front door. All is static and calm, compared with the rush and panic of the accident in the twin oval at the other side of the emblem.

Sharples's Nike is again at the top, seated, holding the attribute of Nike, the laurel branch of victory, and a dish of fruits (i.e. the fruits of labour) with the hive of industry beside her with fasces beneath and, on her other side, a dove of peace. Behind her is the sun with its rays, forming a halo behind her head. Sharples's mandorla of smoke has become a background of blue cloud or mist out of which emerges a suspension bridge on the right (most probably, from its design, Telford's 577-foot Menai Bridge, opened in 1826). Beneath is seated the female figure of Science, clothed in a similar robe to that of Nike. With a globe of the world, square and compass and scientific instruments at her feet, she is lost in creative thought as she holds her drawing board. To the left is a large crane with a male figure of Labour beneath, holding a hammer and seated on an anvil beside cogwheels. The dove of peace at the feet of Nike is turned towards him, her wings outspread like the great wings of the goddess of victory, as though about to fly to him, to show the association of labour with peaceable intent, but also with victory. Above the mists rise classical buildings, indicative of church and state.

At the base of the edifice are two white marble classicized androgynous youths with brass pots beside them, supporting with one hand the accident and superannuation benefit ovals whilst supporting cameo portraits with the other hand. On the left is James Watt, in classical toga as in Sharples's emblem, whilst on the right in modern dress is J. Starley, bicycle manufacturer of Coventry,[25] so it may be his factory that is represented in the central scene. Beside the two cameos are the laurel wreaths of the victor, hanging on the plinths with shading to indicate three-dimensionality, and at the base are the words 'It is by helping others we best help ourselves' on scrolling blue strapwork, entwined through further branches of laurel.

Well into the twentieth century, Sharples's influence can be still seen. The certificate of the Associated Society of Locomotive Engineers and Firemen of 1916 (Plate 25), designed and engraved by Goodall & Suddick of Leeds, features his stepped crepidoma or ziggurat once again but this time it takes up the whole of the design with figures of

the gods and personifications standing on it. The lower portico has gone, with simply two levels of vignettes, the lower one featuring locomotives and the upper one a factory and a ship, and a central roundel with a fireman and a locomotive engineer shaking hands within a railway engine cab. This certificate will be discussed in detail in Chapter 7, 'Men, Myths and Machines'. It is sufficient here to show the heavy reliance on the design of Sharples.

A further late variant of the crepidoma or ziggurat is seen on a banner – that of the Transport and General Workers' Union, Export A. 12. C. Branch (Plate 7), a union formed in 1922, a successor of Tillet's Dock, Wharf, Riverside and General Labourers' Union. It appears as a painted scene within a medallion. Gorman theorizes that this banner may be an earlier dockside union's banner and had been painted over with the new name at the time of amalgamation, as he does not see what he calls this 'picture of servility' being in accord with the position of the new union.[26]

In a complete reversal of tradition, it is not the workers who are the heroes or gods on the crepidoma or ziggurat. Here, the 'gods' represent the establishment – on the left an army officer, resplendent with medals; in the centre, an academic; on the right an industrialist, with a gold watch-chain across his bloated stomach, a gold pin on his tie, a cigar in his left hand and money bags around his fashionably spat-shod feet.[27] It is interesting to observe that, by this time, the church is no longer seen as a power of the establishment and it is not represented here. The army officer and the industrialist lean casually with one arm on the upper section of the structure. The army officer turns away, arrogantly ignoring the pleas of the worker (the Duke of Wellington had referred to the ordinary soldier as 'the scum of the earth' and the Earl of Cardigan had actually flogged his men, a practice not abolished in the army until the late 1870s). The industrialist is looking toward the worker but not at him. Like the army officer, he is looking beyond the worker, over his head, at the viewer; his dour expression leaving no doubt that the plea falls on deaf ears. The worker throws open his arms in a gesture of pleading, whilst underneath the motto in quotations 'We Seek Knowledge That We May Wield Power' may refer to Bacon's 'Nam et ipsa scientia potestas est' (Knowledge itself is power) from *Religious Meditations, Of Heresies*.

At the highest point of the *rostrum*, crepidoma or ziggurat stands the teacher with the academic gown and mortarboard of higher education. His lined face and sagging neck reveal his years, spent in learning, and the pince-nez glasses add to his intellectual air. The top surface is his desk, with a globe of the world, scientific glasses, vials and papers. The two volumes on which he rests his right hand may perhaps represent the law. His left hand is raised in a gesture of denial, and he looks down on the worker and refuses his request. In this, he resembles the figure of the blacksmith on the left of Sharples's upper section, who holds up his left hand in a similar gesture of refusal.

Behind the three figures of power is a background of books containing the knowledge to which the motto refers ('We seek knowledge that we may wield power'). The officer, teacher and industrialist are placed between that knowledge and the worker, separating him from it, blocking his way to it. They represent what must be removed in order for him to have access to what he craves. And what splendid impertinence to actually

depict the class system, with such self-satisfied, arrogant members of the establishment as 'gods' on the crepidoma or ziggurat!

The army officer and the industrialist may represent Parliament itself – the army officer may be the son of an hereditary Peer, thus representing the House of Lords, whilst the industrialist may be an MP in the House of Commons. Although Gorman sees this as 'a picture of servility', the worker is by no means cowed or servile, and appears to be making a great oration.[28] In fact, he is the hero of the narrative: vocal, articulate and passionate in his plea. His arms reach out to each of them, forming a diamond-shaped composition with the educator at the apex and the worker at the nadir. The industrialist is old, grey-haired, bloated and flabby; the teacher is elderly and gaunt and needs spectacles in order to see; the army officer is younger, but with his booted spurs he is used to being carried about by his horse. The worker, however, is muscular and strong. Of the four figures, he is the more 'manly'. The self-satisfied figures on the ziggurat either ignore or refuse his pleas, which makes the viewer question whether they are fit to govern.

The crepidoma or ziggurat, first introduced by Sharples, originally supported worker 'gods' at the top, secure, respectable and nonconfrontational. Here the balance has been overturned. With growing self-confidence, the worker is now realizing his own power to storm the barricades, to challenge the status quo and to create a new social order.

Chapter 5

THE DEVELOPMENT OF THE
ARCHITECTURE OF THE EMBLEM

Annie Ravenhill-Johnson

As we have seen in the preceding chapter, the crepidoma or ziggurat employed by
Sharples as an architectural setting on which to place workmen, portraits, gods and
goddesses was widely copied. In this chapter further architectural and sculptural forms
employed in emblem design are examined, together with the artistic traditions and
social factors that influenced these choices.

In 1861, the Operative Bricklayers' Society commissioned a new emblem
(Plate 46) used for both certificate and banner, from Arthur John Waudby. The basis
of Waudby's design is part crepidoma or ziggurat, part Roman triumphal arch. As
with the crepidoma or ziggurat that supported a shrine, the triumphal arch also
had its origins in temple architecture. It was originally a monument to celebrate a
great victory, often decorated with bas-reliefs depicting incidents of the campaign or
conquest, which might perhaps be why it features in many trade union emblems as the
unions probably felt that they themselves had won a victory when the Combination
Acts (which, together with other laws, could send union members to jail for two years
or transported for seven years) were repealed in 1824, and men were somewhat freer
under the law to meet together and to form associations.[1] If not this, then certainly
it signals victory in more general terms. It signified a triumphal entrance, and so it
was used on certificates to mark a man's entry into the union. Sometimes, as with
the Arch of Titus, the Roman triumphal arch also served as a reminder of the actual
deification of the hero. So it is not surprising that many of the new unions use this
structure as the basis of their emblems.

Waudby's design, discussed more fully in the following chapter, is in the shape of a
lunette with roundels in corners above. It features a three-level structure. The upper half
is formed from a triangle resting on a rectangular base with the crepidoma or ziggurat
form in the upward stepping leading to the small flat-topped section on which is sited
the throne of Justice. Waudby's edifice is more structural, more architectural, than
those in earlier emblems, which is of course entirely fitting for a design for the building
trade. It has thermal windows resembling those of Roman baths, and fashionable

polychromatic brickwork in the style made popular by the architects Butterfield & Street, under the influence of Ruskin's *The Stones of Venice* (issued in three volumes over the years 1851–53)[2] and Owen Jones's plates illustrating the coloured tiles, stone and plaster of the Alhambra Courts in Spain.[3] It has scaffolding, sculptural classical figures, and it is crowned with a throne, decorative urns and lictors. It is very like grand architectural portals that mark out the place of entry into a building.

Very different in style to Waudby's emblem but of a similar date is that of the certificate of the General Union of House Carpenters and Joiners (Plate 47). In November 1864, the Bolton Lodge had proposed that a new emblem be designed, following which the Executive Council decided (as had, in 1851, Sharples's own union, the Amalgamated Society of Engineers) that the most cost-effective way of securing a new emblem was to advertise for it in a competition. Accordingly a notice was placed in the local newspapers of Manchester, Liverpool, Bristol and Birmingham, and in the *Beehive*, offering a prize of £7 for the best design and £3 for the runner-up.[4] The winning design was issued in 1866 accompanied by a key and a pamphlet giving a full explanation of the intricacies of the design.[5] It is a Gothic fantasy, reminiscent of Tennyson's 'many tower'd Camelot' and very much of its era.[6] The 1860s was the pinnacle of the Gothic Revival style, exemplified in the vast Medieval Court in the Crystal Palace, and around the country new buildings were boasting portcullises, watchtowers, turrets and pointed, Gothic windows and doors such as those in this emblem. The upper section (from the blue base of the certificate scroll and the feet of the farthest groups of two figures on either side) is again formed from an equilateral triangle. The entire design is enclosed within a lunette, with decorative infill in the top corners.

Although the Gothic Revival was at first associated with Catholicism, Neo-Gothic became the architectural style of the Anglican Church – the established church, the church of the ruling elite – and its architecture was seen to embody traditional values of continuity and history. Pugin, who designed a very large number of churches, had raged against the merging of the ecclesiastical and the secular, the distortion of scale and the false decorative details of Picturesque Gothic architecture. And in this emblem, the Picturesque (with architecture as scenery and memory) collides with medieval manuscript illumination and Pre-Raphaelite colour. Decorative, structural and lighting elements are distorted, whilst paganism, myth and Christianity mingle – the secular with the sacred. Foliage serves to disguise architectural discrepancies and odd perspectives in this imaginative and magical flight from the grim realities of the industrial world. Intricate workmanship in wood is foregrounded.

Although the Gothic wooden structure has turrets that are dissimilar (perhaps to emphasize the differences between the carpenter and the joiner placed on either side of the central scroll bearing the certificate), the whole design bears allegiance to the classical in its total sense of balance. There is nothing on one side that is not repeated on the other, even down to the pathways beside the widow and children on the left and the elderly worker supported by the younger one on the right in the tiny scene below the scarlet arch or 'bow' bearing the union's name. It even shows the influence of

Sharples in the windowed workshops each side of the central arched section with their lancet arches topped by finials, becoming here more like medieval cloisters.

This union, founded in 1827, was a collection of small, independent branches and did not provide friendly society benefits until faced with competition from the new Amalgamated Society of Carpenters and Joiners, which had adopted the rules of the engineers.[7] The new emblem introduces these benefits.

The largest figures at the base of the emblem on pedestals are identified in the key as Hope (with her right hand on the anchor and wearing a star on her forehead) and Justice on the right with her scales, sword (which rests on a Bible to indicate that justice is founded on righteousness) and a triangle and compass in her hair. Above them, a carpenter is on the left, with a plane tucked under his right arm:

> [...] In his face is pourtrayed [sic] the Divine expression of 'Joseph' the Carpenter, reflecting the heavenly beam of mildness and benevolence, combined with manly determination to lead the way to truth, and act man's noblest part in honest labour. He is conversing with the modern and manly-looking *Joiner* opposite who is leaning on the post with saw in one hand and compass in the other.[8]

Behind the carpenter, Peace holds the olive branch and a dove. Opposite her, above the joiner, is Plenty, who holds a cornucopia and points to the workshop behind her to indicate that plenty is derived from industry. Behind them are four female angels 'supposed to have come from brighter regions to bear up the scroll, to witness its righteousness, as it were, and sanctify the certificate of membership'. Traditionally, angels are of course male, but in the Victorian era they become female, due to Victorian unease concerning portraying men in dresses.

Above the entrance to the building behind them with the ogee arch is written, 'In holiness and purity live, and in a high enlightened love do ye unto others as ye would that they should do unto you.' Tools of the trade are in the apex above the central doorway,[9] which is surmounted by crockets or finials, below which is the religious symbol of the dove of the Holy Spirit in a further ogee arch. An equilateral triangle (symbolic of the Holy Trinity) is formed from the apex to the lower corners of the emblem. The Hand and Sacred Heart, and the Lamb and Cross are in the roundels at the apexes of the pointed arches of the workshops on each side, set against the same deep blue background of the roundel of the dove. In Renaissance art, ultramarine, this vivid blue, obtained from *lapis lazuli* and originally brought 'across the sea' from Asia, was the most expensive of the pigments and used almost exclusively for the most holy parts of a religious painting.

At the far end of the arched interior, with its ogee arch and blue ceiling dotted with golden stars in the manner of medieval altarpiece *scraffito* work or Giotto's Arena Chapel, the goddess Fame is seated at the top of a golden staircase. She crowns with wreaths of immortality two carpenters who shake hands. In the tower at the very top, beneath the 'Allseeing Eye of the Omnipotent King of Kings, looking down and diffusing the rays of glory on all beneath that never fail to light the path of the earnest

worker and fearless spirit who believes in His Eternal Love and Almighty Power', is a figure of Charity, clothed in blue, sheltering children, very similar in form to traditional depictions of the Virgin and Child with John the Baptist.

Beneath the trees at the left side of the emblem are Holiness, holding a cross, with the Lamb of Innocence at her feet, and Resignation who, oppressed with the sorrows of mortality, gazes at it and is comforted. On the right is Fortitude, with a compass at her breast to indicate science supporting and strengthening the mind, who leans on Industry with the 'ancient flaxspool spinning' near the beehive.

Under the arch or 'bow' with the name of the union lettered in gold against a red background, topped by a handshake surrounded by tracery, is a small scene to the left with winged angels flying in to bring comfort to the widow and her children. They are beside a gravestone, behind which are Picturesque Gothic ruins silhouetted against the sky. In a caption below is written 'Comfort the Fatherless and Widow'. To the right is the aged carpenter, supported by a younger one, and the sick being administered to with water, with a caption beneath reading 'Be a Staff unto the Sick and Aged'. Between the two groups are the arms, a square and compass on a white or silver shield surmounted by fasces and an oak tree. To the left of it is a bust of Minerva/ Athena, palette and brushes to indicate Art and on the right a globe, telescope and instruments to indicate Science, all resting on ornamental joinery or fretwork with the motto 'Honour God'. Beneath, at the lowest level, are shipping, factory and a train running across the bottom. In the lower corners of the emblem are regional flowers. How long it took the artist to design and execute this glorious confection one can only imagine. He (or she) certainly earned the meagre prize of £7.

What is very obvious from this emblem is the use of High Church (Anglican or Anglo-Catholic) religious iconography, which also reflects in the language used in the descriptions in the key. The Oxford or Tractarian movements had reintroduced Catholic styles of ritual, liturgy, vestments and furnishing into High Church worship, and this emblem advertises the skills of the union's members in the intricate carvings of such church furnishings. The shrine-like central recess guarded by angels and placed above the bow with water beneath is also reminiscent of well dressings. Constructed on wooden surrounds and covered with wet clay, flowers and foliage were pressed into the clay to form brilliantly colourful temporary shrines containing religious images and texts (see Plate 26, a well dressing of 1899 at Tissington, Derbyshire). Originally celebrating a pagan festival honouring the gods of water, such rituals were frowned upon by Christianity but then adopted by it. The arrival of piped water in rural areas in the early 1800s was celebrated in this way and during the nineteenth century (and continuing into the present day) well dressings were celebrated with processions, marching bands and the crowning of the May Queen.

In 1866, the year that the members of the General Union of House Carpenters and Joiners received their certificates, a rival union, the Amalgamated Society of Carpenters and Joiners – one of the largest and most important unions of the age – turned to the professional artist, Arthur John Waudby, who had designed the Bricklayers emblem, to form their new emblem (Plate 2), which members received in December 1868.

And how very different it is from the General Union's emblem (Plate 47). Gone is the High Church gothic, reminiscent of the intricately carved rood screen, reredos and pulpit, gone are the ultramarine and gold of the scraffito work of the medieval religious icon, gone are the winged angels. Was this rejection of the Gothic in favour of the classical a way of expressing difference? Was the demonstration of affluence in having the funds to commission a known artist (as opposed to offering a cash prize in a competition), coupled with the adoption of a different mode of expression, a way of claiming superiority over a fellow craft union? Or does it go deeper than that? Was the adoption of the classical a way of expressing a rejection of the values of the established church (the Church of England) embodied in Gothic architecture, and endorsing the values of the Nonconformist chapels, missions and gospel halls of the working classes, constructed in the severe classical style? Nonconformists, or dissenters, had been harshly discriminated against until then quite recent times. They could not hold public office or enter university until 1828, and their births went unrecorded unless the child was baptized in an Anglican church and (with certain exceptions) their marriages were only legal when performed in an Anglican church. Certainly many leading trade unionists were Nonconformists, which may be why the classical architecture of the Nonconformist chapel (and the classical temple architecture of Freemasonry) is echoed in their emblems.

This new emblem by Waudby is less cluttered, less busy, less ornate than that in his design for the Bricklayers (Plate 46) and the structure is far less heavy. As with many of the Renaissance trade pegma, it follows the model of a Roman triumphal arch such as that of the Arch of Constantine in Rome (317 CE), where the post and beam, trabeated system meets the arcuated system, with tripartite division effected by four equal columns unequally spaced, affording a narrow–wide–narrow rhythm. Naturally, instead of featuring a brick arch, Waudby's design for the Carpenters and Joiners is more like furniture, in wood, with carved detailing. It is not truly arcuated in the manner of a triumphal arch. The pilasters are purely decorative and enriching. They purport to support a returning entablature, with an attic storey above. It is heavily embellished with composite capitals on the pilasters and the spandrels of the arch are carved with painted roses. The cornice is decorated with dentils, picked out in white, and there is a great deal of gilding. This emblem is discussed in more detail in the following chapter devoted to the work of Waudby for the unions.

Rivalry between the General Union and the Amalgamated Society of Carpenters and Joiners was relentless. A struggle against employers in 1877 lasted for 53 weeks and exhausted the finances of the General Union. After their defeat, the Amalgamated Society of Carpenters and Joiners invited them to discuss amalgamation but were refused, and full-scale enmity ensued. Members of the Amalgamated Society joined the General Union in order to sow discontent. They also induced lodges to make impossible demands on headquarters that the General Union could no longer meet, nor could they pay benefits. Lodges changed sides in droves, and by 1883 there were only 1,750 remaining members.[10] In 1920, the General Union finally merged with the Amalgamated Society of Carpenters and Joiners to become the Amalgamated Society of Woodworkers, but Waudby's emblem remained in use, with simply the title being altered.[11]

According to Leeson, it was the Tamworth Lodge of the Stone Masons who, in December 1866, proposed that a new emblem be commissioned, and after several months of debate an 'eminent artist' (Arthur John Waudby once again) was commissioned.[12] The basis of Waudby's design for the certificate of the Friendly Society of Operative Stone Masons (Plate 10) is a heavy, imposing, sculptural and solidly stone edifice, described in the key as 'a Screen displaying Pilasters and a Cornice with enriched mouldings of the Corinthian order'. With its triglyphs, swags and colonnade, Waudby's design evokes a temple front. The centre section of the elevation, as in the Carpenters emblem, appears to be a breakfront type of construction, projecting forward, as evidenced by shadowing down the right-hand side. The figures seated at each side at the base are recessed back from the projecting central section on which the details of the certificate itself are lettered.

Waudby's great stone edifice is similar in many ways to the sculpted monumental tomb of the Renaissance and also to chimney pieces. The chimney piece in the Van Dyck room at Hatfield, Hertfordshire, circa 1610 (Plate 27), is attributed to Maximilian Colt from Arras, who also designed and sculpted tombs, and from this example one can see the similarity to Waudby's design in the overall concept and in the sculpted classical figures. But Waudby's design also has strong similarities to the monumental sculpted tomb, which is not surprising as death benefits and insurance benefits were an important part of friendly society and union membership, and also of course references to the monumental tomb foregrounds the skill of the stone sculptor. Sansovino's[13] double tomb of Antonio Orso and Cardinal Michiel in the Church of San Marcello al Corso, Rome, circa 1520 (Plate 28), is a fine example of the genre, later brought to Britain by European craftsmen. Like Waudby's edifice, it breaks forward at the centre and contains two scenes (Madonna and Child above, deceased beneath) with the textual details at the base, in the same position as Waudby's certifying details. On each side, figures are in niches, sectioned off by elaborately figured pilasters, and at the very top is the escutcheon or coat of arms. Waudby's certificate of the Carpenters and Joiners (1866, Plate 2) is also similar, particularly in the pronounced arching of the upper central vignette of the centring of the bridge, and the squared cornice at the top of the entablature, bearing the coat of arms.

The monumental wall tomb finds echo, too, in the certificate of the Durham Miners' Association by Alexander Gow (1890s, Plate 29), who was very active in the production of trade union emblems and certificates in the 1890s. Here, the outline of the arch survives, but it has become overgrown with ornamentation and is barely recognizable. There is, however, still recession in the central space. Gow's smaller central arch is embellished by fictive iron arrowheads of the type found in iron railings of the period with an inner decoration of lilies, and it is supported on each side by wrought iron brackets. Decorative ironwork also appears to crown the top of the outer arch. The iron industry was, of course, heavily dependent on the coal produced by the miners for its fuel.

Portraits of union leaders each side of the inner arched space are reminiscent of the saints sited in this position on the monumental tomb.[14] Between them, in the lower

section of this inner, smaller arched space, a miner reclines in his tomb-like (or womb-like) space, rather in the manner of the portrait effigy on a sarcophagus. Above him, small surface workers pull and push wagons of coal along tracks. The shape of the central pulley resembles a cross. In the monumental tomb, typically the figure below is of this world, and the figures in the arch above are in the heavenly world, as with the certificate with the figure below in the bowels of the earth and the figures above him up on the surface in the daylight, whilst a pick spreads its twin arms protectively. And at the top is a painting of the pithead rather than the Godhead.

Another fine example of the influence of the Renaissance monumental wall tomb occurs in the emblem of the National Amalgamated Tin and Iron Plate Sheet Metal Workers and Braziers of the 1900s (Plate 30).[15] The overall design is Gothicized with pennants at the base, and both ogee and pointed arches. The shield at the peak (flanked by a heavily ornamented bath tub and painted barge ware, with port and starboard lights in the roundels topping the elaborate columns) bears the inscription 'Omnia Vincit Labor' – a popular motto usually expressed as *Labor Omnia Vincit* (Labour Conquers All), and which appears in the coat of arms of the City of Bradford, in the state motto of Oklahoma and is a motto frequently occurring in the labour movement in the United States. It originates in Virgil's *Georgics* (1.145–6), in near quotations in Xenophon's *Memorabilia* (2.1.20) and in Horace's *Satires* (1.9.59), after Hesiod's *Works and Days* (287–91) and appears in later emblem books (e.g. that of Johannes Lobbetius). Two further quotations are beneath, at each side. To the left is 'The labourer is worthy of his hire', from 1 Timothy 5:18. To the right is a quotation from William Cowper's *Ninth Satire of the First Book of Horace* (1759): 'Labour like this our want supplies' (the rest of the quotation is 'And they must stoop who mean to rise').

Between the two columns with their decorative twisted rope carvings is a fictive curtained canopy, of the type held back by putti in many Renaissance wall tombs. Behind the swags of the drapes in this emblem are further swagged back curtains of fine, transparent lace. Roundels containing a gas lamp and a coal scuttle are suspended in front of the curtains by cords. The upper vignette, reserved in the tombs for the heavenly world of the Deity or Virgin and Child, is occupied by Athena, goddess of craft, whilst the lower section, reserved in tomb sculpture for the earthly world of mortals, is here populated by members of the craft at work. The 'bier' with its pennants bears the details of the certificate and shields.

A later emblem, a chromolithographed certificate of the Amalgamated Society of Tailors from 1898 by Blades, East & Blades (Plate 48), also features a type of Renaissance wall-tomb structure with its projecting centre section and figures in niches. According to the key that was published in *Tailor's Journal*, May 1898, it is

> surmounted by the Arms of the Guild which represent our trade in the early and medieval ages, with the motto 'Concordia, Parvae, Res-Crescunt' which means 'From small beginnings great things come by union, harmony, friendship and sympathy'.

This motto is from the works of the Roman Republican historian, Sallust (*Bellum Iugurthinum,* Chapter 10) and it also appears in Seneca the Younger's *Letters to Lucilius* (XCIV, 46). It was popular with newly formed republics, such as Belgium.

The Amalgamated Society of Tailors was formed in 1870, but it was closed to Eastern European workers and admitted only a very few Jewish skilled journeymen tailors until 1883.[16] The Bradford conference of 1882 had voted, under the General Secretary of the Executive Council, George Keir, that an emblem should be provided to represent the trade, and the design was actually suggested by members of the Executive Council, who entrusted it to Gow & Butterfield (later Blades, East & Blades). In a Special Notice to Members, it was proudly stated to be 'not excelled by that of any other association in either trade unions, friendly societies, or such orders as the Freemasons' and it would be priced at 3s.[17] The Christian symbol of the Lamb of God with a banner, signifying victory over death, is at the very top of its emblem, but of course the lamb also represents the wool from which fabric for the tailors is made. Beneath is the crest with the British lion above the tent or silk pavilion, the tailor's old guild emblem, traditionally striped in red and white.

Adam and Eve are represented in the central roundel as, of course, according to the Old Testament, they were not only the first people in the world, but the first people to sew clothing: 'And the eyes of them both were opened, and they knew that they were naked; and they sewed fig leaves together and made themselves aprons.'[18] No other trade association could locate its origins in the Garden of Eden, and in the race to claim ancestry as far back in history as possible, the Tailors were definitely first past the post. Even the apron given to the naked candidate at the end of initiation ceremonies, such as that of the Order of Oddfellows (after, whilst blindfolded, he had been enmeshed in brambles, fallen down in 'rocks', burned, drenched with water and threatened with death), symbolized that worn first by Adam.

Adam and Eve are listed by the Catholic Church among the patron saints of tailors, their feast day being Christmas Eve, although it is difficult to understand how they can be numbered as 'saints', having been the cause of the Fall of Man and Original Sin, and dating from before Christ himself. It is not even made clear in the Bible if they actually repented. However, the thirteenth-century Dominican theologian, Vincent de Beauvais, in his *Speculum Maius*, gives a theological explanation of the seven mechanical arts (which include textile crafts) in that the souls and bodies of Adam and Eve suffered due to their exclusion from Paradise, and mankind's redemption is achieved through work, the means of mitigating Adam's Original Sin.[19]

Costumes of various periods feature in the recesses – the 'Judge of Israel', Solomon, Julius Caesar, Alfred the Great, William the Conqueror, Henry V, a 'gentleman of the period of George III' (George III, who lost the American colonies and therefore the southern cotton fields, is presumably not himself represented due to his unpopularity and insanity) and the Very Reverend Canon Charles Kingsley, named as 'author of *Alton Locke, Tailor and Poet*'. The history of male costume is traced from Adam himself to the present day via male costume (only female riding habits and cloaks were tailor-made until the advent of department stores – a woman would either make her own

clothes or have them sewn by her dressmaker). Women (apart, of course, from Eve herself) appear in this emblem in unspecific classical robes.

The 'Judge of Israel' is a somewhat androgynous figure. Twelve judges are listed in the Book of Judges, two more in the Book of Samuel and one in the Book of Joshua. Deborah is the only female judge (a title which refers to not only a judge but also to a king and a leader of the army), believed to have lived between 1202 and 1169 BCE, and she is often referred to as the 'Judge of Israel'. The figure in the emblem might possibly be female, but it does appear to sport a moustache and perhaps even a goatee beard, which does rather rule her out. Solomon, of course, is featured because of the biblical reference to his clothing and the moral lesson to be learned:

And why take ye thought for raiment? Consider the lilies of the field, how they grow; they toil not, neither do they spin; And yet I say unto you, That even Solomon in all his glory was not arrayed like one of these. Wherefore, if God so clothe the grass of the field, which today is, and tomorrow is cast into the oven, shall he not much more clothe you, O ye of little faith? (Matthew 6:28–30)

Tiny roundels illustrate benefits of the union. On the left, Justice leans her arm on a roundel of 'The Lockout' whilst Mercy, on the right, leans upon 'Trade Protection'. At the base are further roundels – 'Travelling' (the old system of tramping in search of employment), 'Relief of Sick', 'Superannuation' and 'Funeral', flanked by putti with the hive of industry and the fasces of unity. Truth, with her hand mirror, and Art with palette and brush, are the highest figures (wrongly described in the key and in the Special Notice as Truth and Justice), whilst on plinths each side, supporting the main structure, are grisailles of a naked, helmeted woman who may represent Athena, goddess of craft and spinning. Various foliage representations are also present of the cotton boll, and figs and their leaves.

According to Pierre Macherey, in any text there is always a critical discourse 'constantly alluded to, though never announced openly' – he calls it a 'silence'. Quoting from Nietzsche, he asks,

When we are confronted with any manifestation which someone has permitted us to see, we may ask: what is it meant to conceal? What is it meant to draw our attention from?[20]

Here, of course, this very beautiful emblem draws our attention away from the appalling conditions in the sweated workshops and homes in which underpaid workers, mostly female, or Jews escaping the pogroms of Russia and Poland for safety in the East End of London, stitched as outworkers. As far back as 500 BCE, Jewish tailors were working in the markets of New Jerusalem. Garments had to conform to the Torah's exhortation that no garment should contain linen mixed with wool, a practice still continued today amongst strictly Orthodox Jews.[21] In the influx into London, Leeds and Manchester in the second half of the nineteenth century, the skilled tailors of

the Pale of Settlement (Ukraine, Belorussia-Lithuania, Polish territories and parts of the Balkans) were Talmudic scholars, but the semiskilled and unskilled were for the most part illiterate.[22] Tailors' shops were supplied by middlemen who took orders for garments and handed the work out, forcing down the price paid to the manufacturers in order to enhance their own profits, and thus perpetuating the 'sweating system'. In overcrowded, windowless cellars or tiny, filthy rooms with no ventilation, tailoring workers would labour from before dawn until after dark in the intolerable heat caused by the gas and coke fires which heated up the smoothing irons.

By 1889 the sweating system had become so notorious that the government called for an official enquiry, and the tailors' unions went on strike. Eight years after this emblem was produced and circulated, George Cadbury, owner of the *Daily News*, mounted the Sweated Industries' Exhibition at the Queen's Hall in London to highlight the pitiless exploitation of workers in sweated trades.

Thomas Hood's poem, 'Song of the Shirt', first published in *Punch* on 16 December 1843, describes a needlewoman working from dawn through into the night in abject poverty, with raw fingers and worn out eyes, a theme taken into art by several contemporaries: Richard Redgrave in 1846, George Frederick Watts in 1850 and Anna Blunden in 1854. The investigative journalist and first editor of *Punch*, Henry Mayhew, highlighted the plight of young seamstresses in *London Labour and the London Poor* (1851–62), which first appeared as a series of articles in the *Morning Chronicle*. He quotes one young woman, a 'slopper' employed as an outworker in the making of moleskin trousers. He recounts her struggles to earn enough merely to live on and how, when she could not afford food and clothing for herself and her mother, she 'went wrong' and was now consequently pregnant:

> I am satisfied there is not one young girl that works at slop-work that is virtuous, and there are some thousands in the trade. [...] I've heard of numbers who have gone from slop-work to the streets altogether for a living [...]. It was the little money I got by my labour that led me to go wrong. [...] I am ready to say again that it was want, and nothing more, that made me transgress.[23]

In March 1907, the *Arbeiter Fraint* (Workers' Friend), a Yiddish London-based weekly paper founded in 1885 (suppressed by the British Government after 1914) records,

> It is heartbreaking to see how people, fathers of children, workers, good craftsmen work, so hard, such long hours with heads bent, tremble for their bosses [...] and all for what, for a slice of bitter bread in the busy time barely just to keep alive and, in the slack time so little.[24]

The emblem depicts the social reformer, Charles Kingsley, author of *Alton Locke, Tailor and Poet*, a novel of 1850. In it, as in *Cheap Clothes and Nasty* of 1850, a tract written by him under the pseudonym of Parson Lot, Kingsley describes the filthy conditions of clothing workshops, where workers (many of whom were consumptive) worked,

ate and slept in one unventilated room, sharing beds. He exposes the ability of employers to dismiss workers to work in their homes on piecework for far lower wages, he exposes the exploitation of child labour and he promotes the Chartist campaign in which he himself had been involved. In April 1848, some two years before the publication of *Alton Locke*, the government surrounded Parliament with thousands of troops and artillery in preparation for a Chartist march formed to present a petition for political change. 150,000 Chartists were assembled on Kennington Common and the government allowed only the leaders themselves across the river to Parliament, such was the fear of conflict. In Kingsley's book, Locke raises himself from his lowly origins, becoming a poet. He dreams of social revolution and is jailed for his Chartist activities, but eventually comes to the conclusion that the true charter is the Holy Bible, and that class co-operation rather than revolution is the only solution. Thus, through the figure of Kingsley in the emblem, the appalling conditions endured by outworkers are only hinted at, and this is balanced out by the vision of class co-operation with the factory owners. There are no portraits of union leaders here, no vignettes of tailors or garment workers actually at work, no depictions even of workshops or the new sewing machines and cutting machines which, from the 1850s on, were revolutionizing the trade. Representations of the trade at work were probably too sensitive an issue to be included and instead the union commissioned a handsome emblem that concentrates on the products, the finery produced by the trade, rather than its working processes.

However, if we look closely at the figure of Mercy to the right of the roundel of Adam and Eve (and twinned with Justice on the left of the roundel), she has a length of material in her lap, her eyes are closed and her left hand is raised to her head in a gesture of utter fatigue and despair as though she herself were one of the wretched needlewomen. Amongst all the elegantly and richly clad male figures in the niches, the elaborate architecture and sculpture, she is just a woman, a personification, and so easy to overlook. In the mind of the late Victorian artist/viewer, the precedent for the anguished woman was well established, both in sixteenth-century paintings of female Christian martyrs and in the work of artists such as Dante Gabriel Rossetti (*Found*), Augustus Egg (*Past and Present*) and Walter Langley (*But Men Must Work and Women Must Weep*). The portrayal of the suffering of one individual, as opposed to that of a group, is more poignant and dramatic for the viewer.

According to Genesis 3:7, it was their sin in eating the fruit of the tree of knowledge that opened the eyes of Adam and Eve to the fact that they were naked, and caused them to sew fig leaves together to make themselves aprons, which they are wearing here, in the roundel. Adam's punishment was hard labour all his life. To Eve, God said, 'I will greatly multiply thy sorrow and thy conception; in sorrow thou shalt bring forth children.'[25] Both Mercy and Eve have their hands raised to their heads in an attitude of despair. Adam supports Eve, but looks towards Mercy, but there was no mercy for Adam and Eve, cast out of the bountiful Garden of Eden and forced to till the land for their food. The personification of Mercy, holding the material of tailoring, exemplifies the hard labour of Adam and the sorrow of her counterpart, Eve, the active male and the passive, dependent female. Between the expensive, elegant clothing of the men

portrayed in the niches, and the back-breaking sweated labour of women on starvation wages, she highlights the terrible inequalities and injustices in Victorian society.

Banners, like emblems, also reflect tomb imagery. The banner of the No. 6 Branch of the United Order of General Labourers of London manufactured by H. Bosworth, dated by Gorman to circa 1911 (Plate 31), illustrates a table-top or altar tomb set against a black funereal background.[26] Its lid is supported by sturdy incised columns whose encircling pink strapwork bands read 'United to Help' and 'By Unity Safe', topped by Ionic capitals. Beneath, further strapwork reads, 'Bear ye one another's burden' (a quotation from Galatians 6:2), whilst, in case the form of the tomb has not been sufficiently understood, the word 'DEATH' is engraved on the entablature. The scene within this frame is of a young widow dressed in black, handkerchief in hand, seated at a pedestal table covered with a cloth. The only other chair, her husband's chair, is empty, his membership certificate hangs above on the wall, and his portrait is above the fireplace. She is humbly receiving funds from a union brother who is wearing his sash of office, and her outstretched finger is on the coins to which he points. The reverse of the banner features the same tabletop tomb design. The title is changed: 'ACCIDENT'. Here, the injured brother (with his right arm in a sling) receives alms from a union official with a sash across his breast. He is seated at a plain table with no other chair, a roaring fire in the grate behind him and his certificate above the fireplace. This banner is focused entirely upon the compensation paid by the union, and its imagery is couched in terms of the grave.

Waudby's great triumphal arches of the 1860s set the style for many certificates (and in some cases the banners that derived from them) for the next 30 years. The Boiler Makers and Ship Builders (1870s, Plate 14), the Cotton Spinners (1882, Plate 32), the Card and Blowing Room Operatives (1890, Plate 33) and even the London Society of Compositors (1894, Plate 15) employed variations of his format. The low platform first introduced by William Hughes's union and developed by Sharples became a great towering monument, a metaphor for the pride, strength and solidity of the union itself. In 1850, only a quarter of a million workers (elite, skilled men) belonged to unions out of a working class population of 20 million. The Stone Masons doubled their membership during the 1860s following the 1859–60 building strike, employers grew more willing to accept unions in their workforce and Waudby's magnificent certificate of 1868 for the Stone Masons (Plate 10) reflects this newfound strength in its great, heavy stone arch and its confident workmen. By 1870 union membership in the United Kingdom had doubled and by 1875 legislation covering union activities had greatly improved in favour of the unions.[27]

It is during the 1880s that the Roman triumphal arch or classical temple front format first developed by Waudby begins to go out of fashion. The certificate of the United Machine Workers' Association by Blades, East & Blades (1880s, Plate 16) shows the trend away from the arch by featuring a lower plinth with what appears to be a metal-studded lower decorative edge and a type of egg and dart upper border, with four decorative frames with raised 'metal' borders. The 'foundation stone' of the certificate is elevated above it, with the national flowers of rose, daffodil, shamrock and thistle beneath. The certification block is flanked by two pedestals, recessed both in and from

the sides of the plinth, on which raised bands of strapwork encircle foliate decoration. Engraved on this strapwork are the names of the various trades that comprise the union membership. These pedestals support thrones on which are seated Justice (on the left, with sword and scales) and Hope (on the right, with her attribute, an anchor).[28] Behind them, sheet metal forms a screen, pierced and decorated, with two oval 'frames' each side of the figure of Nike. She stands on a cornucopia with laurel wreaths in each hand and a dove above with its olive branch, from which streams rays of glory, copied from Sharples's certificate of the Amalgamated Society of Engineers (Plate 45). The whole is enclosed in the mirror-like lunette framing device of Waudby and with a motto ('Be United and Industrious') also borrowed from Sharples's Amalgamated Society of Engineers certificate, a union with which they were later to amalgamate.[29] The influence of photography is foregrounded, with depictions of seven different pieces of machinery set into ornate framing devices, two at the top (milling machine and vertical drill), one in the large central space (planing machine) and four beneath (radial drilling machine, shaping machine, slotting machine and boring machine). Portraits and proud representations of members of the union are missing entirely, and instead, pride is indicated by the mastery of the new, up-to-date machinery.

In Alexander Gow's certificate of the Associated Carpenters and Joiners (Plate 34), also of the 1880s, vestiges of the old classical entablature are just visible behind and beneath the large central space in which the details of the certificate are printed. The whole is encased in a mirror-like surround but this time three-dimensional, as though carved in wood, and curving in a concave manner. It is whimsical, ornate, even Rococo in decoration. It is as though, in looking into the central space of this 'mirror', the viewer sees not his own image but that of his name and his union reflected back to him. In a carved roundel at the top, Joseph is posed beside his workbench, patron saint of the trade. Beside him is a building with a classical rounded arch. Beneath him is the English lion, whilst Scottish thistles stand out three-dimensionally through heavy shadowing, framing the roundel. Carpenters' tools are discretely placed each side. In an oval on the right, the scene of a joiners' workshop – very similar to that in Waudby's certificate for the Carpenters and Joiners (1866, Plate 2) – is again in the tradition of Sharples, with receding depth and windows at the side. On the opposite side, three members of the trade work on scaffolding high up in the roof space of what appears to be a church, as if the workers themselves were a Trinity. Beneath, in shell-incised recesses are figures of Athena, goddess of craft, with her attribute the owl of wisdom and the anchor of Faith, and Justice, with her scales and a sprig of laurel to indicate that Justice will be victorious. The ribbing of the shell niches affords the illusion that beams of light radiate from their heads. In smaller roundels beneath them are carpentry tools that relate also to Freemasonry and a sailing ship to represent the 'craft' and also as a tribute to their workmanship in shipping, together with the cornucopia.[30] In the central arched space at the bottom, beneath English roses, Irish shamrocks and Scottish thistles, an elderly couple sit beside their fireside in comfort and leisure, reading and knitting, with a steaming kettle on the hob and their well-fed cat at their feet, illustrating the caption 'Superannuation Benefit'. To the left and right are roundels of domestic interiors with

union officials seated at tables dispensing benefits – 'Receiving the £100 bonus' and 'Sick Benefit'. Beside these roundels, large putti empty cornucopiae, one with fruit, to symbolize the fruits of labour, and the other with English roses, Scottish thistles, Welsh daffodils and Irish shamrocks. They flank the hive of industry with bees buzzing industriously around it. The cornucopiae and their contents, together with the hive, symbolize the different areas of the United Kingdom working together in harmony, like the bees, in order to produce the fruits of labour that are dispensed by the union.

Certificates such as those for the Model Unions reflect pride in their descent from ancient guild ancestry and their patron saints. They were unions exclusively for members who had been trained according to the statutes of the guild, and who vigorously excluded the unskilled. According to Engels, bricklayers, carpenters and joiners were amongst the landlords who owned and leased out cottages to artisans. From this we know that these craftsmen were the cream of the working classes, earning high wages – high enough to have surplus money to speculate and invest in property. Many social observers at the time decried the condition of these working-class cottages. They were built in large numbers on land leased for the purpose, crowded together, built back to back for maximum utilization of land. Built in terraces facing onto a court with another row of terraced houses attached to their rear walls, each individual house was attached on three sides to another dwelling. A narrow passage from the street gave access to the court, which contained a water pump and communal dry privy.[31] Overcrowding meant shared beds and no privacy, and often entire families lived in single-room, unpaved, damp cellars with no windows. Engels writes,

> The builder, therefore constructs the cottages of a type unlikely to survive beyond the period of the lease. Since some leases are as short as twenty or thirty years it is easy to understand that builders are not likely to sink much capital into cottages built on such land. Moreover, the owners of the houses who are either bricklayers, joiners and carpenters or factory owners, are generally not prepared to spend very much money on repairing and maintaining their property. This is partly because they are not prepared to sacrifice any part of their profits, and partly owing to the system of short leases to which we have referred.[32]

Robert Applegarth, General Secretary of the Amalgamated Society of Carpenters and Joiners in the years 1862–71, introduced high contributions and high benefits. The high contributions ensured that only the best joined the union – those who were well paid, in stable employment, and able to afford the fees. Once they had joined the union, of course, they could not afford to drop out and abandon the money they had already paid in, nor would they strike if it endangered the monies put aside for their own retirement.[33] Postgate writes,

> The words of Marx, 'You have nothing to lose but your chains' for this period and for this section of workers became untrue. They had something to lose, and they became conservative accordingly.[34]

Engels, in 1871, writes of these unions,

> They are rich, but the richer they become, the more they degenerate into mere sick-funds and burial clubs; they are conservative and they steer clear above all of that socialism, as far and as long as they can.[35]

But, as he points out, such rigid exclusion of unskilled workers exposed them to competition from those not in the guild. And when the new unions were born, for example that of the National Union of Gas Workers and General Labourers of Great Britain and Ireland, they admitted and embraced every fellow worker. Will Thorne, an illiterate gas worker from the Midlands, attempted to form a union in 1872 at Beckton, but was unsuccessful and the men actually received jail sentences for 'conspiracy'.[36] In March 1889, led by Will Thorne and Eleanor Marx, the Gas Light and Coke Company's London stokers formed a union to fight to reduce the 12- and 18-hour shifts they had been working. The company gave way under pressure without a fight. In the opinion of Engels, the East End of London, the world's largest and most wretched working-class district, stirred gradually to action. He goes on to say,

> They are essentially, and the Gas Workers even exclusively, strike unions and strike funds. And while they are not yet socialists to a man, they insist nevertheless on being led only by socialists.[37]

Their certificates, for example that of the National Union of Gas Workers and General Labourers of Great Britain and Ireland (1890, Plate 35), still exhibit remnants of the old designs but are far freer in concept, more like the modes of advertising, for example that of Cremorne Gardens (circa 1850, Plate 5). And references to insurance against accident, incapacity, old age and widowhood are no longer there.

Gas had rapidly replaced oil as the main form of lighting and the huge circular forms of gasworks (as here, in the upper section, under the clock) were a feature of the working-class areas of Victorian cities. Gas was made from coal and in the bottom left scene it is being transported by horse and cart. In the top right roundel are the vertical retorts that, around the turn of the century, replaced horizontal retorts. These narrow tubes were charged with coal, gas was given off, and the resulting coke was removed.

Gas works polluted the air around them and the ground they stood upon, and there was always the frightening risk of explosion. The Gas Workers had no ancient heraldic crest to display and, instead, at the peak of their arch, within a horseshoe, is a clock with its hands at eight o'clock and the words 'New Time', flanked by the jubilant announcement '8 HOURS LABOUR!' to proclaim their success in the winning of the eight hour day from their employers. The triumphal arch has been reduced to a purely decorative scroll with the rose of England, the leeks of Wales, the shamrock of Ireland and the Scottish thistle, and the words 'Estd.' and '1889' at each curled end. There is lingering classicism with two classical kneeling figures, one breaking the single stick and one unable to break the fasces, and the old tripartite arcuating system (which

has now degenerated into a central arch and two lower roundels), but apart from that, and the seal with the handshake within a triangle, all vignettes celebrate the modern world and those who labour in it at the various trades, skilled and unskilled. There are even three washerwomen working at wooden tubs in the bottom right corner. No wooden washing dollies or possers are in evidence, so they may be performing the rinsing process (after being presoaked and washed by hand, usually with the help of a pronged dolly or posser that was turned back and forth by hand, clothing and linen was normally rinsed three times to get rid of the soap and dirt).

During the 1880s, tens of thousands of casual labourers were packed into the London dockside slums of Poplar, East Ham and Rotherhithe. The stevedores, the watermen and the lightermen who manned the barges had secure jobs and their own unions. But the casual labourers who unloaded the vessels (many of whom were gas workers in the winter and dockworkers in the summer) were unrepresented and employed only by the day. A day's work lost could mean actual starvation. Sleeping rough in summer, in winter these men perched like flocks of birds on the stairs of overcrowded rooming houses known as 'rookeries'. Ben Tillett, their leader, a radical Liberal, describes how they were herded daily, like cattle, into a pen surrounded with iron bars, whilst a foreman walked around outside it, picking out suitable men to work:

> Elsewhere I have described the 'cage', so termed because of the stout iron bars made to protect the caller-on. In a building that would hold very few in comfort, men were packed tightly into suffocation, like the Black Hole of Calcutta, and this struggling mass fought desperately and tigerishly, elbowing each other, punching each other, using their last remnants of strength to get work for an hour or half-hour for a few pence.[38]

This account is supported by the testimony of the General Manager of the Millwall Docks, who gave evidence on the sweating system in the *Second Report to the House of Lords Committee* in 1888:

> The poor fellows are [...] in a most miserable state: and they cannot run, their boots would not permit them. [...] There are men who come without having a bit of food in their stomachs since the previous day. [...] They have not anything to eat in the middle of the day [...] and by four o'clock their strength is utterly gone. They pay themselves off.[39]

Within months of the success of the Gas Workers struggle, Tillett demanded for his men a minimum hiring time of four hours per shift, a minimum hourly rate of 6d. and organized a strike that began on 14 August 1889. Even though the stevedores had nothing themselves to gain, they supported them, and by 18 August, the London docks were at a standstill. The dock owners tried to starve the men into surrender, but they received massive support from the press, from public appeals and from other unions. Australia was especially sympathetic, £20,000 being sent from the city of Victoria alone.

The strike brought together the different sections of dockworkers, those who had skilled work and unions with the unskilled who had none. Socialist banners were banned from their protest marches, underlining the fact that they still believed in the capitalist system of men and masters, the dominant ideology that made such divisions appear 'natural'.

The new Dock, Wharf, Riverside and General Labourers' Union of Great Britain and Ireland was formed from what had previously been the Tea Operatives and General Labourers' Union, issuing food vouchers to 25,000 men a day.[40] By 24 August, about 50,000 workers were on strike. By then most of their homes were completely bare, their possessions pawned. Eventually a settlement was negotiated by Cardinal Manning, head of the Roman Catholic Church.

According to Engels, the London Trades Council, made up of delegates from the London trades union and mostly from the older unions of skilled workers, was a conservative body preaching equal rights for capital and labour, whilst the Social Democratic Federation merely played at radicalism, and only talked of social revolution when it was safe to do so. Glyn A. Williams agrees, when writing of the New Model Unions, that

at the crunch, their class commitment was apparent […] it was a class consciousness which was essentially corporate, integrated into the system which they largely accepted and tried to work to the benefit of their class […]. Increasingly they expressed it in terms of a general system of values which could not fail to be 'middle class'.[41]

John Burns, in a speech on the Liverpool Congress, said:

The 'old' delegates differed from the 'new' not only physically but in dress. A great number of them looked like respectable city gentlemen; wore very good coats, large watch-chains and high hats – and in many cases were of such splendid build and proportions that they presented an aldermanic, not to say a magisterial form and dignity. Amongst the 'new' delegates not a single one wore a tall hat. They looked workmen. They were workmen. They were not such sticklers for formality or Court procedure, but were guided more by common sense. […] The difference between them, if any, is entirely due to the fact that the 'new' see that labour-saving machinery is reducing the previously skilled to the level of unskilled labour, and they must, in their own interests be less exclusive than hitherto. […] Except in tactics, there is no difference between the 'new' unionists of to-day and the pioneers of unionism of sixty years ago, who, mainly through the efforts of Robert Owen and others, were very Socialistic in their principles and action, as is witnessed by the Engineers' Rules.[42]

As a result, the Sunday 4 May rally of 1890 in Hyde Park, organized by a central committee of trade unions in the East End was split into two parts – on the one hand the conservative workers flanked by a socialist sect and on the other hand the vast bulk of workers recently included within the trade union movement who wanted

emancipation from the old guild mentality. Engels wrote that it was the day that the English proletariat finally awakened and allied itself with the great international army – the grandchildren of the old Chartists finally stepping up to the battle lines.[43]

The certificate of Tillett's new union, the Dock, Wharf, Riverside and General Labourers' Union of Great Britain and Ireland by Blades, East & Blades (1891, Plate 36), is founded on a classical plinth bearing pedestals engraved with the names of all types of workers surmounted by Justice and Hope. The format is very similar to that used previously by Blades, East & Blades for their United Machine Workers' Association certificate of the 1880s (Plate 16). The top section has ovals or circles each side of a central feature, with an undulating scroll beneath bearing the union's name. Justice and Hope are atop similar pedestals above a projecting base with a large oval between them, with foliage at its base and certifying details beneath it.

In a fictive outdoor setting with countryside and hills visible behind the two virtues, the old temple front has gone. Instead, a decorated plinth with two pedestals bearing the classical virtues supports a great ornamental superstructure of elaborate mirror-like frames, decorated around the edges with curling foliate strapwork, whilst above, flanking the coats of arms and flags of Britain and Australia and their respective worker representatives and national animals (lion and kangaroo), ships sail on an ocean whose horizon merges into the roof of a building in the top right circular vignette. It is a flamboyant and busy design and yet, like the older emblems, it remains entirely classical in its balance and symmetry. Indeed, it is a celebration of difference – difference from the old exclusive dyed-in-the-wool craftsmen's unions of the comfortably off and their Freemasonry ties with the middle and upper classes, and their reliance on insurance and retirement benefits. Furthermore, it celebrates its unity between all the various types of work, unskilled or semiskilled, listed on the pedestals, and with not only Australian counterparts but internationally – the lettered strapwork at the top of the certificate, just beneath the image of the handshake, reads, 'The Grip of Brotherhood the World Over'.

In foregrounding their links with Australia, of course, this new union is celebrating Australia's financial support for the dock strike. However, it would also bear a dangerously subversive message because of Australia's earlier status as a penal colony. Deportation of criminals to Australia had begun in 1788 and had only ended in 1868, just 23 years before the date of this certificate, during which time some 160,000 British felons had been deported there. The motto, central to the image and lettered around a large vignette of a ship at the dockside, declares, 'A nation made free by love, a mighty brotherhood linked by a jealous interchange of good. *Shelley*'. This is a quotation from Canto V of *The Revolt of Islam* by Percy Bysshe Shelley, which reads more fully:

Thus the vast array
Of those fraternal bands were reconciled that day.

Lifting the thunder of their acclamation,
Towards the City then the multitude,
And I among them, went in joy – a nation

Made free by love; a mighty brotherhood
Linked by a jealous interchange of good;
A glorious pageant, more magnificent
Than kingly slaves arrayed in gold and blood,
When they return from carnage, and are sent
In triumph bright beneath the populous battlement.

This motto is a joyful declaration of the celebration of fraternity, brotherhood and a triumphant return from 'carnage'. However, by 1896, with court judgements awarded against them, unions had become vulnerable to the payment of damages to employers occasioned due to strike action. Employers were free to use blacklegs in an attempt to break union power, and indeed many still refused to even recognize trade unions.

Later certificates exhibit the influence of Modernism with their increasing orientation to flatness, the arched structures becoming insubstantial and purely decorative. However, the triumphal arch symbolism, so beloved by trade union artists such as Waudby, was still a popular item of decoration, imbuing with its implied values those heroes and gods who, in illustrated form, passed beneath it. The cover of the 1895 'Empire of India Exhibition' at Earls Court even depicts a type of highly decorated and exotic Indian 'triumphal arch' set in the countryside, attached to nothing, with a parade mounted on elephants coming through it.

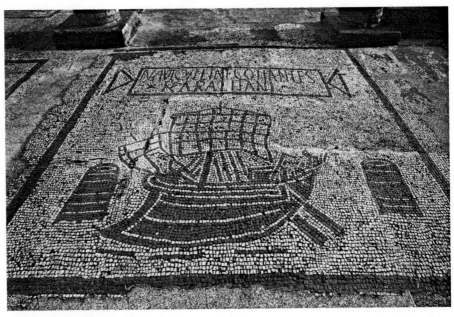

Plate 1. Photograph, late Roman mosaic floor, room of the ship owners and merchants of Cagliari, Sardinia, in the Forum of the Corporations, Ostia. Courtesy of Professor Mary Sullivan, Bluffton University, Ohio.

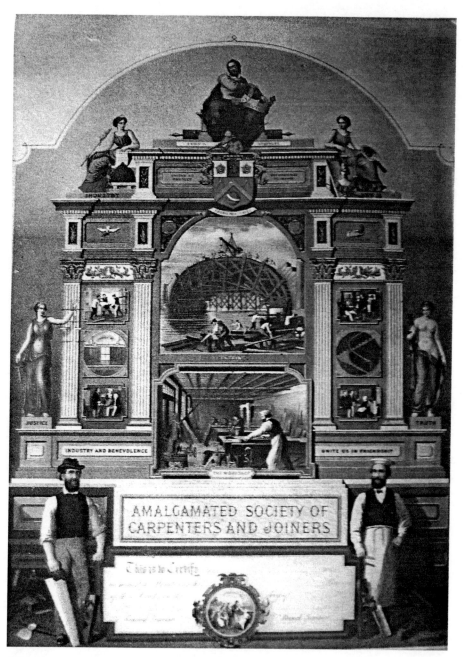

Plate 2. Certificate of the Amalgamated Society of Carpenters and Joiners, 1866, A. J. Waudby. Working Class Movement Library, Salford.

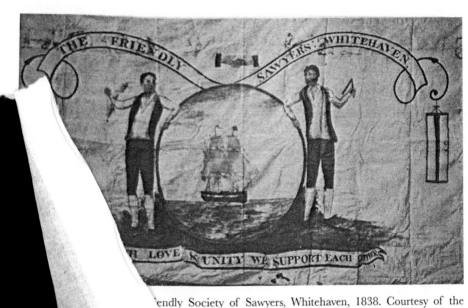

...iendly Society of Sawyers, Whitehaven, 1838. Courtesy of the
...Borough Council.

...circa 354 CE.

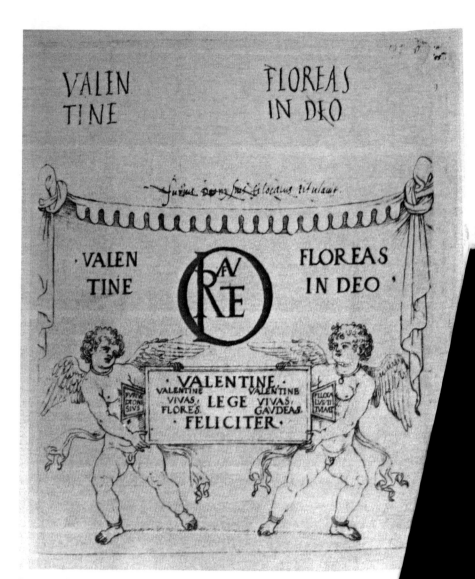

Plate 4. Renaissance drawing from a medieval copy of a title page of codex,
Featured in H. Stern, *Le Calendrier de 354*, Paris, 1953, plate 1.2.

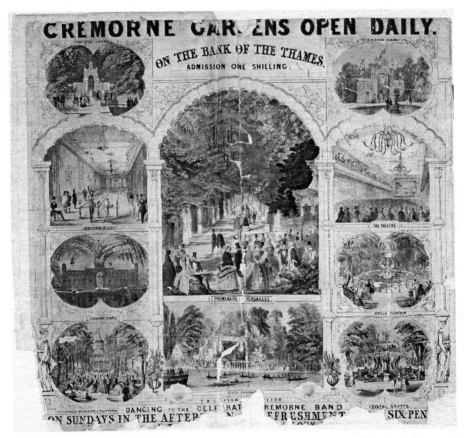

Plate 5. Cremorne Gardens playbill advertisement, c. 1850. Courtesy of Kensington Central Library, photograph by John W. Rogers.

Plate 6. Print of the Confraternity of Farm Labourers, woodcut, 1771, Raynaud Sc. Musée National des Arts & Traditions Populaires, Paris.

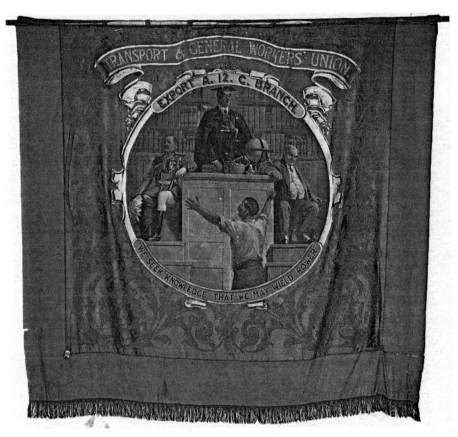

Plate 7. Banner, Transport and General Workers' Union, Export A.12.C. Branch, post-1922. People's History Museum, Manchester.

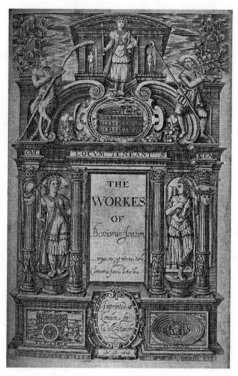

Plate 8. Frontispiece, Workes of Beniamin Jonson, engraving, 1616. William Hole.

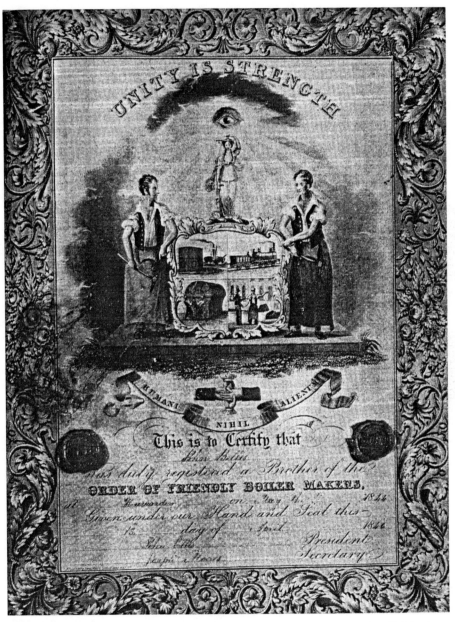

Plate 9. Certificate of the Order of Friendly Boiler Makers, 1844. Featured in J. E. Mortimer, *History of the Boilermakers Society, Volume 1, 1834–1906*, 48.

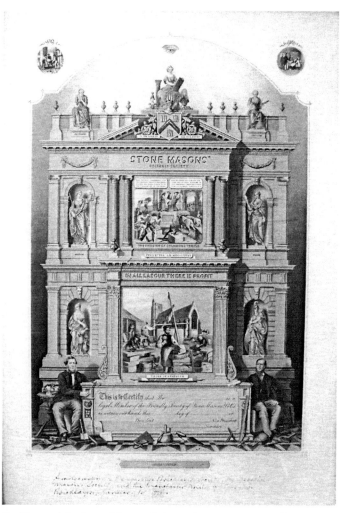

Plate 10. Certificate of the Stone Masons' Friendly Society, 1868, A. J. Waudby. Working Class Movement Library, Salford.

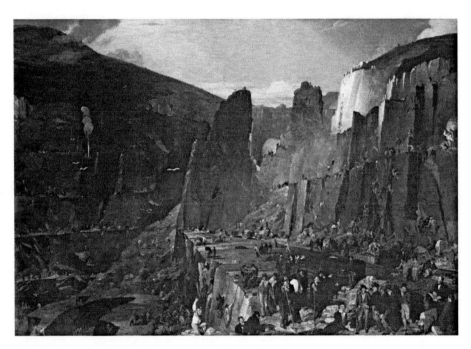

Plate 11. *Penrhyn Quarry in 1832*, oil, 1832, Henry Hawkins. National Trust.

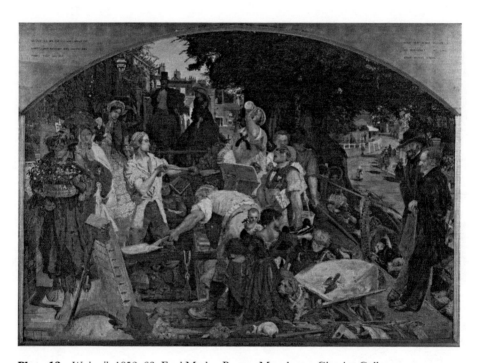

Plate 12. *Work*, oil, 1852–63, Ford Madox Brown. Manchester City Art Gallery.

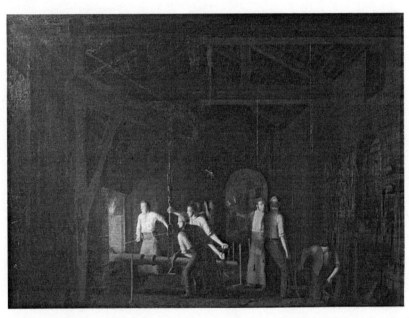

Plate 13. *The Forge*, oil, 1844–47, James Sharples. Blackburn City Art Gallery, courtesy of the Sharples family.

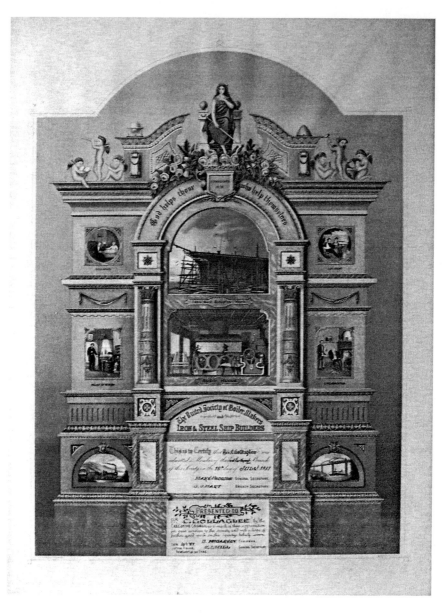

Plate 14. Certificate of the United Society of Boiler Makers and Iron and Steel Ship Builders. Working Class Movement Library, Salford.

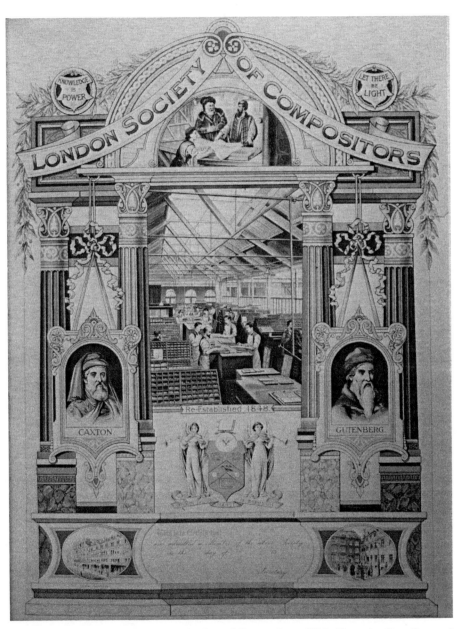

Plate 15. Certificate of the London Society of Compositors, 1894, Alexander Gow. Featured in Leeson, *United We Stand*, 67.

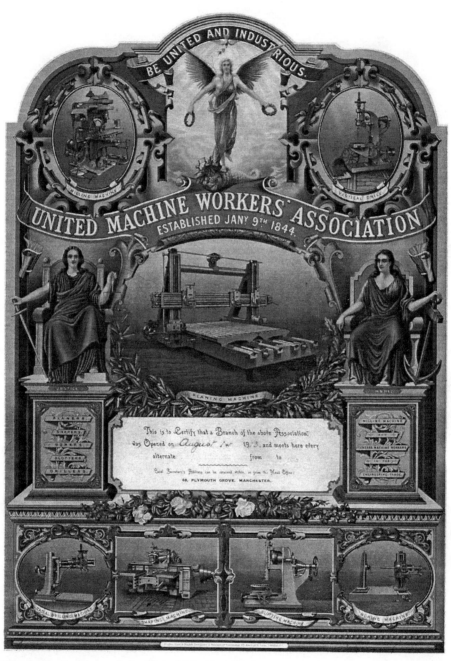

Plate 16. Certificate of the United Machine Workers' Association, 1880s, Blades, East & Blades. Working Class Movement Library, Salford.

Plate 17. Emblem of the United Society of Brushmakers, 1839, J. Shury. Working Class Movement Library, Salford.

Plate 18. Certificate of the Woolcombers' Union, 1838. Featured in E. P. Thompson, *Customs in Common*, plate 111.

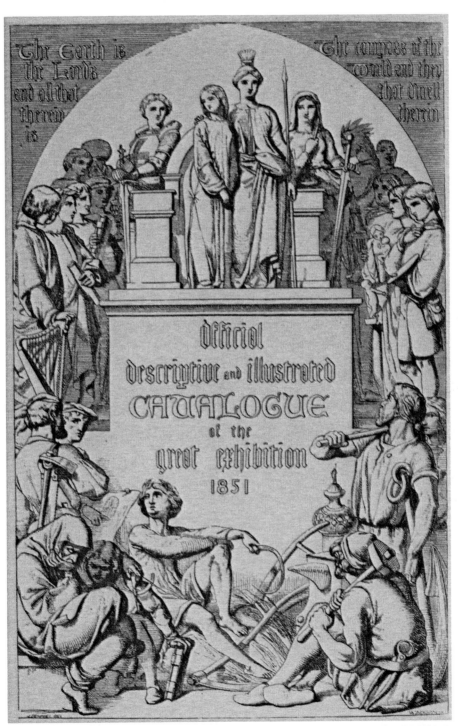

The Earth is the Lords and all that therein is

The compass of the world and they that dwell therein

Official Descriptive and Illustrated CATALOGUE of the great exhibition 1851

Plate 19. Frontispiece, *Official Descriptive and Illustrated Catalogue of the Great Exhibition,* 1851, Mason Jackson after John Tenniel.

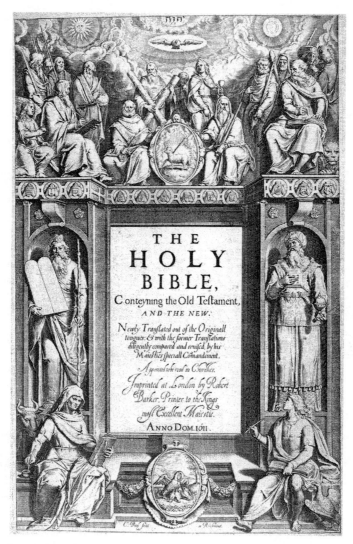

Plate 20. Frontispiece of the King James Bible, 1611, Cornelis Boel.

Plate 21. Certificate of the Friendly Society of Iron Founders of England, Ireland and Wales, 1857, John James Chant, engraved by John Saddler. Working Class Movement Library, Salford.

Plate 22. Co-operative emblem (unfinished), pencil on paper, undated, James Sharples. People's History Museum, Manchester.

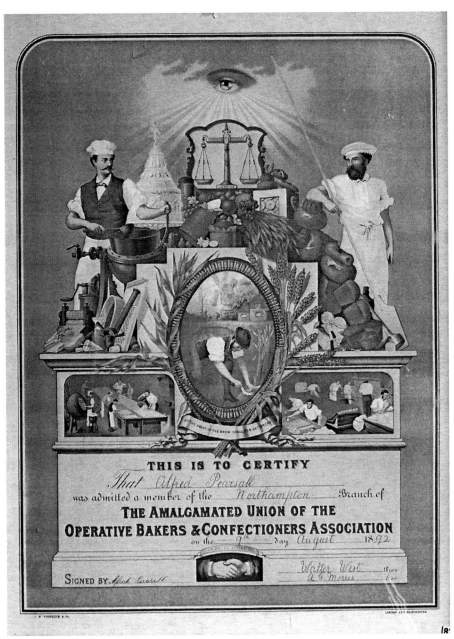

Plate 23. Certificate of the Amalgamated Union of the Operative Bakers and Confectioners Association, 1890s, engraved by J. M. Kronhein & Co. Working Class Movement Library, Salford.

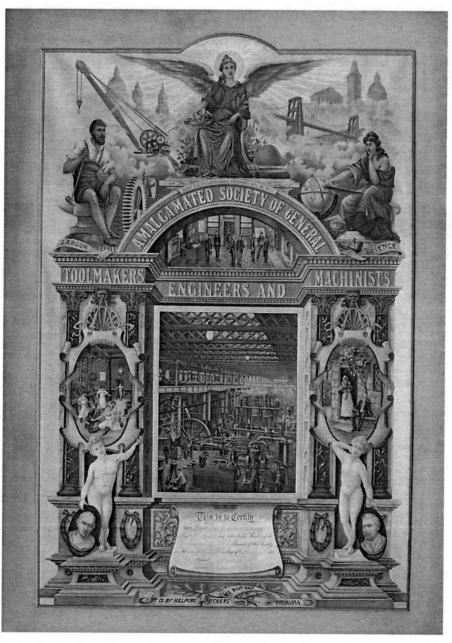

Plate 24. Certificate of the Amalgamated Society of General Toolmakers, Engineers and Machinists, c. 1892, Percival Jones. Working Class Movement Library, Salford.

Plate 25. Certificate of the Associated Society of Locomotive Engineers and Firemen, 1916, designed and engraved by Goodall & Suddick. Working Class Movement Library, Salford.

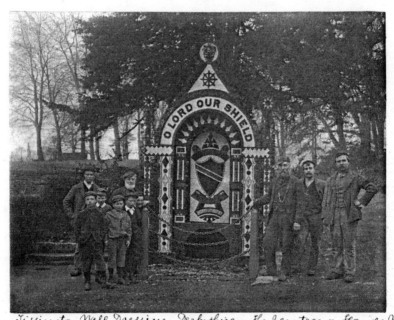

Tissington Well Dressing. Derbyshire. The Yew-tree or Hands Well and its decoration, William Wright, Blacksmith & others 1899.

Plate 26. Photograph of well dressing, Tissington, Derbyshire, 1899. Courtesy of the Archives and Heritage Section of Birmingham City Library.

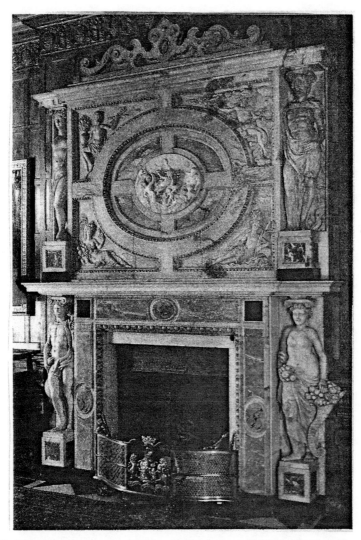

Plate 27. The chimneypiece in the Van Dyck room at Hatfield, Hertfordshire, c. 1610, attributed to Maximilian Colt. Featured in Whinney, *Sculpture in Britain*, 59. Image reproduced courtesy of Hatfield House.

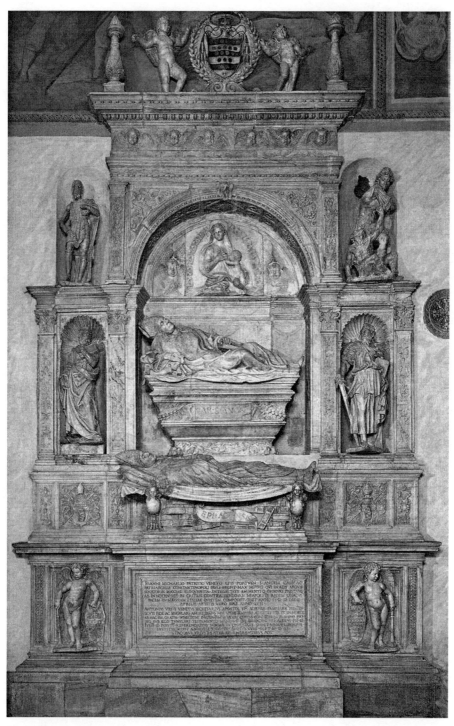

Plate 28. Double tomb of Antonio Orso and Cardinal Michiel, Church of San Marcello al Corso, Rome, c. 1520, Sansovino.

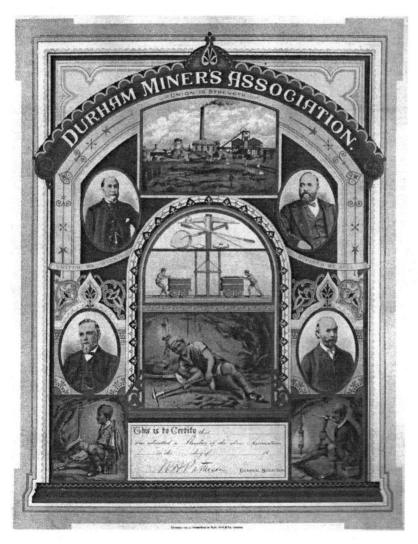

Plate 29. Certificate of the Durham Miners' Association, 1890s, Alexander Gow. Working Class Movement Library, Salford.

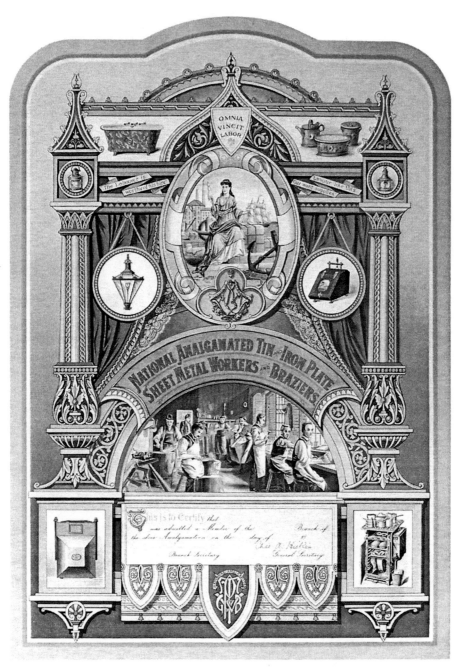

Plate 30. Emblem of the National Amalgamated Tin and Iron Plate Sheet Metal Workers and Braziers, 1900s. Working Class Movement Library, Salford.

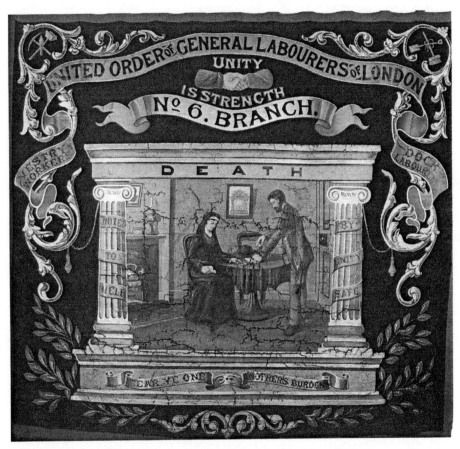

Plate 31. Banner of the No. 6 Branch of the United Order of General Labourers of London, c. 1911, manufactured by H. Bosworth. People's History Museum, Manchester.

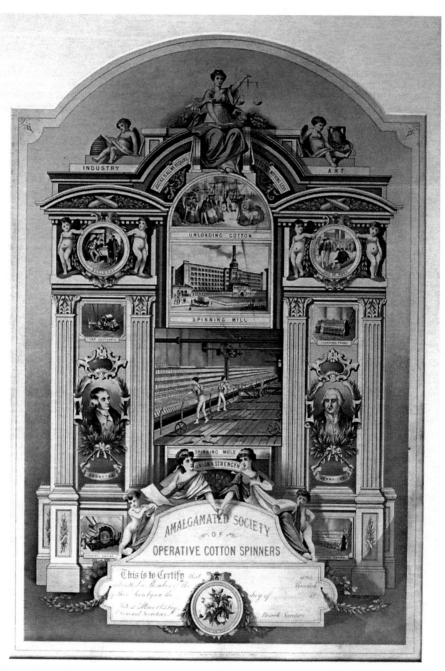

Plate 32. Certificate of the Amalgamated Society of Operative Cotton Spinners, 1882, Gow & Butterfield. Working Class Movement Library, Salford.

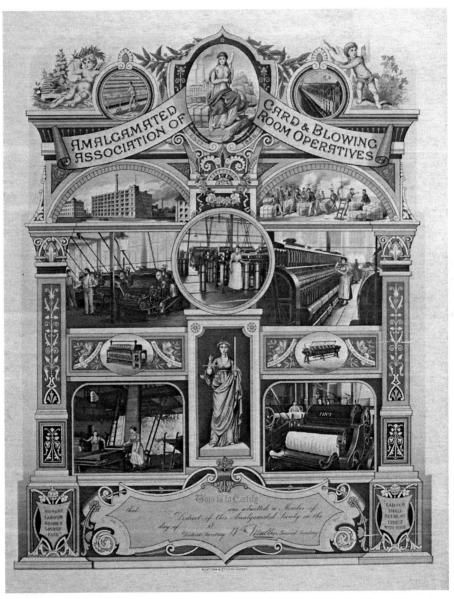

Plate 33. Certificate of the Amalgamated Association of Card and Blowing Room Operatives, 1890, Alexander Gow. Working Class Movement Library, Salford.

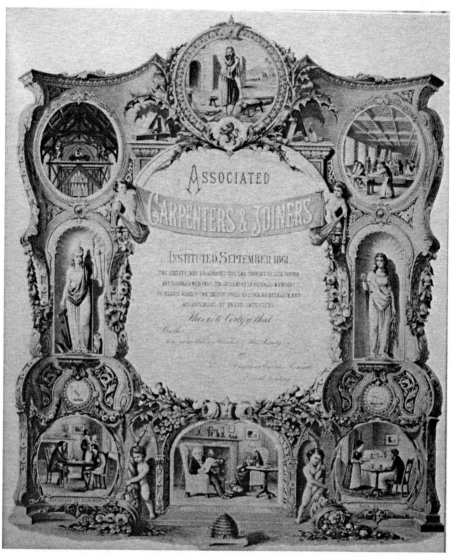

Plate 34. Certificate of the Associated Carpenters and Joiners, 1880s, Alexander Gow. Featured in Leeson, *United We Stand*, 41.

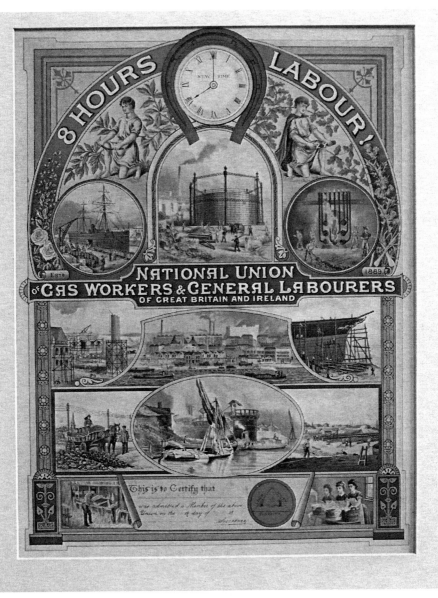

Plate 35. Certificate of National Union of Gas Workers and General Labourers of Great Britain and Ireland, 1890, Alexander Gow. Working Class Movement Library, Salford.

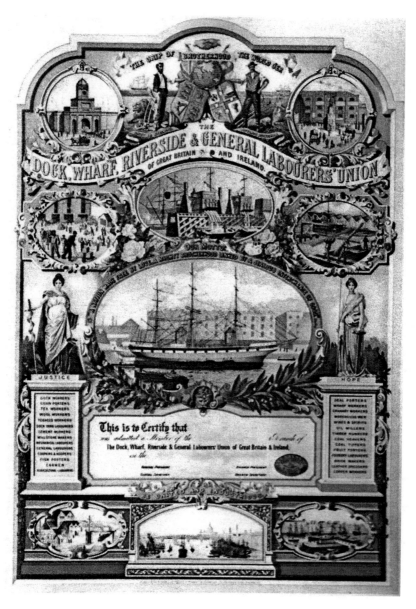

Plate 36. Certificate of the Dock, Wharf, Riverside and General Labourers' Union of Great Britain and Ireland, 1891, Blades, East & Blades. Trades Union Congress Library.

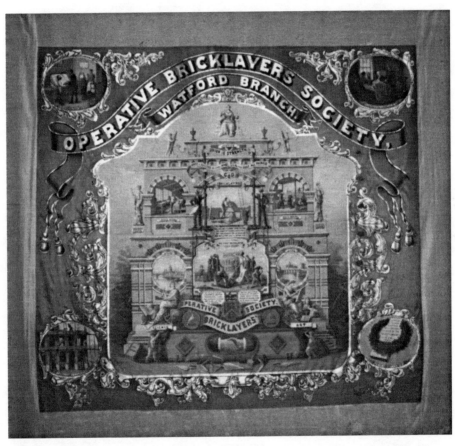

Plate 37. Banner of the Operative Bricklayers' Society, c. 1865, A. J. Waudby. People's History Museum, Manchester.

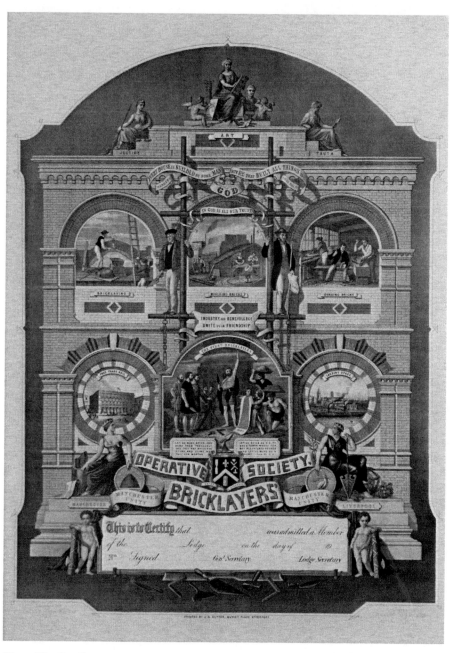

Plate 38. Certificate of the Manchester Unity of the Operative Bricklayers, 1887, A. J. Waudby, printed by J. S. Dutton, engraved by C. H. Jeens and J. H. le Keux. People's History Museum, Manchester.

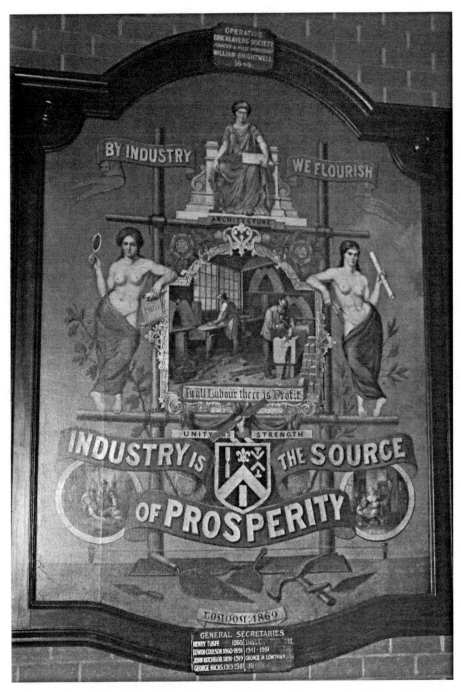

Plate 39. London emblem of the Operative Bricklayers' Society, oil, 1869, A. J. Waudby. People's History Museum, Manchester.

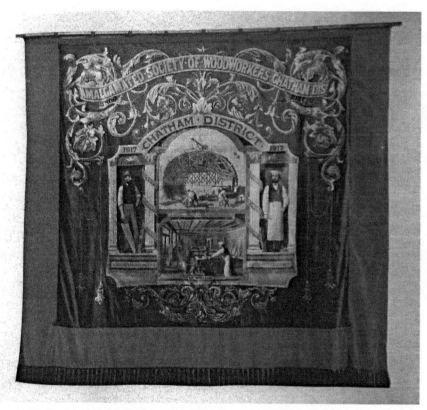

Plate 40. Banner of the Amalgamated Society of Carpenters and Joiners, Chatham District Branch, 1899, refurbished after 1927. People's History Museum, Manchester.

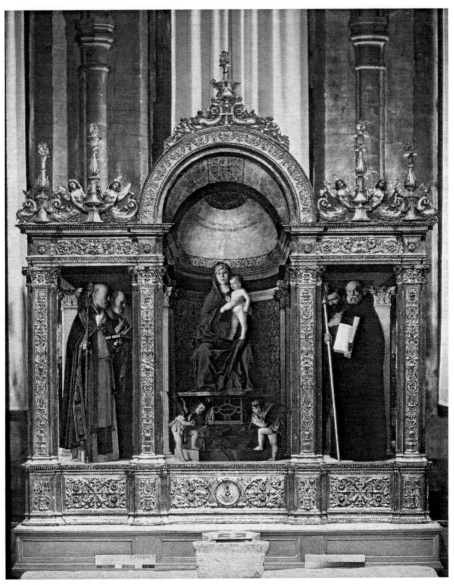

Plate 41. *Madonna and Child with Saints*, oil, 1488, Giovanni Bellini. Courtesy of Apollonio Tottoli of Convento Santa Maria Gloriosa dei Frari, Venice.

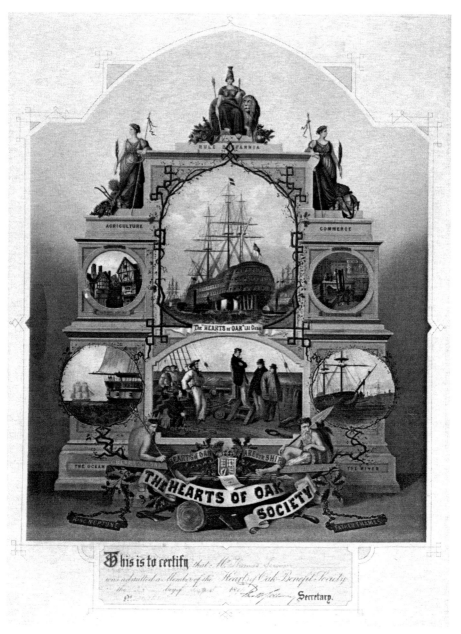

Plate 42. Certificate of the Hearts of Oak Benefit Society, 1869, A. J. Waudby. Courtesy of the Science and Society Picture Library.

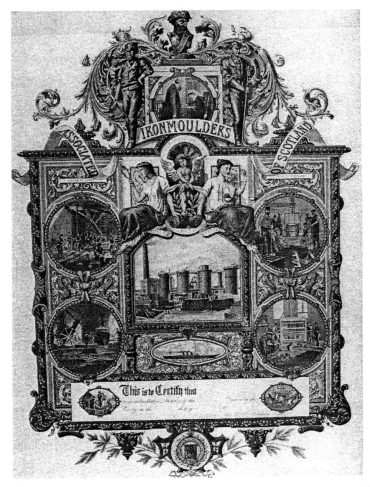

Plate 43. Certificate of the Associated Ironmoulders of Scotland, by Johnstones of Edinburgh, 1880s. Featured in Leeson, *United We Stand*, 42.

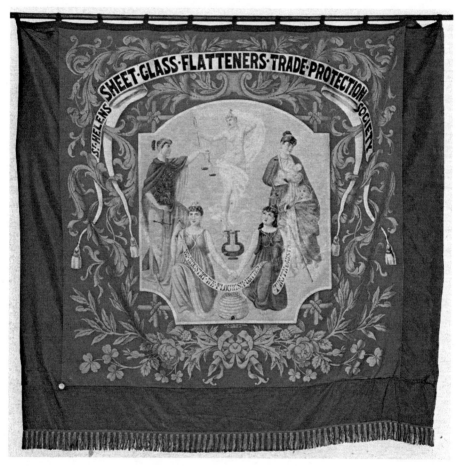

Plate 44. Banner of the St. Helen's Sheet Glass Flatteners Trade Protection Society, 1900s. People's History Museum, Manchester.

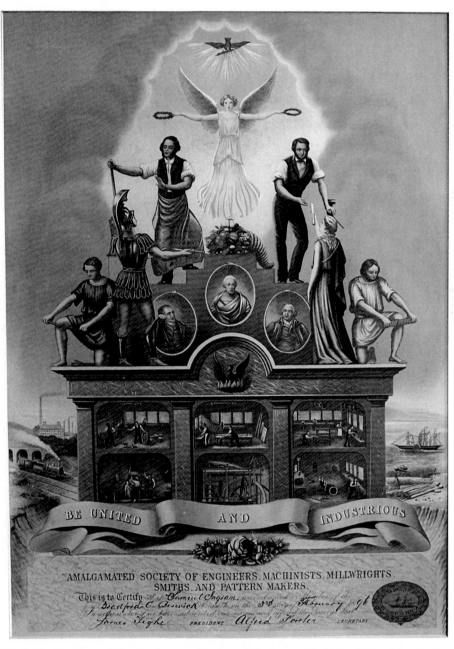

Plate 45. Certificate of the Amalgamated Society of Engineers, Machinists, Millwrights, Smiths and Pattern Makers, 1852, James Sharples. Working Class Movement Library, Salford.

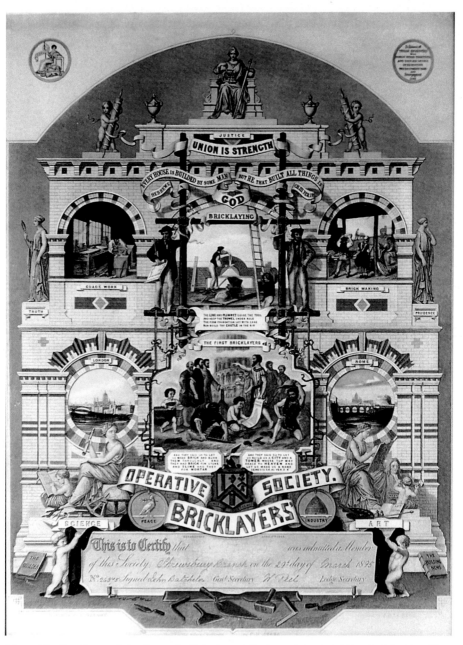

Plate 46. Certificate of the Operative Bricklayers' Society, 1861, A. J. Waudby. Working Class Movement Library, Salford.

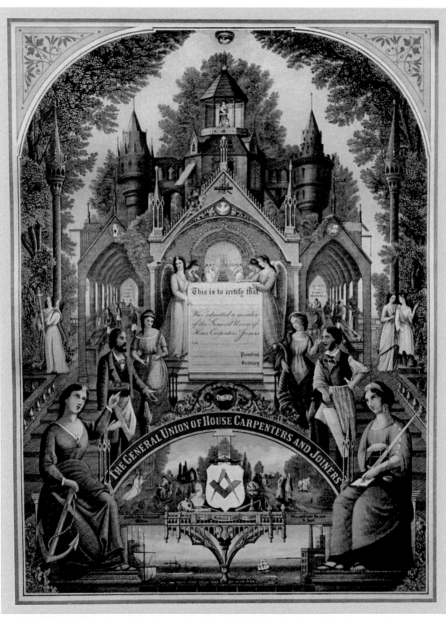

Plate 47. Certificate of the General Union of House Carpenters and Joiners, 1866. Working Class Movement Library, Salford.

Plate 48. Certificate of the Amalgamated Society of Tailors, 1898. Working Class Movement Library, Salford.

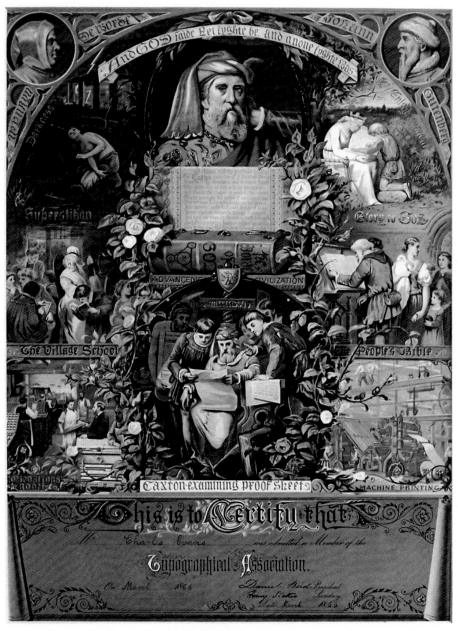

Plate 49. The Typographical Association, 1879. Working Class Movement Library, Salford.

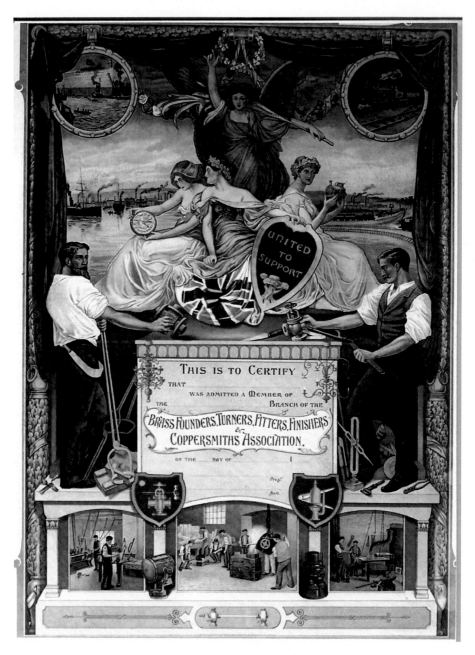

Plate 50. Brass Founders, Turners, Fitters, Finishers and Coppersmiths Association, designed and printed by Blades, East & Blades, 1890s. Working Class Movement Library, Salford.

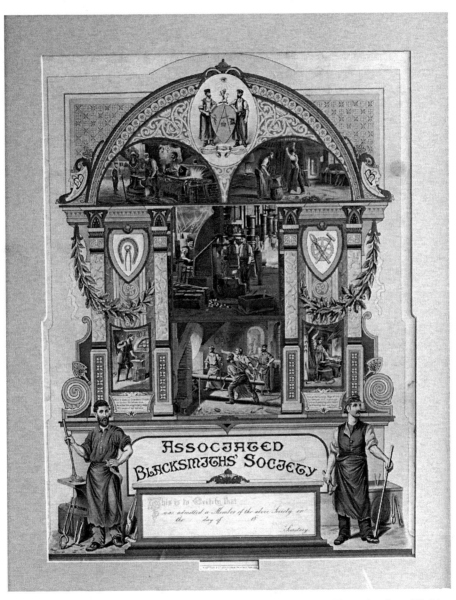

Plate 51. Certificate of the Associated Blacksmiths' Society, 1890s, Alexander Gow. Working Class Movement Library, Salford.

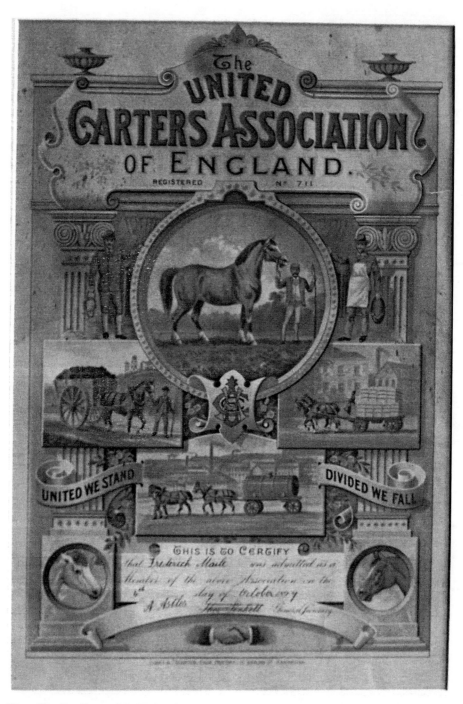

Plate 52. Certificate of the United Carters Association of England, 1890s, Sharp & Thompson. Working Class Movement Library, Salford.

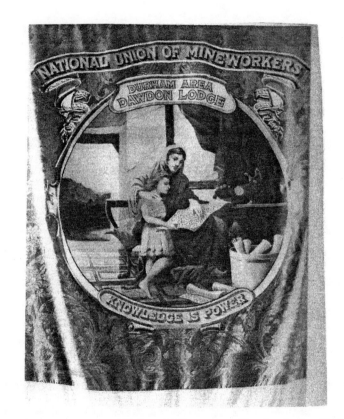

Plate 53. Banner of the National Union of Mineworkers, Dawdon Lodge, Durham, 1900s. Courtesy of Norman Emery.

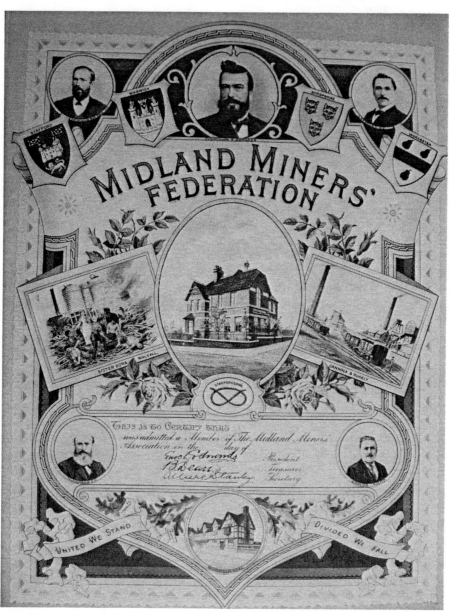

Plate 54. Certificate of the Midland Miners' Federation, 1893, Alexander Gow. Featured in Leeson, *United We Stand*, 58.

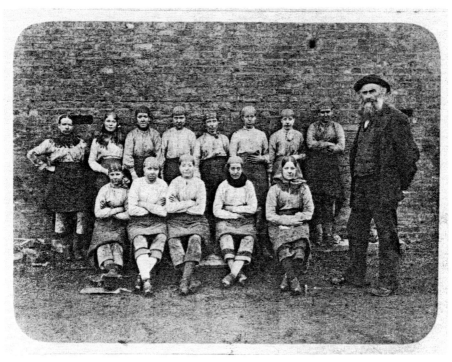

Plate 55. Photograph, 'Pit Brow Lasses', 1890s. People's History Museum, Manchester.

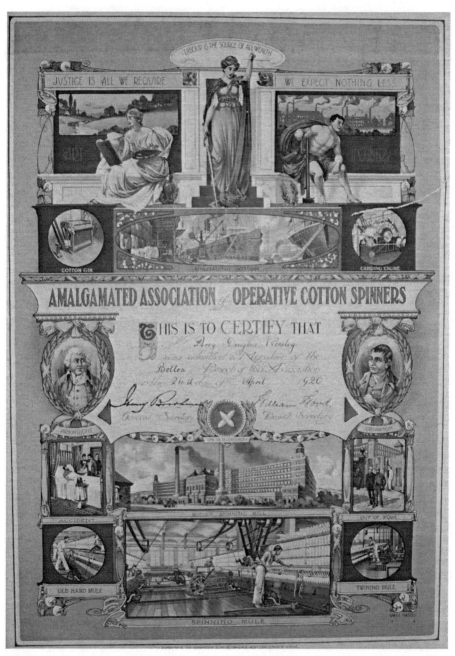

Plate 56. Certificate of the Amalgamated Association of Operative Cotton Spinners, 1890s, Charles E. Turner. Courtesy of Bolton Library and Museum Services.

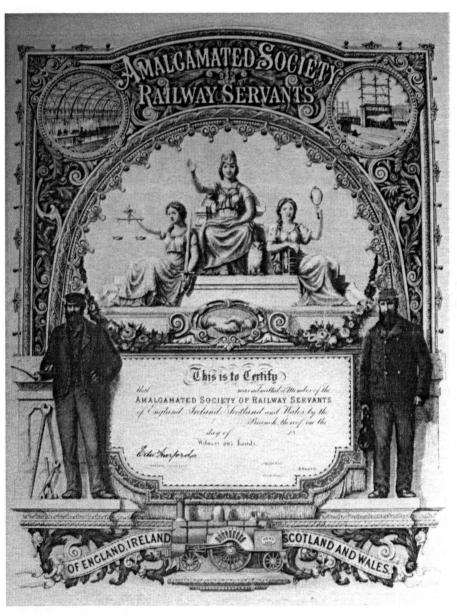

Plate 57. Certificate of the Amalgamated Society of Railway Servants, 1888. Featured in Leeson, *United We Stand*, 44.

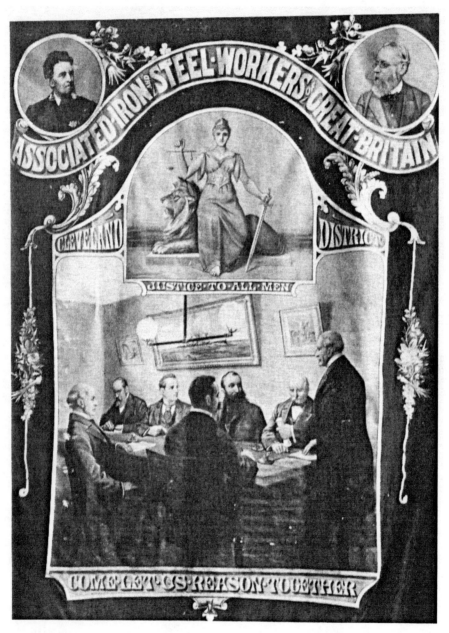

Plate 58. Banner of the Cleveland District of the Associated Iron and Steel Workers, 1897. People's History Museum, Manchester.

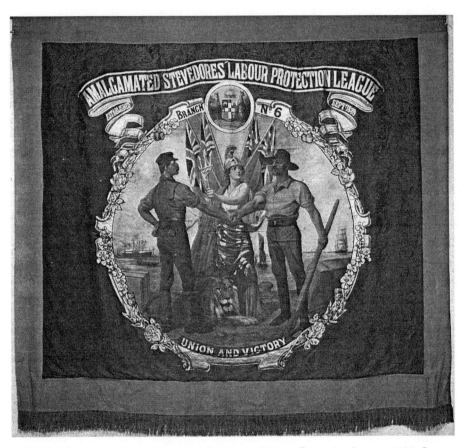

Plate 59. Banner of the Amalgamated Stevedores' Labour Protection League, 1889, George Tutill. People's History Museum, Manchester.

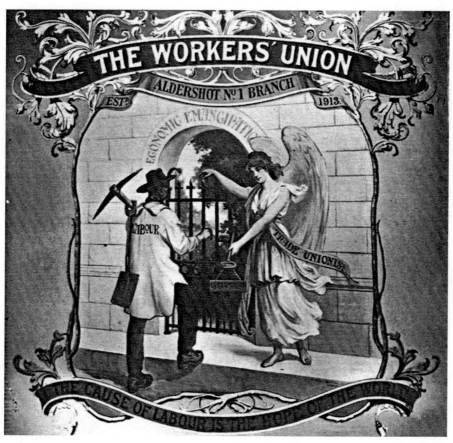

Plate 60. Banner of the Workers' Union, Aldershot No. 1 Branch, 1913. Featured in Gorman, *Banner Bright*, 179.

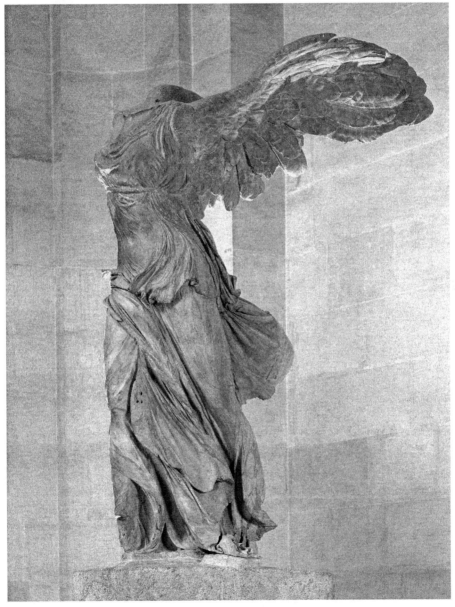

Plate 61. *Winged Victory of Samothrace*, marble sculpture, 190 BCE. Musée de Louvre, Paris.

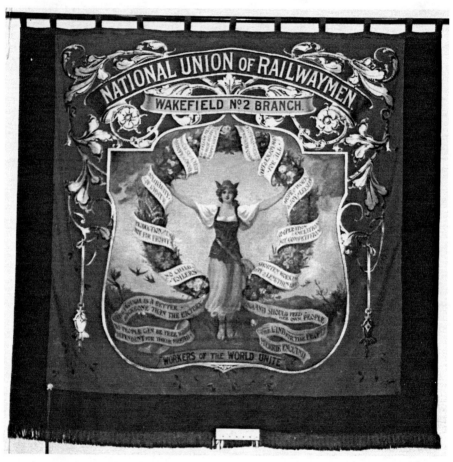

Plate 62. Banner of the National Union of Railwaymen, Wakefield No. 2 Branch, c. 1913. People's History Museum, Manchester.

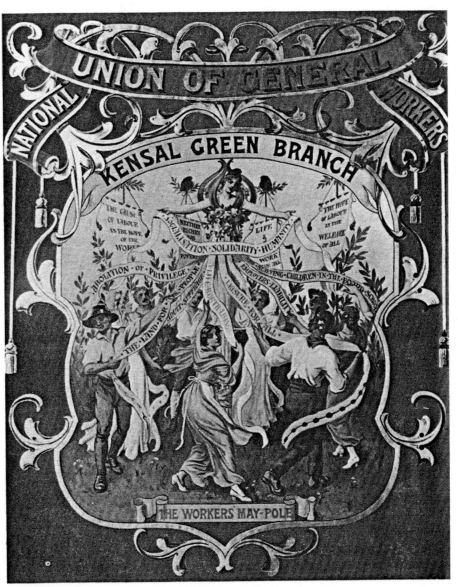

Plate 63. Banner of the Kensal Green Branch of the National Union of General Workers, 1910. Featured in Gorman, *Banner Bright*, 178.

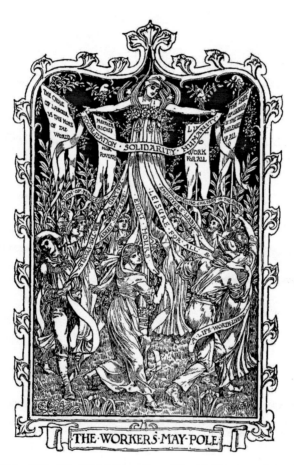

Plate 64. *The Workers' May-Pole*, 1894, Walter Crane (*Justice*). Courtesy of the Marxist Internet Archive.

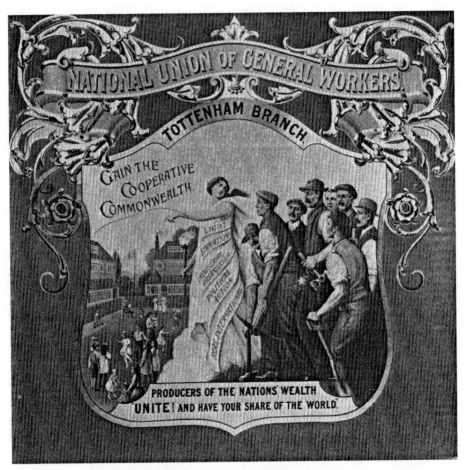

Plate 65. Banner of the National Union of General Workers, Tottenham Branch, c. 1919. Featured in Gorman, *Banner Bright*, 125.

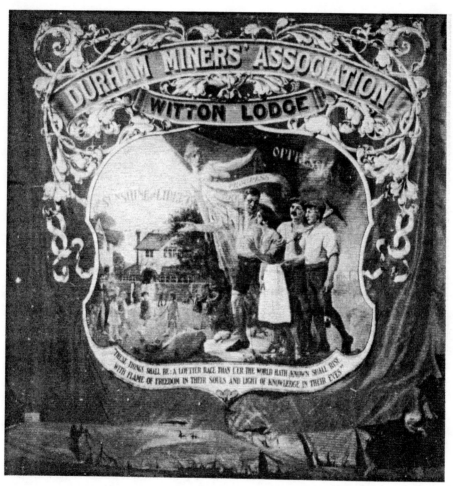

Plate 66. Banner of the Durham Miners' Association, Witton Lodge, c. 1915. Courtesy of Kate Reeder, The Beamish Museum, The Living Museum of the North, Durham.

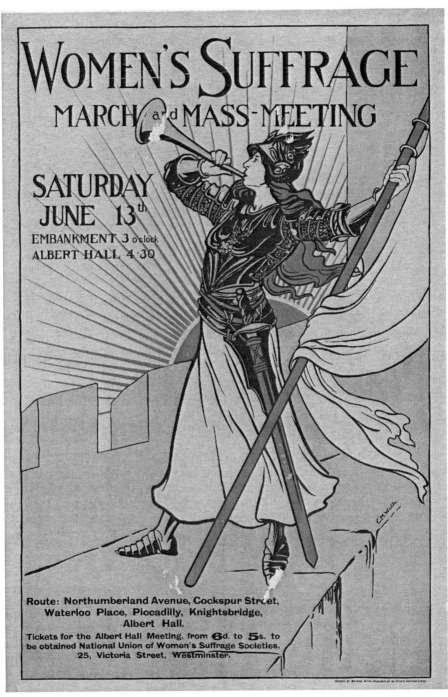

Plate 67. Advertisement, National Union of Women's Suffrage Societies' Procession, 13 June 1908, Caroline Watts, published by the Artists' Suffrage League. Courtesy of Diana Carey at the Schlesinger Library, Radcliffe Institute, Harvard University.

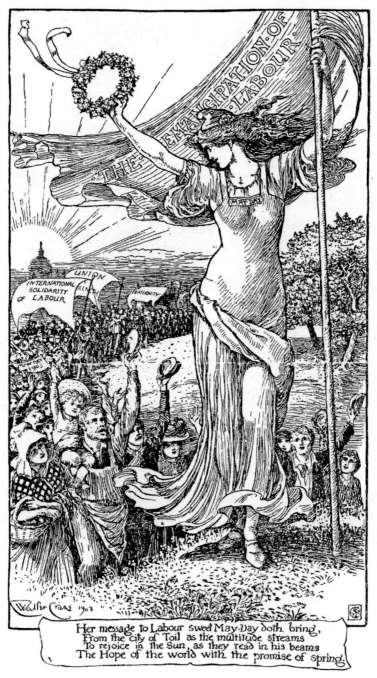

Plate 68. 'Cartoon to celebrate May Day', Walter Crane, *The Sun*, 1903. People's History Museum, Manchester.

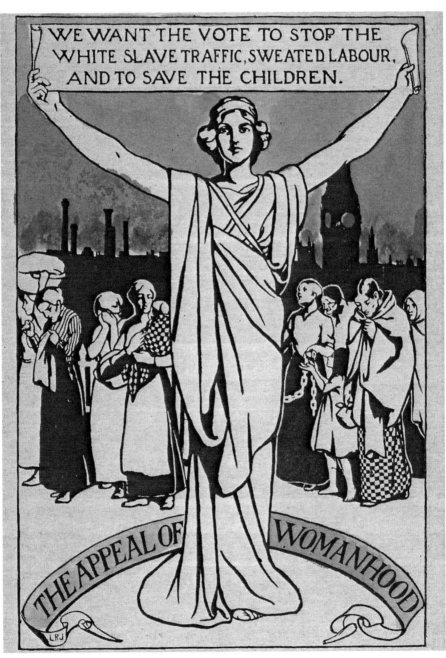

Plate 69. Suffrage poster, 1912, Louise Jacobs. Courtesy of Jenna Collins, Museum of London.

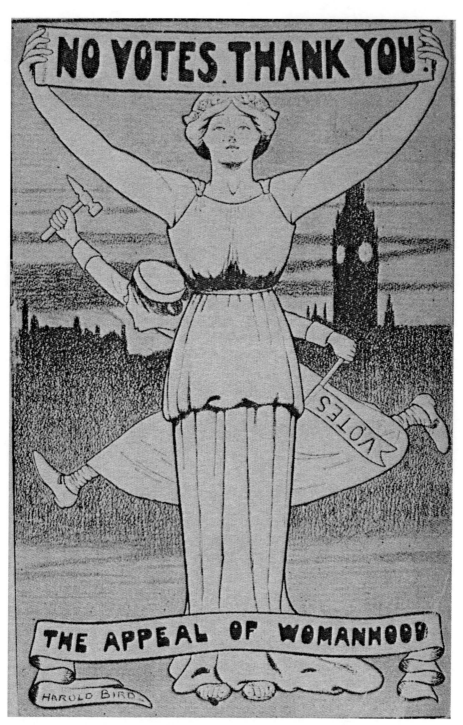

Plate 70. Anti-Suffragette poster, 1912, Harold Bird. Museum of London.

Plate 71. *Triumph of Labour*, 1891, Walter Crane, engraved by Henry Scheu. People's History Museum, Manchester.

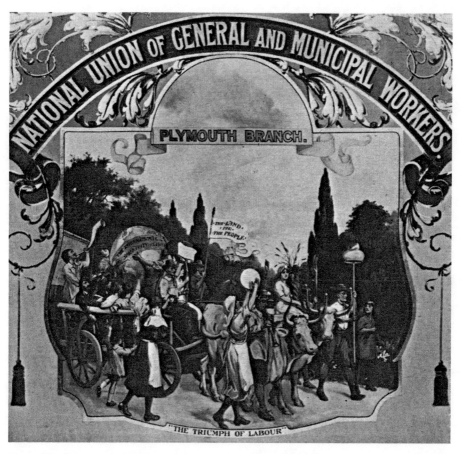

Plate 72. Banner of the National Union of General and Municipal Workers, Plymouth Branch, c. 1915. People's History Museum, Manchester.

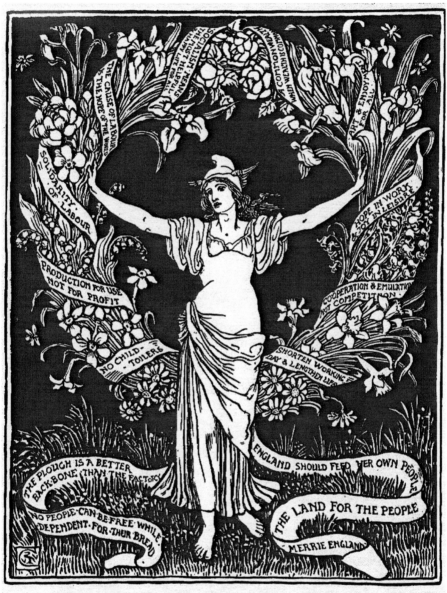

Plate 73. *A Garland for May Day*, 1895, Walter Crane, engraved by Carl Hentschel (*Clarion*). People's History Museum, Manchester.

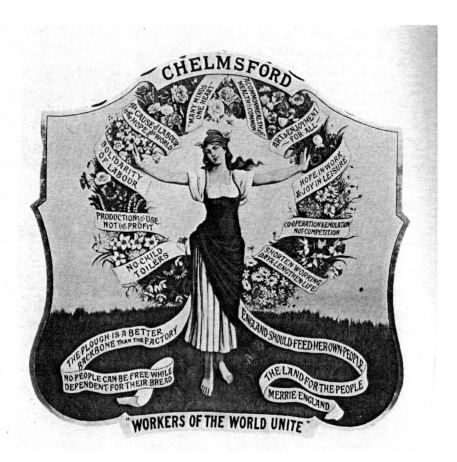

Plate 74. Banner of the National Union of General Workers, Chelmsford Branch, c. 1915. People's History Museum, Manchester.

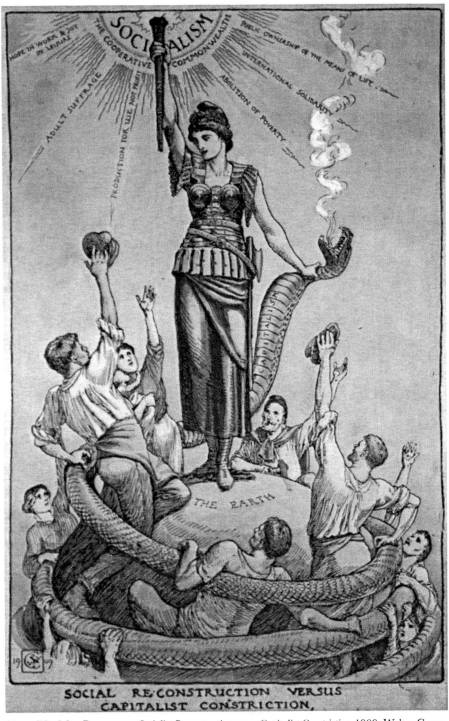

Plate 75. May Day poster, *Socialist Reconstruction versus Capitalist Constriction*, 1909, Walter Crane. People's History Museum, Manchester.

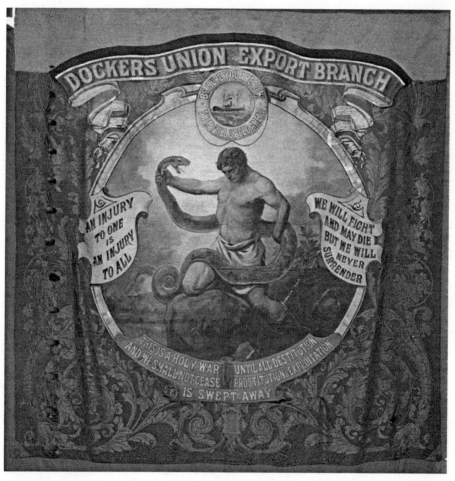

Plate 76. Banner of the Dockers' Union, Export Branch, early 1890s. People's History Museum, Manchester.

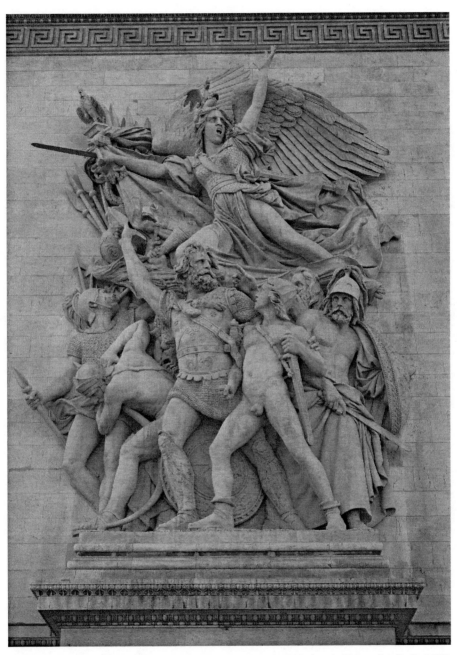

Plate 77. *La Marseillaise, The Departure of the Volunteers of 1792*, Arc de Triomphe, Paris, 1836, François Rude.

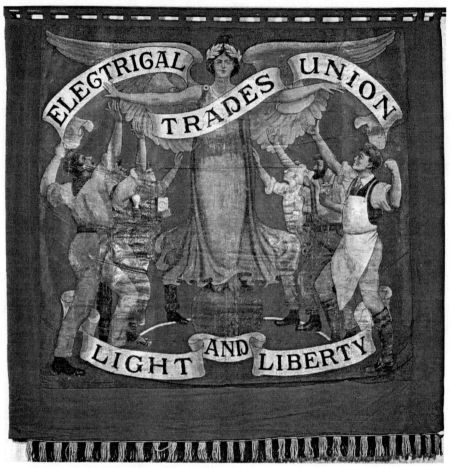

Plate 78. Banner of the Electrical Trades Union, 1899, Walter Crane. People's History Museum, Manchester.

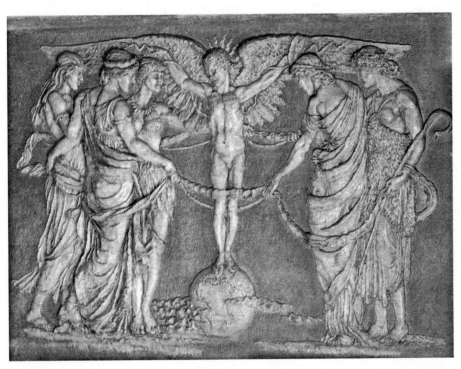

Plate 79. *Icarus*, 'Transport' frieze, 1896–97, Walter Crane. Courtesy of Worth Abbey. www.worthabbey.net

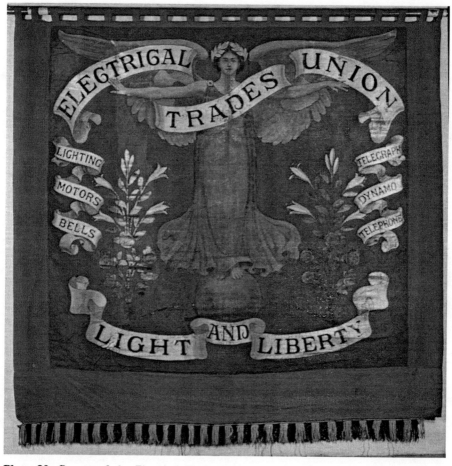

Plate 80. Banner of the Electrical Trades Union, 1899, Walter Crane. People's History Museum, Manchester.

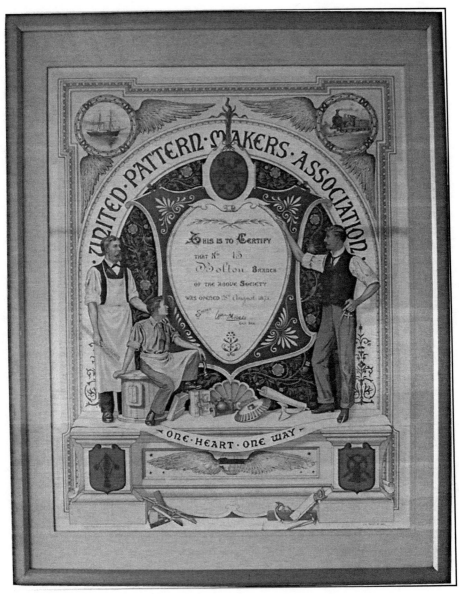

Plate 81. Emblem of the United Pattern Makers' Association, 1897, Blades, East & Blades, Walter Crane and G. Twist. Working Class Movement Library, Salford.

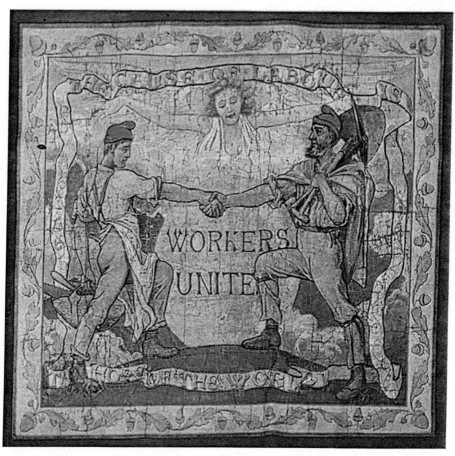

Plate 82. Banner of the National Union of Gas Workers and General Labourers, Bristol District No. 1 Branch, after Walter Crane, 1893. People's History Museum, Manchester.

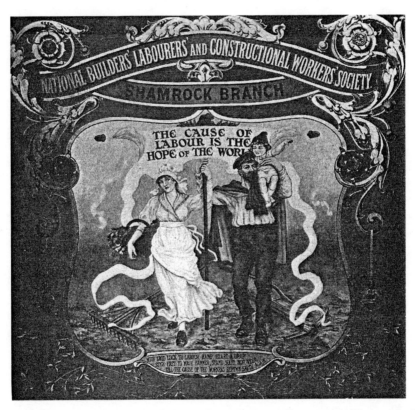

Plate 83. Banner of the National Builders', Labourers' and Construction Workers' Society, Shamrock Branch, c. 1915, George Tutill. People's History Museum, Manchester.

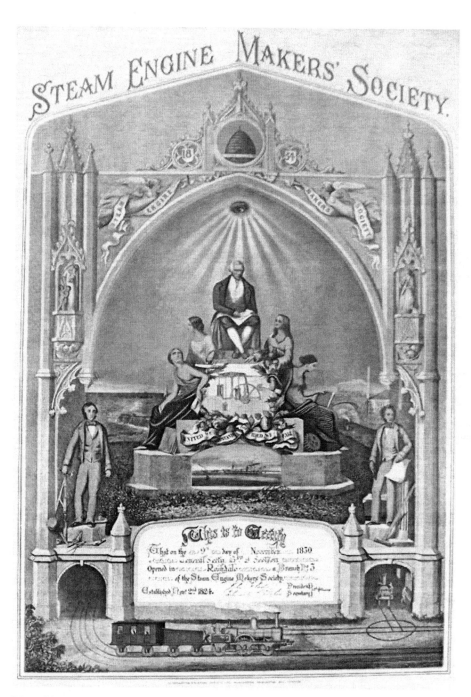

Plate 84. Emblem commemorating the opening in 1830 of the Steam Engine Makers' Society, Rochdale Branch No. 3, c. 1865. Working Class Movement Library, Salford.

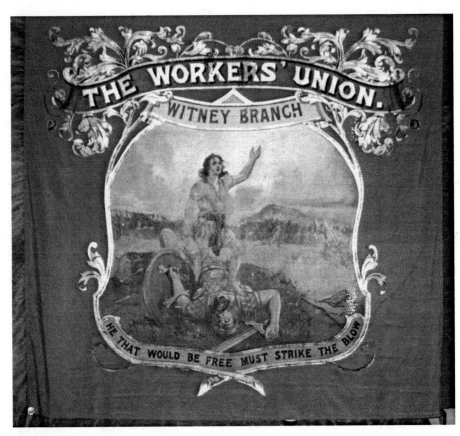

Plate 85. Banner of the Workers' Union, Witney Branch, c. 1920. Featured in Gorman, *Banner Bright*, 134.

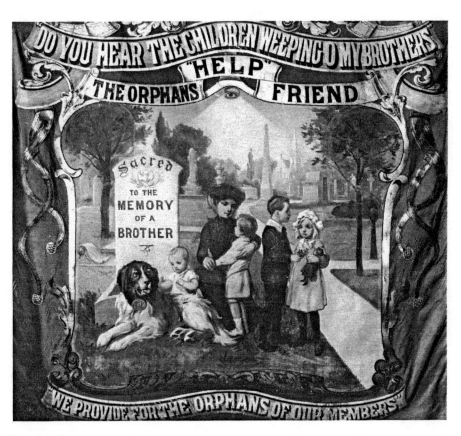

Plate 86. Banner of the National Union of Railwaymen, Stockton Branch, 1914. Courtesy of Stockton Museums.

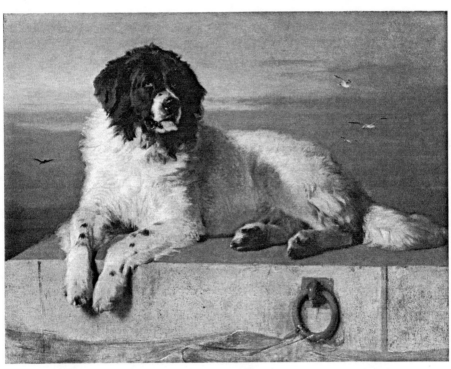

Plate 87. *A Distinguished Member of the Humane Society*, oil, 1838. Sir Edwin Henry Landseer. British Museum.

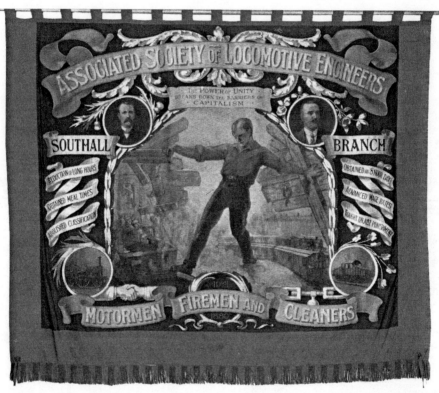

Plate 88. Banner of the Associated Society of Locomotive Engineers, Southall Branch, 1920s, George Kenning & Son. People's History Museum, Manchester.

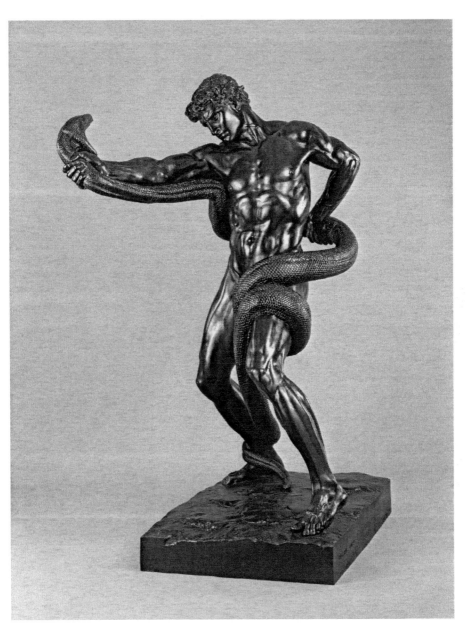

Plate 89. *Athlete Struggling with a Python*, bronze, 1877, Lord Frederic Leighton. Tate Gallery.

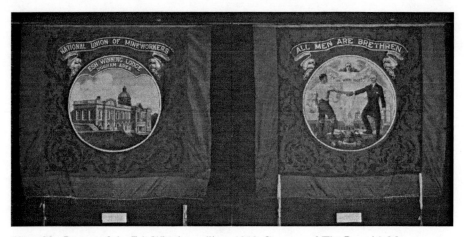

Plate 90. Banner of the Esh Winning colliery, 1946. Courtesy of The Beamish Museum.

Chapter 6

ARTHUR JOHN WAUDBY AND THE SYMBOLS OF FREEMASONRY

Annie Ravenhill-Johnson

Arthur John Waudby's designs featuring his 'trademark' triumphal arch must have been very well regarded by the unions and friendly societies, as evidenced by his commissioning by at least five that we know of. In this chapter his oeuvre is examined, together with the influence of Freemasonry on his designs.

In times long gone, before the advent of passports or border crossings, our stonecutters, carvers and sculptors travelled around Europe and beyond, expanding their knowledge as newer and greater cathedrals, churches and castles were built, and in search of higher pay as their expertise and skills increased. The 'lodge' of these masons was a building on-site, for example at the location of a new medieval cathedral, where they ate, slept and kept their tools. In bad weather they could work inside the lodge preparing stone. The earliest known rule regulating life in these lodges was laid down in 1352 by a chapter in York.[1] These lodges, which were almost like clubhouses, are the origins of the 'lodge' of the Freemasons.

The special handshake of recognition and the secret signs (later adopted by Freemasonry) are believed to have originated in Scotland, the only place in these islands where the entered apprentice was to be found and where there was an absence of freestone. Skilled stonecutters were in competition with the barely qualified cowans (originally builders of drystone walls) and so the stonecutters developed a system by which they could recognize each other for employment purposes. The secrets that they guarded were technical, not esoteric.[2] In 1459, for example, stonecutters from Strasbourg, Vienna and Salzburg met in Regensburg to ensure that the statutes of their different lodges were in accord with each other and to ensure that the method of taking an elevation from a plan should not be revealed to the uninitiated.[3]

By the end of the sixteenth century, the old masonic craft in Britain was dying with the completion circa 1512 of Kings College Chapel at Cambridge, and for a time masonry seemed to be becoming an hereditary craft.[4] As the secrecy and ritual of the ancient guild began to fall into disuse, it was adopted by the rich and stylish, the new 'Speculative Freemasons'.[5] Elias Ashmole, founder of the Ashmolean

Museum in Oxford, is said to have been the first in England, joining in 1646.[6] This new 'Speculative Freemasonry' became immensely fashionable, and by 1787 both the Prince of Wales and his brother had been initiated, along with many eminent scientists and scholars, such as Christopher Wren. Freemasonry itself became a strong influence in the Enlightenment because, within the confines of the lodge where everything was protected by secrecy, it was safe to discuss potentially dangerous and radical new ideas on religion, science and politics.

With the coming of the Industrial Revolution, social mobility began to increase, with Freemasonry providing a ladder that extended from the lower middle class right up to the royal family itself. Friendly societies (legal during the period of the Combination Acts when trade unions were banned) adopted much of the regalia and ceremony of Freemasonry. The first Freemasonry certificates were in manuscript form and did not have a design. The earliest example of an engraved certificate with a design is that of 1767. As the number of lodges increased it became necessary for Freemasons to prove membership when travelling and also for claiming financial assistance.[7] These certificates included symbols of the three-grade system of the craft, and it is this legacy that is to be found in the emblems designed for the Model Unions by Arthur John Waudby, a professional artist born in 1821.

In 1839, at the age of 18, Waudby had published a book of river views, *Sketches on the Wye*. He exhibited *A Student* at the Royal Academy in 1844 and *Devotion* and *An Interior of a Cottage* in 1847.[8] Other exhibited works on record include *A Checkmate* (1842), *The Love Letter* (1844), *The Proposal* and *Devotion* (1848) and *The Appointment* and *Crossing a Stream* (1854).[9] In 1861, the Operative Bricklayers' Society commissioned a new emblem from Waudby that was used for both for their certificate and banner (Plate 46).

As we have seen in the forgoing chapter, his design is based on a triumphal arch in fashionable, polychromatic brickwork. According to Anderson, who reformed Freemasonry in 1723, 'the whole Body (should) resemble a well-built Arch'.[10] Brotherhood was its cement. Such an arch (in stone of course) is the basis of Waudby's design for the Stone Masons (Plate 10) and also (in wood) for his Carpenters and Joiners emblem (Plate 2).[11] However, it is in his emblem of the Operative Bricklayers (Plate 46) that Waudby demonstrates the most blatantly obvious use of Freemason iconography.

Every age recreates classical civilization in its own image and Waudby's 'triumphal arch' of the Operative Bricklayers emblem commemorates or deifies the working-class hero. And when the banner bearing his arch of triumph is carried in procession by the working man, those marching beneath it themselves become the heroes. And if we are still in doubt as to who the hero is, his tools are lying at the foot of the foundation stone. He has built the arch himself; he is the hero who has transformed himself via his apprenticeship, his knowledge, his skills and his labour. The foundation stone of the certificate bears his name. He himself is the foundation upon which the union itself is built – a similar theme to Freemasonry, wherein the initiate is placed in the north-east corner of the lodge to symbolize the foundation stone that is traditionally placed in the north-east corner of a building.[12]

At the top of Waudby's arch, Justice is enthroned, and on each side a putto holds a Roman fasces, symbol of the unity expressed in the motto between them ('Union is Strength'). These two putti resemble lictors, Roman civil servants who were bodyguards of magistrates and carried the fasces, and here they guard the figure of Justice. Fasces are to be found in French Freemasonry certificates, as, for example, in a certificate of 1774 engraved by R. Bricket, Toulouse.[13] Justice holds her attribute, the scales, but these are also indicative of the tools of the alchemist, used in the three stages of refining base metal into gold, and are also a Freemasonry symbol. Her left hand rests on a globe.

In the centre of the Operative Bricklayers emblem is a vignette depicting the Tower of Babel, beneath which is a quotation from Genesis that describes how the first bricklayers who built it used slime for mortar (as opposed to the 'cement' of brotherhood). The Tower of Babel is another moralizing emblem, originally symbolizing the sin of pride. It was a common theme during the Renaissance; it is one of the tarot cards in the 'Marseilles' or 'Bergamasque' Tarot pack[14] and Maurice Scève illustrates it in emblem CXXX11 of *Delie, obiect de plvs havlte vertv* (1544).[15] Waudby appears to have modelled his Tower of Babel on this, or else on a similar, circular Renaissance campanile, rather like that at Pisa, with a colonnade around each layer.

The Tower of Babel features prominently in all versions of *The Constitutions of Free Masonry*[16] because it was believed that the 'Masonic Word' dated back to it when, suddenly unable to understand each other, masons were forced to communicated by means of signs.[17] The *Regius* manuscript of Freemasonry cites the King of Babylon, Nemrod or Nemroth, as the builder and the first Master, who gave the masons their first 'charge' (i.e. rules of conduct and code, and the 'science' of masonry).[18] In Waudby's emblem, Nemrod or Nemroth is the figure holding the plans who, with outstretched arm, gives the 'charge' to three men of different ages who are representative of the first three degrees of Freemasonry (Entered Apprentice, Fellow, and Master). Later, with the 1726 *Graham* manuscript, Freemasonry rejected Babel as its origin and adopted King Solomon as the first Grand Master. Babel, however, remained as a signifier of the universality and brotherhood of the builders because, despite their division by language, they are united by their skills.

The figure in the foreground on the right appears to be an Atlas type. According to Ovid, Atlas was turned into stone as a punishment by Perseus for denying him shelter and Zeus punished him further by condemning him to hold up the sky forever. However, this Atlas figure seems strangely out of place in a biblical scene depicting the building of the Tower of Babel. He is posed in an awkward kneeling position on his left knee with his left arm raised. Atlas is featured in Scottish Freemasonry certificates bearing the globe of the world[19] and various contorted kneeling positions are used in Freemasonry ceremonies, so he may therefore represent an early Mason of the new lodge. And because he is bearing mortar, we know he is not a cowan (a drystone waller, forbidden to work with lime mortar). Having become stone, Atlas also serves as a reminder to Freemasons that they themselves are the 'freestone', the soft, chalky stone used for sculpting, as opposed to the harder 'rough stone' for building work, and it is their duty, by means of introspection, to make new and better men of themselves. This

act of individual metamorphosis is intentionally trivialized in Freemasonry in the act of putting on regalia and acting out a role, signifying this journey of transformation.[20] The concept of symbolism encouraging subjective knowledge can be traced back to Socratic thought.

In the vignette above the Babel scene, a modern bricklayer is placing a brick keystone at the centre of a brick arch. The keystone in the centre of an arch, for example above a door, is a feature of some Masonic temples.[21] King Solomon's architect, Hiram Abif, was murdered because he would not share the secrets of centring.[22] The new Freemason is asked when he first became aware that he needed to become a Mason, to which he replies 'In my centre', and Freemasonry describes itself as the study of the spiritual centre – the Mason's own introspection.[23] So the concept of the 'centre' is extremely important in Freemasonry, which describes itself as 'the Centre of Union', the 'Means of conciliating true Friendship among Persons that must have remain'd at a perpetual Distance',[24] so this centring scene is doubly symbolic, as is, perhaps, the play on the word 'union'.

The ladder in the vignette leading up to the word 'GOD' is indicative of the tradition of Jacob's Ladder in Freemasonry. In the lodge it leads up to the starry canopy of heaven painted on the ceiling of the lodge and which is explained in the Initiation Ceremony. The ladder's many staves or rungs represent moral virtues, principally the theological virtues, Faith, Hope and Charity.[25] And in the vignette, a bricklayer is climbing up it.

Beneath, a little poem is inscribed:

The Line and Plummet guide the tool
And keep the Trowel under rule
The firm foundation lay with care
Nor build thy Castle in the air

Keeping the trowel 'under rule' refers to the fact that this union actually forbade general labourers from using the trowel.[26] In Amos, God himself is described as a builder, standing beside a wall with a plumb line in his hand.[27] The plumb line and trowel are, of course, also references to Freemasonry and feature prominently in the Second Degree. The plumb line is a metaphor for the uprightness of the Freemason, whilst the trowel, a tool used at the end of building to apply mortar or plaster, represents the final stages of his work. The 'firm foundation' refers again to the Masonic tradition that the foundation stone is laid in the north-east corner of the lodge where the newly installed Freemason is placed so that, built upon the 'foundation' laid during his initiation, he may raise a perfect superstructure, a living stone.[28] The castle signifies the 'square' of the lodge – a symbolic representation of Solomon's Temple – but the square also symbolizes earth and matter.

On each side of this little scene, the architect and the bricklayer each has a foot resting on what may be a plumb line or rope, tied to which are bow-like ribbons. These are reminiscent of the ropes that decorate the walls of Masonic temples and which have

knots at given distances, to produce units of measurement. The knots are not drawn tightly and appear as the number 8 (as in these bows). The two ellipses that form a number 8 are known as 'lemniscates' and have the property of 'squarability', that is to say the area of one of these rings is the area of a square whose sides are equal to the length of the diameter of a circle inscribed within a ring. In Freemasonry, lemniscates serve to encourage reflection on the links between appearance and reality, and the passage from knowledge to experience.[29]

On the strapwork streamer toward the top of the scaffolding is the legend 'Every House is Builded by some Man, but He that Built all Things is GOD, Hebrews Ch III Ver IV'. Here, God is associated with having built not mere houses, as men do, but having constructed all things. Freemasons call him 'The Great *Architect* of the Universe' and they see their own mission as a continuation of his work – they are heirs to a world still being constructed and perfected.[30] Standing each side of the centring scene are the architect with the plans, a metaphor for God, and the bricklayer, a metaphor for the Freemason who will execute God's divine plans and bring them to fruition. He holds the trowel, used in the final stage of building when mortar or plaster is applied over the walls, a potent symbol separating the Freemason from the uninitiated, unapprenticed cowan. The figures are located on either side of the centring scene of the arch, which acts as a bridge across which the concept will travel, connecting the two. The scaffolding itself represents, firstly, the framework of Freemasonry on which all lodges base their work and, secondly, the unfinished work of the individual Mason in constructing his new self.

On the base of the structure, personifications of Science and Art are the largest figures in the entire composition, like huge marble sculptures depicted in grisaille. Stripped of colour, they imply the purity and the silence of a dead world of timeless truths. From their sheer size, we know they must be very important as bearers of meaning. In Freemasonry, the 'Charge to Admitted Brethren' requires the Freemason to love the arts and sciences and to improve himself, which is probably why Art and Science occupy positions of such importance in this certificate.[31] Science appears to have been copied from the figure of Ars (Art) in the 1750s illustrated editions of Ripa's *Iconologia*, first published in 1593. Art draws in a book of architecture, with her palette, brushes, bottles of paint and a copy of *Art Journal* at her feet. She appears to have been based on the figure of Art in the ceiling of the Royal Academy in London by Angelica Kauffman (1778), perhaps in order to identify Waudby himself with the Royal Academy, where he had exhibited.

The compasses at the feet of Science in the lower left-hand side of Waudby's emblem are another familiar sign from Freemasonry wherein tools are given to the Freemason at his various degree initiations with the instruction to apply them to his ethics.[32] Together with the set square, the compasses stand for the interaction between mind and matter, and the progression from the material to the spiritual.[33] A metaphor for standing firm, they were also the tools of the working mason. The roundel in the top right corner of the emblem reflects this. It reads, 'In honour of those Members who nobly stood together and paid all levies in resisting the Document 1859 and Hourpayment 1861'.

A small putto studies Euclid at Science's feet. Euclid or Euclydes also features in the Freemasonry legend of Nemrod. He came to the king and offered to teach the sons of the lords the Seven Liberal Sciences so that they might live honestly like gentlemen.[34] Masonry therefore became synonymous with geometry, which was regarded as the foundation of all knowledge.[35] In Freemasonry, another name for God is 'The Great Geometrician'. Geometry is considered superior to rhetoric and grammar because measuring entails proof, and the demonstration of the truth of a proposition. A theory about the properties of a shape can only be accepted when it has been verified using reason (for example, by the use of a square and compass, the tools of a free-thinking man).

Science is seated beside a globe of the world and a sextant, with the compasses, set square, scroll and locked book beside her feet. The wreath on her head is of laurel, symbolic of victory but which is also the evergreen associated with Apollo and his music, and therefore she represents the *quadrivium* of the Liberal Arts (geometry, arithmetic, astronomy and music), the study of which is part of the 'good work' of the Freemason, and the focus of Masonic study.[36] And at her feet, to emphasize this, a little putto earnestly studies a book of Euclid. The globe is also an important Masonic symbol, the celestial globe and the terrestrial globe signifying Masonry Universal.[37] Beside her is a roundel containing the dove of peace – perhaps serving a secondary purpose in representing the new science of ornithology. Above her is a larger roundel depicting London and, although she points with a telescope to Wren's St Paul's Cathedral, she looks towards Rome in the matching roundel on the other side where, at the feet of Art, a small boy sculpts a bust of Christopher Wren. Wren himself became a Freemason in a ceremony actually held in St Paul's Cathedral on 18 May 1691.[38]

Art is seated beneath the roundel of Rome, which contains Castel Sant'Angelo and its bridge, built by Emperor Hadrian in 136 CE, and Michelangelo's great church of St Peter. The carved bust of Wren beside her establishes a connection between him and Michelangelo, the two architects of the Pantheon-inspired classical domes of London and Rome, which are in the two roundels. Wren's dome of St Paul's is actually constructed of two domes, with a brick cone between the two, the skill of bricklayer lying at its very heart or 'centre'. An early English Freemasonry certificate, the 'St Paul's Certificate', contained a view of London.[39] By pointing to London whilst looking back to Rome, Science is reminding the viewer of the trade's origins in the classical period. The classical architecture and the wisdom of the ancient world inform the architecture and science of Victorian Britain. A new Rome is being built here, a new age of architecture and engineering and municipal pride whose glories equal that of the ancient world. So, taking the three images of this lower level together, London, Rome and Babel, we can trace a continued tradition of Freemasonry, masonry and bricklaying, hand in hand, from Wren back to Michelangelo, to Hadrian and back to the Tower of Babel – the very first building, immediately after Noah and the Flood.

The Roman bridge and the modern day bridge that appear in the two roundels are also important bearers of meaning. Bridges are structures which connect two separate places and over which traffic can flow, so one may view them as metaphors for the transmission of ideas. The skills and knowledge of the ancient world are being

transported to the modern day by generations of craftsmen. This transmission of knowledge is also taking place above between the architect and the bricklayer on the scaffolding. We may see the architect as representing the Platonic theory of the contemplative. He holds the plans that he will pass to the bricklayer, the active, to execute. What is an essentially manual trade is, in this emblem, being elevated to the realms of the philosophical and cerebral.

The hive of industry, just beside Art on the right, is an emblem that appears in many trade union emblems of the period in the form of the traditional coiled straw 'skep'. In Egyptian and Roman symbolism, the bees are symbols of industry, regeneration and wisdom, and they abound in ancient literature. According to Horapollo, the Egyptians saw the bee as the symbol of an obedient people because they alone had a king.[40] In Virgil's *Georgics* the bees signify a perfect society in which the individual work of each bee contributes to the larger good of the ideal community.[41] Alciati's Emblem 148 depicts a hive of wasps. It speaks of 'The Clemency of the Prince'. The fact that the queen never uses her sting indicates a merciful rule. Whitney uses Alciati's emblem but to refer to bees in the manner of Virgil in order to symbolize patriotism. And in Freemasonry, the bees and the hive symbolize the work of the lodge.

Vitruvius recommended that the true architect should study the perfection of nature and copy from it (and a Second Degree Freemason is required to study the 'hidden mysteries of nature and science'),[42] which is why Science is seated near a roundel containing a dove and Art is sat beside the hive at a drawing board. The hive is a natural form that is thought to have influenced the great domes of architecture, such as St Paul's and St Peter's here. Wren's dome of St Paul's fulfils Vitruvius's criteria of *utilitas*, *firmitas* and *venustas* (suitability or harmony, strength and beauty). And of course, 'Union is Strength' is the actual motto of the Operative Bricklayers' Society, lettered in the blazon between Science and Art. Waudby has explained this motto visually, in the tradition of the emblem. Unity between the arts and sciences is echoed in the unity between architect and builder (i.e. between God and the Freemason) on the scaffolding, between brickmakers, gauge workers and bricklayers in the arches, and in the keystone in the top central vignette that holds the arch together. The entire composition is a visual sermon on unity and its immediate result, strength. It is extremely sophisticated in its symbolism, and Hobsbawm is obviously incorrect when he writes that the emblems of this period are 'uninfluenced by intellectuals'.[43]

Science and Art are pointing out that Freemasons and masons such as Wren and Michelangelo fulfil the plan of the Great Architect of the Universe through the building of great Christian temples. Freemasonry brings together people of different origins to work on a common project – the creation of a temple for all humanity.[44] The trowel held by the bricklayer on the scaffolding will smooth over the finished edifice, obliterating differences. Temples mediate between man – the microcosm – and the universe – the macrocosm – as this union mediates between its members and their employers.

The banner (Plate 37) is very similar to the certificate, but embellished with larger corner roundels and an elaborate gilded and pierced 'frame' with a strapwork streamer

above, bearing in large lettering the name of the society. The roundel in the lower right-hand corner commemorates William Brightwell. The 12 founders of the London Order met in the Sun Tavern, Lambeth, on 8 April 1848, under the Presidency of Brightwell.[45] The order had no benefits at that time, but here in the banner (circa 1865) the three other corner roundels depict the new benefits. The banner further reinforces the similarity to the Roman triumphal arch by placing the fictive structure in an outdoor setting, with sky and trees behind. Light enters from the left side, throwing deeper shadows of the projecting figures against the structure. Clouds viewed through windows and behind the keystone-laying vignette and the brickmaking scene in the upper section appear also in the sky on either side of the structure, affording the feeling that we have stumbled upon this edifice in a great park, and we can see the 'real' world around and behind it. The roundels of London and Rome also appear to be actual views, but we know this cannot be true and they contradict our reading, destroying the illusion.

Centrally placed at the very bottom of the structure in the banner is the foundation stone. In the certificate this bears the member's name and certifying details but here it simply features the handshake, which, as it is one of the largest symbols in the banner, indicates that it is very important. It is a symbol that appears in very many banners and certificates and signifies concord. But of course it also represents the secret handshake by which two Freemasons (or two union members) may identify themselves to one another.

At the top, in both certificate and banner, personifications of Truth and Prudence are at the outer edges with two small vignettes of gauge work and brickmaking. Truth is beside the exacting gauge work, which involved sizing, shaping and cutting each brick to fit (the gauge is another important Freemasonry reference), whilst Prudence is beside brickmaking. Prudence holds a finger to her lips to indicate caution when speaking. Different coloured courses and patterns of brick in the arched structure itself remind the viewer of the coloured layers or strata of the earth from which brick is actually made, and so brickmaking may be read as the harvesting in the fields of the earth's produce, whilst gauge work can be read as the threshing and milling to the finished product.

Bricks were handmade and it was a highly skilled trade. The fully skilled brickmaker was the 'moulder', and working beneath him were 'Off-Bearers, Temperers, Wall-flatters, Pugboys, Pushers-out and Barrow-loaders' who were not admitted to local trade clubs and who were little more than general labourers.[46] However, in 1861, machinery was first introduced into brickmaking by Renshaw and Atkins in Manchester, causing great suffering and deprivation amongst the hand workers and resulting in the smashing of machines by men driven to desperation. Renshaw's engine was blown up by the union the year it was introduced and later Atkins' engine was sabotaged by iron thrown into the machinery. Machine-made bricks were also destroyed, one Manchester firm having as many as 50,000 bricks spoiled in just one raid. After two masked brickmakers returning from a raid were convicted of the murder of a constable and injuring an inspector who tried to apprehend them, eight disparate societies came together to help defend the accused men, later amalgamating and becoming the Brickmakers' Society.

Machine breaking and brick spoiling, burning down sheds and hamstringing horses became organized and paid for by the union, as entered in their accounts. But the tide could not be reversed, and the brickmaking unions declined and then ceased. In the 1870s the workers became general labourers, only resurfacing in the title of the Amalgamated Society of Gasworkers, Brickworkers and General Labourers at the end of the century.[47]

The later 1887 Manchester Unity's regional version of the certificate (Plate 38) (possibly produced after Waudby's death)[48] was engraved by J. H. le Keux and the figures themselves by C. H. Jeens, with the address of 93 Charrington Street, North-West London. Interestingly, in both this and the original certificate, and in the banner, the word 'gauge' under the left arch in the upper section is misspelled as 'GUAGE', leaving one to wonder if this was in Waudby's original design, and why neither the Operative Bricklayers' Society itself, nor the engraver, nor the banner maker (George Tutill) saw fit to question it and correct it.

In 1869, eight years after Waudby designed their emblem, the Operative Bricklayers' Society commissioned him once again, this time to produce a large emblem in oils (8 ft by 6 ft) for their London offices (Plate 39). Scaffolding poles are again a feature of the design, but instead of bricklayers on the scaffolding, there are three large personifications. In the central part of the image we recognize Truth from her attribute, the mirror, whilst her counterpart on the opposite side is named on the scroll that she carries, so we know that she is Science. Architecture is at the top of the scaffolding, named at the base of the plinth on which she sits. Truth and Science lean against a frame in which two men in an interior space perform gauge work, a very similar image to that in the emblem for the Operative Bricklayers' Society, and labelled 'In all labour there is profit'. The concept of 'centring' is again foregrounded in this image as there are three arches in evidence, each awaiting its keystone, the number three finding an echo in the three trowels of different sizes at the base of the emblem and the three women on the scaffolding. Three is a Masonic number, representing the three attributes of God – will, wisdom and intelligence – all of which are being demonstrated by the work of the men. Two small roundels illustrate the benefits of membership – the accident and the widow's benefit. Large scrolling strapwork announces 'By Industry We Flourish' and 'Industry is the Source of Prosperity'. A small plaque at the very top honours the first President, William Brightwell, 1848, whilst at the bottom are the names of the General Secretaries.

Waudby's work for the Bricklayers must have been well received because he was again commissioned to design an emblem – this time for the Amalgamated Society of Carpenters and Joiners (Plate 2). Like many other designs of the era that were remodelled and exported by British banner makers, it was taken up and used by sister unions across the empire. It appears in surprisingly far-flung places, for example (with local variation) on the banner of a small mining town of Western Australia – the Kalgoorlie Branch of the Amalgamated Society of Carpenters and Joiners.[49] Francis Chandler, General Secretary of the union from 1888, gives insight into the commissioning in his *History of the Society 1860–1910*, published in Manchester in 1910.[50] According to his

account, the emblem, engraved on steel, was issued in December 1868 at a cost of 3s. for India proof copies and 2s. 6d. for the cheaper plate paper. Waudby profited well from his union work. For example, in their records of June 1870, item 167 records that the Independent United Order of Mechanics Friendly Society agreed to pay him the handsome sum of 250 guineas for a steel plate engraving of their emblem, as per his written offer.[51] Back in 1852, Sharples had received only five pounds for his design.[52]

Waudby's emblem for the Carpenters and Joiners was described in the union's *Monthly Report for May 1866*, prior to its distribution to members. According to the key, the emblem had been engraved 'in a superior style, and no pains have been spared to make it a work of art'. (This is an interesting statement in itself, revealing that the union regarded their emblem as elevated, and having artistic merit.) In the panels between the Corinthian capitals of the pilasters are the fir and pine cones and the oak and acorns, 'to represent the materials principally employed in the work'. It calls the structure 'an elaborate screen executed in joiners' work'. The word 'screen' is very revealing. It suggests a structure designed to veil from sight something behind it, something secret, not to be displayed openly. The rood screen of a church separated the sanctuary, chancel or quire from the laity, protecting the mystery of the rites and some, for example that at Clare College Cambridge, can be seen as similar in design to a triumphal arch. So Waudby's 'screen' may be symbolic of the obscuring from view of something not to be openly revealed.

In fact, this design is a variant of Waudby's design for the Operative Bricklayers, with a similar framing lunette containing an arch structure, two large central vignettes, and a seated figure at the top with a supporter each side. The two allegorical women have been moved further down the emblem with Justice, from the top of the Operative Bricklayers' Society emblem, now on the left of this new design, and a Truth (now a very 'naked truth') on the right. The little putti each side at the base of the emblem are here replaced by the large figures of the carpenter and joiner.

Joseph, patron saint of carpenters, is seated at the top of the structure, like a Christ in Majesty. He is enthroned, but his foot rests on a Roman fasces and the motto 'Union is Strength' is immediately under it, explaining the fasces. As in the Renaissance convention, he wears a toga-like garment and his name is on his sash. His contrapposto pose appears to be based on Michelangelo's *Delphic Sibyl*. Like her, he holds a parchment scroll to the side and looks across the shoulder of his raised arm.

This figure of Joseph is described in the *Monthly Report for May 1866* as representing 'the most distinguished member of the craft upon record, being the reputed father of the Saviour'. This is an extremely interesting statement when read together with the motto of *credo sed caveo* ('I believe but I am wary'). Is this an innocent mistake, a slip of the pen, or does this in fact imply that Joseph was the *actual* father of Christ, denying the teaching at the heart of the Gospels of the Immaculate Conception? Although Chandler, in his *History of the Society*, comments on other aspects of the key, he is silent on this point.

Joseph is flanked by personifications of Industry and Art, who each lean on one elbow and look inwards towards each other, symbolic of the products of industry that

have their beginnings in art. Art on the right holds a palette and brushes and at her feet is a bust of Athena, the goddess of craft (referred to in the description in the *Monthly Report for May 1866* as 'the Patroness of the Arts'). Industry at the left is beside her usual attribute of the hive. She holds a scroll that reads 'Labour is the source of wealth' but also the distaff or flax pole of Athena. Art is inspired by Athena, but it is Industry who possesses Athena's flax pole and who will carry out her work. Between them is the shield bearing the joiners' guild coat of arms together with the reassuring motto 'United to protect, not Combined to Injure'. At the outer edges of the arch, elevated on pedestals, are Justice and Truth. They wear flimsy, pseudoclassical garments, and although identifiable by their usual attributes – sword and scales for Justice, mirror for Truth – their names are lettered on the plinths on which they stand.

The central space is divided into two separate scenes, one above the other, together enclosed in a lunette, a smaller version of the outer lunette of the emblem's actual frame. The upper scene is of 'Centring', which, according to the key, is 'an adaptation of a plate forming the frontispiece to Nicholson's *Practical Carpentry* with the addition of two prominent figures representing carpenters at work'. Because this process of 'centring' is featured in the most important vignette in both this emblem and the Bricklayers' emblem (in which the keystone voussoir of the arch is being put into place), it is obviously of very great significance. The 'lewis', the device for lifting, is at the very top of the arch. 'Centring' is an important Freemasonry reference (the badge of Mark Masonry is a keystone and it is used in their rituals). But the keystone is not simply a reference to the process of centring. It is also a veiled reference to a key, the key of a locked door, and to secrets that are withheld behind it that are revealed only to those who are in possession of the key.

The scene below is of a joiners' workshop, 'all the incidents of which have been carefully drawn on the spot from actual facts with almost photographic exactness; the leading figure showing a workman shooting a joint, and another sharpening a saw'. It is very much in the tradition of Sharples, illustrating work within a workshop with receding depth and windows at the side. It is a metaphor for the work of the lodge, the preparation for the building of the bridge above, the universal joining place of brotherhood. The scaffolding constructed by the carpenters and joiners is the essential foundation upon which the stone of the bridge will be laid.

At each side of the emblem are flat, incised, fluted pilasters with Corinthian capitals, similar to those in John Chant's design for the Iron Founders (Plate 21). Between these pairs are six small scenes, three on each side. In each case, the top and bottom scenes show the benefits of the union in rectangular frames, but those in the middle are quite different and are in circles within the frames. On the left is a sectional detail of a ship's cabin and on the right a geometrical spiral staircase. The staircase transports us from one unseen level to another unseen level, whilst the section of the ship's cabin is like a portal *within* a portal. Both images may represent not only the work of the carpenter and joiner but also the movement *through* one level of apprenticeship *up* to another level during the apprentice's training within the 'craft' (for which the 'ship' is a metaphor). The winding staircase is a feature of Second Degree Freemasonry, wherein the Mason

must act out the stepping up and around a spiral staircase; it appears on Second Degree tracing boards and it is indicative of the Freemason's intellectual ascent to hidden truth that he finds in his own 'centre', which is why the personification of Truth is here beside the staircase. Like Jacob's Ladder, it is the Freemason's path to higher realms of the intellect and the ascent to the Third Degree. It has its origins in the spiral staircases in medieval cathedrals that were hidden within the walls for construction and maintenance purposes, and therefore indicate hidden knowledge.[53] And here, in Waudby's certificate, it is the only one of the eight scenes with no explanatory label.

The four small square plaques of benefits are of life outside the working environment – the accident (where the injured man is being carried away by his comrades), the sickness benefit payment (where a disabled workman with a wooden 'peg' leg is given the £100 benefit), superannuation (a white-haired couple in their home) and the widow's benefit (the widow with her hand out to receive her money, her children gathered at her knee). In the last three, the same union official, the treasurer or almoner, proffers a bulging bag of money, underscoring the reassuring benefits of union membership.

A major new development in this certificate is that the iconic workmen have now come down from the highest places of the arch where they were in Sharples's and in Chant and Saddler's Iron Founders emblems, and are instead standing at the very bottom, outside the structure. With their tools still in their hands and lying at their feet, these men appear to have built the arch themselves. These tools are the tools of both construction and destruction – the tools that slew Hiram Abif, architect of Solomon's Temple, are also the spiritual tools with which the Freemason constructs his own personal temple.[54] According to Chandler, the figures represent a shop joiner and a fixer (carpenter), and both were taken by Waudby from an actual portrait of James Payne, Chairman of the Executive Council in 1862 (later Branch Secretary of the Camden Town Branch in 1866).[55] Chandler was appointed General Secretary of the Union in 1886, having been made Secretary of the Hammersmith Branch in 1873 and a member of the General Council in 1876, his history of the union being written in 1910. Gorman, in *Banner Bright*, erroneously refers to James Payne as 'James Blayne'.[56] He appears to have taken this information from S. Higenbottam in *Our Society's History*, published by the Amalgamated Society of Woodworkers in 1939, some thirty years after Chandler's published account. However, research into the archives of the union leave no doubt whatsoever that the Chairman of the Executive Council in 1862 was actually James Payne. The *Third Annual Report, December 1861 to December 1862*, is signed 'J. Payne, Chairman'. The address of the Camden Town Branch is given as the North London Coffee House, Camden Town, and James Payne, Auditor to the Council the previous year, is recorded as residing at 50 Pratt Street, Camden Town, London.[57] According to Chandler, Payne did not retire as a union member until 1896, so he must have known him. Chandler relates that James Payne stated that the scrolling handrail by the figure on the right was work in which he was actually engaged at the time of the design of the certificate, and that he still possessed the saw held in the hand of the figure on the left.[58]

The portraits of Payne as joiner and carpenter act in several ways. Firstly, they afford the union member a personal link with the hierarchy of his union – he is able to

identify with them and visualize himself in their place. Secondly, because the portraits are both of the same union official, the carpenter and the joiner are afforded equal rank. And, thirdly, the two representations of Payne rest their hands on the foundation stone or plaque containing the union member's own name, unique and personal to him. The two are like the choric figures who stood at the side of the stage in medieval drama and explained the proceedings to the audience. They look out to the viewing audience, mediators between our world and theirs, and as guardians of the portal. This is, of course, reminiscent once again of Freemasonry, which also has guards outside the door of its lodge. The viewer may observe but not enter their preserve.

So far we have considered the certificate of the Amalgamated Society of Carpenters and Joiners in relation to triumphal arch or portal architecture, but it also bears certain resemblances to the Renaissance altarpiece and to the monumental tomb.[59] This is not surprising because many of the mid-Victorian banners bearing the emblem of their union or society reproduced from their certificate were frequently employed as backdrops on the stage at union meetings or at funerals of members. Banners not only served as a rallying point and a unifying symbol of identification at marches, they also served as a decorative icon of the trade. And the certificate in the home reinforced the reassurance of funerary benefits.

Waudby's design displays Renaissance influences not only in its use of depth and recession but, for example, in the elaborate wooden scaffolding centring for the bridge, similar to the coffered ceilings in Renaissance architecture and altarpieces. During the Renaissance, rich merchants donated altarpieces to local churches, and often their portraits appear either outside the sacred space, or within it. The figures of the carpenter and joiner are like these donors, represented outside the 'sacred space'. But whereas donors of the Renaissance merely provided the money for the construction of an altarpiece, Waudby's 'donors' hold the tools of their trade, and appear to have built the 'altarpiece' themselves.

A roundel at the bottom, within the space of the certification details, is entitled 'Emigration'. Its metallic punched and scrolling cartouche-like frame is described in the key as of 'Elizabethan character', and depicts a scene with a young family on board a ship making an ocean voyage to a new country, a traditional subject based upon depictions of the Flight into Egypt by the Holy Family. Similarly, the *Navicella* was a favourite subject for Renaissance praedella paintings (the small narrative painting placed at the bottom of a painted altarpiece). Being conveyed to a new life across water is also of course a classical funerary reference – in ancient mythology, the souls of the dead were conveyed across the River Styx by Charon, the boatman. Placed as it is at the very bottom of the emblem, it refers to the embarkation upon a spiritual journey to a new life of the Freemason or union member whose name appears directly above.

This 'Emigration' medallion ostensibly refers to the £6 Emigration Benefit payable to members under certain rules. As Chandler wryly remarks,

The result of having these provisions in the rules was that whenever a member of five years' standing in the society turned his attention to the subject of emigration

he naturally referred to this rule, but, as might well be expected, never happened to find the two conditions, viz., a high cash balance and excessive unemployment running parallel together, with the result that great disappointment was experienced [...]. This rule is rendered inoperative, *no member ever having received it.*[60]

The similarity to the Renaissance altarpiece becomes even more pronounced in a local variant of Waudby's original design, the 1899 banner of the Amalgamated Society of Carpenters and Joiners, Chatham District Branch, refurbished after 1927 (Plate 40). This banner is discussed more fully in Chapter 10, 'The Art of Copying', but here it is sufficient to say that it is quite obviously based on a very famous altarpiece, the Giovanni Bellini triptych, *Madonna and Child with Saints* (1488), in the Frari, Venice (Plate 41).

In 1869, Waudby was again commissioned, this time by the Hearts of Oak Benefit Society (founded in 1842), to produce their new certificate (Plate 42). A friendly society, it concentrated on savings and insurance rather than specific craft interests, but it is worth examining here because it expands our understanding of Waudby's oeuvre. Following the passing of the Friendly Societies Act of 1850, friendly societies such as this were open to artisans, shopkeepers and mechanics who were of good character and reasonably well off. Many of these societies had elaborate rituals, regalia, medals and jewels, with emblems full of arcane, esoteric symbolism, but Waudby's design appears to be refreshingly free from this.

In his design for them, encased in his 'trademark' lunette, now with an upper, squared storey, his structure harked back to that of his Operative Bricklayers certificate (Plate 46) with two large central vignettes placed one above the other, smaller side roundels and with a crepidoma or ziggurat section at the top. And, as with his Carpenters and Joiners emblem, the two central scenes are also enclosed within a lunette that echoes the outer lunette of the emblem's frame. The motto, 'Hearts of Oak are our Ships, Hearts of Oak are our Men' was taken from the hymn 'Hearts of Oak' (with words written by the actor David Garrick in 1759 and music by Dr William Boyce), which became the official march of the Royal Navy. The society itself was named after the wooden ships that had protected Britain from invasion, a metaphor for the society's ability to protect its members, for example against the expense of sickness. The oak is the national tree of England, famous for its great height, age and strength, and is a symbol of endurance. The ships of Drake and Nelson were built of it, and its very name evokes qualities such as bravery, reliability, steadfastness, security and, of course, patriotism.

The design features whimsical rustic vernacular decoration of a single flowering twig of oak, twisting and framing the vignettes, a reference to the 'branches' of the society, very similar to the twig-like embellishments to the side of the Babel vignette in Waudby's Operative Bricklayers emblem (Plate 46). The overall design harks back nostalgically to the preindustrial past of wooden sailing ships, Elizabethan timbered houses and 'Old Oak Furniture'. In the upper, larger vignette at the centre or 'heart' of the design is the vast 131-gun warship, HMS *Hearts of Oak*, dwarfing smaller shipping. The lower central vignette, entitled 'Homeward

Bound', shows both crew and passengers relaxed and at ease. This reference to safe returns is a metaphor for the safe returns on monies invested in the friendly society itself. The society was only founded in 1841 (the base of the certificate has the words 'Instituted and Enrolled June 20th, 1842'), yet the certificate gives the impression of a friendly society originating in the distant past with a long history and mighty roots.

Two small roundels of 'Old Oak Lodges' and 'Old Oak Furniture' with dates above are perhaps a bow to Freemasonry in the word 'Lodges' and the furniture of the lodge. Oversized roundels of ships at the lower level (perhaps references to the 'craft') appear as though seen through the magnification of the naval telescope, and beneath are personifications of the ocean and the river. 'King Neptune' is posed with a crown and the trident of the ocean, and 'Father Thames' with a pointed deltor oar and an urn, from which issues the source of the river. Their names are engraved on plates attached to chains flanking woodmen's tools and a sawn section across an oak tree trunk revealing the rings of its 'heart'. Neptune's trident points to ocean shipping, whilst Thames's oar points to river shipping.

It is a very different Father Thames from that drawn 14 years earlier in a cartoon in *Punch* of Father Thames rising from his river covered in excrement and with the bloated bodies of dead animals floating around him.[61] London sewers had originally been constructed to divert rainwater into the Thames, but with the introduction of the new flushing water closets, the cesspits serving them could no longer cope. They overflowed, the raw sewage running into the street drains and thence to the river, which was already taking the output of factories and slaughterhouses. Most of London's drinking water was taken from the Thames and as a result typhoid and cholera were on the rise. The hot summer of 1858 caused even further growth of bacteria in the water and what came to be known as 'The Great Stink'. Within the Houses of Parliament, so appalling was the stench from the river that sacking soaked in chloride of lime was hung over the windows and there were even plans to evacuate. Swiftly, the members passed a bill providing money for a new sewer system, and plans by Chief Engineer Joseph Bazalgette were adopted by the new Metropolitan Board of Works.[62] By the date of this emblem, the new system had been completed some four years, the Thames was a great deal cleaner and so Waudby could depict Father Thames with, perhaps, a little pride.

At the very top of the emblem is Britannia beside the British lion, a ship's bell and regional flowers at her feet, with the motto 'Rule Britannia' beneath them. Originating in a poem by the Scottish poet and playwright, James Thomson in 1740, 'Rule, Britannia!' was set to music the same year by Thomas Arne. In the original version, the exhortation was that 'Britannia rule the waves', as Britain did not then have superiority on the high seas due to Spanish aggression towards British merchant ships. The wording was later changed by the Victorians to 'Britannia rules the waves' after she had actually gained control of the seas. At each side of the upper section supporting Britannia are female personifications of Agriculture and Commerce. Agriculture has a cornucopia at her feet and she holds a sickle, a stalk of grain and a sceptre, whilst Commerce also holds a stalk of grain and a sceptre, but at her feet is a globe and an anchor, indicating the movement, import and export of goods by water. At the

base of the emblem, above the scroll containing its name, is the crest of the society, topped by a crown, decorated with oak leaves and surrounded by national flowers (a nod to Sharples) and resting on a mighty fasces with the motto 'Union is Strength'.

It must have been a difficult and challenging task at this particular time for Waudby to produce a certificate that used shipping as a metaphor for security. In the winter of 1850, 200 people died in one night alone in shipwrecks around the coast. By 1851, Britain was controlling almost two thirds of the world's shipping, but unscrupulous ship owners (some of whom were Members of Parliament) were notorious for sending unseaworthy and overloaded vessels to sea covered by heavy insurance. If the cargo reached its destination, they received their payment. If the ship sank, they claimed the insurance. It was a win–win situation for the owners, but not for the unfortunate crews of these 'coffin ships'. Samuel Plimsoll entered Parliament as Liberal MP for Derby in 1868 and tried in vain to introduce reforming legislation. In 1875 he created an angry and emotional scene in Parliament, shaking his fist at the Speaker, refusing to sit and accusing ship-owning MPs of sending sailors to their deaths. His Merchant Shipping Act was finally passed and the sailors honoured him by portraying him as a bearded mariner on their certificate of the National Sailors' and Firemen's Union of 1891 by Tutill and Fowiniss.[63] Waudby's Hearts of Oak certificate of 1869, produced at the height of the coffin ships scandal, endeavours to hark back to earlier times and strong naval traditions. It speaks of patriotism and sentimentality for a Britain of the past, not the Britain of the coffin ships.

A year earlier, Waudby had been commissioned to produce an emblem for the Friendly Society of Stone Masons (Plate 10). Stone masons had bonded together in various small local trade clubs from at least the mid-eighteenth century, but little is known about these organizations. Following the repeal of the Combination Acts in 1824, trade unionism gained a footing with the short-lived Operative Builders' Union in 1831. The new union of stone masons of England, Ireland and Wales grew from this with Scotland (where building was almost entirely in stone) forming a separate union, the United Operative Masons' Association of Scotland, both unions being founded in 1831.[64] By 1838, the Friendly Society of Operative Stone Masons had almost 5,000 members and within 30 years it had become the strongest and most independent of the building unions.[65]

The emblem cost the society £473, and members were charged 2s. 9d. (with frames, if required, costing an additional 5s. or 7s. depending on the style) but only after a long debate on prices.[66] Again, Waudby's design is surrounded by his usual enclosing lunette frame. This time the arch is of heavy, sculptural, solid stone, with the name 'Stone Masons Friendly Society' appearing as though carved into it. The structure is described in the key as 'a Screen displaying Pilasters and a Cornice with enriched mouldings of the Corinthian order'. Even though the structure appears to be a solid stone building, it is another of Waudby's screens, announcing the fact that it hides something secret. It is, again, the superstructure that a new Mason, the 'foundation stone', has to build for himself, a metaphor for the good works a Freemason should do to ensure his own immortality. The words 'Lodge Opened' are at the bottom, beneath the enclosing

frame, indicating the links to Freemasonry.[67] It was by far the most neoclassical of Waudby's designs to date.

God, or the 'Great Architect', is present at the top of the image in the all-seeing eye, symbol of knowledge and control, from which beams of light stream down, illuminating everything beneath. The eye in a triangle, symbolic of the Holy Trinity, appears in Jacopo Pontormo's *Cena in Emmaus* of 1525. Here in the Stone Masons emblem, the triangular canopy formed by light from the eye may symbolize the Holy Trinity, but it may also symbolize the triangular headrest of the chair of Freemason's Worshipful Master.

Quoting from the society's records, Leeson writes that there was then a 'considerable amount of extra communication in submitting to the artist the usages of the trade in various departments, tools used and the form of attitude of figures when working'.[68] This is extremely interesting information and reveals the degree of input and control that this particular union exercised over their emblem. The key to the emblem claims, with great pride, that this is 'the most elaborate and artistic device yet executed by the artist for the purpose of a Trade Emblem'.

Waudby had been instructed to represent the building of Solomon's Temple in the central panel, and he took his inspiration from *The Building of Solomon's Temple* by Raphael, part of the frescoes for the Loggia at the Vatican, which depicts the building of Solomon's Temple in its higher central panel. The architect, Hiram Abif, is portrayed in the act of showing his plans to King Solomon, whilst building work goes on around. Two tablets above Waudby's image read,

And the king commanded and they brought great stones, costly stones, and hewn stones, to lay the foundation of the house.
 And Solomon's builders did hew them and the stone squarers; so they prepared timber and stones to build the house. (1 Kings, c.V, v.17–18)

Waudby simplifies Raphael's fresco, for example he leaves out buildings in the background at the top left, two stonemasons and a carpenter who is central to the image. But, most tellingly, Waudby depicts only three figures behind Solomon rather than Raphael's four, a major adaptation that would indicate he was wishing to represent the three murderers of Hiram Abif according to Masonic legend. Hiram Abif, the 'son of the widow' from the tribe of Naphtali, the architect of Solomon's Temple, was killed by three of his fellows with the plumb, the level and the heavy maul because he would not reveal the secrets of the centre, a legend around which the ritual leading to the grade of Master is enacted, and taught in all the rites.[69] Waudby's vignette is flanked on either side by two columns, indicative of Boaz and Jachin, the two pillars of the porch of Solomon's Temple, which stand for *Sagresse* and *Forte* (Wisdom and Strength). 'Boaz' and 'Jachin' are also passwords in the Masonic Initiation Ceremony.[70] Boaz was the great-grandfather of King David and is a name connected with strength, and Jachin was David's high priest of Jerusalem and is a name connected with stability.[71]

Hulme Lodge objected to Waudby's vignette of the building of Solomon's Temple, and wanted it removed because

> it is not according to scriptural writ. We read there was not the sound of a hammer or axe nor any tool of iron head in the house while it was building and according to some authors the stone was prepared at the quarries and fitted together and then it was taken to the temple and fixed.[72]

Their objections were overruled, and the panel stayed. Ware Lodge wanted a widow and orphan inserted into the emblem and the mason's pick removed because modern masons disliked using it. Liverpool wanted a trowel inserted. Both lodges got their wishes.[73] The widow's benefit that Ware Lodge requested was added, together with an accident at work scene to balance it, as roundels at the top corners, copied by Waudby from his Carpenters and Joiners emblem, whilst the trowel that Liverpool requested was inserted in a central position at the base of the edifice. The trowel is an important Freemasonry tool – to spread the cement of brotherly love and affection, the cement that unites them into one sacred band or society of brothers.

The tiled floor of the temple front is in decorative stone, black and white, as in a Masonic lodge where it signifies light and shadow or the joy and sorrow of man's chequered existence. The two pilasters at the bottom level are incised and topped with Corinthian capitals (the pillar of the Junior Warden in Freemasonry) and are supported at their bases by scrolling decorated consoles with reversed volutes. Each side, the lower arches in which stand Temperance with her jug and ewers and Fortitude with helmet and shield are heavily rusticated with sunken joints between the stones, carved faces in the keystone voussoirs and triglyphs in the frieze above. Rustication was used in the base of facades of Renaissance buildings to imply strength and power, and to give character and interest to the stonework, which was sometimes even tooled for maximum effect (Serlio discusses it particularly in association with the Tuscan order). The arched niches, with their surrounding rustication, are flanked by heavily decorated Doric pilasters (the pillar of the Senior Warden in Freemasonry). The arched recesses each side at the level above contain Justice and Truth, and have incised pilasters three quarters of the way up, from which spring an arched top with a carved face in the centre. On each side of the four recessed arches there are pilasters and the whole centre section of the screen projects forward (as evidenced by heavy shading to the right) to emphasize its importance. This centre section is topped by a broken pediment backed by a balustrade crested with urns.

On each side of the broken pediment is a seated figure. Prudence, on the left, points to her own sealed lips 'to indicate silence and reserve' and holds her bridle 'with which Prudence restrains profuse or needless expenditure'. Industry is at the right with the distaff of Athena in her hand and the hive of industry at her feet. The figure of Architecture is in the centre at the very top because architecture is 'the art with which the Mason's craft is identified'. She is seated at her drawing board beside a single Corinthian column, the Masonic symbol of Beauty, flanked on the left by a bust

of Minerva/Athena, goddess of craft and wisdom, copied from Waudby's Carpenters and Joiners emblem, and on the right by the Freemason and 'the most distinguished of British architects', Christopher Wren, taken from Waudby's Operative Bricklayers emblem.

Beneath Architecture are the ancient Masonic guild arms of the union, the most highly coloured part of the emblem, illustrating the compass or measuring device within a set square and depictions of the three orders of architecture, Doric, Ionic and Corinthian. This emblem reproduces the elements of the First Degree tracing board of Freemasonry, in which the points of the compass are symbolic of the greater world outside and are marked around the outer edges of the tracing board. The three pillars, Wisdom, Strength and Beauty, represent approaches to the understanding of the hidden order of the world, but also to Solomon, who in his wisdom built the Temple; Hiram (King of Tyre) who acted as what we would today call his civil engineer, and who provided both men and materials; and Hiram Abif, for his skill in decorating the Temple. Three is also the number of blessings that Solomon gave at the sanctifying of the Temple in Jerusalem.[74]

Central to the image, in large capitals carved into the stone beneath a moulded stringcourse, and appearing to be infilled with black lead, are the words 'IN ALL LABOUR THERE IS PROFIT', from Proverbs 14:23. This is not simply a message to the membership eulogizing the work ethic, but it also transmits a reassuring communication to employers and to the middle and upper classes that their capitalistic system is to the benefit of all.

Beneath the vignette entitled 'The Building of Solomons Temple' and in contrast to the classical architecture of the Temple, is a larger scene depicting the construction of a Gothic church that the key describes as 'a Parish Church in the fourteenth-century style of decorated work'. Because it is larger than the scene above in which the founding of the Masonic craft is depicted, it must be of even greater importance. To the left is the masons' lodge, whilst a figure at the right of it, working with a level, is disproportionally large. Central to the image is a figure of a mason at work. From his size and prominence, we know that he must be a very important figure in this emblem. Behind him is a 'lewis', a metal tool dovetailed into a stone that clasps and grips the stone and allows the mason to lift large masses with relative ease, and which signifies strength (immediately below this vignette is the motto 'Union is Strength').[75] The term 'lewis' (a corruption of *Eleusis* and of other Greek and Latin words associated with 'light') also means the son or daughter of a Mason, and indicates an hereditary duty. This is explained in part A.2.9 in the Ceremony of Initiation.[76] The mason working in front of the lifting device, almost a part of it, would therefore be such a 'lewis'. These two central scenes illustrate firstly the origins of the masonic craft in biblical times and then its continuation through many generations of British craftsmen. Postgate notes that by the 1890s 'the masons retained their system of apprenticeship, on the whole, though the decline of the craft meant in effect that few apprentices were entered or accepted who were not sons of working masons. Hence masonry for a time seemed to be becoming a hereditary craft.'[77]

As in the certificate of the Amalgamated Society of Carpenters and Joiners (Plate 2), Waudby inserts portraits of union officials flanking the arch. On the left is a portrait of Richard Harnott, Secretary of the Union, with inkwell, pens, minute books, ledgers and papers, pointing to where his signature will appear on the certificate, and on the right, Thomas Connelly, President of the Union, with a ruler beside him (to indicate that he 'rules') and symbolic tools at his feet. Harnott served as General Secretary from 1847 until his death in 1872 and is credited with having been the leading force in the union. A triangle is formed by taking an invisible line from the head of the 'Lewis' to the head of Connelly, across to Harnott and back to the 'Lewis', and a larger triangle is formed in the same way from the head of Solomon, demonstrating the connection between these present day heirs to the working tradition originating with Solomon. An even larger triangle connects the two officials with the figure of Architecture, and to the eye of God, the Great Architect of the Universe.

In 1872, after the sale of the first 3,000 emblems, the Hulme branch demanded that further orders be suspended because Richard Harnott had died in February of that year, and Connolly had been in America, his membership had lapsed, and therefore was no longer a union member. Some lodges demanded that both figures be removed; some even covered figures on the emblem with blank paper, whilst other lodges argued that to remove Harnott would be an insult to his memory. Connolly returned, paid his dues, and once again became a fully paid-up member, and after a vote, the emblem remained in its original form.[78]

The Manchester *Times* noted that Harnott 'was as well known in trade circles as Mr. Gladstone is in the political world' and that he had received presentations from as far away as Australia. Certainly the union *Returns* of December 1860 show that he had received a gold ring with a value of £10. Five hundred delegates of various trades followed his coffin on foot to his grave in Salford cemetery. Leading the procession was a band playing 'The Dead March' from *Saul*. There was great competition amongst his fellow stonemasons for the carving of his headstone, and he was so well loved that members eventually decided not to remove his signature from the certificate and retained his portrait on the emblem throughout the life of the union.[79] However, their devotion did not apparently extend to giving his widow £50 to keep her from the workhouse.

At the base of the certificate, on the black and white tiles, like those of the lodge, are the tools of the mason and the Freemason. For Freemasons, the gauge represents the 24 hours of the day, part of which is to be spent in prayer, part in labour and refreshment and part to serve a friend or brother in need. The gavel represents the force of conscience and the chisel points the Freemason to the advantages of education by which means the mind may become cultivated.[80] At the bottom left are books, possibly indicating the Volume of Sacred Law (i.e. the Bible) that supports Jacob's Ladder in the Freemasonry lodge. The newly elected mason's name on the foundation stone not only marks his entry into the friendly society, but also represents his duty to build, on his admittance to the craft, an honourable and perfect 'superstructure', 'great temple' or good life that will survive his physical death.[81]

Most striking in this emblem are the two different types of 'reality' that are presented. There are the two contemporary portraits of Harnott and Connelly who sit in front of an apparently solid piece of architecture, whilst the two central vignettes are quite obviously different. They transcend time, occupying quite literally an 'inner' place, a place of secrets and contemplation, surrounded and protected by the great stone edifice. The new information any artist can give the spectator is limited because he must employ symbols and figures his spectators already recognize and understand. Painting cannot teach what the viewer does not already know.[82] This may be why, in the classicized images of Waudby, personifications are labelled, but the secrets of the lodge are obvious to initiates, not to the casual spectator.

Gwyn A. Williams, in his introduction to Gorman's *Banner Bright*, writes 'what these men were creating was a cathedral [...]. On those banners union men raised cathedrals to labour', but he is, of course, incorrect.[83] What they were raising was a classical temple, and more specifically in many cases, a Masonic temple. Waudby could very well have used the Gothic form of the rood screen separating nave from choir for his edifices, which would have been very suitable for the purpose. Architects such as Augustus Welby Pugin and Sir Gilbert Scott had declared the Gothic to reflect true British heritage. The style was employed in the design of new Catholic churches, as well as established Anglican churches with their special status protected by political and economic privileges. In addition, many medieval churches were 'restored' in a manifestation of 'historicism'. Nonconformist churches declared their difference, their 'otherness' by using neoclassical forms. The neoclassical form of buildings such as Scott's new government offices in Whitehall of the mid-1850s and Barry's Halifax Town Hall of 1862 served to identify politics with their perceptions of democracy in the ancient world. Both in trade union and in Labour Party histories, Nonconformists (especially Methodists and, in the case of the Durham Miners, Primitive Methodists) were predominant. In fact, a national survey in March 1851 revealed that only 20 per cent of the people of England and Wales had gone to an Anglican service that Sunday and almost 30 per cent to other denominations. Nonconformists were forced to pay church rates towards the maintenance of the Anglican Church yet were denied burial in Anglican churchyards. So divisions between Anglicans and Nonconformists were not merely religious but also political which is why the Gothic, cathedral form of the established church of the upper class establishment is mostly eschewed by the unions in the edifices in their emblems.

Arthur Waudby's three magnificent emblems for the Bricklayers, the Carpenters and Joiners, and the Stone Masons are filled with Freemasonry symbolism. He is believed to have died in 1872, not long after completing the Hearts of Oak emblem, and there were no more to follow that we know of at present. His Bricklayers, Carpenters and Joiners, and Stone Masons emblems were designed for traditionally peripatetic trades that employed the tramping system wherein skilled men had to travel from town to town to find building work. In order to produce evidence of the level of their skills, various passwords and recognition signs, handshakes and gestures, needed to be employed, and these became part of the ritual of their lodges, reproduced in the emblems that

Waudby designed for them. In addition, the members of many of these trade lodges were also in Freemasonry lodges.

The instructions given to him by the unions regarding the design and content of their emblems must have been immensely precise and detailed because no evidence can be found at Freemasons' Hall in London that Waudby himself was ever a Freemason.[84]

Chapter 7

MEN, MYTHS AND MACHINES

Annie Ravenhill-Johnson

It has been argued that, in order to define itself and give its members a sense of their place, any political movement employs a cultural framework or a 'master fiction', the centre of which has sacred status.[1] This is certainly true of the iconography of Freemasonry, which we noted in the preceding chapter in the emblems designed by Arthur John Waudby. The capitalist system, with its new technology – resisted so violently during the years of the Rebecca Riots and the smashing of modern machinery – had disrupted the old patterns of working, and workers were left with little choice other than to reluctantly adapt to the new industrial world in which they found themselves. Thus it may be argued that a cultural framework or 'master fiction' had to be found in which to bond with fellow workers and share the experience of labouring under a repressive and exploitative capitalistic system. This chapter will look at how trade union emblems depict this 'master fiction' or 'sacred centre', its importance, and how its subject changes over time.

R. W. Postgate, in *The Builders' History*, writes:

> For thousands of years the crafts of plasterwork, carpentry, masonry, bricklaying and tiling have been handed down from father to son and the history of the trade is written all over the world, not in pen and ink, but in brick and stone and wood. [...] Carpenters, masons and bricklayers have expressed the ideals and civilization of their age as much as and as well as writers, soldiers and statesmen.[2]

The desire to depict the origins of their trade in order to imply great age, long traditions, continuity and stability underpins the 'master fiction' of many nineteenth- and twentieth-century emblems. The 'sacred centre' is achieved by the harking back to classical mythology, to biblical mentions of the trade, and to the patron saint of the guild and trade. Some emblems, as we have seen, even resemble altarpieces. The 'sacred centre' is also expressed through portraits of famous men, especially those who have brought improvements to the trade (the portrait of James Watt, for example, appears in many) and their heirs, the present day workers and leaders of the union,

portrayed up high amongst gods and virtues. And it is also referred to in vignettes of past times, old machines, old ways of working, juxtaposed against the most modern and up-to-date technology in great industrial complexes – an old testament versus a new testament, a 'gospel' of work. Slowly, this trend diminishes, and in its place the machines themselves come to feature more and more prominently as, with the division of labour, the workers become more and more subservient to them.

Sharples's 1852 certificate of the Amalgamated Society of Engineers (Plate 45) employs this 'master fiction' of a 'sacred centre' by placing the worker on high amongst Mars, Nike or Fame, a Muse and the dove of the Holy Spirit, together with Arkwright, Crompton and Watt, fathers of the industry. New methods of working and transportation are juxtaposed against the phoenix of rebirth and regeneration. Similarly, in Waudby's Friendly Society of Stone Masons emblem of 1868 (Plate 10), Freemasonry provides the 'master fiction' and 'sacred centre' around which to build the emblem. In it, the stonemasons of Solomon's Temple and the master masons of the fourteenth century coexist with modern masons and modern working methods and tools. Personifications of virtues abound, under the eye of God. Working practices are often shown in scenes too small for the viewer to really see and understand what is going on, or are sanitized and idealized. This 'cultural framework' is a formula reproduced in emblem after emblem.

In his *History of the United Pattern Makers' Association*, Walter Mosses writes:

> It would be exceedingly congenial to the writer, as well as giving a fine flavour of antiquity to his labours, if we could claim a direct and unbroken genealogical descent from the founder of the metal trades – Tubal Cain – but the biblical references are somewhat uncertain and much too vague to justify a claim that this grand old master craftsman numbered our trade amongst those he founded, practised, and taught, so we must perforce allow our friends the blacksmiths to claim a monopoly of the first and greatest industrial figure in history.[3]

The very fact that Mosses begins his history in such a negative way by expressing his regret that he is unable to claim descent from Tubal Cain for his union reveals just how important it was to be able to establish a 'sacred centre' for the trade. Tubal Cain is mentioned in Genesis 4:19–22 as one of the descendants of Cain, only seven generations from Adam:

> And Zillah, she also bare Tubal-cain, an instructor of every artificer in brass and iron.

Tubal Cain is a password in German Freemasonry for the First Degree, due to his involvement with the building of Solomon's Temple, when three workers attempted to stop the founding of the two pillars, Jachin and Boaz, and he halted their act of sabotage.

A bust of Tubal Cain, patron of the union, is at the very top of a magnificently detailed frame in decorative ironwork in the certificate of the Associated Ironmoulders

of Scotland by Johnstones of Edinburgh, from the 1880s (Plate 43). The name of Tubal Cain derives from two Hebrew words: *yabal* (to flow, to bring forth, to carry and lead) and *quwn* (to strike a musical note, to lament, to chant or wail at a funeral). Thus he gives his name to the *tuba terribilis*, the trumpet of the Last Judgement. By the fourteenth century, Vulcan was being identified with Tubal Cain in *Ovide Moralisé*.[4] And because in art the two entities have such similar iconography, it is sometimes difficult to differentiate them. For example, an illustration, 'The Children of Lamech' from the *Speculum Humanae Salvationis* (1471), depicts a Tubal Cain in the manner of a Vulcan, in the act of making music by singing to the rhythm of hammering at an anvil. Music is portrayed as a product of work, played on an anvil, paralleling the work of the forge. Homer, to whom the canonical epics of the *Iliad* and *Odyssey* were attributed, has a name (*Homeros*) that suggests a meeting or joining, but a more powerful conceptualization of the craftsman musician who fastens or fits songs together can be found in Pindar's third *Pythian Ode*: 'We know of Nestor, and of Lycian Sarpêdòn, whose names are on the lips of men, thanks to those lays of sounding song, such as wise builders framed for them.'[5]

On the right of the topmost zone of the first pier of the west front of Orvieto Cathedral, early fourteenth century, is a seated figure of Tubal Cain using two hammers to make music. Prominent is a wheeled mechanism by means of which the bells revolve, thus conflating the arts of metalworking, invention and music. And in the depictions by Andrea Pisano and others on Giotto's campanile of Florence Cathedral, circa 1330–1350, Tubal Cain is placed under a depiction of Mercury, god of commerce, more smith than musician, as much Vulcan as biblical figure. The presence of Tubal Cain on the cathedrals of Florence and of Orvieto celebrates the masons who built these magnificent edifices – the ringing of their hammers was the first music to echo through their great naves and choirs. And in this emblem of the Associated Ironmoulders of Scotland the four circular medallions in the main centre section contain depictions of foundry work in which the sound of the ringing of the tools on metal and the noise of the machinery is to be imagined.

Beneath Tubal Cain, flanking a vignette of the widow receiving benefit, are two modern workers of the trade whose facial features indicate their familial links with him. A winged god of love ('Amity') binds together personifications of Truth and Justice, whilst to each side are the mottoes 'Wisdom is Power' and 'Union is Strength'. Tubal Cain presides over representations of modern working practices, blast furnaces and transportation, as well as further benefits offered by the union ('The Accident' and 'Superannuation' in small ovals within the certification plaque).

The certificate of the Associated Society of Locomotive Engineers and Firemen (Plate 25), designed and engraved by Goodall & Suddick of Leeds, 1916, is that of a later union. In the accompanying key to the emblem, the union actually states that its aim is to show in the emblem the history of locomotion 'from its earliest stage', and to honour the men who were responsible for its development:

The pictorial representations upon the certificate are designed to tell the story of the development of the means of locomotion, with which the Society is so

intimately connected, from its earliest stage to its present advanced position. Honour is fitly given to the two men whose genius so largely contributed to this development. On the left is shown a portrait of James Watt, a mechanician, who by his improvements upon the invention of Thomas Newcomen, a Dartmouth locksmith (the first user of steam as a motive power) so regulated the action of the Steam Engine as to make it capable of being applied to the finest, and most delicate manufactures, and whose son, James Watt, made, in 1817, the engines of the first steam vessel which sailed from an English port. On the right, appropriately appears a portrait of George Stephenson, the self-educated colliery fireman, who by his powerful genius became the founder of the great school of railway engineering.

This new union, of course, lacked the old guild traditions and had no patron saint, but it makes up for this by instead co-opting appropriate Roman gods. Vulcan, one of the 12 great Olympian gods, god of fire, metalworking and magical manufactures, is at the right at his forge (according to the key he is 'more usefully employed in forging couple-chains than thunderbolts'). To the left is Hercules, deified after his death in flame, a hero of superhuman courage and strength, famed for his arduous labours, with the great Nemean Lion that he choked to death with his bare hands (described in the key as 'couchant in subjection to him'). Rather than patron saints, this union displays its 'patron gods'. The inclusion of Hercules is interesting. 'The Philanthropic Hercules',[6] was an attempt at organising a general union launched in 1819 by John Gast, a worker in the Deptford shipyards in London and also a dissenting preacher, but by 1916 this movement would have been virtually forgotten. However, Hercules had been chosen in 1793 as the emblem on the seal of the French Republic, designed by the official engraver, Dupré, and as the representative of the French people in a 46-foot high statue by David. Neither ever came to fruition, although silver coins bearing the image of Hercules were minted.[7]

The Scottish-born James Watt is pictured at the top left in a roundel surrounded by a garland of Scottish thistles, whilst the English-born Stephenson is at the top right in a garland of English roses. These roundels are echoed at the bottom of the certificate by the hive of industry ('Industry and Reward') set in a garland of Irish shamrocks, and two doves perched on a book ('Knowledge and Peace') in a garland of Welsh daffodils.

Central to the image is a large roundel with the title 'Brothers in Unity for Mutual Help', featuring the fraternal handshake between a driver and fireman on the footplate of the Manchester, Sheffield and Lincolnshire Railway Company's engine number 431. The fraternal handshake often appears at the bottom of an emblem, as in the Operative Bricklayers' banner (Plate 37), but here instead this joining in brotherhood is expressed by the depiction of couplings at the bottom of the emblem, a delightful allegory. To the left of the central roundel is a factory and to the right of it a four-funnelled ocean liner, possibly the red-funnelled Cunard *Mauretania*, built by Swan, Hunter, Wigham and Richardson, launched 20 September 1906 and holder of the Blue

Riband for the fastest transatlantic crossing for 22 years from 1907. Above the central roundel is George Stephenson's 'Rocket', winner of the £500 prize for a locomotive engine for the Manchester and Liverpool Railway, 'now a national monument in the South Kensington Museum'. The key goes on to say,

> This rude engine is brought into strong contrast with the wonderfully developed engines now in use, which are represented by a Great Northern Express, an express passenger train on the London, Brighton, and South Coast Railway, and a Great Northern Piccadilly and Brompton Electric Tube Train.

Finally, the key, in grandiose style, gravely reminds the member of his own importance and his moral duty:

> The possessor of this Certificate is therefore reminded by it of the important part which he, as a member of the 'Associated Society of Locomotive Engineers and Firemen' individually plays in the vast chain of intercourse between man and man the wide world over, and upon which all progress in Art, Science and Literature, and the diffusion of the advantages of civilization, largely depends; as well as in the multitudinous exchanges of commerce, the source of commercial prosperity and well-being of our nation, and lacking which, life itself in our communities could not be sustained.

So this certificate is an excellent example of the 'master fiction' and the 'sacred centre'. It features two 'patron gods', one of which, Vulcan, demonstrates the ancient origins of the trade in classical times, whilst the other, Hercules, is referred to in the key's admonition to the holder of the certificate that he is a part of the philanthropic 'diffusion of the advantages of civilization'. It pictures portraits of the famous men who have brought improvements to the trade and also their modern heirs, the driver and firemen, and finally it shows the earliest locomotive engine and its most modern descendants. Ships and engines are always referred to in terms of the feminine and in their sleek, bodily appeal they are the new 'goddesses' of the age. Despite this, however, embodiments of Justice, Agriculture and Commerce are on the edges of the highest levels. It seems as though the modern world is reluctant to part with these old favourites – as if no emblem is truly complete without them.

In the early days of rail travel, the train was a dangerous mode of transport. Tunnel collisions were the most feared form of rail accident due to the risk of fire in the tunnel. The Claydon Tunnel disaster of 1861 occurred near Brighton when two trains collided in a tunnel due to signalling error and trains travelling too close to each other. Twenty-three people died and one hundred and seventy-six were injured. There were many such 'smashes', Dickens himself being in an accident at Staplehurst in Kent in 1869 when a train was derailed, and where he gave assistance to the injured and the dying. By that time the train was capable of speeds of 60 miles an hour; there were more trains on the tracks, yet there were no safety regulations and as a result, many collisions.

In *Dombey & Son*, published in monthly instalments from 1846 onwards, he criticizes the railways for the destruction of the countryside, and there is death by train in the novel whilst, in 'The Signal Man', published in the 1866 Christmas edition of the *All the Year Round* magazine, he writes of a signal man whose visits by a ghost precede rail tragedies, and who is finally killed by a train. Novels played on other fears such as sitting in railway carriages in close proximity to total strangers, the soot, smoke, steam and the inhuman shriek of the engines that carried people into the unknown. In Tolstoy's *Anna Karenina*, published in instalments between 1873 and 1877, she commits suicide by jumping in front of a moving train. The period between 1860 and 1880 saw the worst of the rail disasters and by the end of the nineteenth century rail travel was no longer perceived as such a grave threat. Edward Thomas wrote *Adelstrop* on a glorious June day in 1914 when his train passed through the Gloucestershire countryside. By the time this emblem came into being in 1916, up to a third of the male workforce of the country was serving in the armed forces in the First World War, and ambulance carriages and hospital trains were in use.

One might perhaps expect the Typographical Association, in its certificate issued in 1879 (Plate 49) to hark back to Moses with the Ten Commandments engraved on a tablet of stone, but this is not the case. Their magnificent emblem was designed by Edward Henry Corbould (R.I. 1838).[8] A watercolour painter and book illustrator, Corbould had studied at Henry Sass's Academy and at the Royal Academy schools, and between the years of 1851 and 1872 was instructor to the royal family.[9] He exhibited with the Royal Institute of Painters in Watercolour between 1835 and 1880, specializing in figure painting, and won gold medals from the Society of Arts for a watercolour and a sculpture. In all, he exhibited a total of 293 paintings in the principal London exhibitions, including 17 in the Royal Academy.[10] In 1879, when this certificate was issued, he was living at Eldon Lodge, Victoria Road, London, aged 64.[11]

The certificate reproduced here (Plate 49), although signed and dated 1856, was first issued in 1879 after the name of the union was changed in 1877, when it dropped the word 'Provincial' from its title. In their *Half-Yearly Report of June 1879*, the Executive Council reported that the new emblem had been 'highly appreciated and met with a large scale'.[12] The particular certificate reproduced here must have been issued and signed in 1887, as that was the only year that Daniel Bird was President (the other signatory, Henry Slatter, was General Secretary from 1869 to 1897, retiring on a pension of £100 per annum). The certificate has been backdated to 1856, the year in which Charles Evans, the named member (number 1271), actually joined the union in March of that year, aged 39. Coincidentally, this was also the year that the President, Daniel Bird, joined. The backdating of certificates in this way appears to have been common amongst unions, when members wanted the newest certificate but still required that their original date of joining be shown, and as a result many certificates are today catalogued in collections as dating from much earlier than their true date.

At the top is a depiction of William Caxton. There are no known portraits of Caxton, but several imagined portraits exist, dating from the eighteenth and nineteenth

centuries. The likeness in this emblem is possibly copied from James Thomson's fictive portrait of Caxton published by Henry Fisher after Thomas Griffiths's stipple engraving, published in 1819. To the left of Caxton's image is a scene entitled 'Darkness & Superstition'. A seminaked pale-skinned woman clad in rough skins, a dark-skinned man and a dog cower in terror as lightning illuminates the night sky beyond a construction made of tall stones capped with lintels. It is not Stonehenge as Corbould would have known it, as the stones are straight and dressed, but it is perhaps his concept of how it might have looked when it was first constructed. It certainly refers to that period of history as, according to Slatter's description, the scene is of 'ancient Druids [...] crouching down in a loathsome den' and the dog is in the act of howling. To the right of Caxton's portrait is a scene entitled 'Enlightenment' and 'Glory to God', in which the mother of Alfred the Great, wearing a crown, holds an open book from which her son, kneeling on a cushion at her knee, is reading. According to Slatter, the book is the Bible, the legend attaching to this being that Alfred was to be given the manuscript once he had learned to read it. Above the portrait of Caxton are the words 'And GOD saide let lyghte be, and anone lyghte was' (from Genesis 1:3). According to the previous two verses of the first chapter of Genesis, after the creation of heaven and earth, light was the next thing to be created, before the land was even divided from the waters. So Caxton is here being compared to God in bringing enlightenment to Britain. The light of learning and reason eliminates the darkness of religious superstition.

Beneath the 'portrait' of Caxton is an engraved tablet standing on a book with locks entitled 'The Worde of God' and beneath that is 'Advancement' and 'Civilization' with Caxton's colophon (a printer's logotype or mark) inset into a blue shield between the two. The engraved tablet reads,

> O Albion still thy gratitude confess
> To Caxton founder of the British Press:
> Since first thy mountains rose or rivers flowed
> Who on this isle so rich a boon bestowed?
> Yet stands the chapel in yond Gothic shrine
> Where wrought the father of our English line;
> Our art was hailed from kingdoms far abroad
> And cherished in the hallowed house of God,
> From which we know the homage it received,
> And how our sires its heavenly birth believed.
> Each Printer hence, howe're unblest his walls,
> E'en to this day, his house a Chapel calls.

Interestingly, in this engraved tablet, Slatter, in his history of the union, interprets the second line as reading 'To Caxton, founder of ye British press'. [13] In actual fact, Corbould uses the 'thorn' here and the word is not 'ye' but 'the'. 'Ye', in this context, was never an English word, and was created by Caxton when, printing in English

in Bruges, there were not enough printing blocks of the Anglo-Saxon 'thorn' letter representing the 'th' sound, so he used the 'y' instead, the nearest approximation.[14]

Reference is made to a 'chapel in yond Gothic shrine' and states that a printer 'E'en to this day, his house a Chapel calls'. These lines refer to Caxton's first printing press, which was set up under the patronage of Abbot Tomas Milling either in Westminster Abbey's almonry or in a small chapel near the abbey. He began printing in 1473, continuing until his death in 1491. In the collection of Brasenose College Library, Oxford, is a card printed by Caxton: 'Come to Westmonester into the Almonestrye, at the Reed Pale' (the house in which he lived in Little Dean Street, demolished in 1845). To this day, printing offices are referred to as 'chapels' and their staff as 'chapelonians'.

In the top right and left corners of the emblem are further fictive portraits of Caxton's predecessor in printing, Johann Gutenberg, and Caxton's apprentice and successor, Wynkyn de Worde, in medallions set into spandrels, with their names on scrolls threaded through raised strapwork of the kind used by Tudor printers to decorate borders or title cartouches, and similar to that illustrated by Owen Jones (joint architect of the Great Exhibition) in the Elizabethan section of his book *The Grammar of Ornament* (1856). Caxton is lauded as successor to Johann Gutenberg, having given the most beneficial gift to Britain in its entire history. Wynkyn de Worde (a.k.a. Jan van Wynkyn or Wynkyn of Woerth, Alsace) was brought to England by Caxton as his apprentice, and he improved Caxton's print quality. After Caxton's death, he introduced less-expensive books for a larger market, and became the first printer to set up in Fleet Street.

Caxton appears in a further large, black-framed roundel, flanked on each side by climbing English roses. Entitled 'Caxton examining proof sheets', he is portrayed with his assistants crowding around him, and the great screw thread of the press is in the background. He is seated in an elaborately carved throne-like chair, and his right foot is resting upon an English lion, whose mirror image is at the other side of the roundel. Looking over his shoulder is a compositor holding a frame of moveable print. Beside his chair are his books – great, heavy, leather-clad books bound with wooden boards and closed with hinged metal clasps. The image itself is copied from a painting by E. H. Wetomert of Caxton reading his first proof sheet, but it has been drastically cropped, and Wetomert's abbey background has been omitted. The three figures to the right, the hand of the nearest upon proof sheets, the ornate chair, the large book at its base and the apprentice to Caxton's left are all fairly faithfully reproduced. The figure at the rear holding a printer's block is actually taken from the far left of Wetomert's painting. And in Wetomert, Caxton's foot rests not on a lion but on a block.

In the centre section of the emblem, to the left and right of a great book entitled 'The Worde of God',[15] are two small scenes where the book is used to educate. That on the left is entitled 'The Village School', in which children read books and write on slates whilst the dame, or school mistress, turns from her high-backed chair at her spinning wheel to give instruction. (Interestingly, in an 1887 oil by Frederick Cotman, *The Dame School*, there is also a spinning wheel in the schoolroom, but it is not in use, as it is here.) Behind her,

an unfortunate pupil wears a dunce's conical cap. The scene on the right, entitled 'The People's Bible', shows a church interior with a Gothic arched doorway and a chained Bible on a lectern being read by a layman, whilst a mother and her three children (perhaps his own family) stand respectfully behind him. This vignette may refer to Caxton's 'chapel' at Westminster, although of course he did not print a Bible in English. The first New Testament in English (burned by the Catholic Church because they perceived it as a threat to their authority) was printed by Tyndale in 1526, some thirty-five years after the death of Caxton. Coverdale printed the first complete Bible in English in 1535.

To the left, at the lower level, is the 'Compositors Room' in which men are setting type, and modern and up-to-date printing methods are depicted, whilst to the right in 'Machine Printing' a vast industrial complex is shown (according to Slatter, the machine room of the *Bradford Observer*) with a huge mechanized printing machine in an iron-framed building with several floors, in which men are dwarfed by the machine they tend. In contrast to the modern printing processes is the member's certification, which is printed on a curling scroll.

The whole emblem is a masterpiece of chiaroscuro, colour and Gothic script, with narrative in fine detail showing the printed word as instrumental in bringing mankind out of darkness, superstition and fear of the power of electricity (top left) and into the modern, brightly lit mechanized world of printing, in which the natural elements are mastered to man's enlightenment and advancement (bottom right). The scenes at the top left and bottom right rhyme like poetry – the primitive stone structure, with uprights and cross members, is echoed in the several stories of metal framing whilst the great roll of paper feeding into the printing press echoes the curve of the kneeling woman. Similarly, the scene (top right) of Alfred the Great reading a manuscript finds echo in the compositor bringing a board of type for checking.

Caxton's fictive portrait from this certificate is reproduced in the 1894 certificate of the London Society of Compositors by Alexander Gow (Plate 15). Together with a fictive portrait of Gutenberg (which also bears marked similarities to that in the earlier certificate), they appear in ornate frames suspended by cords embellished with strapwork bows between the heavily incised columns on either side of the structure. Like all the other ornamentation in the certificate, they are also heavily influenced by Owen Jones's pattern book.[16] Roundels on each side at the top read 'Knowledge is Power' (Bacon's 'Nam et ipsa scientia potestas est' – Knowledge itself is power – from *Religious Meditations, Of Heresies*) and 'Let there be Light' (Genesis 1:3), a nod to the earlier certificate. Between is a depiction of Caxton displaying to Edward IV his first specimen of printing, a scene taken from the painting of 1851 by Daniel Maclise. It is a very poor reproduction, only bearing a fleeting resemblance to Maclise's excellent and detailed painting, and certainly not one of Gow's finest pieces of work. The central scene, together with two ovals at the bottom corners, focuses on the new headquarters at St Bride's, with the emblem incorporating the Stationers' Guild's coat of arms beneath.[17] The motto reads 'Verbum Domini manet in Eternum' (The Word of God Endures for Ever), which was the motto of the Reformation and derives from 1 Peter 1:24–2.[18] In 1522, Frederick the Wise had this motto sewn onto the right sleeve of the official clothing of his courtiers

and servants. It became the official motto of the Schmalkaldic League and was used by the Lutherans on their banners. Here it implies that the work of the compositors is part of God's plan and will similarly endure. Compositors at work are depicted in the central image ('Re-established 1848'), whilst at the bottom left are 'New Premises', and, to the right, 'Old Premises'. Gutenberg (the earliest printer) appears over the image of the Old Premises, whilst Caxton over that of the New Premises.

When the Typographical Association's certificate was reissued in the early twentieth century by Taylor, Garnett, Evans & Co. Ltd, Manchester Reddish and London, the two lower vignettes of the compositors' room and machine printing were replaced by updated vignettes showing what was by then more modern machinery and ways of working.

Late nineteenth-century emblems, rather than having 18__ printed on the certificate have just 1___ (or no indication of year at all) in order that, as the turn of the century arrives, the other digits of the year may be hand-written in. Such an emblem is that of the Brass Founders, Turners, Fitters, Finishers and Coppersmiths Association designed and printed by Blades, East & Blades, 23 Abchurch Lane, London (Plate 50), indicating that it comes from the final years of the nineteenth century, during the working period of George Rowland Blades, grandson of the founder, who joined Blades, East & Blades in 1886 at the age of 18, later becoming Chairman and, in 1905, President of the Institute of Printers. He was knighted, became a Member of Parliament, Lord Mayor of London, was created a baronet, First Baron Ebbisham and was known for his philanthropic work for Guy's Hospital, the Seamen's Mission, Barnardo's Homes, the Red Cross and other charitable organizations.[19]

In a stone-coloured base, flanked by a frame made of brass or copper decorated with oak leaves and standing in urns, are three 'rooms' in the manner of a narrative praedella at the base of an altarpiece. They depict a machine shop with lathes and belts, hot metal being poured into casts and a forge. Beneath, in the centre where the handshake is frequently placed, there is a drawing of valves and a tap, the pipe connecting them being the joining device of the 'handshake'. Above, two fine and manly members of the trade stand, with valves in their right hands, tools in their left hands and at their feet, flanking the block containing the certificate from the top corners of which two differently designed brass chandeliers are suspended. The man on the right is in a waistcoat whilst the one on the left can be identified by the 'heart and square' at his feet as a moulder. Their poses are classical, in the manner of the *Apollo Belvedere* and Ford Madox Brown's labourers in *Work* of 1852–65 (Plate 12). The two men have the rolled-up shirtsleeves of the manual worker. Around the waist of the moulder is either a strop for polishing and honing or a brace (attached to a harness under his shirt) to enable him to rest on it items – such as the heavy moulding boxes – to take the load from his back.[20] It may even be the right-hand side of his braces – in James Sharples's own posed photograph working as a smith, the right side of his braces hang down to allow him to swing his right arm without restriction.[21]

Three allegorical women are seated above, surmounted by a Nike, forming an equilateral triangle. Two brass or copper roundels containing images of an ocean liner and a steam engine respectively hang from the figured and embellished brass frame

that surrounds the scene, with deep red drapery swagged back and suspended at the very top by a brass or copper T-connector, which also holds a garland of shamrocks and supports a swag of roses and thistles.

In front of this garland, a red-haired Nike has just descended from higher realms, her brass and copper-coloured garments and coppery hair still billowing out. Her magnificent outspread wings curve in towards her upper back and then out again, like the wings of a great butterfly. Across her shoulders she holds a branch of palm, the oil of which was used to lubricate machinery and as a grease to protect metal objects left uncovered in the open air. Her right hand is held up in greeting (a boilermakers' recognition sign). With her flying draperies, she brings to mind the Nikes who adorned the prows of ships. Beneath her, the three allegorical women are reminiscent of the Three Graces and are, like her, in the languorous style and colouring of Burne-Jones and his followers. The woman in the centre is dressed in lavender, with a garland of oak leaves in her hair, a brass breastplate decorated with coins, and holding a heart-shaped shield bearing the inscription 'United to Support'. There is about her a rather unsettling likeness to the ruined girl in Rossetti's *Found* of 1853 due to the turn of her head and the flow of her skirt (here culminating in the union flag). If this is the case, the artist might perhaps have found a more suitable precedent to copy from, unless, of course, he intended to be deliberately subversive. On the other hand, the similarity may be purely accidental.

The young woman in turquoise to the right of the Nike has a garland of laurel in her brassy hair and she holds a small steam locomotive, the same colour as her hair, similar in design to the one in the roundel above her. Behind her is an industrial landscape with a rail network. The woman to the left is dressed in gold, and she holds a ship's telegraph, the hands of which point to 'full' and 'ahead'. Such a device would be used in the great ocean liner in the roundel above her and there is a maritime scene behind her. She has a moulded brass decoration in her hair. The horizons on each side join behind the group under a single sky.

In earlier trade union emblems, allegorical women represent an abstract concept such as justice, prudence or faith; they hold their traditional, identifying attributes and frequently their names are inscribed beneath them, but here the women are nameless. One must identify them from what they hold, the one on the left being Shipping or Navigation, the one on the right Engineering or Rail Transport. The central figure with oak leaves in a garland in her hair is holding the shield of unity and with the union flag in her skirts would be a figure representing National Brotherhood. She may even be a very modern Britannia, looking away, far out to sea, to her colonies.

In this emblem, the allegorical women and the Nike are used to great effect for colour, action and drama, and to highlight the gender difference of the manliness of the heroic men, but it is the products of the industry and their lineage that are foregrounded. The trade of boilermaker began once the steam engine was invented, and specialization within the trade developed early due to the many and varied processes and techniques that required new and special skills. The godlike men are holding up and displaying the finished product of their transmutation of matter, a

magical metamorphosis. This theme of metamorphosis is repeated in the praedella at the base where metals are heated, cast and finished. At the top, the magnificent butterfly wings of the Nike also evoke three stages of metamorphosis – the caterpillar, the chrysalis and the butterfly.

Typical of his work for the unions in the 1890s, the certificate of the Associated Blacksmiths' Society by Alexander Gow (Plate 51) employs one of his highly fanciful and decorative arches against a tiled background, with swags of laurel (attribute of the victorious hero) and oak leaves with acorns (metaphors for strength), containing images that somehow seem completely removed from the structure that contains them. Beneath an oval emblem suspended from the top of a semicircular 'fanlight' with ornamental grille are two half-moon shapes depicting scenes of the working lives of blacksmiths. To the left are the farrier and the smith shoeing a horse, whilst to the right horseshoes are being made. Beneath are two central images again showing the workings of the industrial forge, the lower one being a fairly faithful reproduction of James Sharples's oil painting, *The Forge*, 1844–47 (Plate 13) and his steel engraving of 1859. Two aproned blacksmiths stand, holding tools, at the base of the edifice.

The emblem is devoted to modern blacksmiths and their work. There are no classical references, no depictions of Vulcan at his forge or of Tubal Cain, just modern men and their working practices, apart from two small scenes of earlier village blacksmiths. Beneath these two small scenes are lines from *The Village Blacksmith* by Longfellow. The first of these, on the left, is part of the third verse, whilst that on the right is the conclusion of the poem in verse eight:

> Week in week out from morn till night
> You can hear his bellows blow.
> You can hear him swing his heavy sledge
> With measured beat and slow.
>
> Thus at the flaming forge of life
> Our fortunes must be wrought.
> Thus on its sounding anvil shaped
> Each burning deed and thought.[22]

These lines describe what was an essential trade, that of the village blacksmith, who was a hard-working and respected member of the community. As he carefully shapes and moulds his metal, so we must shape our lives and our actions with equal care to morality. This presents a moralizing, didactic message to the union member.

The certificate of the United Carters Association of England (Plate 52), an emblem from the 1890s by Sharp & Thompson, Colour Printers, 10 Watling Street, Manchester, has a classicized background with incised pilasters and Ionic capitals, and English roses, with classical lamps at the top. Two 'portrait' roundels of horses' heads are recessed into the pilaster bases with the certification details between, which curve in a scrolling arc over the handshake of brotherhood beneath. Three rectangular,

unframed, unembellished depictions of carters at work with differing types of cart in rural, city and industrial settings are inset behind and beneath a large roundel of a very fine horse being displayed in a landscape in the manner of a painting by Stubbs. The top pair is tucked behind the roundel but overlap the one beneath to give a three-dimensional quality to the emblem. A carter stands on each side, supporting the roundel with one hand. Personifications of virtues, mythological figures, cornucopiae and Latin quotations have been banished. Not even Pegasus is featured. There is simply the ubiquitous motto 'United We Stand, Divided We Fall' on a strapwork scroll in this quietly unpretentious certificate, which reflects the trade of transport by horse and nothing more.

Banners, unlike emblems, are meant to be viewed from afar and are designed to afford maximum impact on the viewer. A George Tutill banner, thought to date from the last decade of the nineteenth century, that of the St. Helens Sheet Glass Flatteners Trade Protection Society (Plate 44), is unusual in that there are no working men whatsoever depicted, nor are there any depictions of machines or of the workings of the trade. On the front, a naked Truth, whose pubic regions are only just covered with a twisting length of white cloth, gazes at her own reflection in her attribute, the mirror, which here also represents the products of this industry. Beside her to the left is Justice, with sword and scales and, to the right, Caritas or Charity with her babies. Kneeling below and supporting a banner that reads 'By industry we flourish united by truth and justice', are two of Charity's sister virtues, Faith and Hope, with a beehive of industry between them. Woman, under the guise of 'art', is portrayed in the dual stereotypical roles of the era as whore (as in Truth, in erotically flimsy covering that is just tantalizingly slipping away and with her hand raised to her hair, an action that raises and extends the breast – a favoured pose for glamour models) and in mother (as in Charity with her baby at her breast).

On the reverse, 'Defence Not Defiance', are male figures. Aesop (holding a scroll with the words 'United we Stand, Divided we Fall') is teaching his sons the moral – the elder cannot break the fasces, whilst the younger easily breaks the single stick. Without the scrolling tasselled ribbon on the front of the banner as identification, the viewer would have no idea at all which union it represents. The Aesop scene was a popular 'stock' scene that Tutill often replicated – it appears, for example, on the early twentieth-century banner of the National Union of Public Employees, East Ham Branch with a scene on the reverse of the widow and three children receiving alms from a union official with the letters NUPE on his bag. The worker, his factory and his working methods are entirely absent and there are simply the old personifications, the old 'sacred centre'.

The certificate of the United Machine Workers' Association by Blades, East & Blades, Designers and Printers of Emblems, 25 Abchurch Lane, London (1880s, Plate 16), is similar in that it does not portray a single worker. Instead, it depicts seven different types of machine, a Nike and personifications of Justice and Hope. Hope is enthroned above a pedestal that bears the lettering 'Milling Machine and General Machine Workers in the Engineering Trade', whilst, on the other side, Justice's pedestal displays the words 'Planers, Shapers, Borers, Slotters, Drillers'. Whilst these are the names of the workers of the machines, they are also the names of the machines themselves. In

cartouches usually reserved for portraits of union leaders are 'portraits' of machines. The machines, without exception, are clean, pristine and new, and they stand idle, bathed in a golden light. The Nike at the top stands on a cornucopia with the dove of peace and its olive branch above her. In her hands are the garlands of the victor, but she is awarding them not to the workers but to the machines on either side of her – the milling machine and the vertical drill. It is as though the worker himself has been replaced by the machine. And it is the large central image of the planing machine that is resting on the garland of laurel and oak leaves, symbols of victory and strength. How far the British working classes had come since the Luddite revolts and the wrecking of new machinery in the second decade of the century!

Marx and Engels, in the *Communist Manifesto* of 1848, concluded that the division of labour resulted in the loss of the individual character, both in mass-produced goods and in the workman himself, who became merely an appendage of the machine, his work reduced to dull and monotonous repetition. William Morris, too, believed that the division of labour resulted in the dehumanization of the worker and in the loss of craftsmanship. Certainly this certificate unwittingly reflects this – the certificate itself is dehumanized in that it lacks a single worker, the female figures being merely fictive. It is in itself a myth – an artificial, barren workplace of perfect, unused machines without materials to work on or workers to operate them. The machine is now the 'sacred centre', the 'god'. In any other context, this might be viewed as a critique of bourgeois culture, the alienation of the worker and supremacy of machines that were replacing trained craftsmen, but here it is simply demonstrating pride in the new technology of the age.

In this certificate (as was later to be expressed in Filippo Tomaso Marinetti's Futurism movement in Italy of 1909 and in the art of Percy Wyndham Lewis's Vorticism movement of 1914) the machine itself is glorified as the centre of production and virile male power – man's triumph of technology over nature. Yet even still, the female personifications are present.

Chapter 8

THE CLASSICAL WOMAN

Annie Ravenhill-Johnson

In the preceding chapter it was noted that the classical woman was an enduring feature of many trade union emblems. In trades dominated by the male worker, women appear on their emblems in the guise of young, slim, beautiful personifications and embodiments of virtues. This chapter explores the representation of women in union emblems, and in particular the role of the classical woman. Who is she, what is she and why is she there?

Many of the trade union emblems of the Victorian and Edwardian eras are populated with earnest, respectable, worthy tradesmen, the skilled and the unskilled, together with portraits of the heads of unions, officials and lodges. Yet, although women represented a large proportion of the workforce (a vast body of working women were employed as domestic servants without union representation), the working woman is far less frequently represented. Children, who also formed a large section of the workforce, usually appear merely as putti. Widows are represented fairly frequently, because they are the respectable wives of union men, not working women. Following the death of Prince Albert, when Queen Victoria became 'The Widow of Windsor', images of widows became patriotic.

Before the industrial revolution, records show that women earned less as day labourers than men for performing the same work. Women were considered to be inferior to men and their labour was therefore judged to be less valuable. These entrenched attitudes and traditions formed the basis of the pay structure in the textile industry in the early nineteenth century, and in other industries as they developed. For example, union records of 1829 show that certain masters in the Brushmakers' Union were employing women to do men's work at half the men's wages.[1] In 1838, only 23 per cent of textile workers were men but, because women were excluded from apprenticeships, men performed the skilled jobs.[2] Employers, however, especially favoured employing married or widowed women with dependent families as they were cheaper to hire and they caused less trouble, due to the fact that they were desperate for their wages. Skilled jobs for women were mainly in millinery and dressmaking.

Engels, in *The Condition of the Working Class in England* (1845), described the long hours and bad working conditions suffered by women, which made them vulnerable to bone

deformations, diseases, high miscarriage rates and difficult births. Fear of loss of wages or dismissal forced women to work until the last moment during pregnancy so it was not uncommon for babies to be born in the mills or factories amongst the machinery. Women would return to work two or three days after giving birth and rushed home during breaks to feed their babies. Most nutritional food was reserved for men, resulting in malnutrition of pregnant and nursing mothers and babies.[3] Not surprisingly, some 50 per cent of working-class children never reached their fifth birthday. Rather than lose their employment, women workers would endure brutality and seduction by men in the workplace. Until 1886, the age of consent, legislated by an all-male Parliament, was 13. Working women suffered unwanted pregnancies, alcoholism, and there was widespread prostitution due to their inability to earn sufficient wages to keep themselves and their families.[4] There were many suicides.

Not only did women share in the struggle between employees and employers for a living wage, shorter hours and improved working conditions, but they also had to fight for the recognition and support of their male colleagues who viewed them as second-class citizens. Male trade unionists adopted the dominant sexist ideology of the era that considered women as inferior beings, which in effect meant that the actual principles of trade unionism were at odds with their practice in relation to women workers.[5] Even the Fabian Sidney Webb, writing as late as 1891 on the 'Difference in Wages Paid to Men and Women', maintained that wage rates based upon gender were entirely justifiable. Women's average earnings were only 40 per cent of that of the average male, and he claimed that women were paid less not only because they (supposedly) produced less and because their work had a lower market value, but because women had a 'lower standard of life, both in physical needs and mental demands'.[6] As Sarah Boston comments, 'That Fabian writers like Webb put forward the employers' and men's case for the exploitation of women indicates how little support women had in their struggle for basic rights.'[7]

In fact, denying the right of women to earn a living wage was viewed as both reasonable and natural. The unions were institutionally biased against women in the workplace, believing the place of women was in the home, bearing and raising children. Middle-class women such as Elizabeth Gaskell also supported the patriarchal social structure and the dominant ideology of the day. Her novels set in Manchester (*Mary Barton*, 1848, and *North and South*, 1854) criticize the higher wages paid to young factory women as she was not in favour of encouraging their independence and certainly not at the cost of their household skills.

An act of 1844 restricted women's employment in textile factories to 12 hours a day, but employers evaded it with relay systems, making it impossible for inspectors to discover the actual hours the women worked. The 1850 Factory Act brought in a 10-hour working day for women textile workers, but not for outworkers toiling long hours in 'sweated' labour. They worked at home, usually in overcrowded, dark, dirty and disease-ridden conditions, with marriage and motherhood a second, unpaid job. As the century progressed, women came under more and more pressure to conform to the Victorian notion of separate spheres for men and women and to remain in

the home, which left the workplace to the very poorest and neediest of women. It is not, therefore, surprising that the working woman is excluded from so many trade union certificates and banners. Sarah Boston notes that even the historians of the trade union movement have largely ignored women workers and their struggles, thus further reinforcing women's concept of their own inferiority.[8]

Middle-class women, on the other hand, were put on a pedestal. Most education or work was denied to them in order that they might remain unsullied by contact with the outside world of men. The 'Angel in the House' is a role defined in Sarah Ellis's conduct manuals[9] and in Coventry Patmore's 1854 and 1862 poem of that name. It is a role set against that of the 'Fallen Woman', the woman who existed outside of celibate spinsterhood or legal marriage. Men, of course, were not categorized in this way, being considered the absolute human type, the essential as opposed to the 'Other'.

John Ruskin sets out the prevalent ideology of the time in relation to the role of woman, safe within the home, protected, child-like, and uncontaminated by contact with the world:

> But the woman's [...] intellect is not for invention or creation, but for sweet ordering, arrangement and decision. [...] Her great function is Praise: By her office, and place, she is protected from all danger and temptation. [...] Home – it is the place of Peace; the shelter, not only from all injury, but from all terror, doubt, and division. In so far as the anxieties of the outer life penetrate into it, and the inconsistently-minded, unknown, unloved, or hostile society of the outer world is allowed by either husband or wife to cross the threshold, it ceases to be home. [...] But do you not see that, to fulfil this, she must – as far as one can use such terms of a human creature – be incapable of error? [...] She must be enduringly, incorruptibly good; instinctively, infallibly wise.[10]

He also sets out clear and conservative opinions about a woman's education:

> A woman ought to know the same language, or science, only so far as may enable her to sympathise in her husband's pleasures, and in those of his best friends. [...] Keep the modern magazine and novel out of your girl's way.[11]

Change, however, was on the way, albeit slowly. In 1874, Mrs Emma Paterson (née Ann Smith) founded the Women's Protective and Provident League – a friendly society but with trade union leanings, financed by middle-class sympathizers and by fund raising, which paved the way to establish unions for women.

In the banner of the National Union of Mineworkers, Dawdon Lodge, Durham (Plate 53), woman occupies her familiar socially constructed role of 'The Angel in the House'. The circular 'medallion', dangling from painted ribbons, echoes the form of Michelangelo's *Taddei Tondo* (marble, 1504), adding a religious dimension to this image of mother and child and harking back, of course, to the Madonna and Child. Here, in a domestic space with a mosaic-tiled floor, a mother in classical garments is educating

her small son from one of many scrolls bearing invented 'ancient' hieroglyphs. Woman is in the home, performing the 'natural' duty of the middle-class wife. It is a 'stock' catalogue image also used on the Easington and Eden banners and also on Sunday school banners.[12] Here, the legend beneath reads 'Knowledge is Power', from Bacon's *Religious Meditations, Of Heresies*. The conspicuous absence in the image is that of the figure of the husband and father. In the context of mining this would indicate that he is outside the home, working, or even dead. Either way, it is clear that knowledge does not empower this woman – it is the son who will benefit from her knowledge and learning.

In 1844, Parliament required factory children to have six half days per week of free schooling and Gordon's Ragged Schools were set up to educate the children of the poor. Children rose at five in the morning to work in the factories, which of course meant that they were exhausted by the time that they attended school in the afternoon. William Foster's Elementary Education Act was introduced in 1870 providing a basic education for children aged 5 to 12. Sandon's Education Act followed in 1876, giving parents the responsibility for ensuring that their children attended school, and Mundella's Act of 1880 made education between the ages of five and ten compulsory. But it was not until 1891 that all education became free. The powerful message of this image, whatever its date, is that the only way out of the life of the miner, lived underground in darkness, heat and danger, is through education. Behind the boy is the door to a sunny outside world where he will exercise his knowledge and power whilst his mother remains within the home. The clothing in which she is wrapped and enclosed from head to foot is symbolic of the restrictions of her life. During the First World War, women were brought into teaching to fill the positions left vacant by men who had enlisted, but they had to fight for equal pay, something not universally achieved until after 1945.

Education on a par with the male, and the legal right to divorce her husband, were denied the Victorian woman. In 1857 the Matrimonial Causes Act allowed women to inherit and bequeath property, but not until 1882 did married women gain equal property rights with men. The Divorce Law Reform Association was formed in 1903, and in 1909 a royal commission was convened. Even though there were a few women on the commission, the King declared that it was 'not a subject upon which women's opinions can be conveniently expressed'.[13]

Working-class men did themselves no favours by refusing to demand equality for all workers, regardless of age and sex. Because an employer paid the working woman half the rate he paid a man for performing the same job, it was of course in the employer's interests to hire women, which meant that woman's cheaper labour was a threat to a man's own income. The working woman (and child) became the rival and enemy of the working man, and unions rigidly enforced their exclusion from membership in an effort to eliminate them from the workforce altogether. It is not surprising, therefore, to find that in many certificates and banners of the Victorian and Edwardian eras, woman is elevated out of the sphere of the working man's workplace and safely removed onto their pedestals into the realm of the gods, the realm of the

imagination. Work is portrayed as an adult male enterprise, the 'rightful' place of the male breadwinner.

In *The Communist Manifesto* (1848) Marx and Engels observe:

> The less the skill and exertion of strength implied in manual labour [...] the more is the labour of men superseded by that of women. [...] All family ties among the proletarians are torn asunder, and their children transformed into [...] instruments of labour'.[14]

The certificate of the Midland Miners' Federation designed by Alexander Gow in 1893 (Plate 54) has a heart-shaped bottom section, the arms of various Midlands towns and the Staffordshire knot. It depicts the patriotic symbols of the rose, acorns and oak leaves, portraits of five union officials and a depiction of their headquarters, 'Miners' Hall', in the central oval. 'Shakespere's House' is proudly depicted in the bottom roundel. The certificate is very balanced, with two 'cards' tucked at an angle behind the central oval containing the headquarters. They explain the motto ('United we Stand, Divided we Fall'), using the then current definitions of masculinity and femininity. The card on the right is 'masculine', i.e. orderly (*united*) with *standing*, phallic chimneys. The card on the left (or sinister) side is 'feminine', i.e. disordered, chaotic, *divided*. It depicts a scene where Sister Dora tends the *fallen*, injured in Walsall in the 1875 Birchills Ironworks explosion. A middle-class woman, she ran a hospital in Walsall, tending the dying when 'not even the doctors could stand the stench, agony and horror of nursing them'.[15] It is interesting that the Midland Miners' Federation chooses to honour a middle-class woman from outside their industry.

The *Report on Mines and Collieries* (1842) revealed that children as young as 4 were working underground in the mines.[16] R. H. Franks gave the evidence of Jane Moffatt from East Scotland who was only 12 years old. She worked 12-hour shifts in the pitch dark (nights on alternate weeks) pulling wagons of five hundredweight, crawling along tunnels only 24 to 30 inches high, harnessed, like an animal, to the wagon that she dragged behind her. She took bread with her to eat, but in the dark the rats often stole it from her. Betty Harris, aged 37, who was employed at Little Bolton, Lancashire, said:

> The road is very steep, and we have to hold by a rope; and when there is no rope, by anything we can catch hold of. [...] I have seen [the water] up to my thighs [...]. The belt and chain is worse when we are in the family way.[17]

The commission reported that many women worked naked to the waist (men often worked entirely naked). Some women told of being thrashed by the men they worked for – men of their own class.

Faced with such reports as the Sadler Committee on Child Labour (1833), and the report of the Children's Employment Commission on Mines and Collieries, which actually moved some Members of Parliament to tears, acts were passed such as Lord

Shaftesbury's Mines Act of 1842, which barred women and girls, and boys under 10, from working underground. A survey in 1886, however, revealed that there were still 4,131 women employed in the collieries, some even on night work, despite the fact it had been illegal since 1872.

In a photograph contemporary with the certificate of the Midland Miners' Federation (Plate 54), the 'Pit Brow Lasses' of Wigan's Ackers Whitley Colliery (Plate 55) are pictured. These single women or widows screened coal, loaded and 'thrutched' tubs, and acted as points women or greasers, which was dirty and dangerous work. They earned between a shilling and a shilling and a half a day whilst men doing the same job earned two shillings and a half per day.[18] The Surface Manager, Thomas Burns, stands aside like a ringmaster exhibiting the women for our scrutiny. There is a huge contrast between the regimented, tight line-up of women with their backs to the wall who face the directly into the camera, and the self-assured, arrogant stance of Burns who separates himself from them by presenting himself from the left side, looking across his shoulder. The women's trousers, which were safer than long skirts near moving machinery, were considered indecent by 'polite' society. Those at the front are seated on benches or chairs that make the display of ankle and calf more obvious, so there is something unsettlingly voyeuristic about this photograph. The women realize they are being exploited for the camera – you can see the resentment on some of their faces. Women such as these do not appear on certificates – instead we see Sister Dora, clean and demurely dressed in pure white. Middle-class and 'respectable', she fulfils the accepted feminine role of the carer of the male, tending to his needs, nursing him like a mother, the unsullied 'Angel'.

Not all unions were short-sighted and bigoted. The textile union introduced mixed unions for men and women workers, and as early as 1853 achieved a 'rate for the job'. The Grand National Consolidation Trades Union of Great Britain made a specific point in its charter for the establishment of separate organizations for women, although probably motivated less by wishing to end female exploitation than by preventing women from undermining men's strikes by continuing to work. But even when new, clerical work became available to women, for example in the Civil Service, only single women were employed and they were forced to leave once married.

In Arthur John Waudby's certificate of the Operative Bricklayers' Society of 1861 (Plate 46), Justice is seated on top of the structure whilst at the bottom of the edifice sit Science and Art. They embody or personify the law, scientific research and art, professional occupations from which women were excluded. The tradition of female personifications originates in European languages deriving from Latin where abstract virtues such as justice are expressed in the feminine ('la giustizia'), the female body becoming the metaphor for transcendence – elevation above the worldly.[19] Justice, science and art are, in the Platonic sense, abstract ideas existing in their perfection only as concepts, and as such might be expressed by the perfect body of the virtuous, beautiful, young, white-skinned woman, a blank screen onto which might be projected any concept because she was assumed to contain no original ideas of her own. In Waudby's emblem the statue-like, stone colour of Science

and Art removes them into this Platonic ideal, rather in the way George Eliot describes relations between the sexes: 'Men say of women, let them be idols, useless absorbents of previous things, provided we are not obliged to admit them to be strictly fellow-beings'.[20]

There is one 'real' woman in the certificate, visible in the top right arch, where the brickmaking trade (which had no union) is represented. Her back is turned to us, and she is picked out by a touch of bright red. In the 1850s, some 500 million bricks a year were being made within a 5-mile radius of London Bridge and the whole of the night sky was lit up over London during the summer months.[21] Clay was dug in the autumn and left to 'sour' throughout the winter in readiness for the brickmaking season, usually between March or April and October, when the bricks were made out in the open air. Brick workers would live on-site, all ages and sexes sleeping together on the ground in the same hut. Lord Shaftesbury wrote: 'In these brickfields, men, women and children, especially poor female children, are brought down to a point of degradation and suffering lower than the beasts of the field'.[22]

During the 1860s, at the time Waudby was designing this emblem, evidence presented to the Children's Employment Commission reveals that children as young as five were employed in the trade. John Long, a brickmoulder at Saltland Works, Bridgwater, was assisted by two boys of ten, a girl of nine and 'an older girl'. The boys fetched the clay, which Long moulded into 9lb bricks. The small girl would load 20 into a barrow, which the older girl would then wheel the 50 yards to the drying yard and unload. As Long estimated that he made 3,000 bricks a day, the girl must have hauled 150 loads every day, each weighing 180lb – perhaps almost double her own weight. Rising at five in the morning, she worked until seven in the evening, earning 1s. 11d. per day. The 9-year-old girl, besides loading the barrow, fetched water, washed the boards on which bricks were made and shovelled sand, earning 4d. per day.[23] If John Long was typical, for every brickmaker, four children were employed to assist him. The imagery of the banner and certificate conceals the fact that the prosperity of the members of the Operative Bricklayers' Society is built on bricks made in appallingly long hours by child labour.

Waudby's emblem for the London offices of the Operative Bricklayers' Society (Plate 39), a huge painting in oil, once again features scaffolding poles, but instead of bricklayers on the scaffolding, there are three large allegorical women – Architecture at the top, Truth to the left and Science to the right. Truth and Science are no longer stone-coloured statues as in the banner and certificate but are flesh coloured. Naked to well below the waist, they are draped like the *Venus de Milo*, the pubic triangle being barely covered. Truth, holding an unfurled scroll, has stopped contemplating her own mirrored reflection and looks out at the viewer, inviting instead the viewer's gaze. Science holds a scroll and dividers. It is as though two caryatids have emerged out of the Platonic ideal into the 'real' world, elevated and classical yet powerless and degraded by nakedness – objects of desire. There is no indication of shame, as in a *Venus Pudica*,[24] resulting in a look of bold invitation in an image supposedly representing the union. Waudby used these figures again in the certificate of the Amalgamated Society of

Carpenters and Joiners, 1866 (Plate 2), where the drapery of Truth on the right of the edifice is essentially the same. Justice, on the left, is clothed in such diaphanous clothing as to be virtually naked. Industry and Art, seated each side of Joseph the Carpenter, are more decorously clothed, as befitting, perhaps, the companions of a saint.

In 1857, some ten years before Waudby's emblem for the London offices of the Operative Bricklayers' Society was produced, Marx had posed a question, here quoted in Chapter 1, 'The Genre', but well worth repeating:

Is the view of nature and of social relations which shaped Greek imagination and thus Greek (mythology) possible in the age of automatic machinery and railways and locomotives and electric telegraphs? Where does Vulcan come in as against Roberts & Co., Jupiter as against the lightning rod, and Hermes as against the Credit Mobilier? All mythology masters and dominates and shapes the forces of nature in and through the imagination; hence it disappears as soon as man gains mastery over the forces of nature. What becomes of the Goddess Fame side by side with Printing House Square? Greek art presupposes the existence of Greek mythology, i.e. that nature and even the forms of society itself are worked up in the popular imagination in an unconsciously artistic fashion. [...] Is Achilles possible where there are powder and lead? Or is the *Iliad* at all possible in a time of the hand-operated or the later steam press? Are not singing and reciting and the muse necessarily put out of existence by the printer's bar; and do not necessary prerequisites of epic poetry accordingly vanish? But the difficulty does not lie in understanding that the Greek art and epos are bound up with certain forms of social development. It rather lies in understanding why they still afford us aesthetic enjoyment and in certain respects prevail as the standard and model beyond attainment.[25]

Certainly these observations go some way to explaining the presence of the classical woman in Victorian trade union emblems, and the voyeuristic nature of some of the images.

In Waudby's emblem for the London offices of the Operative Bricklayers, a 'real' woman is represented in the roundel on the right beneath the scaffolding, which depicts benefits being paid by the society to a widow and child.[26] The widow is nothing like the seminaked figures of Truth and Science above, but replicates the ideal of the demure bourgeois woman in the home. According to Freud, civilized man splits love between affection and sexuality in order to avoid erotic attraction to the mother: 'Where they love they do not desire, and where they desire they cannot love.'[27] This categorization is well represented in this emblem, an unwitting testimony to Victorian double standards – private vice and public purity. Designed to hang in the offices of the building industry, one cannot help wondering if this emblem is the forerunner of all 'girlie' calendars?

The different spheres for men and women are set out quite clearly in the very beautiful fin-de-siècle certificate of the Amalgamated Association of Operative Cotton

Spinners by Charles E. Turner (Plate 56). On the right, a seated classical, muscular male leans on a hammer whilst behind him is a scene of industry. The classical woman who is seated at the left with brushes, palette and painting board is in a tranquil pastoral setting, with its associations of nature and fertility, which she is reproducing in her painting – reproduction being of course her 'natural' biological role. The caption above her reads 'Justice is all we require', yet even though the proportion of women workers to men in the cotton industry was extremely large, particularly in the card room where material was prepared for the spinners, only male workers are depicted at the various machines and outside the factory.

Justice herself is centrally placed at the top between the female and male classicized figures. She may be Themis, goddess of justice, who ruled over moral order among both gods and men, or her daughter, Dike ('Justice'), one of the Horae, goddesses of the seasons or the hours. The hair of Justice is centrally parted to indicate her impartiality, and she holds her customary scales and sword, but she is without her blindfold. The sword of Justice is not a weapon, but an instrument for separating good from evil. Her breast is armoured with reptilian scales, and bears a face with two strands of hair trailing down from it like entwined serpents. Further snaking curls encircle her midriff. Indeed, she appears to be wearing the aegis of Athena, which bore the head of the gorgon, Medusa, entwined with writhing snakes.[28] Medusa was sometimes represented as beautiful, and according to Apollodorus, Athena assisted Perseus on his mission from Polydectes to capture the gorgon's head because Medusa had had the temerity to compare her own beauty with that of Athena.[29] Athena, who was herself a mighty warrior, wore it as a threat to her enemies. She oversaw the use of war as a means of bringing justice and protection to a community, which may be why here Justice has adopted her aegis.

According to Warner, in the Renaissance, Sophia or Sapienta, leader of Liberal Arts, began to assume the features of Minerva, as did Prudence, one of the four Cardinal Virtues.[30] Fortitude and Justice, however, were assimilated into Minerva's earlier Greek counterpart, Athena, and this may serve to explain why, in this emblem and in many others, Justice wears Athena's head of the Medusa.[31]

Athena, in her guise as goddess of craft and of wisdom, was herself a popular choice with emblem designers, and we find her gracing many trade union emblems. In 1869, John Ruskin gave a series of lectures, published as a book, *Queen of the Air*, in which he argues that the Greek myths should be taken seriously, along with the sincere faith and moral wisdom that had inspired them. He saw Britain as a New Athens, and in Athena he saw all that was good:

> The sea-beach round this isle of ours is the frieze of our Parthenon; every wave that breaks on it thunders with Athena's voice; nay, whenever you throw your window wide open in the morning, you let in Athena, as wisdom and fresh air at the same instant; and whenever you draw a pure, long, full breath of right heaven, you take Athena into your heart, through your blood; and, with the blood, into the thoughts of your brain.[32]

Alexander Gow depicts Athena in his certificate of the Associated Carpenters and Joiners of the 1880s (Plate 34), where she stands in a classical shell-incised niche to the left of the emblem, with helmet, spear, anchor and her owl at her feet but without a Medusa head at her breast.[33] Flanked by Justice and Truth, she hails the viewer from on high in the centre of the certificate of the Amalgamated Society of Railway Servants of 1888 (Plate 57). Here, she wears her helmet, and her owl is at her feet, and here again she has no Medusa head at her breast. She lifts her hand in the boilermakers' recognition sign.[34] Waudby employs a little bust of her in both his certificate of the Amalgamated Society of Carpenters and Joiners (Plate 2) – where it is at the feet of Art, helmeted and with the Medusa head – and again at the top of his certificate of the Friendly Society of Stone Masons (1868, Plate 10) – at the feet of Architecture.

Flanked by large, playful, winged putti, Athena is pictured in the large oval vignette at the top of the certificate of the Amalgamated Association of Card Blowing Room Operatives of 1890 by Alexander Gow (Plate 33). Holding her distaff or flax pole for spinning, she sits at a dockside beside a globe of the world, with a factory or mill with tall smoking chimneys and a sailing ship behind her, so she may also represent Commerce. Justice is on a pedestal in the rectangular niche in the central bottom section. Between the two is a 'real' woman posing beside her machine, and there are three other women workers depicted in the other scenes of the workplace. Scrolls flanking machines in small ovals to the right and left of the upper part of Justice's body read, 'Let us then be up and doing, With a heart for any fate, Still achieving still pursuing, Learn to labour and to wait', the final verse of the poem of 1838 by Henry Wadsworth Longfellow, *A Psalm of Life*.

The Amalgamated Association of Card and Blowing Room Operatives had come into being in 1885, and had begun to recruit women into the movement.[35] Their acceptance, at long last, as union members has given them an almost equal place with men in this emblem (five male workers are depicted and four female workers), whilst the shield at the bottom left bears the inscription 'Honest Labour Bears a Lovely Face' – a quotation from the works of the Elizabethan poet and dramatist, Thomas Dekker, and a tribute, perhaps, to these women workers.[36] That on the right shield reads 'Labour shall refresh itself with hope', a quotation from Shakespeare's *Henry V*.[37]

In emblems, allegorical women sometimes serve a clearly didactic purpose. Hanging on the wall of the home, in Waudby's certificate of the Friendly Society of Stone Masons (Plate 10), Prudence at the top left holds a bridle, whilst Temperance at the bottom left holds ewers of water. Together they serve as a reminder of restraint, especially with regard to the consumption of alcohol.[38]

The 1897 banner of the Cleveland District of the Associated Iron and Steel Workers (Plate 58) also depicts the female personification of Justice. As in so many emblems, she occupies a key position at the top of the image. Elevated above a meeting of the Northern Conciliation Board (all portraits of officers of the union and the board, some of whom also appear in roundels at the top of the banner), she is seated rather precariously on a sculpture of the English lion, which is on a low plinth. Richard the Lionheart adopted three lions for the King's shield and they have since become the

recognized heraldic symbol for England, usually combined with the chained unicorn of Scotland as, for example, in the Order of the Garter. According to Alciati, Emblem 15, the lion is a guardian because he sleeps with his eyes open (a belief held during the medieval period and into the Renaissance). On his plinth, Justice's lion resembles the lions by Edwin Landseer installed in Trafalgar Square in 1868, so we have no doubts that it is British justice that is being meted out here.

Justice does not wear her customary blindfold, but she holds her scales aloft. According to the system of Manilius's *Astronomica II*, circa 453–65, which conflates the 12 gods and their zodiacal signs with 12 parts of the body, September is Vulcan's month, under the sign of Libra, the Scales (which he forged). The tipping action of the scales resembles the gait of the lame smith god, Vulcan. The sign itself signifies justice and harmony, because an argument can be balanced and weighed in the scales before they tip in favour of one side. The scales that Justice holds aloft in the banner are echoed in the lights of the room beneath, thus implying that the decisions of the board are truly just.

The ribbon around the bosom of Justice is like the ribbon worn around the bosom of Aphrodite, a band elaborately embroidered, interwoven in which were her magical powers of allurement and seduction. In this banner, Justice too bears the face of the gorgon at her midriff.

The quotation 'Come let us reason together' is taken from Isaiah.[39] The men are grouped around the table in a manner evoking a Last Supper. Paper and ink replace bread and wine, according conciliation and arbitration the dignity of Holy Communion, which reconciles man to God. The elevation and separation of the figure of Justice from the world of men below is also reminiscent of a Last Judgement. However, divine justice is here replaced by secular justice, and the light of reason replaces the Light of the World – very much an Enlightenment theme.

Justice, however, is not represented as female because women were thought capable of dispensing justice. According to Warner, the symbolic order represented by allegorical virtues, and the actual order of men in positions such as judges, is marked by difference, and the unlikelihood of women practising the concepts they represent.[40] The caption beneath her, which reads somewhat fittingly 'Justice to all Men', is a quotation from the First Inaugural Address of Thomas Jefferson, given on 4 March 1801.

In an earlier banner of 1889 by Tutill, that of the Amalgamated Stevedores' Labour Protection League (Plate 59), it is Britannia, not Justice, who is with the English lion, this time behind him. The design of the banner is very similar in its medallion shape, suspended by ribbons, to that of many other banners, for example that of the National Union of Mineworkers, Durham Area, Dawdon Lodge (Plate 53), and was a popular 'stock' design or template. Britannia is draped in the Union flag, the English lion is at her feet, and behind her are four red ensigns, designated by the Admiralty for use by merchant shipping from 1864 onwards.

Britannia's origins date back to the Roman Empire where she appears as the personification of these conquered islands on coins minted for Emperor Hadrian (and indeed this banner takes the shape of a coin or medal decorated around the edges

with roses, thistles and shamrocks). Later, Britannia became conflated with Boudicca, Queen of the Iceni, whose name means 'Victory', and who resisted the invasion of the Roman Empire. Subsequently, Britannia became conflated with Queen Elizabeth I in her idealized guise of Glorianna in Spenser's *Faerie Queene*. And, by the Victorian era, Britannia had become identified with Queen Victoria, a female symbol of power but holding no formal political power.

The sailing ship to the right of Britannia and the trident she holds are similar to those of the seated Britannia on coins of the era, indicating that Britannia now 'rules the waves'. However, her pictorial origins in Athena are clear from Athena's helmet, which appeared on the head of Britannia after 1821 and the defeat of Napoleon, and from the trident that Athena gained in the Attic tradition by her victory over Poseidon in the vote instituted by King Cecrops. According to Hesiod, Athena was also called Tritogeneia, because she was born on the banks of the River Trito.[41] Athena Tritogeneia, who sprang from her father's head, represents the patrilineal social structure. When an Athenian prayed to Athena Tritopatores, it was not just for children, but for true born children (i.e. children born in wedlock of their lawful father)[42] and it is in this sense (and in the sense that Athena was patroness of cities) that Britannia stands as the true mother of the nation.

This banner is 3.66 m high, and is painted in oils onto an embroidered silk background, woven on a Jacquard loom. An Australian emblem with the emu and red kangaroo appears in the roundel immediately above Britannia. During the Great Dock Strike of 1889, Australian wharf workers sent more than £25,000 to London's starving dockers,[43] and this banner of the same year displays their gratitude and their solidarity with them. The scene is at the dockside, with a British stevedore on the left shaking hands with his Australian counterpart, a figure on the right in a wide-brimmed hat, across the central figure of Britannia. She looks towards the Australian but gestures towards the British stevedore to whom she also presents Neptune's trident (which signifies mastery over the oceans) in order to acknowledge Australia's part in obtaining victory for the dockers. The British stevedore has his left arm akimbo, a pose that in portraiture has military associations and implies strength and self-assurance.

This banner comes into being some ten years before the Great Rapprochement between the British Empire and the United States in the years after 1895. With the rise of new powers such as Germany and Russia, Britain and her colonies formed a new alliance with the United States based on mutual commercial interests, on their shared language and their common heritage. In 1899, John Philip Sousa wrote the march *Hands Across the Sea*, and images of John Bull shaking hands with Uncle Sam across the Atlantic Ocean were in currency. Following on from this, the emblem of the disembodied handshake across the sea was used in items such as postcards sold on ocean liners to be mailed at destination points. Here, however, the handshake between British and Australian dockers is between workers from two countries united not just by membership of the empire, but also by their joint struggle against the common enemy of British bourgeois exploitation. Their unity and victory (celebrated triumphantly in the motto beneath) is symbolized by their handshake across Britannia.

Male bonding is achieved by using the classical female body as the 'conjunction' or point of connection.

Britannia comes in various guises in trade union emblems. For example, she appears on the certificate of the Association of Locomotive Engineers and Fireman by Goodall & Suddick, first quarter of the twentieth century (Plate 25). Here, she is given a label to identify her as 'Commerce'. With a ship at her back to transport British goods abroad, she has an oar and an anchor that enable her to move her goods through the water and also to dock in port to unload them. Most interestingly, she has the wings of Hermes or Mercury, god of travellers and merchants, sprouting directly from her head. Mercury was the father of the Lares, guardians of the home and state, which may be another reason why Commerce has been conflated with Britannia. Beneath her arm is her shield with the vague outline of the Union flag.

The Greek shield was round,[44] so too was the Roman *clipeus*. The ordering of shields by mothers for their sons was a Greek custom. The Spartan mother, presenting the shield to her son when he went out to war was supposed to say, 'return with this or upon this' (alluded to in Plutarch's *Moralia* 235A and Latinized as *aut cum hoc, aut in hoc* by Valerius Maximus, this second phrase perhaps meaning 'or fall upon the shield in battle'). Even in Vico's day,[45] a bier was still called a *scudo* (shield). According to him, the first shield in the world was the ground of the field where the dead were buried; hence, in heraldry, the shield is the 'ground' of the arms. Hephaistos had made the arms of Peleus, the father of Achilles, as a wedding present, which were later given to Achilles as his first arms, but they were lost by Patroklos.[46] The arms that Thetis requested were their replacement. Ovid, reworking the famous ecphrasis in Book Eighteen of Homer's *Iliad*, describes the shield of Achilles as embossed with 'the ocean and the lands/the constellations in the height of heaven/the Pleiades and the Hyads and the Bear/Banned from the sea, Orion's shining sword/the cities set apart'.[47] It is no coincidence, therefore, that Britannia, that icon of empire and ruler of the oceans, bears a circular shield.

On May Day 1898, Tom Mann (who was to become a founder member of the Communist Party in 1920) founded the Workers' Union, known for its militancy. The banner of the Workers' Union, Aldershot No. 1 Branch (Plate 60), dates from 1913. It depicts the Greek Nike, goddess of victory. Her siblings are Zelus (Aspiration), Bia (Might) and Cratos (Power), all qualities required by a Victory. Nike appears on vase painting and on Greek and Roman sculpture and coinage, and her wings are often golden. She embodies the inescapability of destiny. An emanation of Athena, who also brings victory, a temple to Athena Nike (begun in 448 BCE) is on the Acropolis. Nike (the Roman 'Victoria') was a popular goddess in a country ruled by a queen also named Victoria and in this era, and that which followed, Nike was appearing on monuments everywhere, even promoting commercial products. Rolls Royce, for example, introduced her as the 'Silver Lady' by Charles Sykes, on top of the 'temple' of the car's radiator.

In the banner of the Workers' Union, lettering on Nike's sash identifies her as a personification of 'Trade Unions'. Her right foot forward, her two layered skirt and her

windswept, flying draperies reveal her iconographical origins in the *Winged Victory of Samothrace* (Plate 61). Dating from circa 190 BCE, executed in soft, apricot-coloured stone by a disciple of Lysippus or pupils of Scopas, and only rediscovered in 1863, it was in the collection of the Louvre by 1867, following which Victories became extremely popular in art and sculpture.

Nike wears the Phrygian *bonnet rouge* or cap of liberation, and brings a message to a figure identified as 'Labour', offering him the key of 'organization' to unlock the gate of a walled garden whose name is 'Economic Emancipation'. In Freudian terms, it is a phallic key (symbolizing virility) to unlock a virgin, walled garden.[48]

The figure of Labour wears a rural smock, and has his tools over his shoulder in the manner of the staff and sack carried by the medieval pilgrim. Nike has the power to change human destiny, and here she encourages him to take his key and claim his entry to 'Economic Emancipation', both literally and figuratively a 'step up' in the world. A virtually identical scene is replicated in a banner of the Durham Area Fishburn Lodge of the National Union of Mineworkers,[49] and also on the reverse side of a banner of the National Union of Railwaymen, Wakefield No. 2 Branch (Plate 62 illustrates the front of the banner), where the figure of Labour is replaced by representations of a miner and a railway worker respectively. The image on the front of this banner is taken from Walter Crane's *Garland for May Day* of 1895, which is discussed in Chapter 9.

In the banner of the Kensal Green Branch of the National Union of General Workers, 1910 (Plate 63), a *cartellino* at the base identifies the central woman as 'The Workers' May Pole', an image taken almost directly from Crane's cartoon *The Workers' May-Pole* of 1894 (Plate 64) but with a few changes – perhaps most notably the demand for 'Eight Hours' has been altered to 'A Life Worth Living'. Although the image seems extraordinarily novel, with her outstretched arms and the banners behind her on each side topped with bonnets rouge, the image is based on the Crucifixion and the crosses of the two thieves crucified with Christ. The image is remarkable for its combination of the pagan, phallic maypole and a secular, joyful, female Christ of socialism. We encounter this feminized Christ again as late as 1956 in the guise of 'Humanity' in the banner of the Durham Miners, South Hetton Lodge where a scientist, a fisherman, a farmer and a miner offer gifts to her using the convention of an Adoration of the Magi.

In a further banner of the National Union of General Workers, Tottenham Branch, circa 1919 (Plate 65), a very different monumental, wingless, allegorical female looks to a group of eight male workers to her left and points them to a 'Promised Land', an idealized, co-operative world on her right, where happy, well-dressed children are in a street or playground in front of modern buildings (perhaps a school) with a Union Jack flying from the flag pole. This dream world is separated from the workers by clouds at their feet.[50] 'Producers of the Nations' Wealth, Unite! and have your share of the world', she urges. She has no flowers, no bonnet rouge, but in her right hand she holds a flaming torch.

The torch was the attribute of Hephaistos/Vulcan, brother of Athena, and accompanies him in Greek vase paintings and Roman statuary. However, perhaps due

to its early Greek association with flame as an expression of the life force, and the extinguishing of it with death, and also with the torch's role in the fires of the funerary pyre, the torch as Vulcan's attribute becomes less important in the later Roman Empire where the dead were buried, rather than cremated. In the Renaissance world of powerful craft guilds, Vulcan's other attributes, the hammer and tongs of the artisan, were brought to the fore. Fire is, of course, a major agent of transformation. Hesiod equates the fire that Prometheus stole with man's means of life.[51] The early Greek view was that man was led from brutishness to crafts and civilization by means of fire, which was given to man either by a god or a hero.[52] Here, the allegorical woman's torch is an agent of transformation, lighting the path to the achievement of a better share in their world and an improved life. She is in white (the first of her slogans, inscribed on a ribbon on her body, is 'light'), so we recognize her as a Virtue, generic and universal. The academic conventions of heroic scale, pose and rhetorical gesture in themselves imply moral and social order, and her healthy physique denotes moral health. Taller than the men, they look up to her, uncertainly, like children to a mother.

Several banners of the Durham Miners' Association of the early 1900s are similar, for example that of the banner of the Durham Miners' Association, Witton Lodge (Plate 66).[53] They feature the allegorical woman in a red Phrygian cap with streaming ribbons attached to her clothing, bearing slogans 'Progress', 'Education', 'Art', 'Science'. She lifts a curtain labelled 'Oppression', which hangs like a fog over the little group, revealing an idyllic scene under 'The Sunshine of Liberty'. A male worker points out the future to an enraptured girl. In this confrontation between a 'real' woman and an allegorical woman, what is remarkable is the difference between them, both in scale and in confidence. The male worker adopts an open, active pose, with a protective arm around the girl, who is shorter. Her lack of body curves and passive, hesitant pose make her seem young and vulnerable. The legend at the base of the banner reads, 'These things shall be: a loftier race than ever the world hath known shall rise with the flame of freedom in their souls and light of knowledge in their eyes', a quotation from *The Days That Are To Be* by John Addington Symonds, 1840–1893.

By the 1880s, public health acts and building controls had brought new and better terraced housing for skilled artisans who had previously been packed into shared, insanitary, cramped, back-to-back homes in courts with shared water pumps and with squalid, communal privies. Most girls were attending school by the 1880s, where they were taught the hierarchy of discipline within both home and society, and their place as subservient to the male. Motherhood was sentimentalized in literature, sculpture and painting. Domestic duties within the home were a female responsibility, where order and cleanliness were the mark of respectability. In his speech to the TUC in 1875, Henry Broadhurst maintained that the main aim of a trade union with regard to women was to

bring about a condition [...] where their wives and daughters would be in their proper sphere at home, instead of being dragged into competition for livelihood against the great and strong men of the world.[54]

In both the banner of the Durham Miners' Association, Witton Lodge (Plate 66) and in the banner of the National Union of General Workers, Tottenham Branch (Plate 65), the workers are shown or point to large houses with neatly trimmed hedges, in front of which children play. So, for the girl, the future pointed out to her is a return to the male ideal of woman's 'natural' place – dependent and in the home. These banners are inspired partially by utopian socialism, by the desire to leave the filth and overcrowding of the great industrial cities and return to the old ways of living in rural communities. Robert Owen, the Welsh utopian thinker and social reformer, experimented with a model community, 'Harmony', in Hampshire, 1841, and in 'New Harmony' in Indiana. He believed in equality for women in education, rights, privileges and personal liberty, and looked to a time when women would be independent, not the slaves of men.[55] In 1817, he had opened the first infant school and crèche for the children of working mothers at the New Lanark cotton mills, of which he was part owner. His belief was that employers had a responsibility for both the moral and the intellectual wellbeing of their employees. Reformers such as Lever, in the 1880s, and Cadbury, in the 1890s, removed their factories to the countryside and provided their workers with clean air and decent accommodation. William Booth's book of 1890, *In Darkest England and the Way Out,* also echoed these aspirations. By the beginning of the twentieth century, local councils were building homes for the workers such as the Boundary Estate by architect Owen Fleming, which was opened in 1900 by the Prince of Wales. Built at the boundary of Bethnal Green and Shoreditch on the site of the Old Nichol, an infamous slum, it was the world's first council housing, designed with a central bandstand and surrounding brick-built homes. Sadly, the slum dwellers whose homes had been demolished to pave the way for the new estate could not afford the rents and moved on to further insanitary slums. Like the workers in these two emblems, for them the new housing was just a dream.

In contrast to emblems that depict women as personifications, the Nike of destiny, the female Christ or the dependent working woman, women themselves sought to utilize the classical woman to rally other women to the cause of women's suffrage. Lisa Tickner's excellent book, *The Spectacle of Women,* gives a detailed analysis of the women's suffrage campaign.[56] The women who led the campaign were from the middle classes – educated, sometimes professional, women. Just such a woman was Caroline Watts, who had studied at the Slade and who worked as an illustrator.[57] She designed the advertisement for the National Union of Women's Suffrage Societies' Procession of 13 June 1908 (Plate 67), published by the Artists' Suffrage League and used again in 1908 for the front cover of the official programme of the Manchester Women's Suffrage Demonstrations. In this, 'The Bugler Girl', an armour-clad woman (still modestly covered by a skirt) stands high atop the battlements. She raises her standard and puts a bugle to her lips whilst facing into the rays of the sun and heralding the dawn. A standard bearer was one of the bravest officers, expected to defend the standard to the death rather than allow it to be captured as a trophy. He would never relinquish it, and if he were gravely wounded and unable to secure the safety of the standard he would wrap himself in it and await his end. Here, the iconographical origins of the

standard-bearing Bugler Girl lie in images of Joan of Arc, in the trumpeter in Robert Blatchford's socialist newspaper, *Clarion*, founded in 1891 and in Crane's 'May Day' for the *Sun* in 1903 (Plate 68) with her great banner. However, it is perhaps Crane's armed bugler maiden on the battlements in his illustrations of Spenser's *Faerie Queene* in 1894, 1895 and 1897 that is the greatest influence.[58]

The wings on her helmet reveal her to be a feminized version of Hermes, who brings messages from the gods to earth and who was actually born at dawn of day in a cave on Mount Cyllene in Arcadia. Patron of travellers, Hermes is certainly an apt god to guide the Suffragettes coming into London to march through the city to the rally. The Bugler Girl is inviting them to storm the castle on whose battlements she stands, to storm the male bastion. The red rays of the sun of the 'New Dawn' of socialism appear in both socialist iconography and suffrage iconography of the time, relating the causes to Eos, 'rosy fingered Dawn', conqueror of darkness and bringer of the new day. The programme for the demonstration in Hyde Park on Sunday 21 June 1908 announces that an actual bugle will sound at five minutes to five to indicate that the speakers at the 20 platforms will conclude their addresses, and again at five o'clock when the resolution will be put: 'The Meeting calls open [sic] the Government to grant a vote for women without delay', following which a final bugle call heralds the Great Shout: 'One, two, three – Votes for Women! Votes for Women! Votes for Women!!!'

Whilst armour makes the body appear more masculine, it also protects the body against violation and (as in the case of the virgin goddess Athena) speaks of chastity. Indeed, the Bugler Girl evokes the poetry of Song of Songs 6:10:

> Who is this arising like the dawn,
> Fair as the moon,
> Resplendent as the sun,
> Terrible as an army with banners?

The banners of the Suffrage movement differ from those of the trades union. In the first place, rather than being painted in oils by commercial banner makers, they were made by the women themselves using women's traditional skills – they were stencilled, appliquéd and embroidered. Bold and geometric, harking back to heraldry, they are closer to avant-garde, oppositional art and collage than to academic, middle-class art. However, in Suffragette and anti-Suffragette propaganda posters (Plates 69 and 70), both sides laid claim to the allegorical, idealized woman.

In a Suffragette poster by Louise Jacobs of 1912 (Plate 69), sobbing, cowed, barefoot, chained women, a baby and a little girl are ranged in front of Big Ben, Parliament and factory chimneys, symbols of the British male establishment. The classical woman displays the demand: 'We want the vote, to stop the white slave traffic, sweated labour, and to save the children'. Even men of the newly formed Labour Party were opposed to women being given the vote, because they feared that it would be given to middle-class women only, who would vote against them.

In the anti-Suffragette poster by Harold Bird (Plate 70), also from 1912, the allegorical woman has patriotic flowers – roses, thistles and shamrocks – in her hair, and Big Ben and Parliament are also behind her. She is made to look more 'feminine' and 'natural' by deep shading to give her a large, heavy bosom, and a low hairline that shows that she has little brain. This, combined with her blank, expressionless face, indicates she has no original thoughts of her own, merely echoing her father's or husband's, and she holds a placard reading 'No votes thank you', very politely. The slogan 'The Appeal of Womanhood' may, of course, be read not simply as the appeal for no votes, but as also referring to her own 'natural' sex appeal – the allure of a compliant, subservient woman. Running past behind her is a caricature of a Suffragette.[59] Undisciplined and 'unfeminine', her legs are wide apart, she lacks 'feminine' curves, her stockings are wrinkled and disorderly, and she wears unfashionable clothing. There is no wedding ring on her left hand, so she is a stereotypical 'old maid', unfulfilled and sour. In one hand she holds a sign saying 'Votes' and in the other a hammer to indicate her supposedly destructive purpose (and certainly Suffragettes burned buildings, disrupted court rooms and Asquith even had an axe thrown at him). Her body forms the X of the 'no' vote. Her image contrasts with that of the straight and upright classical woman, who here serves to embody the 'natural' ideology of the male establishment. Deviance was thought to be inscribed on physical features, and in 1871 an MP had suggested that Parliament should demand photographs of women supporting the bill for enfranchisement – not a requirement made of the men who sought the vote in 1867.[60]

By the mid-nineteenth century, the theory of the unconscious mind that governed the conscious mind was well established, both in the materialist approach of Charcot and in Freud's development of psychoanalysis. Freud believed that the unconscious centred on repressed sexuality, whereas Jung considered it to be more mystical, holding collective, inherited, ageless images of ancient mythologies. He saw the essence of religion as the giving of conscious expression to these archetypes. It was 'dynamic' in that it roused men to great crusading movements.

Jung is the first to define the Anima, which is always female, an archetype that represents the whole of a man's unconscious. 'She is wise [with] a secret knowledge or hidden wisdom [...] and she may be endowed with great power.'[61] She has two aspects, the pure virgin or goddess figure, and also the seductress. Jung perceives her to be the soul. Locked away safely in the unconscious, she helps to explain Catholic (and Victorian) culture, which celebrates the Madonna yet is deeply disapproving of female emancipation.

Hobsbawm identifies the allegorical woman in trade union imagery of the socialist era as goddess or muse, inspired by French Revolutionary imagery.[62] He is, of course, correct, but his explanation does not go nearly far enough and he has been challenged for his general assumptions about the portrayal of women in socialist iconography (see the discussion by Paula James in the concluding chapter). All the female allegorical figures we have seen in these banners, certificates and posters, even those based on

the Nike or Victory, have their origin in Athena, who was born out of the head of her father, Zeus.

If Jung is correct, the allegorical woman is man's own soul – *he* is Justice, Science, Art, Angel, Saviour, Leader. The Galatea of his own creation, so frequently uncorseted and liberated, is the embodiment of *his own desired self-image*. The Romans carved Virtues next to a great man on sarcophagi, as manifestations of *his* inner goodness.[63] According to Warner, 'Men act as individuals, and women bear the burden of their dreams'[64] and this certainly seems to be true in many of these images.

Man may be displaying his highest aspirations, his own soul, his Anima, when he paints the allegorical woman on his banner and certificate. A connecting device, men of all classes can be unified in and through her image. Or she may simply be the subversive 'Other' to Christ the virgin peacemaker, ideological difference being expressed via sexual difference. Whoever or whatever she is, the probability is that she is not woman at all, because in patriarchal culture, femininity is not an alternative to masculinity but its negative.[65] There is no Hegelian unification (synthesis) between thesis and antithesis, between male and female. The allegorical woman is a colonized body, merely an idealized photographic negative of the male. She stands as propaganda for the status quo.

Both sides of the political spectrum are able to lay claim to her because she is a *tabula rasa* upon which anything may be written.

Chapter 9

WALTER CRANE

Annie Ravenhill-Johnson

The previous chapter noted that the banner of the Kensal Green Branch of the National Union of General Workers, 1910 (Plate 63), contained an image taken almost directly from Walter Crane's cartoon *The Workers' May-Pole* of 1894. An artist, designer, illustrator and writer, Walter Crane was a wealthy man of the middle classes. In 1884, he had declared himself a socialist, and this chapter considers how his politics influenced and impinged upon the designs he produced for the working classes.

As discussed in Chapter 7, it has been argued that any political movement employs a cultural framework or a 'master fiction', the centre of which has sacred status, by which to define itself and give its members a sense of their place.[1] Within trade union emblems, the 'sacred centre' had been present in the harking back to the patron saint of the guild and trade, to biblical mentions of the trade, to classical mythology and to the inclusion of portraits of famous men and their heirs, the present day workers and leaders of the union, amongst gods and virtues. But, over time, the machine itself came to occupy this 'sacred space'.

Marx and Engels, in *The Communist Manifesto*, had concluded that mass production by machine had resulted in the loss of the individual character of goods, the workman becoming merely an appendage of the machine, his work monotonous and boring. William Morris, who became a socialist in 1883, was also of this opinion. The machine was the enemy that made the worker its servant rather than its master, and which destroyed the pleasure gained from making a beautiful object by hand. In *News from Nowhere* (1890) he describes a vision of an England of the twenty-first century. It is summer, hot, lush and idyllic, with no rain or mud. Money has ceased to exist and food is in plentiful supply in a society where it is communally owned. Work is considered to be pleasurable and people engage in a variety of occupations, swapping them at will. In this society of equality of status and common ownership of property, work is performed in congenial surroundings and it is for the benefit of others rather than for the profit of the individual. The machine has been eliminated, apart from machines designed to make irksome labour easier. Man is once again the master of the machine, no longer enslaved to it.

In Morris's sugary-perfect utopian Britain of the future, capitalism has been defeated by a workers' uprising and the ownership of private property has been abolished. Medieval methods of craftsmanship have been reinstated and labour is again akin to 'art'. Smoky, foggy, filthy cities are gone, whilst in their place are postindustrial communities of pretty villages and happy, smiling people now living a healthy, communal, leisured rural life. They dress in a comfortable variant of fourteenth-century costume, beautifully decorated and embroidered – the dustman, for example, has rich embroidery on his coat and is a lover of art. Formal education is no longer mandatory and people educate themselves, but only if they so desire. There is no central government and, because there is no private property to protect, there are no police, no prisons, no gamekeepers, no army nor navy. His utopian England is very much a male dream, with all the women beautiful, healthy and looking far younger than their actual years. Marriage has also been abolished and there is sexual freedom, yet women are still in their 'natural' place – looking after the men and the children. They continue to perform the housework and wait on the men because, Morris writes, the women find it so *pleasurable*. (If it were, indeed, quite so pleasurable, one wonders why the men do not also elect to perform housework? They do, after all, exchange occupations as and when they feel like it.) He believes that because women would no longer need to compete with men in the workplace, the 'women's question' would cease to exist.

In his writings and work, William Morris attempts to fuse aesthetics and politics with an aim to see the hierarchical distinctions between art and craft broken down. The writer, the artist and the manual labourer would all be labourers together for beauty in the new socialist era and, through this, human nature would become perfected whilst bodily pleasure would be achieved in artistic creation. However, he himself designed for an elite set of clients, and the craftsmen who undertook the realization of his own artistic creation would probably not have been able to afford the fabrics, furniture and tapestries that they produced for him. As Crane wrote,

> A common reproach hurled at Morris has been that he produced costly works for the rich whilst he professed Socialism [...]. Such objections appear to ignore, or to be ignorant of, the fact that according to the quality of the production must be its cost.
>
> If anyone cares for good work, a good price must be paid. Under existing conditions, possession of such work is only possible to those who can pay the price, but this seems to work out rather as part of an indictment against the present system of production, which Socialists wish to alter.[2]

Middle-class notions of manhood were founded on ideals such as integrity, good judgement and strength of character, but in the second half of the nineteenth century the bourgeois man, in comparing his own physical body with those of the men of the labouring classes, found himself sadly wanting. Capitalism had rendered his body effeminate, soft, flabby, diseased and decadent and it seemed that a simple, harmonious,

aesthetic life could result in a body made muscular through work, and could reclaim for him his virility and manhood.

In the final quarter of the twentieth century, a raft of fashionable socialist tracts and utopian novels such as Morris's were published. In 1878, Laurence Gronlund, a Dane who had emigrated to America, published *The Coming Revolution: Its Principles*, followed by four other treatises and books. The American, Edward Bellamy, published *Looking Backward* in 1888 and its sequel *Equality* in 1897, whilst in England, Robert Blatchford, founder in 1891 of the socialist weekly, the *Clarion*, similarly promoted the cause of socialism in his book *Merrie England* (which sold 750,000 copies in penny edition).

Blatchford maintained that Britain could produce all it needed to feed its population three times over, yet instead it used cheap labour to work in factories producing goods for export whilst importing vast amounts of foreign wheat, making Britain dependent upon other countries. Those in our society who worked longest and hardest were the worst paid. They survived on minimum subsistence and ended their days in the workhouse. Some died of starvation. The profit from their labour went to those who owned the means of production and who never did a day's real labour in their lives. Blatchford argued for the abolition of the factory system and recommended state ownership, social housing, communal facilities for all, retirement for all at the age of 45 and wrote that by using intelligent farming systems, food production could be increased by 75 per cent and costs reduced by 60 per cent.

According to Marx, in a capitalistic society there exists an economic base from which emerges a superstructure composed of the dominant ideology of the ruling class. This is fed back to the roots of society via law, politics, religion, education and ethics, and percolates back up the social system to reinforce the superstructure. This may explain how the middle classes were able to control a relatively subservient labour force. Using religion as a tool of social control, they mounted great reforming crusades, encouraging the belief that no matter how bad their lot on earth, the labouring classes would be rewarded in heaven if they obeyed Christian and civil law. There was also Carlyle's 'Gospel of Work', in which labour itself was revered as noble and sacred. The theory of removable inequalities was promoted – the supposed ability of any man to rise in wealth and class through work. Morals and ethics were said to make the gentleman, not money and class, despite the fact that those who did actually rise through the ranks through their own endeavours were considered *nouveau riche* and common upstarts by those with old money and old family names.

Britain's working classes never rose in revolution. It has been argued, for example by Stanley Pierson, that the type of socialism entwined with aesthetics preached by William Morris actually served to stunt the growth of social democracy and Marxism in Britain.[3] In addition, not everyone is equally gifted intellectually and physically to exchange occupations and multitask in the way Morris envisages. For those whose daily life was a matter of working hand to mouth, the prospect of actual starvation during a period of revolution and anarchy would have been far less attractive than putting up with the status quo, however bad that might have been. And, when the chips were down, the workers were never going to rise up in revolution merely in order

to produce beautifully handcrafted goods and live the simple life. As George Bernard Shaw (himself a Fabian) argued, Morris and his group failed because the working classes did not

> share their tastes nor understand their art criticism. They do not want the simple life, nor the aesthetic life. [...] What they do dislike and are ashamed of is poverty.[4]

Living a simple and aesthetic life, he argued, was merely the privilege of those 'who had a surfeit of goods and pleasures to turn away from'.[5]

A man wealthy in his own right through inheritance, Walter Crane was an associate of William Morris and Burne-Jones, and a leading light in the Arts and Crafts Movement, which fought a losing battle against the rising tide of mass manufacture. He joined Hyndman's Social Democratic Federation in 1884 and later the breakaway Socialist League led by William Morris. Apprenticed in 1859 to the Chartist engraver W. J. Linton, Crane was (initially) a Fabian. Along with others such as George Bernard Shaw, Sydney Webb and Annie Besant, he preferred the ballot box and education to active revolt, believing in Comte's 'religion of humanity', which aimed at a spiritual reorganization of society, with political reorganization to follow. Despite this, he did, however, produce cartoons to commemorate the Paris Commune in 1887 and 1891. His designs for the Social Democratic Federation, the Socialist League and the Fabian Society include leaflets, pamphlets, posters and membership cards. He also designed the covers of many left-wing journals such as the *Pioneer*, *Time*, the *Labourer*, *Woman Worker*, *Concord* and more.

Even though he disapproved of art colleges, believing that art cannot be taught and that the workshop was the natural place in which to learn, he himself taught in them (for example, at Manchester's School of Art) and was even an examiner for the National Art Training School. He undertook commercial design work for the textile and wallpaper industries, for a Dutch temperance campaign and advertising material for companies such as Hau Champagne and Pears Soap. He is, however, perhaps best known for his illustrations in children's books. In 1896, the year that Morris died, Crane's folio edition of 12 prints, *Cartoons for the Cause*, was published by the Twentieth Century Press as a souvenir of the International Socialist Workers and Trades Union Congress of that year. *Cartoons for the Cause* was used as a resource by trade union banner designers and was reissued in 1907.

In 1891, Crane designed *The Triumph of Labour* (Plate 71), a tribute to commemorate the first international May Day, and inscribed 'Designed to commemorate the International Labour Day May 1 1891'. It was engraved by Henry Scheu and sold not just in Britain but abroad, with the mottoes in different languages. Based on the Renaissance 'triumph', it is frieze-like, depicting the workers riding in an ox cart along a country path, led by a winged victory and a worker on a horse, followed by banner bearers. The workers, one of whom is identified as Crane himself, are in pseudomedieval peasant dress with sturdy boots. Some, including Crane, wear the bonnet rouge or *pilleus* (worn by the Roman freed slave) in combination with the Phrygian cap worn by

foreigners (i.e. those from Phrygia). Crane holds his palette and brush, implying that painting is a form of manual labour, yet rather than taking an active part in leading the workers on, he sits as a passenger at the very back of the cart.

In his writings, Crane refers to *News From Nowhere* as having been written

as a sort of counterblast to Edward Bellamy's 'Looking Backward', which on its appearance was very widely read on both sides of the water, and there seemed at the time some danger of the picture there given of a socialized state being accepted as the only possible one.[6]

He continues:

Bellamy [...] gives a striking and succinct image of modern social and economic conditions in his illustration or allegory of the coach and horses. The coach is Capitalism. It carries a minority, but even these struggle for a seat, and to maintain their position, frequently falling off, when they either go under altogether, or must help to pull the coach with the majority toiling in the traces of commercial competition.[7]

Crane's use of the ox cart may therefore be his own 'counterblast' to Bellamy's coach – a further allegory, this time representing the security of co-operative socialism. Unlike Bellamy's coach of capitalism, Crane's ox cart of socialism depicts the majority as safely seated, with no-one struggling for position.

Crane's image depicts workers who, despite embarking on a triumphal entry or parade, appear placid, contented and unthreatening. Although some wear the bonnet rouge, it blends in amongst the various other headgear worn, and the general air of contentment and timeless rural festivity in which the workers engage serves to neutralize its threat. The wealth of detail and the complex linearity of the image cause the perusing eye to weave and dance as though looking at an actual parade in motion. His figures parade not through city streets, but past trees and birds, along paths edged with wild flowers. There are no onlookers apart from a woman with a baby in her arms, a flag-waving child and a further woman waving a tambourine, and the viewer must ask: what is the reason for the parade? And where is the torch-bearing angel in the bonnet rouge actually leading them? Although he himself criticized Whistler for avoiding in his 'Nocturnes' the horror and ugliness of industrial London, Crane depicts the celebrations of an imaginary, rural, co-operative society, not the subversive unrest of an industrial, revolutionary one.[8]

In fact, the guilt of the middle classes could be assuaged in such an image of happy peasants as it fails to depict the actual deprivation, hunger and suffering being endured at that time in the countryside. Six years before Crane's *Triumph of Labour* was issued, Hubert von Herkommer's great painting of 1885, *Hard Times*, portrays the economic depression in rural Britain when hundreds of workers on foot were looking for work – a common sight. He paints a family tramping the lanes seeking employment, wracked

with despair, the woman and children collapsed in exhaustion beside the roadside. Crane (despite his great respect for Ford Madox Brown's *Work* and painters such as Stanhope Forbes) writes,

> Grim pictures of the industrial war not infrequently appear in Italian and French salons. [...] I have seen large and lurid canvases depicting strikers on the march with a background of factory chimneys looming through smoke. Apart from their economic and historic significance, however, such subjects may fall in with a certain mood of gloom and pessimism which, in violent reaction from superficial grace and beauty and classical tradition, manifests itself in some quarters. Now and again a new sensation is made by some eccentric genius, as it were, dragging a weird red herring across the fashionable artistic scent, and diverting attention to side tracks in artistic development, often mixed with morbidity, or, as a change from the pursuit of superficial and ephemeral types of beauty, debased and revolting types and loathly subjects are drawn under the pictorial limelight and analysed.[9]

When Crane's *Triumph of Labour* was taken up and used almost a quarter of a century later, circa 1915, for the banner of the National Union of General and Municipal Workers, Plymouth Branch (Plate 72), both the horse leading the procession and the Nike or Victory were omitted, as was the large banner with the legend 'Equality, Liberty, Fraternity'. The ox cart remains, but the workers themselves have undergone a considerable change. They are now attired in modern clothing and the women's skirts are shorter. The little girl to the left of the painting is in white socks and shoes, and the women walking beside the procession wear dark stockings and shoes, but the aprons and headscarves remain. Inside the cart, a woman wears a traditional sun bonnet, whilst the young woman at the front who holds the cornucopia now wears a turban (perhaps representing India). Some of the men still wear smocks, but now with ties. Others wear shirts and knee-length trousers, with long socks and shoes, and modern headgear. The result is a strangely uneasy compromise. Crane's medievalism has been virtually eradicated, as have his references to the French Revolution. Although the title, *The Triumph of Labour*, remains, removed to the bottom of the banner, the image is more related to that of a pageant, with modern workers applauding a cart of farm workers, globe and banner. It is quite self-referential, in that this banner, which may itself be in a procession, is depicting a procession with banners. Even so, it seems a strange choice of subject for municipal workers; one more related to nostalgia for the countryside than to their actual work. It is very far removed from depictions of the triumph of labour that we encountered in banners and certificates from earlier decades – the triumphal arches and the proud workmen building them.

In 1894, during his time as Head of Manchester's School of Art, Crane drew *The Workers' May-Pole* (Plate 64) as a gift to the workers of the world. It was published in the April edition of *Justice* along with his accompanying poem in which he names the female figure in the bonnet rouge (who, with outstretched arms, forms the maypole

itself) as 'Freedom'.[10] Encircling her breast is a wreath or garland of flowers, attached to which are the ribbons that the dancers hold. Legends on the ribbons announce the demands of the workers: 'The Land for the People', 'Eight Hours', 'Employers' Liability', etc. The workers themselves are dressed in the pseudo–fourteenth-century style of clothing combined with modern items such as the shoes and boots that William Morris described his workers as wearing in *News from Nowhere*.

A pagan, phallic symbol, the maypole was bedecked with ribbons and flowers each spring, to ensure that the (female) land would be fertilized and productive. The dance, in which, traditionally, male dancers go in one direction, female dancers in the other, weaving in and out, represents the rhythms of procreation. The ribbons, which symbolize the threads of life and the seasons, are woven and unwoven in an ordered pattern. Crane also sketched out a new banner design in pencil, pen and watercolours for the Manchester Workers' Union, founded on May Day 1898, with workers dancing around a tree bearing fruit or blossom, the rising sun in the background and a winged globe with clasped hands at the top on both sides.[11] This design may again refer to the French Liberty Tree and the maypole tradition. As Greg Smith writes, Crane grafted political meaning and social unity onto the folk tradition of May Day and in his celebration of the renewal of the seasons he 'gave to the workers' struggle something of the historic inevitability fundamental to Marxist thought, without any hint of violent struggle'.[12] The Workers' Union was a militant union, so the design seems a strange choice for them.

Crane's poem that accompanied *The Workers' May-Pole* is simply concerned with keeping merry, being birds of the spring, celebrating May Day with banners and a maypole with garlands, ribbons that flutter from 'Freedom's heart' and is full of references to nature. It is far removed in concept from the slums of the industrial cities. Nostalgia for old, country traditions like the maypole is part of the yearning for preindustrial England. Edward Said explains that, under colonization (and the Victorian working classes may certainly be viewed as a 'colonized' people), 'there is a pressing need for the recovery of the land, which, because of the presence of the colonising outsider, is recoverable at first only through the imagination'.[13] However, it is also a bourgeois dream, constructed in the city by those who wish to escape it, of the natural, organic and rural life in which the relationship to the countryside and to the soil is a form of patriotism but also a retreat in the face of increasing competition from foreign markets.

Folds of the clothing of 'Freedom' appear to rise from her breast at the front and back of her body to join behind her head like petals or stamens of a flower. There is no doubt that she is a goddess of the land, promising fertility and plenty. May Day is associated with the festival of Flora and in the Roman Catholic tradition with the Virgin Mary, the 'bread oven' who gives birth to the Bread of the Eucharist. Many of Crane's later designs for the unions also feature a classicized woman with outstretched arms, but of course any vertical figure with outstretched arms evokes the Crucifixion. Crane appropriates it to symbolize the death of the old order and rebirth of the new era that he envisaged. His cartoon was copied fairly faithfully on the banner of the

National Union of General Workers, Kensal Green Branch, 1910 (Plate 63). By this time, the first Labour MPs had entered the hallowed portals of Parliament and change was beginning, but not the type of change envisaged by Crane.

After the Social Democratic Federation met in London at Hyde Park on 1 May 1894, May Day celebrations became an annual event for the trade union movement. In 1895, Crane drew *Garland for May Day* (Plate 73) as a gift for the workers. It was offered for publication in the *Clarion*, engraved by Carl Hentschel and then sold separately for framing. It formed the inspiration for the banner of the National Union of General Workers, Chelmsford Branch (Plate 74) and, later, for the banner of the National Union of Railwaymen, Wakefield No. 2 Branch, circa 1913 (Plate 62). On the head of May Day is a bonnet rouge. She appears to be based on the most famous Nike of all, the *Winged Victory of Samothrace* (Plate 61), in that she stands with her right foot forward, the lower part of her costume is similar and her outstretched arms evoke the great wings, but now her wings are actually attached to her bonnet rouge rather like the wings of Mercury, the messenger god. Certainly she has come from higher realms, but unlike the great, windswept, rushing Nike of Samothrace, she is strangely still. Behind her is a large wreath of flowers bound together with a ribbon bearing legends such as 'the plough is a better backbone than the factory', 'England should feed her own people', sentiments taken from Blatchford's *Merrie England*. The wreath itself was around the breast of 'Freedom' in his *Workers' May-Pole*, published in *Justice* the previous year, 1894. The flowers in this garland are spring flowers – daffodil, bluebells, iris, daisies, roses. In the banners, her skirt is slightly shorter, and in the Wakefield banner she wears open sandals and the ribbon that snakes around her on the ground is attached to her via a belt. In winged Revolutionary bonnet and folksy, peasant frock, before a wreath of flowers, with 'Merrie England' (not bleak, industrial England) beneath her bare feet, Crane's Nike is a romantic 'Lady Bountiful', not a warlike Nike. The slogan 'Workers of the World Unite' is taken from the *Communist Manifesto*.

In 1903, Crane produced a further *Cartoon to Celebrate May Day* (Plate 68), this time for the front page of the *Sun*, which Horatio Bottomley had purchased in 1902. Originally launched in June 1893, edited by the Irish nationalist MP, T. P. O'Connor, it was printed on salmon-coloured paper and supported the Liberal government of Gladstone. The issue of May Day 1903 was given over by Bottomley to the labour movement, with Ben Tillett, who had led the Dockers' strike, acting as editor. Crane's 'May Day' (her name is inscribed on her bosom) looks towards a huge sun (or perhaps the *Sun*) and its rays, which extend outwards in all directions into the sky. She is the woman from Crane's title page of his *Cartoons for the Cause* of 1897, but her position is reversed. The sun was on the left of the page, she was holding her banner in her right hand and with her left hand sprinkling seed. In this new image of 1903, the dark dome of St Paul's Cathedral is silhouetted against the sky and she is leading the people away from the city and into the countryside. As with his earlier cartoon for May Day and title page for *Cartoons for the Cause*, the lower part of her clothing is based on the classical draperies of the *Winged Victory of Samothrace* (Plate 61), whilst the upper portions are more Central European in style, and she is wearing shoes. She is no longer

a true Nike, however, as she is wingless. On her head is the bonnet rouge, with her left hand she supports a great banner ('The Emancipation of Labour'), which swirls along behind her, and in her right hand she waves a small floral wreath that was around the breast of 'Freedom' in 1894 (Plate 64) and behind the Nike in Crane's cartoon of 1895 (Plate 73). It has now become a corolla or floral chaplet, as described by Pliny the Elder in Chapter 5 of his *Naturalis Historia*. A crown made of flowers, it was awarded as a great honour and reward to victors in sacred contests, with severe punishment meted out to those who misused it and who wore it undeservedly. Crane's Nike waves the chaplet aloft as an incentive and prize to the crowd below who respond by raising their caps in return.

She bears similarities to the Marianne, a female figure holding a lance topped by the bonnet rouge and leaning on fasces, who replaced the king as the insignia on the official seal of the French Republic in 1792. She is young, shapely, monumental, raised up on a grassy hill, and she leads a long parade of workers and their families who also carry banners, and who look up to hear and hail her. But she is completely separated from them. Although they are very close to her, there is no path up to her and they cannot reach her. They are quite literally an 'underclass' to her, in her commanding, upper-class pose.

Apart from a few individualized 'types' at the front, the workers are merely a mass, bearing banners with slogans such as 'International Solidarity of Labour' and 'Fraternity'. However, the eye is drawn to the bottom left to a family (despite the fact that marriage was an institution abolished in socialist utopian thinking). The husband has a child on his shoulder and beside him his wife is respectably clothed with her shopping basket on her arm. The working class has been fitted into the bourgeois mould of the family, perhaps to negate middle-class notions of working class women as immoral and 'easy'. The woman is the producer of children whilst the husband, with his apron, is the producer of craft, their 'natural' roles. A strong contrast is drawn between the two women, this working class woman and 'May Day', both in bodily shape, clothing and pose. Whereas 'May Day' radiates energy with a confident, open pose, her hair flying freely in the breeze and her tightly fitting clothing clearly revealing the lines of her body, the working class woman is still, with her hands protectively across her body, engulfed in a shawl, her hair hidden beneath her sun bonnet – a very closed pose. This contrast in clothing, confidence and pose contributes to and reinforces notions of class identity, and exposes the fiction of art transcending class barriers. Crane himself deplored the trend of women who 'descend into the industrial and professional arena and compete commercially with men'.[14] As working-class women had been there all along in the workforce, Crane must have been referring only to middle-class women who were, in his words, 'descending' – demeaning themselves by working.

Crane's 1909 May Day poster, *Socialist Reconstruction versus Capitalist Constriction* (Plate 75), was dedicated to the workers of the world. He portrays a woman resembling his 'May Day', but now she is armoured. She holds aloft the flaming torch diffusing the light of socialism, the rays of Eos, promising hopes of 'adult suffrage', 'abolition of poverty' and 'public ownership of the means of life'. Eos was the daughter of

Hyperion and Theia, sister of Helios and Selene, her name implying the rosy red of the new dawn.

On the head of Crane's woman is the bonnet rouge with a circle of the laurel wreath of victory and she has a battleaxe hanging from a leather strap across her hip. She stands on a green globe (labelled 'The Earth' – Gaia or *Terra Mater*), which is encircled by a great snake (labelled 'Capitalism'), which she holds by the throat. Beneath her the workers, ensnared and encircled by the snake of Capitalism, struggle to either free themselves from its coils or else to climb up on it to hail her.

This image of woman and snake may have been inspired by the bronze figure of a woman who is in the act of defending a child by slaying a serpent on *The Gladstone Monument* (1905) by Sir William Hamo Thornycroft. She, too, holds the serpent by the throat with her left hand, and with her right hand she raises her sword. The combination of woman and phallic snake has very ancient origins. Gaia gave birth to Erichthonius, the snake god, from the seed discarded by Athena. Her amorous brother Hephaistos had ejaculated over her thigh.[15] The python, on the other hand, was born from mud and was Hera's pet. It was slain by Apollo with an arrow – a metaphor, perhaps, for the sunbeams with which the sun defeats darkness. It was buried under the *omphalos*, or navel of the earth, at his oracle. In this poster, the allegorical woman stands at the pinnacle of the earth, the beams from her torch seemingly having defeated the python of capitalism (although it still seems to be breathing smoke), in order to bring a new dawn of social reconstruction. Because she wears armour and carries a battleaxe, her iconographical origins lie once again in Athena, goddess of war, and of wisdom and crafts, but also in Crane's own armoured warrior, Britomart, in his illustrations to Spenser's *Faerie Queene*. In her pose as torchbearer, she also appears to owe much to the Statue of Liberty in New York (begun 1875, erected 1886, sculptor Frederic Bartholdi, structural engineer Gustave Eiffel), which also holds a torch and is crowned in the rays of Eos. Inscribed at the base of the Statue of Liberty are the words of Emma Lazarus:

> Give me your tired, your poor,
> Your huddled masses yearning to breathe free
> The wretched refuse of your teeming shore
> Send these, the homeless, tempest-tost to me,
> I lift my lamp beside the golden door!

Ben Tillett had been guest editor of the 1903 May Day edition of the *Sun*, for which Crane's *Cartoon to Celebrate May Day* (Plate 68) had featured on the front page. Tillett had led the Dockers' strike, and the early 1890s banner of the Dockers' Union, Export Branch (Plate 76 – discussed in Chapter 10), featured an heroic struggle against the serpent of capitalism. Crane would most probably have been making reference or paying homage to this in his 1909 poster (Plate 75). In the banner of the Dockers' Union, Export Branch, Hercules lowers his head and stares menacingly into the open jaws of the attacking serpent, which he holds firmly at bay. The legend reads, 'We will

fight and may die but we will never surrender.' However, compared with this hugely active, compelling and powerful image, Crane's woman is lifeless, unemotional and drained of any true confrontation with the serpent. There is no strength in her grip and she holds it like a feather boa. There is also a very marked class distinction between the workers and this elegant woman, who has all the poise of the upper class engaged in a philanthropic mission. Her colourful skirt, her sexualized body with armour-encircled breasts and her confident stance all serve to separate her from the bodies and clothing of the working class below her. As in Crane's previous depiction, she literally *looks down* on the poorly clad workers. Unlike the lower-class woman at the bottom left, she has not a hair out of place, despite her supposed struggle with the serpent.

On 1 May 1886, workers in North America went on strike for an 8-hour day and in Chicago six workers were killed in the ensuing violence. The following day a bomb exploded in Chicago's Haymarket, killing eight policemen. Subsequently, four trade unionists were executed by the State of Illinois. In 1889, 1 May (which traditionally celebrated the end of winter) was declared an international workers' holiday in their memory, and the Red Flag symbolized the blood shed for the cause.[16] Crane's woman wears the Red Flag as a skirt.

What of her predecessors? In Rude's *La Marseillaise (The Departure of the Volunteers of 1792)* (1836), Arc de Triomphe, Paris (Plate 77), the body of 'Liberty' is alive with violent action, whilst Crane's woman is static. Rude's great, terrifying woman is a Nike who cries out and rallies with open mouth and uplifted arm, whilst Crane's expressionless figure merely gazes down and holds aloft a torch of socialism. Rude's figure has drawn her sword from its sheath, and she thrusts out to her right with it, her body lunging into a battle charge with a great rush of wings and draperies. She embodies a militant call to liberation via battle and bloodshed. Crane's figure, however, simply holds the torch whose rays state ideals. Her battleaxe remains firmly sheathed. Rude's figure has great, feathered wings with which to soar to tremendous heights, but Crane's is flightless and earthbound. She does not possess wings, the gift of the imagination, the ability to soar in freedom. Delacroix's *Liberty Guiding the People* (1831) depicts a strong, banner-bearing warrior mother who rallies the people and 'gives birth' to a new regime and who, like Rude's terrible, warlike woman, was a Nike who brought change – unlike Crane's unruffled, static woman. It is a familiar pattern in art. Radical protest evaporates, leaving behind it a visual form that is taken up by others.

According to Gorman, the design for the banner (circa 1899) of the Electrical Trades Union (Plate 78) was commissioned from Walter Crane.[17] However, it is quite obviously an adaptation of Crane's earlier depiction of Icarus in a panel in his 'Transport' frieze (1896–97) in Worth Abbey (Plate 79). Electricity was considered miraculous and awesome. But it was also extremely dangerous. Accidental electrocutions were common, sparks from faulty connections caused gas mains to explode and there were many fires. So Icarus would have been a somewhat appropriate model for a union concerned with light but also with danger. He flew too close to the sun and his wings of feathers and wax melted away (rather like the demise of candles with the coming of gas and electric light) and he plummeted to his death.[18]

Icarus stands with outstretched arms and wings on a globe of the world, as does the Nike of the Electrical Trades Union. He is enclosed within a circle formed by figures holding ropes or ribbons in the way that the Nike of the banner is encircled by men who are stepping on or over a circle of light. She wears flowing classical robes caught on one shoulder by a ruby and gold brooch and she has great white wings which, when folded behind her, would reach to her feet. Her arms and wings are spread wide and, as with his May Day of 1895, she wears the laurel wreath, above which, just visible, is the bonnet rouge, and she stands barefoot on a globe of the world. Her hair and wreath of laurel are entirely symmetrical, as are her outstretched arms and wings, so that we know she is completely impartial, but she does not look down to acknowledge the workmen who are reaching up to hail her. She is a vision, an emanation of their dreams. As with her sisters in the old Model Union emblems (Justice, Prudence and Truth), her desirable body represents the desirability of the abstract values she embodies. Once again, she is separated from the workers, of a different class.

Crane's depiction of the worker differs from that of previous emblem and banner designers in that he does not depict the worker as the proud hero, confident and in command of his working environment. The image is constructed in a balanced and overtly classicizing manner with three figures each side of a central figure in paired poses, but he does not depict the workers as conquering heroes. Each wears the bonnet rouge and holds a symbol of the uses of electricity (light bulb, clock, lamp, etc.) and each has one foot just entering the circle of the dream, striving, reaching out and yearning to touch the Nike. To the eye of the educated Victorian it would evoke religious paintings such as the *Assunta* by Titian, where earthbound mortals reach upwards towards a celestial vision of the Virgin Mary, or to the Velázquez painting of 1618 of the Virgin Mary from the description in Revelations 12:1–2, standing on the moon with a crown of 12 stars.

On the reverse of the banner (Plate 80), this association of the Nike with the Virgin Mary is made even clearer. Here, an identical Nike stands in the same pose on the globe of the world within a circle, but the workers have been completely eliminated as though they were unimportant. Instead she is flanked by lilies and roses, flowers associated with the Virgin. We are in no doubt, therefore, that this Nike is as pure and virginal as Mary, and brings into the world not simply electric light, but 'The Light of the World', as Mary brought Christ into the world.

The original design of the 1897 emblem of the United Pattern Makers' Association by Blades, East & Blades (Plate 81) is attributed by Walter Mosses in his 1922 history of the union to Walter Crane.[19] Mosses relates that Crane was responsible for designing the rough outline and how a Woolwich member (G. Twist – 'with exceptional artistic gifts') completed the emblem. Twist is named at the bottom of the emblem as 'J. G. Twist, '97, Del.' (i.e. 'Delineator'). The question of an emblem for the association (which had been formed in 1871) was first raised in 1878 by the Birmingham branch. According to Mosses, the Birmingham branch

must have been in particularly optimistic mood when they made that suggestion, which was accompanied by a proposal that any surplus accruing from the sale

be devoted to the management Fund! The E.C. very prudently deferred action until they received a sufficient guarantee to ensure that the cost of designing and engraving the plate was covered. [...] Needless to say nothing further was heard of the suggestion, and the society had soon enough to occupy their attentions without troubling with emblems.[20]

The question of an emblem was again raised in 1880, when Mosses reports that members were invited to:

send in designs for their inspection and only after a design had been selected and sufficient orders received to cover the cost would they proceed. It was also intimated that any accruing profit would be credited to the Management Fund! These conditions were quite sufficient to quash the wish for an emblem, until, at all events, we became more opulent than we were in 1880.[21]

It was reviewed again in 1893[22] and yet again in 1897 when 'we definitely settled on a design for our emblem, which was issued during the early part of 1898'.[23]

Plate 81 is of a specially issued emblem backdated to 12 August 1873, commemorating the opening of the Bolton Branch, No. 15. It bears the signature of William Mosses as General Secretary. The certifying details were in the centre heart-shaped space in membership certificates.[24]

The overall design of the emblem is, of course, traditional, with an arch (rather in the manner of Alexander Gow's designs) containing the name of the union. There are roundels each side at the top depicting scenes of sea and rail transport with wings attaching to their frames that follow and enclose the line of the arch. There are heraldic influences in shields and cartouches. Workmen, with tools, moulds and products of their labour, stand on a classical plinth with recessed central panel with the governor from a steam engine and a ship's propeller. The winged globe at the base of the supporting platform on which are three workmen, and the winged roundels at the top containing forms of transport, are very much in the style of Crane. Crane used the winged globe with clasped hands on both the front and back of his design for the banner of the Worker's Union, Manchester Branch, circa 1890, possibly copied from the chapter on Renaissance ornamentation in Owen Jones's *The Grammar of Ornament*, where he illustrates a winged wheel with a daisy motif in the centre, itself copied from a panel of the *piscina* of the high altar of the Certosa, Pavia.

Two standing workmen each have one foot, as though to anchor it, on the ribbon bearing the motto of the union, 'One Heart, One Way', taken from Jeremiah 32:39: 'And I will give them one heart, and one way, that they may fear me for ever, for the good of them, and of their children after them.'

In 1872, the triumphal arches on the route of the royal family's procession to St Paul's (to give thanks for the recovery from illness of the Prince of Wales) were decorated not only with flowers and greenery, but with the motto 'The Nation's and the Mother's Heart are one'.[25] So the motto may be seen not merely as a Christian

message but also as a patriotic one. The 'one heart' is echoed in the heart-shaped central portion of the emblem containing the member's certificate. The 'one way' may be an overtly Christian message whilst also referring to the 'one way' of Freemasonry, as the cartouche above the central heart bears the Freemasonry symbol of dividers and set square surrounded by the initials of the association, 'UPMA'.

Growing out of the top of the cartouche, with its roots firmly in its frame, is a stylized Welsh leek, whilst English roses, Scottish thistles and Irish shamrocks form a decorative background behind the three craftsmen.

The patternmakers illustrated are of different ages. Seated on a mould box, holding brace and bit, and looking eagerly upwards towards the certificate where his name will one day appear, is the apprentice. Standing to the right, in a very active, commanding pose, reminiscent of the *Apollo Belvedere*,[26] with his right hand resting actually on the certificate is, perhaps, the journeyman, apronless and holding callipers. At the left, behind the apprentice, is the senior worker, the master craftsman with greying beard and hair, with one hand on the shoulder of the apprentice and in the other holding a rule. It is a visual cycle of the transmission of skills, from master craftsman to young apprentice, thence to journeyman and back again to master craftsman. It is novel in that the name of the new member is, quite literally, at the 'heart' of the emblem, instead of being incorporated into the base of the architecture. It is being looked at and acknowledged by the three workmen, so the new member is being welcomed by them. In their three levels of rank, they are symbolic of the path of his career within the union and what he will achieve.

This design is so very different from Crane's other work, either for unions or used by unions, that one has to speculate why. Leeson is of the opinion that

> the need to assemble a variety of obligatory elements and relate them in a pattern dictated not entirely by artistic considerations, but by the reconciling of various opinions and interests within the client organization, may have presented a task that did not appeal to him.[27]

And, indeed, it has to be said that representing the working classes as proud, part of the modern world and dressed in smart, up-to-date clothing with polished shoes and boots and well-cut hair is not something for which Crane is known. However, it is obvious from the discussions within the union in previous years, quoted above, that there was no spare money for commissioning an emblem (and indeed certainly not from such a leading British artist of the day as Walter Crane). The most probable explanation is that sometime after 1880, Crane did a rough sketch as a favour to the union. Crane is known to have made sketches for trade union banners upon request, and it seems that this may perhaps have been another such favour. It also raises the question as to what extent the finished emblem of the Pattern Makers is true to Crane's original design. The workmen are so unlike any other of Crane's in his designs for the unions that one might decide that Twist had a fairly large influence on their finished appearance, or perhaps also the engravers, Blades, East & Blades.

The purchase of the certificate was, however, an expense that not many of the Pattern Makers were prepared to pay, as Mosses recalls of Crane's emblem: 'We ordered 3,000 copies, and it was many weary years before we exhausted our supply.'[28]

Despite reproducing many photographs of the Executive Council, Presidents, Secretaries, Treasurers, groups of delegates, and even the staff of the General Office, Mosses does not reproduce Crane's emblem in his book of 1922. His use of the words 'weary' and 'exhausted' give us a further clue to his attitude to the certificate, which obviously took a very long time to finally sell out.

One side of a banner of the National Union of Gasworkers and General Labourers, Bristol District No. 1 Branch (Plate 82), is signed 'L. Stracey, Bristol, after Walter Crane'. The other side of the banner is signed 'H. E. Stacey, Bristol, 1893'. The legend 'The Cause of Labour is the Hope of the World' is printed on encircling strapwork, one of Crane's women with outstretched arms is at the centre top, his great sun is in the centre with 'Workers Unite' inscribed on it and two workers perform the handshake of brotherhood across its surface. They wear the bonnet rouge and carry the tools of their trade, but they resemble illustrations from his children's books. The worker on the right with his shovel, pick and cape over his shoulders could be one of the Seven Dwarves or a fairytale elf from Crane's children's books. Crane uses two very similar figures again on the cover of *Fabian Essays* (1889), which advocated a new and equal society brought about not by revolution but by the consent of the majority. In this, the raised feet of the two workmen are on the rungs of the ladder of Capitalism on which is perched the figure of Privilege with a revolver in each hand pointing down at them. As late as 1913, two similarly dressed and styled men flank fasces in his emblem for the General Federation of Trade Unions. Quite obviously the Pattern Makers had not wished to be represented in this way, which, of course, raises the question of why unions such as the National Union of Gasworkers and General Labourers were prepared to be patronized like this. This banner bears no resemblance to their very fine certificate of three years earlier, 1890, by Alexander Gow (Plate 35).

Perhaps the reason the unions adopted his work was because Crane was a successful, middle-class man who, although he never spoke at mass rallies and was far less well known than William Morris, was at the forefront of publicity for socialism, the 'sacred centre'. He was the first President of the Arts and Crafts Exhibition Society and his political cartoons were extremely well known. He even designed the firework display for May Day in 1899 at the Crystal Palace in which four workers appeared with his angel of liberty and the slogan 'The Unity of Labour is the Hope of the World'.[29] But above all, a major factor was that he did not initially charge for his designs for the unions – designs that would have constituted a major, maybe even impossible, outlay for new unions, especially for those of the unskilled (although in later life he insisted on payment for his work).[30] They may not, perhaps, have understood that his work for them represented the aestheticization of his politics. Rather than upholding their factory-made goods as the product of honest working-class labour, he pursued his own cultural mission for the handcrafted. His cartoons for them often resemble the early woodcut, decorative and Blake-like in its poetic linearity, combined with the modern

trend toward flatness, allowing no penetration into the image. Although he reveals openly the means by which the illusion is created, the viewer lacks a sense of *belonging* to the exploited class.

We may remember the comment by John Barrell concerning Constable's work of the 1820s:

> [He] reduces all labourers to serfs, but [...] in the very same act he presents them as involved in an enviable [...] relationship with the natural world, which allowed his [...] admirers [...] to ignore the fact that the basis of his social harmony is social division.[31]

Barrell could have been writing of Walter Crane. Crane's subject matter and style reveal a reforming desire for contented, well-fed workers, but workers who were picturesque labourers or peasants, not his own social equals. Even when he depicts himself with his palette and brushes riding with them in the ox cart, does he genuinely belong there? Whereas Sharples and Waudby had raised the skilled working man to a higher social level by elevating him upon pedestals and by endowing him with middle-class values, Crane (apart from the certificate of the United Pattern Makers' Association of 1897) reduces the working man back to the peasant, rooted to the soil. Whereas Ford Madox Brown in *Work* (Plate 12) had painted the craftsman with a bow tie, an elegant waistcoat and a copy of the *Times*, Crane's worker wears the Phrygian cap of the freed slave, but not the bowler hat of Waudby's carpenters. The pride of the workers in their mastery of new skills and abilities in an age of technology and education, depicted in earlier emblems and banners, has been taken away from them. Instead, they are participants in his own dream of a circular pattern of rebirth and revival, of continuity with the past, a dream that often depicts outdated technology and costume of indeterminate period. They are certainly not the workers whom Karl Marx had envisaged when, in 1856, he had said,

> We know that to work well the new-fangled forces of society, they only want to be mastered by new-fangled men – and such are the working men. They are as much the invention of modern time as machinery itself. [...] The English working men are the first-born sons of modern industry. They will then, certainly, not be the last in aiding the social revolution produced by that industry, a revolution which means the emancipation of their own class all over the world.[32]

During the 1880s, a time of depression and unemployment, large numbers of Eastern European immigrants settled in the East End of London. In Spitalfields alone it was estimated that there were over a thousand inhabitants per acre.[33] On Sunday 13 November 1887, a day that came to be known as 'Bloody Sunday', a mass meeting was held in London of workers and the unemployed to protest against the death sentences handed out to the Chicago anarchists. The meeting was prevented by police, under Sir Charles Warren, Chief of the Metropolitan Police, from congregating in

Trafalgar Square. Many of the marchers, including Morris and his followers, were intercepted and dispersed with considerable force before they could even reach the square. The guards were called out, bayonets unsheathed, and a magistrate read the Riot Act. Some seventy-five people were arrested, some were later jailed, and there were three fatalities. Crane himself narrowly escaped injury, but many colleagues and innocent onlookers were injured and he was immensely shocked at the bloodshed. He recorded his revulsion at the violence, writing,

> I never saw anything more like real warfare in my life – only the attack was all on
> *one* side. The police [...] drove the people right against the shutters of the shops
> in the Strand.[34]

On the following Sunday, whilst attempting to prevent a further gathering in Trafalgar Square, mounted police rode down a young bystander, Alfred Linnell, a law writer, who sustained fatal injuries. His funeral was planned by the socialists. Morris wrote a death song for which Malcolm Lawson composed music and Crane designed a cover.

Crane was not a gifted speaker, and it was said that his style was jerky and lacking in vigour, and that his lectures were only bearable when he drew with chalk on the blackboard to illustrate his meaning. His early papers were published in *The Claims of Decorative Art* in 1892. However it appears that he was snubbed by the establishment.[35] George Bernard Shaw records that he and Crane 'used to be plentifully sneered at as fops and arm-chair socialists'.[36] One cannot help thinking that, despite Crane's undoubtedly deep dedication to the cause, this criticism may, in part, have been justified. Crane had himself been photographed in his studio wearing the bonnet rouge, but one feels that he only played at being a revolutionary because he could afford to. This was a man who took a two-year honeymoon in Italy, a man who moved in the privileged, leisured, country house set – he wrote that he actually first met William Morris in 1870 at a dinner in the home of the Earl of Carlisle.[37] Always the pacifist, he looked to reform, not to violence, anarchy or revolution. In 1892, he and Morris withdrew from the Socialist League as it had become increasingly anarchistic and, along with 18 others, he resigned his membership of the Fabian Society when it failed to oppose British participation in the Boer War of 1900.

If we ask of Crane's 'maypole' imagery the Nietzsche question:

> Whenever a person reveals something, one can ask: what is it supposed to conceal?
> From what is it supposed to divert the eyes? What prejudice is it supposed to
> arouse? And additionally: how far does the subtlety of this dissimulation go? And
> in what way has it failed?[38]

the answer is surprising. For perhaps it may be seen as the most backward step of all for union imagery in that it removes the attributes of rationality, pride, social standing and self-sufficiency depicted in earlier banners and certificates. Most of all, it avoids

social realism. The workers are trivialized and depicted as happy serfs in a romantic, rural, fairy tale idyll.

One side of the banner of the National Builders', Labourers' and Constructional Workers' Society, Shamrock Branch (Plate 83), produced by the Tutill banner manufacturing workshop, reproduces a design by Walter Crane executed for the front cover of the 1894 Christmas edition of the *Labour Leader*.[39] On the left is a woman in apron and sunbonnet with a rake and basket of produce (i.e. 'Nature/Fertility') and on the right is a man in boots, peaked cap, smock-like shirt tucked into his trousers and cape, with a pick and shovel (i.e. 'Manual Labour'). They hold between them a staff with the bonnet rouge on the top and supporting a banner 'The cause of Labour is the Hope of the World'. The man has a small child on his shoulder who also wears a bonnet rouge. Beneath is a poem by Crane:

> With good luck to labour. Hand, heart and brain.
> Stick fast to your banner, stand solid, not veer.
> Till the cause of the workers renews earth again.

It is interesting that it is not the betterment of the lot of the workers being wished for by Crane, but a renewal of the earth by them, a beautifying of the land in which there is still a 'natural' hierarchical order. The pick and shovel, the rake, these are the tools with which he expects the peasant worker to labour to renew the land – a moral discipline, a romantic vision of harmony with the seasons. The reality of such work was, of course, back-breaking, dirty and muddy.

By the time the banner of the National Union of General Workers, Kensal Green Branch, was being made with its maypole (Plate 63), Bleriot had flown the Channel, and both the telephone and motor bus were in use. Why did modern unions accept these archaic images so readily, and adopt them for their banners? Even Isobel Spencer, in her definitive monograph on Walter Crane, writes that his images of 'Rural Merrie England rather than the bleak industrial reality' were used by trade unions 'for a surprisingly long time into the twentieth century'.[40] The *Art Journal* in 1870 had written of Crane's work:

> It would be hard to find anywhere talent associated with greater eccentricity than in the clever, yet abnormal, creations of Walter Crane [...]. Such a style may be set down as an anachronism; yet, beset as we are by the meanest naturalism, we hail with delight a manner which, though by many deemed mistaken, carries the mind into the regions of the imagination [...]. Though not wholly satisfactory, we hail with gladness the advent of an Art which reverts to historic associations, and carries the mind back to olden styles, when painting was the twin sister of poetry.[41]

Socialism and the trade union movement had never been happy bedfellows. For example, in 1862, Professor Beesley, in a letter to the Operative Bricklayers' Society, wrote,

> Holding, as I do, that the relation between employer and labourer is inevitably permanent and that it is the only sound condition of industrial society, I look

to Trade Societies as the chief means for placing it on a more healthy footing. Co-operation can never supersede the present system. [...] Such language as Mr. Kingsley's is simply disgraceful.[42] There is much to mend, no doubt, among manufacturers, but they are an infinitely better and nobler class than squires and rectors. The time, I hope, is gone by when working men will listen to sentimental milk-and-water socialism, preached by men in white ties who hate the manufacturer much more than they care for the workmen.[43]

According to Proudhon, art has a power to incite people into action.[44] Crane appears to have held the same opinion, writing,

From ideals in art we are led to ideals in life and to the greatest art of all – *The art of Life*.[45]

Even in his poster, *Social Reconstruction versus Capitalist Constriction* (Plate 75), despite depicting struggling and downtrodden workers, he resists any temptation to goad them on into action. The hands that reach up are only *hailing* the concept of socialism. Two of the men hold their hats aloft to cheer. They are not reaching out to take anything for themselves.

Because art has the power to incite, Proudhon argues that a society as a whole, not the individual or artist, should determine its subjects and uses. The artist should function as the collaborator of the social reformer, subject matter and style should follow from art's function in social reform, and he calls for a committed art, inspired and directed by society or by those who speak for it. Influenced by, amongst other things, the events of Bloody Sunday, Crane may have decided to create a reactionary art, not a revolutionary one. As he himself wrote:

If it is agreed that art, after all, may be summed up as the expression of character, it follows that the more we realize an artist's personality the clearer understanding we shall get of his work.[46]

Crane is undoubtedly a British icon, but we must allow his work to speak for itself. To some extent he can be viewed as a patron of the art displayed on trade union banners, the very word patronage itself denoting a class difference. His work for the unions is normally viewed as a part of his overall oeuvre, not seen in comparison with the work of other artists producing emblems for the unions and the workers. What is revealed is his own class-based ideology founded on social division. Unlike the proud workers of the worker artist James Sharples, Crane's workers are well-dressed peasants.

As Proudhon wrote,

(Art's) task is to improve us, help us and save us. In order to improve us, it must first of all know us, and in order to know us, it must see us as we are and not in some fantastic, reflected image which is no longer us. [...] Man will become his

own mirror, and he will learn how to contemplate his soul through studying his true countenance.[47]

In his work, Crane does not depict the 'true countenance' of the worker. He stands alone in employing for the working classes what might be stylistically described as Social *Unrealism*. He depicts workers as 'other', as picturesque spectacle in his own 'master fiction' – a Britain that never existed, and never would exist; a nostalgic fantasy; a dead end.

Chapter 10

THE ART OF COPYING

Annie Ravenhill-Johnson

Copying formed a large part of an artist's training. In this chapter, a selection of the vast variety of copied subjects that find their way into trade union emblems is examined. Emblem designers cast their net wide, copying from Renaissance artists such as Raphael to artists of their own era such as Lord Leighton, from portraits and from sculpture. The influence of high art is very much apparent in the emblems, but was the reverse possible? Could the art of the unions, perhaps, have even exercised an influence on high art itself?

The emblem commemorating the opening in 1830 of the Steam Engine Makers' Society, Rochdale Branch No. 3 (Plate 84), features a sculptural edifice with James Watt seated at the top. At the centre of the peak of the emblem, in what might even be a sacred monstrance or reliquary, is the hive of industry, flanked by the date 1854, whilst the certificate itself refers to the date of the establishment of the society as 2 November 1824. The emblem is difficult to date, but stylistically it is probably no earlier than the mid 1860s.

Within an arched niche in this Gothic, stone-coloured framework, James Watt is seated on a tiered, white marble socle in a triangular format with four allegorical women in attendance who hold pens and books (embodiments of the design process). Above, two flying female figures with trumpets (Nikes, angels or goddesses of fame) are entwined with strapwork or ribbon bearing the name of the society. Golden rays of blessings descend on Watt from the eye of God above in the sky as though, with his book and pen, he were a gospel writer. In decorated niches within the stonework on each side of him are the figures of Caritas, with children, and Temperance. Beneath his feet is a technical drawing of his steam engine (an adaptation and improvement of Newcomen's steam engine). An engineer stands on a plinth at each side.

This statue raised to Watt is in an outdoor setting surrounded by lush vegetation. To the left is an horizon with a ship leaving a dock, leaving a white trail in its wake, and on the right a viaduct over a canal with a canal steam boat (such as the *Charlotte Dundas* or the *Pioneer*) also leaving a white plume of smoke, and a mill. At the base of the Gothic frame are two tiny railway tunnels with trains on the tracks. The figure of

James Watt is faithfully copied (with additional colour) from Sir Francis Chantrey's white marble statue of Watt of 1825 in Westminster Abbey (now removed).[1]

This reproduction of a famous work of art on a trade union banner or certificate is part of a long tradition dating back to at least Sharples's certificate of the Amalgamated Society of Engineers, Machinists, Millwrights, Smiths and Pattern Makers of 1852 (Plate 45). The portrait that he reproduces on the right is very obviously copied from the *Portrait of Sir Richard Arkwright* (1790) by Joseph Wright of Derby. The wig, the clothing and the sitter's gaze to his left are all replicated. That of James Watt is copied from the portrait bust with classical toga of 1816 by Sir Francis Chantrey (now in the Kelvingrove Gallery, Glasgow). Similarly, the portrait of Samuel Crompton is copied from the portrait by Charles Allingham, circa 1828. In an age before photography, the copying of a well-known portrait of a famous person was the preferred way of representing them in order for them to be instantly recognized. Where there was no known portrait, as for example with William Caxton and Wynkyn de Worde in the certificate of the Typographical Association, 1879 (Plate 49), a fictive portrait could easily be inserted, duly labelled for identification. Later, when photographic portraits became available, photographic representations of union leaders served to bring a modern, up to date air to a banner or certificate, easily replaced in later certificates by photographs of those succeeding them, and in banners by overpainting. The format used for this portraiture was derived from classical portrait busts or coins and they appear, quite literally, as the 'heads' of the union. The ordinary workers, however, frequently appear as general 'types', and are not dignified by portraiture.

This is particularly apparent in the 1890s certificate of the Durham Miners' Association by Alexander Gow (Plate 29). Each side of the inner, arched space are portraits of union leaders, all four of which would have been copied by Gow from *cartes de visite*. The lower two are defined by curious frames with pierced wrought ironwork at the top, inset into a classical frieze at eye level behind the subject and quarter roundels at the lower corners, all very much influenced in style by Owen Jones's *The Grammar of Ornament* (1856). From this treatment, it is made apparent that these two oval portraits represent union officials who are of a different rank, set apart from the two above who are in plain oval frames. Their high foreheads indicate reason and intellect. Icons of the industry, their framed portraits afford them added dignity, separating and elevating them above the common workers.

Early sociologists such as Herbert Spencer used body metaphors to explain theories on the organic nature of society.[2] 'Heads' (as in these portrait cameos) were the male governing, thinking group. Middle-class women were the soul, whilst working-class women were the body's orifices, the parts most segregated from public gaze and most removed from decision making.[3] 'Hands' were the unthinking 'doers' of either sex. Here, the 'hands' are depicted underground (literally *beneath* the 'heads') simply as stereotypes. Dark-haired and clean-shaven except for neat moustaches, they are all in similar clothing. We know from royal commission reports of the Victorian era that miners worked naked or seminaked in the darkness, dampness and heat of the mine, but Gow has attempted to 'sanitize' these anonymous working miners by clothing them

in short trousers, hats and shirts, which contrast sharply with the expensive dark suits, ties and gold watch chains of the union officials. Gow appears to have been heavily influenced by either *Sketches of the Coal Mines in Northumberland and Durham* (1839) by Thomas H. Hair (reissued in 1844 with additional text by M. Ross), in which the dress of the miners was described, or by a painting by the Newcastle genre artist, Henry Perlee Parker, *Pitmen Playing at Quoits* (circa 1840), who translated this description into paint. Gow has depicted his working miners in the same checked flannel jacket, short-cuffed trousers, knitted leg warmers and turban. What is obvious from this certificate is that the vastly different manner in which the working miners and the union officials are portrayed bears unwitting testimony to the fact that, even within the union itself, a rigid class system operated.

There is something base about Gow's miners in their stooped labours as they crouch in their subterranean caverns, literally 'underground' at the very bottom of the image, stamped out like peas in a pod with no real individuality or personality. Their pose (especially the figure on the left with his lowered hands) resembles the *Scythian Knife Grinder* who prepares the knife with which Apollo will flay Marsyas, one of the few depictions of manual labour in ancient sculpture.[4] The way in which their shirts blouse at the back is also similar to the knife grinder's draperies. One may perhaps read into this certificate a veiled threat of violence. Anyone who challenges the 'heads' of this industry (as Marsyas had challenged Apollo) should know that their minions are already sharpening their weapons.

Artists of the Victorian period were trained to copy before being allowed to draw from life. Working class artists studying at night school or in Mechanics' Institutes copied from art primers, engravings and books. Charles Knight, originally agent for Brougham's Society for the Diffusion of Useful Knowledge (circa 1833–69), issued books for the working classes in cheap monthly or weekly parts, including the works of Shakespeare, a *Pictorial History of England*, a *Pictorial Bible* and a *Penny Encyclopaedia*,[5] and books such as these provided a rich source that could enable social integration and construction of identity to be achieved by the working classes through the appropriation and adaptation of high art. So it is perhaps not surprising that when designing an emblem for a union that artists looked to a readily available source for inspiration, and indeed, as we have already noted, the socialist artist Walter Crane frequently offered his work freely as a resource. The basic design of an emblem was already established from the emblems of the confraternities, the frontispiece and pegma, so it was simply a question of designing a framing architectural screen and then filling in appropriate scenes, or those specifically requested by the customer, then embellishing the result with regional or national flowers, a Latin motto or a literary quotation to add an air of refinement and erudition, the ubiquitous handshake, decorative female personifications and of course the name of the union or society, prominently lettered. The scene illustrating the Aesop fable of the 'Bundle of Sticks' that appears on a banner of the Workers' Union, Watford Branches Nos. 287 and 632, and which is on the front cover of Gorman's definitive account of trade union banners, *Banner Bright*, is an adaptation of an earlier painting or illustration. The figures and their poses are, for example,

virtually identical to those on a Sadler and Green earthenware tile of the 1770s in which the men are in eighteenth-century costume, and this would of course have been copied from an even earlier source. Art is never 'innocent', never uninfluenced by what has gone before and never more so than when it reveals this knowledge by displaying difference.

When, in 1868, A. J. Waudby was commissioned to design a new emblem for the Stone Masons' Friendly Society (Plate 10) with instructions to include a prominent representation of the Building of Solomon's Temple, what could have been easier than to look to the work of the Old Masters and copy from them? He copied from a reproduction of *The Building of Solomon's Temple* by Raphael, part of the frescoes for the Loggia at the Vatican. Similarly, according to the key quoted by Chandler, when designing the emblem of the Amalgamated Society of Carpenters and Joiners (Plate 2), Waudby copied his representation of the centring of an arch from the well-known frontispiece from Nicholson's *Practical Carpentry* (1826), with the addition of two figures representing carpenters at work.[6] Beneath is a vignette of the workshop that, the union is at pains to point out, was 'drawn on the spot'. This information would reassure members that their payment to the artist included a personal visit to view and draw the trade at work, thus representing value for their money.

Manufacturers would use a standard design and adapt it for various unions. Blades, East & Blades, for example, use a very similar style in their certificates for the United Machine Workers' Association (Plate 16) in the 1880s and for the Dock, Wharf, Riverside and General Labourers' Union (Plate 36) in 1891. The general layout is similar, with Justice and Hope on raised pedestals bearing the various occupations within the union upon them. Unions themselves amended and adapted their emblems for local use. So different from the Dockers' Export Branch banner (Plate 76) of similar date this latter certificate (Plate 40) gives more than a touch of class to a new union of the unskilled and skilled to show that they had 'arrived'.

A variant of Waudby's Operative Bricklayers' Society design of 1861 (Plate 46) appears in a regional certificate (the certificate of the Manchester Unity of the Operative Bricklayers, Plate 38), which bears the inscription 'Designed by Arthur John Waudby 108 College St. London N.W., printed by J. S. Dutton Market Place Stockport Engraved by C. H. Jeens & J. H. le Keux'. The Manchester Order of the Operative Bricklayers' Society was the old Operative Bricklayers' Society of 1829, the London Order being an offshoot. The Manchester Order was two or three times bigger than the London Order, but the London Order spread northwards from 1863, and there was much conflict between the two.[7] The certifying details of the regional emblem held by the People's History Museum, Manchester, reveal that it is a twentieth-century certificate, with the date '19_' waiting to be filled in. The basic structure is similar in the bottom half of the design to Waudby's original design, but the top half is no longer stepped with Truth and Prudence at each side. Art, with her putto carving a bust of Wren and a further putto painting at an easel, has been moved from the bottom right of the structure to the very top in place of Justice, flanked by Justice and Truth. The architect and builder are still on the scaffolding, but their positions have been reversed

so that the builder is on the left now, and the architect on the right. The central depiction of the insertion of a keystone into an arch has been moved to the left archway, a new scene of brickmaking with a factory in the background is now in the central position and the vignette of gauge making (now with three figures instead of one) is in the right-hand archway, still with the original spelling of 'Guaging'.[8] The circular window at the bottom left contains a depiction of Manchester's Free Trade Hall in Peter Street by Edward Walters (built in 1854 on the site of the field of the Peterloo Massacre in 1819),[9] rather than that of London and St Paul's, with Science beneath being replaced by a personification of Manchester with a distaff. To the right, Rome and St Peter's have been replaced by 'Landing Stage' with a personification of Liverpool beneath with anchor, trident and cornucopia. Manchester looks towards the Landing Stage of Liverpool for her imports and exports, whilst Liverpool gazes towards the Free Trade Hall of Manchester as the market for her goods. Manchester itself had a port, but the shipping canal was not opened until 1894. The roundels of Peace and Industry appear again but in reversed positions so that Manchester now has her hand on the hive of industry, whilst Liverpool's hand rests on the dove of peace. The dove has the olive branch in its mouth that it brought back to Noah after the Flood, perhaps further underlining the seafaring connections of Liverpool. Two putti at the base now hold fasces, acting as lictors, rather than pulling back cloth to unveil the certifying details. The largest, central vignette of 'The First Bricklayers' has been amended but still contains a depiction of the Tower of Babel surrounded by cloud, the blueprint for its design, and three figures to the left. The architect is now in a commanding position in the centre with his left arm raised and pointing upwards and with a trowel in his right hand. Waudby is thought to have died in 1872, so although the design is accredited to him, he may not have actually carried out these amendments himself.

Artists working for the unions copied not just from the works of famous artists but also from each other. For example, Chant and Saddler in 1857 closely copied the format of Sharples's emblem for their emblem of the Friendly Society of Iron Founders (Plate 21). Not only did they copy the basic design of the emblem from Sharples, but the interior scenes were copied from a drawing of a foundry of Messrs Mare & Co., Baw Creek, Blackwall, London, from one of Messrs Bradley & Nevins, Great Guildford St, Southwark, London and from drawings of two blast or smelting furnaces at Oak Farm, near Dudley. Even the phoenix on its nest of flames in this emblem is copied from Sharples, as is the fictive stone where the certifying details are written, and the regional flowers. Gow and Butterfield's 1882 certificate of the Amalgamated Society of Operative Cotton Spinners (Plate 32) features in elaborate cartouches the same portraits of Crompton and Arkwright that Sharples had used, and even in the same positions in the emblem. Rather than including a portrait of James Watt in the central image, however, the 'Spinning Mule' of Crompton and Arkwright is featured, an image that appears to have been adapted from an illustration in the 1836 book by Edward Baines, *The History of Cotton Manufacture*.

In the certificate of the Typographical Association, 1879 (Plate 49), the artist, E. H. Corbould, has copied from a painting by E. H. Wetomert of Caxton reading his first

proof sheet, with cropping and amendments. Corbould's fictive portrait of Caxton from this certificate is reproduced in the 1894 certificate of the London Society of Compositors by Alexander Gow (Plate 15). This is an interesting development, revealing that a purely fictive, imagined portrait is now being recognized, accepted and reproduced. There is also a depiction of Caxton displaying to Edward IV his first specimen of printing, which has been copied, very poorly it has to be said, from the painting of 1851 by Daniel Maclise.

In the certificate of the Amalgamated Association of Card and Blowing Room Operatives by Alexander Gow of 1890 (Plate 33), at the very top of the emblem in a central oval is a portrait of what Leeson refers to as 'a mysterious lady'.[10] She is, in fact, the goddess Athena, helmetless, without her aegis, in her role as goddess of craft, spinning and weaving, holding her attribute, the distaff. She sits at a dockside on bales, with a sailing ship to the right and factories to her left. Some two years later she appears again in an oval at the top of the certificate of the Tin and Iron Plate Workers, 1900s (Plate 30), in a very similar vignette, holding her distaff and seated again on bales with a factory to her left and a sailing ship to her right. She is a fitting goddess for the tinplate industry because, as Hesiod in *Homeric Hymn XX, To Hephaestus* tells us, she, together with her brother Hephaistos (Roman: Vulcan), god of the forge and metalworking, brings civilizing influences to mankind:

> Sing, clear-voiced Muse, of Hephaistos famed for inventions. With bright-eyed Athena he taught men glorious crafts throughout the world – men who before used to dwell in caves in the mountains like wild beasts.[11]

When depicting classical figures such as Athena, artists had a rich variety of Renaissance models from which to copy or adapt. In addition, they borrowed from emblem books such as that by Alciati.

The certificate of the Associated Society of Locomotive Engineers and Firemen (Plate 25), designed and engraved by Goodall & Suddick of Leeds (1916), depicts Hercules and the lion, and Vulcan. Hercules is very Florentine in concept, with echoes of Bartolomeo Ammannati's *Fountain of Neptune* (1563–75), Baccio Bandinelli's *Hercules and Cacus* (circa 1530) and Piero della Francesca's *Hercules* (late fifteenth century). Vulcan, on the other hand, has been copied straight from *Apollo at the Forge of Vulcan* by Velázquez (1630). Hephaistos/Vulcan, the divine craftsman of the forge, was lame, either from birth or from his fall from Olympus,[12] and he learned his skills from the Nereids. His crippled condition conforms to the authentic social reality in the Greek world where metalworking was one of the few professions available to the lame. In Velázquez's painting, the viewer cannot be certain that the god is represented as lame, as Velázquez teases the viewer, playing with his or her expectations and preconceived notions. Vulcan may be simply leaning to one side to put down a heavy hammer, shifting his weight to one side or even beginning the swing of the hammer. According to John Moffit, Velázquez derived the torso of Vulcan from one of many copies of Polyclitus's famous *Doryphorus* (Spear bearer),[13]

but there are many small Roman bronzes that depict Vulcan in this stance, with his body bent to his left.

The 1899 banner of the Amalgamated Society of Carpenters and Joiners, Chatham District Branch, refurbished after 1927 (Plate 40), was a local variant of Waudby's original design of the emblem for the society. The framing structure is altered and truncated, with the portraits of carpenter and joiner in niches each side. Whereas in the earlier emblem (Plate 2) these figures stood at the bottom, removed from the structure as though they had just finished building it (serving as choric figures, intermediaries or donors), now a very big change has taken place. They have actually entered the structure itself and occupy the position normally accorded to saints in an altarpiece. And, like saints, they are identifiable by their attributes (the saw, the ruler, the plane and the apron). The headgear of the carpenter on the right even resembles a halo, and the figures are as calm and as contemplative as saints. Waudby invests the figures with status and elitism by drawing on the traditions of high art in this way.

Decorative cords and tassels painted within the banner repeat the cords and tassels that would have been actually attached to its pole for carrying purposes. Such self-referentiality is a feature of many trade union banners and is in accordance with the tradition of Renaissance altarpieces such as Mantegna's *San Zeno Altarpiece*, wherein columns and capitals of the actual wooden frame are repeated within the painting, thus appearing to join the 'real' world with the fictive world within the painting.

In the Carpenters and Joiners banner, there is a startling resemblance to the Giovanni Bellini triptych, *Madonna and Child with Saints* (1488), in the Frari, Venice (Plate 41), which is itself based on the configuration of a classical recess flanked by wings, standing on a base and surmounted by a pediment, described by Serlio in his *Architettura* (1537):

> This figure following, may be used by the learned workeman for diuers things, and may bee altered according to the accidents that shall happen: it will also serue for a Painter to beautify an Altar withall, as men at this day doe in Italy: it may also serue for an Arch tryumphant, if you take away the Basement in the middle. Likewise, you may beautifie a Gate withall, leauing out the wings on the sides: sometimes, for setting forth a Window, a Niche, a Tabernacle, or such like things.[14]

This format became extremely popular both in architecture and art and it is used, for example, for the frontispiece of Henry Peacham's *The Compleat Gentleman* (1622).

The same viewpoint used by Giovanni Bellini has been adopted, so that the floor on which the figures stand may be seen by the viewer. Each of the two workmen, in their darkened niches, has a legend beneath and a symbol above. On the left, the legend reads, 'Industry and Benevolence', whilst above, the dove of peace descends, like the Holy Spirit. On the right, the legend reads, like a prayer, 'Unite us in Friendship', whilst above the hand of friendship holds the Sacred Heart. The carpenter's workshop is in the lower scene where music-making angels are below the Madonna and Child in the Bellini. Musical instruments have given way to instruments of labour. We hear no heavenly

music, but instead the clatter and noise of the workshop. Whereas Dominic appears as founder of his order in Giovanni Bellini's altarpiece, in the banner both carpenter and joiner are portraits of James Payne, the Chairman of the Executive Council in 1862.

Thomas Jenner, in his book *The Soules Solace or Thirtie and One Spirituall Emblems* (1631–56) uses the carpenter as an emblem of reconciliation to God, which may be why the banner takes the form of an altarpiece with the carpenter and joiner in the place accorded to saints.[15] The carpenter finishes forms, glues them together, and from the two makes one, in the way that God and man, separated, are reunited by Christ the Carpenter. His may be the significant absence in the lower scene, with its altar-like workbench; the Madonna's, that of the upper with the empty 'halo' of the bridge. It is as though the containing Renaissance space lingers, but the Madonna and deity are absent, and only hinted at. Perhaps the motto *Credo sed caveo* (I believe but I am wary) may also be explained in this way.

The great commercial banner maker, George Tutill, produced double-sided banners in pure silk not only for the unions, but also for churches, Sunday schools and friendly societies. He claimed that his banners were produced on the largest and finest silk looms in the world.[16] His company undertook custom-made commissions, with an additional charge for copying buildings, technical processes or portraits from photographs onto a banner. Full written descriptions of a person's hair and eye colour had to be submitted along with the photograph as of course photography was not in colour. Everything a union should need could be supplied by Tutill – not simply silk banners, printed woollen bunting flags and the woollen death flags lettered with the name of the deceased (which were hung from the window of a lodge to notify the brethren of the death of a member), but ballot boxes, lodge regalia, buttonhole badges, jewelled brooches, emblems reproduced on pendants for watch chains in metal, silver and gold, lettered badges of rank to be pinned on coats, leather cases lettered in gold with name, lodge and number, Foresters' horns, gavels, safes, embossing presses and dies, illuminated testimonials, lodge stationery, printed rule books, contribution cards, etc. His catalogue of stock designs introduced cheaper alternatives to custom designs. In it he promises that his banners come with free insurance for one year (annual payments could then ensure that the insurance policy remained in force for subsequent years) and that he has replaced many destroyed by fire breaking out in schoolrooms.[17] Often his images were interchangeable, and could be used either for religious banners or for trade union and friendly society banners. The Good Samaritan, for example, might be painted in a scene similar to a Pietà and could be used on a church banner, but could also used on the back of a trade union banner to emphasize the union's charitable payments for sickness, injury or death. Tutill's artists would have been familiar with high art from visits to the London galleries, from engravings and from books and journals. In the certificate of the Amalgamated Society of Tailors from 1898 (Plate 48), and on the green silk banner of circa 1892, signed 'Wm. Bridgett, Belfast', the depictions of Adam and Eve pay homage to mighty precedents such as those depictions of the Expulsion in Masaccio's Brancacci Chapel (1424–27) and Michelangelo's Sistine Chapel. In addition, the depiction of Mercy, to the right of

the framed oval bearing the images of Adam and Eve, is in the pose of the exhausted seamstress in George Frederick Watts's *The Song of the Shirt* (1850), with her left hand raised to her head and her right hand resting on her needlework.

The banner of the Workers' Union, Witney Branch (Plate 85), has decorative foliate scrolling at the top bearing the name of the union, a shield bearing an image of David and Goliath and a motto beneath. David was a shepherd boy, caring for sheep, and his most famous representations are by Donatello and Michelangelo in Florence, a town made rich by its woollen industry. It was the Florentines who, in the Renaissance, first converted David from an Old Testament hero into a secular, civic hero. In Gaddi's fresco in the Baroncelli Chapel is a life-sized David, the first known portrayal of David as an iconic image; shepherd, not king. Donatello's first marble *David* (1416), commissioned for the new cathedral of Florence, was instead displayed as a public sculpture in the city centre. It would have had a big, shiny sling made out of bronze, rather like the one that the Workers' Union's David has in his hand.

As with his famous predecessors, the David of the Witney banner is clean-shaven in the Roman manner, whilst Goliath is quite literally a 'barbarian' (i.e. bearded). David stands with his foot on the fallen enemy, a pose derived from Roman tomb reliefs where the enemy is trampled beneath the hooves of the conqueror's horse. The giant Goliath is clothed in armour, and he has a sword and a shield, whereas the boy David has no protection and no weapon apart from a leather sling and a stone. His upper body is against the sky, and he looks upwards and raises his hand in order to acknowledge the help of God. He has defended the faith against the infidel, not on his own but with divine intervention. Even from Roman times, the hero was always aided by the intervention of the gods. David also represents the power of reason overcoming brute force. He uses logic and strikes Goliath in the temple where he is vulnerable. David was, after all, to become the father of King Solomon who symbolizes judgement and wisdom. David also embodies the rise of the humble citizen who, due to virtue and divine intervention, first protects his people from the enemy and then leads them – an excellent choice for a trade union hero, and one especially apposite for Witney, which based its wealth on its famous woollen blanket industry. The legend below proclaims, 'he that would be free must strike the blow' (a quotation from Lord Byron)[18] and from this we understand that Goliath represents the power of capitalism. This is a union that proclaims its militancy. But of course a biblical image such as this may also be used for a church or Sunday school banner as it bears this favourite Old Testament story.

Tomb imagery was prominent in trade union imagery of the nineteenth century, a way of advertising death benefits payable to their members. The 1914 banner of the National Union of Railwaymen, Stockton Branch (Plate 86), is an excellent example. In 1879, the Executive Committee of the earlier Amalgamated Society of Railway Servants had set up an Orphans' Fund, to which every member contributed a halfpenny a week, and it is this fund that is the subject of one side of this banner.[19] The banderole at the top reads, 'Do you hear the children weeping O my brothers', whilst that at the base reads, 'We provide for the orphans of our members'. In the centre is a grave with a large dog lying across the foot of it, a kneeling widow and four children

with the eye of God shedding rays on the scene beneath. The unknown artist of this scene has taken a great deal of care to call upon quite a few traditions of Western art in its construction.

Firstly, he has adopted a very low viewpoint, in order that we may read the inscription on the tomb. Tombstones normally have names inscribed on them, but this one simply states 'sacred to the memory of a brother'. The artist creates a significant absence – the hero of the scene is not named. The viewer may thus imagine himself as the deceased, with his own family grieving for him at the graveside. He is first presented with the fear of death and of leaving his young family fatherless, which is then resolved by the knowledge that the Orphans' Fund is looking after them. The funerary grant from the union has ensured that his grave does not look inexpensive and that his widow and children are well cared for. The words in the banderole at the top, 'Do you hear the children weeping O my brothers', is the first line of the poem *The Cry of the Children* by Elizabeth Barrett Browning, which relates to the plight of child workers in the mines. However, the children in this image have obviously been saved the fate of being forced by poverty into such labour. They appear well fed, clean and smartly clothed, and they are certainly not weeping. Neither is their pretty, fashionably dressed mother. From this, we deduce that the Orphans' Fund has provided handsomely for them, despite the fact that, strictly speaking, the children represented here are not orphans, having one parent still living.

Because the young family has been provided for through the Orphans' Fund, the young widow is able to continue to fulfil her role of the 'Angel in the House', the Victorian 'household saint' who cares selflessly for her children (as defined by Coventry Patmore in his very popular poem of that name of 1862). By seating her on the ground, the artist is evoking the 'Madonna of Humility' convention of the Renaissance. Raphael's *Madonna of the Meadows* (1505) is an example. In an open-air setting, there is a seated Madonna with the infant Christ and the infant John the Baptist at her feet. The compassion that the widow in the banner shows to her small son is mirrored in the compassion that the dog appears to show towards the baby, and in the way the eldest son is comforting his little sister.

The image is also carefully planned out in triangular groupings, like a Renaissance painting. There is an almost right-angled triangle created by the paws of the dog, the left side of the tombstone and then descending down to the right, across the heads of the mother and children. There is a second triangle made up of the dog and the grouping, with its apex just above the widow's head. This triangle is similar to a larger one that contains it, in which the all-seeing eye of Providence encompasses the tomb and the group. The obelisk and the church gable in the background both add to this sense of geometry.

The plainness and flatness of the terrain and the straight paths are symbolic of the plain, ordered and uncluttered moral life of the dead union member. Nature is always considered to be female (we speak of 'Mother Nature'), but in the careful landscaping of the cemetery, nature has been controlled, symbolizing the benevolent control exercised by the deceased over his wife and family. In having had the foresight to make provision for them, he is associated with the head – with brainpower and reason – whilst his

widow is associated with the heart – she is the carer. Because of the Madonna-like pose, we know that she has not been forced out into the workplace, leaving her children neglected and compromising her own moral purity through contact with the outside world. The all-seeing eye watches over the little family to further reassure the viewer that they are receiving divine protection (through the charity of the union, of course). The receding orthogonals create a feeling of deep space, of recession into the distance or into the infinite, ending as they do in the sky. We feel that the dead brother has made his journey into heaven. But the orthogonals also remind us of receding railway lines – after all, this is a Railwaymen's banner.

The large dog in the foreground is named in the subtitle, 'Help, the Orphans' Friend', and on the medal worn around his neck, and he actually existed. There are several accounts of the origins of Help, but it appears to be generally agreed that to equip a dog with a collecting box strapped on his back was the brainwave of John Climpson, a passenger guard on the night-boat train of the London Brighton and South Coast Railway. Through the assistance of Rev. Dr Macleod, he obtained Help, a Scotch Collie bred by Mr W. Reddell of Hailes Haddington, which Climpson himself then trained. In a lithographic portrait print of Help of unknown date, owned by the National Railway Museum, he is depicted wearing a smart silver collar. Beside him, attached to a little saddle, is his upturned collecting box. Hanging from his collar is a silver medal engraved, 'I am Help the railway dog of England, and travelling agent for the orphans of railwaymen who are killed on duty' and also a London address to which larger donations could be sent. He was commemorated in 1883 in the 8 September edition of the *Graphic*, where he is shown standing proudly on a station platform, a railway employee behind him at the open door of a train, and with a well-dressed woman and little girl gazing adoringly at him. And he appears on a circular enamelled badge of the 1800s with the wording 'Help Our Noble Railway Dog' around the edges, an item that would have been mass-produced and sold to raise monies for the fund. Help travelled extensively throughout the country between 1882 and 1891, even twice to France, raising money for the Orphans' Fund.

Further collecting dogs followed, who worked for the various railway companies: 'Prince' at Croydon, 'Nell' at Bournemouth, 'Tim' the Irish Terrier of Paddington Station (who twice received donations from Queen Victoria) and 'Basingstoke Jack' (killed by a train, ironically, at Fullerton Junction). 'Laddie' the Siccawei Airedale of Waterloo Station had better luck, retiring happily in 1956 and becoming a resident at the Southern Railwaymen's Home for Old People at Woking.

The overriding image that the banner artist may wish to conjure up unconsciously in the mind of the viewer is that of the *nubis* who guards the tomb; Cerberus, mythological guardian of the kingdom of the dead, described by Hesiod;[20] the dogs on the tombs of the crusaders at the feet of the dead hero, with the mourning figures around it. And that may be one of the reasons why the women and children are spread out like a frieze across the painting, like weepers on a sarcophagus, and not grouped around it. The effect is to associate the image with the ancient monumental tomb – the knight with his faithful dog at his feet. Dogs are symbolic of watchfulness and faithfulness.

San Rocco's dog brought him bread when he was stricken with plague and kept him alive – it was a material provider, like this dog. In addition, Help is black and white and reminds us of 'the dogs of the Lord', the black and white of the Dominican order, the city monks who took their mission to the people, who were known by this nickname in the Renaissance, because of a pun on the similarity between the name of their order, and the Latin *Domini canes*.

The role of the dog as devoted companion to man features in the literature of the nineteenth century and in art, and especially in the paintings of Sir Edwin Landseer, where human emotions are attributed to it. The poses of his dogs, and the situations in which they are placed, describes their character. In several, they grieve for their dead master. In *Attachment* (1830), for example, a painting that illustrates Scott's poem *Helvellyn*, a small terrier sits in a mountain crevice beside the supine body of his dead master, staring devotedly into his face. According to the poem, the dog had kept guard for 3 months before rescuers came upon them. In *The Old Shepherd's Chief Mourner* (1837), the loneliness and despair of a lover is transposed onto the dog, who rests his grieving head on his master's coffin, whilst in *The Shepherd's Grave* (1829), a faithful collie crouches in front of a headstone, staring into a freshly dug grave amidst a desolate landscape. These paintings invite the viewer to judge the dead owners as worthy men because they warranted so much canine devotion. And here, in this banner, the faithful dog is also still keeping guard at his dead master's feet.

In 1827, Lord Dudley commissioned Landseer to paint his favourite Newfoundland dog, 'Brashaw', and Matthew Cotes Wyatt, in 1831, to sculpt him.[21] Wyatt executed the work in black, grey and white marble with gemstones for eyes, and it was exhibited at the Great Exhibition of 1851 under the title *The Faithful Friend of Man Trampling Underfoot His Most Insidious Enemy*. However, it is another of Landseer's Newfoundland dogs, *A Distinguished Member of the Humane Society* (1838, Plate 87), whom Help most resembles – the head, its angle and its markings, are almost identical, as is the way in which the tongue protrudes. In his lithographic portrait print, his large medal clearly reads 'I am "Help"' (not simply 'Help'). In the portrait, the illustration in the *Graphic* and in the badge, the front legs of 'Help' were white at the base, like socks, with black upper portions. In his portrait his head is slim with a very long, pointed muzzle, but neither this nor the white socks appear on the dog in the banner. When faced with the depiction of a black and white dog, who better to copy from than the master himself, Landseer? Despite the fact that 'Help' was a collie, the image is undoubtedly copied directly from Landseer's Newfoundland dog.

Alas, for poor Help, after nine years of work and fundraising, for him there was no quiet grave beneath a shady tree. The union had him stuffed and installed back on Brighton Station in a glass case with a collecting box above it, bearing a plaque reading, 'Was born in 1878 in Scotland, and died in December 1891 at Newhaven, Sussex'. Even though he was as dead as a doornail, he still continued to raise up to 15s. a week for the fund!

Some of the other famous railway dogs have also been stuffed. After his death in 1960, Laddie the Airedale was stuffed, placed in a glass case and carried on collecting

money on Platform 8 of Wimbledon Station until a fateful day in 1990 when he suffered the indignity of being ousted from his place by a telephone box. Fortunately the National Railway Museum rescued him in the nick of time and placed him on Platform 3 of their Station Hall where he now collects for the Friends of the Museum. 'London Jack' of the Southern Railway also continues to raises money for the Woking Homes at the Bluebell Railway Museum. His original plaque reads, somewhat unsentimentally, 'Though dead, Jack is still on duty and solicits a continuance of your contributions in support of his good work for the Orphans'. But of the final fate of 'Help, The Orphan's Friend', sadly there is no trace.[22]

The certificate of the Midland Miners' Federation by Alexander Gow (1893, Plate 54) reproduces five portrait photographs of union officials, councillors and JPs. President Edwards, Treasurer Dean and Secretary Stanley, whose signatures feature in the certification section, are in place of honour at the top. It reproduces coats of arms, their headquarters building, the Cannock and Rugely Works, even Shakespeare's home, and a depiction labelled 'Sister Dora of Walsall'. Leeson records, erroneously, that she was Dorothy Patterson, but she was actually Dorothy Pattison, born in 1832 and dying in 1878. One of the Sisterhood of the Good Samaritans based at Coatham, Middlesbrough, she ran their hospital at Walsall. The scene on the left of the certificate, which portrays her in the midst of the chaos of Messrs Jones & Company's Birchills Ironworks furnace explosion, was copied directly from one of the four plaques on the socle of the marble statue of Sister Dora by Francis John Williamson, unveiled in 1886 at The Bridge, Walsall.[23]

It is apparent that the artists who shaped the new trade union imagery during the second half of the nineteenth century looked to symbols of high art and Freemasonry, and the values embodied therein, in order to convey their message. In the face of increasing industrialization, leading artists such as Moore, Leighton and Burne-Jones had retreated into a world of classical myth and legend to express a beauty and a refined sense of taste, closer to music than to the harsh and dirty industrial world around them. We see their nebulous classicized women reflected in trade union imagery in the Nikes or angels who lead or point the way for workers. To modern eyes, adaptation of the work of other artists is plagiarism. However, there is evidence that in their own times, this may not have been seen in this way. Certainly, artists were trained in copying, and according to Walter Crane,

> The individuality of modern artists is more apparent than real, and [...] it would not be difficult to classify them in types, or to trace the main influences in their work to some well-known artistic source either in the present or the past, or both. This, however, would be in no way to their discredit, but it shows how art, even in its most individualistic forms, is essentially a social product, and that each artist benefits enormously by the work of his contemporaries and his predecessors.[24]

From this, we see that socialist artists may have felt free to borrow from earlier or contemporary artists in a co-operative spirit, envisaging great works of art as public

property and not subject to individual ownership or copyright. (Conversely, however, we may also be seeing the capitalist commercial banner maker or engraver pilfering past works for his own material gain.)

Although it is not possible to make wide generalizations, we can identify a trend away from the working-class hero on his classicized structure, surrounded by personifications of science, art and justice. Once the higher echelons of the working class had become enfranchised, trade union imagery appears to undergo a change. This change coincides with the birth of new unions for the unskilled, and the admission of women. It also coincides with other changes, such as the weakening of emphasis on traditional friendly society insurance and a greater emphasis on strike benefit. This trend, however, must also be understood in the light of the new, cheaper, 'stock' religious themes from catalogues such as Tutill's, which render old-fashioned the iconography of the lodge. With the rise of socialism, religious imagery is strong. As Christianity had used the vehicle of classical, pagan art to express itself, depicting Christ in the image of Apollo the Sun God, and the Virgin Mary in the manner of Venus, so too, during the birth of the new 'religion' of socialism, the same type of process is employed. Whereas Christianity had depicted the angel as asexual, socialism depicted its angels in the feminine gender, the traditional metaphor for transcendence and elevation above the worldly. Similarly, the pagan female Caritas becomes the union official dispensing charity.

Religious themes (for example, the Last Judgement, a favourite Renaissance subject) are adapted in certain trade union emblems, disguised with great subtlety. The banner of the Associated Society of Locomotive Engineers by George Kenning & Son (1920s, Plate 88) is a prime example. The portraits in the roundels are copies of photographs of Albert Fox, General Secretary from 1901 to 1914, and John Bromley, General Secretary at the time the banner was made. The motto, 'The Power of Unity breaks down the barriers of Capitalism' is illustrated by a giant worker who destroys these barriers, whilst tiny capitalists cling on to their desks for their lives in a vignette reminiscent of Christ overturning the tables of the money changers in the Temple.

The giant worker has a broken chain just behind his left arm, and tramples on reports and ledgers. The image as a whole is based on the *Anastasis* (the Harrowing of Hell) in Last Judgement paintings. In established religious imagery, for example in a thirteenth-century mosaic of the Last Judgement in the Basilica of Torcello, Venice, we see a Christ Triumphant, holding his cross and breaking down the doors of hell, trampling upon the Devil and scattering locks and keys. Similarly, in the *Pala d'Oro*, San Marco, Venice, Christ tramples the two gates underfoot, sending broken chains and keys flying. In scenes of the Last Judgement, Christ is invariably the largest figure in the painting because he is the most important. In the banner, the unionist is the largest figure, and similarly astride the image whilst the capitalists are as tiny as doomed souls. The red, snaking railway train to the right is like the river of blood that travels down from Christ on the right-hand side of a Last Judgement. This right-hand side of the image (i.e. the side depicting the railway and its workings) is orderly and controlled, as in the saintly side of a Last Judgement. But on the left side, the capitalists are like the lost souls who are swept away to hell and chaos. In Last Judgement scenes, the damned

are those who cannot control their baser instincts, such as avarice. Punishment is always meted out according to their crime. Here, they have quite literally lost control of their positions, their desks, their money.

During the 1880s, new, radical unions were formed of unskilled and semiskilled workers. Under Disraeli, strike action had become legal, and in 1888, Annie Besant (who lost custody of her own children due to her lectures on birth control) led the strike of the 'Match Girls' of Bryant and May, with support from the London Trades Council, and organized them into a union. The women had been working up to eleven and a half hours a day for as little as 4s. a week (less innumerable deductions for petty offences), the shareholders receiving that year a dividend of 20 per cent.[25] The banners of these new unions were less complex, less rigidly structured and often more crudely painted, in all probability because money was short and banners expensive. The banner of the Dockers' Union, Export Branch (Plate 76) from the early 1890s is an example, and depicts a male mythological figure, most probably Hercules. Active and heroic, he wrestles the great serpent of capitalism. Above is a lifebuoy containing a ship at sea with the surrounding legend 'Be sure you are right/Then full speed ahead', a quotation attributable to Admiral David G. Farragut of the United States Navy.[26] Legends each side of the main image, curving into the centre, read, 'We will fight and may die, but we will never surrender' (a quotation attributed to Lieutenant Vilian in the Battle of Cameron, Mexico, 29 April 1863) and 'An injury to one is an injury to all' (the motto of the Industrial Workers of the World, known as 'the Wobblies'). And below: 'This is a holy war and shall not cease until all destitution, prostitution and exploitation is swept away'. The artist has used vivid complementary colours of red and green to add to this sense of drama and conflict.

Vitruvius, in the preface to his second book, compared Emperor Augustus to Hercules, his philanthropy bringing the benefits of civilization to his conquered peoples. Hercules wrestled the Hydra, the mythological nine-headed serpent of Lake Lerna, and according to Ruskin, the meaning of this myth is that Hercules did not simply purify the lake but 'he contended with the venom and vapor of envy and evil ambition [...] and choked that malaria only by supreme toil'.[27]

In 1793, the French Republic's National Convention had voted to adopt a new seal of state featuring a giant Hercules as the emblem of the radical republic, a decision reaffirmed on two occasions in 1794, but although sketches were prepared, it was never cast.[28] In the Musée Carnavalet, Paris, there is an engraving of Hercules and the Hydra entitled *The French People Overwhelming the Hydra of Federalism*, designed for a morality play for a festival marking the first anniversary of the uprising that defeated the monarchy. In Britain, 'The Philanthropic Hercules' was an attempt in 1819 at organizing a general union by John Gast, a worker in the Deptford shipyards in London, and also a dissenting preacher. So Hercules is a fitting hero for this new dockers' union, one associated with water, and one that had fought so hard against bitter exploitation and had won a major victory over its oppressors.

According to Gorman, the banner design derives from Walter Crane's illustration of 'Hercules and the Old Man of the Sea' for *A Wonder Book* by Hawthorne, published

in 1892.[29] However, in this illustration the sea creature has the face, the arms and the beard of an old man and the tail of a merman, whereas in the banner Hercules quite obviously wrestles with a python. In addition, the actual pose of Crane's Hercules is quite different from that in the banner. Gorman does not state his source for attributing the banner design to this particular Crane illustration, and indeed Crane's 1886 illustration from *Baby's Own Aesop* of 'The Man and the Snake' is far closer to the banner design. In this, the snake is held right out at arm's length with the right arm, the left arm is bent back to hold a baby, but it is the left knee that kneels. However, the heavy musculature, the outstretched right arm, the eye-to-eye confrontation between man and python and the left arm behind, holding the body of the snake, reveal that the banner image is in fact copied from Lord Leighton's bronze *Athlete Struggling with a Python* (Plate 89), exhibited at the Royal Academy in 1877, acquired for British nation by the Chantry Bequest and very well known at the time. Crane obviously took his image of 'The Man and the Snake' in *Baby's Own Aesop* from this. The origins of Leighton's bronze, of course, lie in the *Laocoön* (circa first century CE), which epitomizes heroic struggle against evil, man against serpent. Leighton's image may, of course, be read as man struggling to sublimate his own sexuality or his sexual identity.[30]

By appropriating Leighton's high art for their banner, working-class men are claiming the image for their own. In this battle for power and supremacy, rather than the body of the athlete representing the middle- or upper-class man, it now represents the working-class man, and it is the evil serpent of capitalism that symbolizes the middle and upper classes. Their high art is taken and used *against* them by the working classes in a rallying call to incite victory over a despotic establishment.

In mid-Victorian Britain it was unusual for a middle-class artist, Ford Madox Brown, to consider the British workman

> at least as worthy of the powers of an English painter as the fisherman of the Adriatic, the peasant of the Campagna, or the Neapolitan lazzarone.[31]

John Linnell, a fashionable portrait painter, had painted workers as the subject of high art in *Kensington Gravel Pits* (1811–12). He, however, represents them as small, nondescript and interchangeable, the same worker appearing to perform tasks in different areas of the painting. In *Work* (1852–63, Plate 12), Madox Brown depicts the laying of a water main in Hampstead during the summer of 1852. A complex painting, it embodies the triangle of the Victorian social structure, with the 'residuum' at the base of the triangle, the vast mass of the working class above, the middle classes above them and, at the apex, the tiny proportion of the upper classes. As a painting, it is very far removed from the patronizing images of amusing country bumpkins painted by David Wilkie or the picturesque peasants of Gainsborough. It is still charged with class division, but the working man is no longer portrayed as servile, stupid or an object of amusement. Instead, he is depicted as having an actual personality and individuality. The threat of social conflict is there, but it is deflected down onto the dogs. What is promoted is the nobleness and sacredness with which Thomas Carlyle (who is portrayed on the right

of the painting) associated the work ethic. Much has been written about this painting, which will not be reproduced here. Instead, an examination of similarities to Sharples's *The Forge* (1844–47, engraved 1859, Plate 13) is more relevant.

In the first place, in both paintings the workmen are depicted as heroic. Secondly, they are depicted in terms of the rural 'Georgic' tradition – preparing the land or processing its 'harvest' (in the case of Sharples, the earth's raw materials), which indicates good government of the country. And, because the land is well managed, this indicates their work to be 'moral'. Images of ploughing and harvesting (here transposed to city work) traditionally reflect the changing seasons of the church, stability and continuity. Thirdly, in both paintings the viewer's way into the painting is 'blocked' and he or she may not enter. In *Work*, this is achieved by the mass of people and by the hole. The viewer is forced to remain outside the painting. The heroic depiction of the worker, work depicted as 'Georgic' and 'moral', and the exclusion of the viewer from the inner sanctum of skilled labour, is not exclusive to the paintings of Madox Brown and Sharples – it is also a feature of trade union certificates and banners of this era. If we consider the proud and heroic workmen of Sharples's emblem of 1852 (Plate 45) and of Waudby's of the 1860s, and the great triumphal arches in which only the master of the trade (he who has passed through the apprenticeship system) may enter through the portal, we see that Madox Brown's painting is of a similar genre.

Conventional art historical accounts contend that Brown's was a radical painting that invited Victorian audiences to view the worker as elevated – something completely novel. But to what extent is this true? Engravings of *The Forge* went on the market in 1859 to much acclaim, and it was even discussed in the leading periodicals of the day. Samuel Smiles contacted Sharples, and as a result included him and his history in later editions of *Self-Help*. *The Forge* itself is even reproduced in an emblem of the 1890s by Alexander Gow, the certificate of the Associated Blacksmiths' Society (Plate 51).

The streets of Victorian towns and cities were ablaze on festival days with trade union banners bearing emblems such as that by Sharples, which clearly depict the British worker as heroic. During the 12 years in which he painted *Work*, Brown roamed the streets looking for models, talking to navvies, even setting up a mobile hut in Hampstead in which he worked. Included in the painting is Rev. F. D. Maurice, a Christian socialist and founder in 1854 of the Working Men's College for skilled artisans. Brown taught painting there from 1858, and invited some of his working class students to his studio to view the half-finished painting of *Work*. There can be no doubt that he must have been familiar with trade union imagery and Sharples's engraving of *The Forge*. Indeed, how could anyone avoid audience involvement and participation in viewing the carefully constructed festive spectacles and parades with their great banners accompanied by bands, winding through the streets? During the long years in which he painted *Work*, Brown was possibly influenced to some degree by trade union imagery with its portrayal of the worker as the hero. Here is, surely, a classic case of popular art, the art of the people, the art of the trade unions actually influencing high art itself?

Conclusion

REPRISE AND REVIEW

Paula James

This is not so much a conclusion as a 'cherry picking' from the preceding chapters. My main purpose is to suggest ways of exploiting this exposition on the emblems. The wealth of material presented here has many ramifications for research across disciplines and subject specialisms. In the introduction I gave a skeletal outline of the implications of this study for labour historians, art historians, classicists, Marxists and political activists on the Left (recognizing that our readership may have multiple identities as academics and practitioners).

Annie Ravenhill-Johnson's insights challenge some long-held assumptions about the artistic provenance of labour movement imagery, its meaning and significance. Her findings compel us to ask pertinent questions about a working class with a consciousness coloured by imperialist ideology, a class rightly claiming entitlement to an 'elite' culture but also corrupted by it, and to address the tensions between revolutionary and revisionist trends that continue to play out in the trade union movement today.

Waudby's carpenters with their bowler hats and Sharples's respectable and peaceable blacksmith espousing middle-class values were never going to change the world, but at least in the earlier emblems the worker was shown with educational aspirations and they displayed their pride in mastering the skills needed for a new industrial and technological age. Marx's speech on the fourth anniversary of the *People's Paper* is worth reading in full as he prefaces his praise of the heroic struggles of the English working classes (the Chartists earlier in the century had been shrouded in obscurity by historians) and his confidence in their revolutionary potential with a sketch of the contradictions of modern capitalism, not least that 'the new fangled sources of wealth, by some strange and weird spell, are turned into sources of want. The victories of art seem bought by the loss of character' (Golby 1986, 10–11).

The Antiquity of the Trades: Classical Connections

The emblems hark back to the earliest formations of free labour through trade associations in a world where slavery underpinned the functioning of society. In her opening pages Annie Ravenhill-Johnson mentions the *schola*, which were the

headquarters of the trade corporations. Morel (in Giardina 1993, 241) cites a combination of archaeological and epigraphical evidence for the ostentation of these places where, in the case of the shipbuilders at Ostia, the poorest craftsman could enjoy a courtyard, pool, banquet hall, mosaics, frescoes, columns and a marble pavement. Morel's chapter in Giardina's *The Roman Man* testifies to the need for active searching before the existence and experience of the free labourer of Roman society and his social formations can be brought to the surface.[1]

Although the Roman educated elite, much of whose extensive literary output has survived, were scornful of those involved in vulgar trade and Cicero baldly stated that 'the workshop was irreconcilable with the condition of a free man' (Morel 1993, 214). Morel (216) goes on to point out that the distinction was not simply one of intellectual versus manual activity. Whether free or enslaved, skilled or unskilled, those occupied in production for utilitarian or practical purposes were lesser beings than men operating on an ideal plane, exercising their minds upon philosophical or aesthetic subjects and doing so for pleasure. We could at this moment think back to those banners and certificates where the treatises upon the crafts as well as the tools of the trade are proudly displayed as part of the transformative education that skilled work entailed.

This seems very different from the conception of craft one finds in the ancient world; according to Morel (218) the finest of artworks were attributed not to the artificer but to the commissioner of the work, the customer. The money behind the monument was the author of the artefact. On the other hand, pride in one's manufacturing business is evidenced by epitaphs and grave stelae in Rome and the Italian peninsula.

The tomb of the baker Marcus Vergilius Eurysacus (near the Porta Maggiore in Rome) imitates the shape of the bread bin that made his fortune. Morel (218) describes the frieze with pictures of dough making and baking by workers in tunics whilst men in togas look on. There is in this monument the same half-humorous or certainly quirky visual statement about the symmetry and dignity of a labour process that characterizes the motifs upon emblems like the certificate of the Bakers and Confectioners Association (Plate 23). Vergilius also held a position as an awarder of contracts and the usual abbreviated Latin on the epitaph testifies to his status as an administrative official. This entrepreneur was a supplier of the army and distributor of public grain; he had arrived in the social hierarchy and was therefore respectable.[2]

Morel does not neglect the scant resources we have about women in the workforce in the Roman world. Ironically, relatively recent historians of the British labour movement stand accused of buying into a male myth of the low impact of females in industrial organisation and of not bothering to tease out social realities from the available evidence.[3] Morel mentions lists found in the Acropolis that contain the names and trades of 35 women active in artisanal and commercial work (predominantly wool working or related) around 300 BCE. He assumes the existence in the Roman Empire of 'an immense army of women who spun, wove and clothed the Romans for a thousand years' (224), but also acknowledges many men worked in the textile industries.[4]

It is also true that the gender composition of a workshop might vary across regions. Women worked on temple tiles in the brickworks at Pietrabbondante and their 'facetious

remarks' were incised on one of the products (Morel, 225). Infant burials (babies born at work) found in the workshops for terra sigillata ware at Puy-de-Dome are just one indication of the harsh conditions and relentless hours of pottery production. The suffering of women should never be silenced by history. It is less easy to ascertain what proportion of the workers were free or whether these were mostly slaves contracted out to labour for local industries. Morel (218) suggests that the slave mode of production in ceramics, as in farming, was mostly a phenomenon of the Italian peninsula, but where it did prevail true craftsmanship was compromised as teams of free labourers would work side by side with slaves on a production line in a factory setting. The patterns and models of the finished artefact were preset.[5]

Morel (236) describes the active involvement of a whole range of ancient crafts with the cults of gods and heroes and their close identification with deities, such as those who embodied weaving and metalwork (Minerva and Vulcan) as well as those who fostered entrepreneurs (Mercury and Hercules). We have seen how abstract figures representing Justice, Truth, Mercy, etc. insinuated themselves in the Victorian emblems as a regular motif and as part of their architecture. It was the Romans who established temples to minor divinities with names like Good Sense or Reverence, and invariably the female (unsullied by her absence from political office and formal power structures in the capital and its territories) was the apt symbol for a plethora of virtues and desired states. It seems to me that much more could be done to advance the study Morel made nearly twenty years ago on the trades and occupations of the Roman Empire, especially in the light of Annie Ravenhill-Johnson's observations on the concept of the craftsman as an emblematic leitmotif in the history of the labouring classes.

Annie Ravenhill-Johnson notes the persistence of mythical imagery and the presence of classical gods and heroes on the nineteenth-century emblem and wryly comments on Marx's statement that such deities (or at least their defining attributes) had been supplanted by the technological forces of human progress in production. However, Maxim Gorky at the 1934 Soviet Writers' Conference regarded ancient myths and fables in which heroic mortals acquired supernatural abilities as part of an ambitious human vision of taming natural forces, prompting the invention of sophisticated tools and changing the environment on a global scale:

> It would be possible to produce many more proofs to show that all these ancient tales and myths contained a purpose, to show how far-sighted were the fanciful, hypothetical but already technological thoughts of primitive man. (1977, 29)

In a sense Gorky is saying the same thing as Marx, but this passage, when read in its entirety, suggests that the wielders of power in the myths of Greece and Rome made highly appropriate symbols for the new technological world of the nineteenth century.

The presence of gods and heroes like Hercules at so many cultural levels in the new industrial world testifies to the power of the imagery their myths continued to

inspire from classical times. As the gods had personal legendary histories and were seen as personae, not simply the sum of their attributes, they exercised their hold on the artistic creative psyche for centuries after belief in them had been supplanted by Western monotheism.[6] Hall notes the popularity of plays on classical themes, the enactments of the labours of Hercules by circus performers and saucy *tableaux vivants* such as 'Diana preparing for the chase' (Hardwick and Stray 2008, 393).

A closer scrutiny of the classical imagery that permeates the banners and other insignia of the working classes would complement the interesting research being done into the popularization of Greek and Latin culture during this period.[7] Rose's important and comprehensive book of 2002 on the intellectual life of the British working classes addresses the dissemination of classical and canonical literary works that captured the imagination of working men and women. Classicists should really seize the opportunity to assess how much of the Greco-Roman iconography the masses and the union membership might have recognized or understood from reading about the ancient world, as well as accessing its history and mythology through theatre and popular entertainments.

As I suggested towards the end of the introduction, the art and ideology of the emblem is not all that we have to work on when looking at the self-image and visual representations of the working classes in the selected period. Another book could be written on the imagery within newspapers, flyers, pamphlets, plays and other performance media. Nor can we neglect the literature of the labour movement from the Chartists and beyond. There too we find references with a distinct classical timbre that the underclass of nineteenth-century society employed in fine rhetorical fashion.

E. P. Thompson (1963, 781) presents a picture of towns and villages of the first half of the century '[humming] with the energy of the autodidact'. He goes onto give examples of working men making use of figurative language in anonymous statements or threats to law court officials (784–5). During the time of direct action by the Luddites, 'Liberty with her Smiling Attributes' was invoked, and an impassioned letter to a Salford coroner included a reference to the Stygian Lake, punctuated with the Latin, 'Ludd finis est'. An imprisoned letterpress printer wrote to his wife that he would face his enemies 'like the great Caractacus when in a similar situation'.[8]

How much of the complex iconography of the more allusive trade union emblems was appreciated by the rank and file members? Annie Ravenhill-Johnson's detailed analysis of the Bricklayers' certificate and other similarly densely packed designs produced for the skilled unions is testament to the artistic and cultural sophistication of such artefacts.

However, the unions did issue keys to their certificates (although we have seen that occasionally their identification of figures can be called into question). The explanatory text would educate and enlighten, which brings us back to the bestowing of culture upon the workers by their leaders (risen, it is true, from the ranks), who negotiated the designs with the emblem producers and, in many cases, were willing to accept the templates of established middle-class artists.[9]

To all who viewed the banners (some of ship sail size), the majesty of their conception and execution must have conveyed the main message. Organized labour

had arrived to take its rightful place in society. The desire to achieve the effects of the three-dimensional architectural artefact on a flat canvas is an interesting prefiguring of trends in Soviet art. Building and monument designs were represented by geometric shapes and patterns on the page to emulate depth and perspective. The conversion of plans into paintings promoted breathtaking architectural images that were symbolic of 'the progress and modernity of the new Bolshevik country.'[10]

The Identities of the 'Emblematic' Worker

Emerging from Annie Ravenhill-Johnson's initial essays is the fascinating duality of the trade union emblem that was simultaneously outward facing and inward looking. She has highlighted the nature of an iconography that continued to use portals, arches and doorways to represent rites of passage. Apprenticeship completed, the worker passed through to the closed shop of his craft and this transformation from trainee to fully fledged member of the union suggested a new kind of man had been moulded, one worthy of his profession's proud history. It is worth noting that the craftsman at one with the tools of the trade and identified by the skills required to operate them did not by any means disappear at the advent of large-scale factory production.[11] The instruments of labour could function as figurative representations of the mind as well as of the hand.

Annie Ravenhill-Johnson has skilfully delineated the ways in which emblem imagery changed in the late nineteenth century once the higher echelons of the working classes had become enfranchised, new unions of the unskilled had been formed and women workers were being admitted into their ranks.[12] These associations placed greater emphasis on strike benefit and moved away from the focus on friendly society styles of benefit and insurance. The iconography of the lodge may have been rendered old fashioned (though it did not by any means disappear), but the cheaper, stock religious themes available to union branches from Tutill's catalogues at times invested the banners with a spiritually fervent message.

It would appear that the response (of those controlling the visual discourse of labour movement struggles) to the alienating effects of large-scale and advanced mechanization, examined by Annie Ravenhill-Johnson in her essay 'Men, Myth and Machines', was to retreat into an enclave of idealism. In spite of some designers espousing the ennobling cause of socialism, later emblems did not always elevate the worker. His subservience might be paraded to shame the bosses and their class allies. In Chapter 5 on the legacy of James Sharples, Annie Ravenhill-Johnson notes the satirical exposure of the suppliant worker, whom we see in the post-1922 banner of the Transport and General Workers' Union, Export Branch (Plate 7). He has been demoted and removed from the ziggurat pyramid, whilst the old 'gods' reassert themselves; the top brass of the military, industry and academia look contemptuously away from the aspirant who seeks knowledge in order to wield power.

In Volume One of *Capital* Marx waxes lyrical about an artisan handling his tools as a virtuoso in an ancient economy of peasant husbandry and independent handicrafts

(before slavery seized on production in earnest). However, he also described the medieval craftsman as having an affectionate and servile attitude towards his work, being dominated by it more than the hired labourer under capitalism (1965, 67). Marx judged the absence of an aesthetic relation to the product of his labour by the labourer as a progressive phenomenon in the precise and profound sense of the word.

This gives an interesting context to the discussion in the essays on Walter Crane. Crane, a Fabian socialist, was not committed to portraying the worker as the new fangled man, the first-born son of modern industry envisioned by Marx.[13] Annie Ravenhill-Johnson interprets the prevalence of Gothic imagery (the swirling, dancing, twisting and flame-like forms and figures) as an expression of a yearning for the unworldly, for spiritual satisfaction, a counterpoint to the rigidity of academic convention based on neoclassicism. This trend interlocked aesthetically with the Arts and Crafts Movement and also with the reverence and mysticism with which the emblems, as the folk art of their age, became associated. Mary Lowndes, designer of Suffragette banners,[14] captures their essence:

A banner is a thing to float in the wind, to flicker in the breeze, to flirt its colours for your pleasure, to half show and half conceal a device you long to unravel: you do not want to read it, you want to worship it. (Tickner 1988, 345)[15]

Marx recognized the role religious belief would continue to play whilst the deprivation and poverty of the exploited classes were maintained by the ascendancy of the capitalist mode of production. He pronounced religion to be 'at one and the same time the expression of real suffering and the protest against real suffering. Religion is the sigh of the oppressed creature, the heart of a heartless world, the soul of a soulless condition. It is the opium of the people' (1970, 1).

Annie Ravenhill-Johnson's critique of Crane reveals how readily revolutionary symbols such as the bonnet rouge might be subverted to serve a romantic and archaic notion of Merrie England, complete with peasant communes in constant festive mood. Crane's motivation may have been to express pictorially what William Morris envisaged in his *News from Nowhere* (incidentally, in which the heroine, Ellen, is an emancipated working woman who simultaneously represents the soul and the spirit of nature). Morris subscribed to a more notional or speculative vein of Marxism that foresaw a future in which all human activities, harmonized by collective endeavour, would become playful and creative. Significantly, the crucial ingredients of revolutionary struggle and the overthrow of capitalism are missing from both Morris's novel and Crane's pictures of pacified peasant workers.

However, the physical labourer was not deprived of nobility in the art of the industrial age, in spite of writers like John Ruskin championing the skilled male worker and the notion of the independent and creative craftsman. As far back as the eighteenth century Adam Smith had disparaged dexterity masquerading as skill (or know-how and technique) and viewed masons and bricklayers as undeserving of high wages. In 1980 Phillips and Taylor argued that 'far from being an economic fact, skill is often an ideological category imposed upon certain types of work by virtue of the sex and power of the workers who perform it'. Clarke and Wall take the idea of skill as a masculine

construct as the starting point for an examination of the exclusion of women from the building trades through the apprenticeship system (Davis 2011, 96–116). They apply their findings to a range of industries including textiles, engineering and potteries. In fact, they draw attention to the purely representational and abstract women in the Bricklayers' and Carpenters' banners, an aspect of socialist iconography discussed by Eric Hobsbawm in 1978 and given a comprehensive context in Annie Ravenhill-Johnson's chapter, 'The Classical Woman'.

It is characteristic of Hobsbawm (whose death in September 2012 deprived the world of a great and still-active historian) that he set more than one ideological cat amongst the pigeons. The critical responses sparked by Hobsbawm's 1978 article on men and women in socialist iconography have helped to widen the debate around negative representations of the female in the service of revolution.[16] Agulhon (1979, 169) posed the problem of classical allegorical figures as a bourgeois-humanist tradition and asked whether the revolutionary should reject them as an outmoded language.

Herculean Labour: A Case Study for Classicists?

The male manual labourer with rippling muscles (and impractically naked from waist up) might be as much an idealized and classicized notion as the detached Tyche-like woman. Annie Ravenhill-Johnson's later chapters address the emblems of the newly emergent unions with a vast majority of the unskilled swelling their ranks. A Hercules figure in the Dockers' banner (Plate 76) presents the body of the worker as a powerhouse of energy and strength. The Dockers were conducting a bitter struggle to survive in one of the most exploitative work environments of the time. In Chapter 10 Annie Ravenhill-Johnson eloquently summarized the appalling and humiliating processes by which they were granted or denied a day's employment. Starvation was a fate for skilled workers as well, as there were occasions when an aristocracy of muscle could command better wages than those who laid claim to a craft. Lummis (1994, 58–9) quotes Charles Booth's social investigations to hammer home the point that the coal heaver disparaged by the artisans at the docks was paid a much higher rate than the skilled worker.[17] To paraphrase the extract: 'He was the pick of a lot of fine men as his work was dangerous, arduous and required the strength of a Hercules.'

However, the life expectancy of a coal heaver was much lower than average so that in reality, as opposed to literary rhetoric and visual fantasy, their physiques fell far short of a supernatural splendour.[18] In any case the central figure of the Dockers' banner does not represent a coal heaver or any specific worker at the waterfront. This Herculean protagonist is much more of a signifier, and as the identity of the designer is not attested we cannot be entirely sure about the influences at work in his composition. We see a similarly heroic and partially naked worker with a Herculean look about him representing the miner of iron ore with his pickaxe in the much earlier membership certificate of the Friendly Society of Iron Founders, Plate 21 (discussed in Chapter 4 for its imitation of Sharples's design and displayed on the cover of Leeson's 1971 book, *United We Stand*).[19]

The interesting aspect of the Dockers' Hercules is that, as Annie Ravenhill-Johnson has conclusively demonstrated, his pose is modelled upon Leighton's *Athlete Struggling with a Python*. The banner design imitates an admired sculpture with a Greek subject but it is a crudely executed figure, a statement about the simplicity of a truly proletarian art, perhaps. Annie Ravenhill-Johnson has pointed out the similarity to Crane's illustration for his *Baby's Aesop* of 1886, 'Man and a Snake', in which case this simplification of Leighton's bronze owes something to its infantilization by Crane. Alternatively, the stark image adopted by the dock leaders suggests that the unions of the unskilled had truly dispensed with the 'ridiculous hieroglyphics of heraldry' (for this banner at least), the religious and sententious motto notwithstanding (Hunt 1983, 97).[20]

Hercules has quite a history in artistic symbolism. Annie Ravenhill-Johnson cites Lynn Hunt's 1983 article on Hercules as a radical image in the postrevolutionary French Republic, in which Hunt comments on the commissioning of a huge statue of the hero to be executed by the artist David, which did not ultimately see the light of day. Hunt argues that the adoption of this Greco-Roman hero by the deputies of the people to represent their sovereign majesty was compromised by the people's lack of say in this important choice. She points out that: 'Hercules was not a popular figure; he did not appear in the woodcuts or *imagerie populaire*' (104). Hercules, in spite of an iconographical metamorphosis, was strongly associated with kingly power.

Hunt provides a persuasive and nuanced exegesis of Hercules as revolutionary symbol, demonstrating that the muscular male presented as hero and as a metaphor for the revolutionary collective was as problematic as the idealized female. Hunt pinpoints the cultural and ideological tensions that occurred when the leaders of the sans-culottes adopted an elite cultural icon (the doppelgänger of kings) to champion and represent the people in revolutionary France.[21] Hunt believes that the colossal male figure of Hercules had internal tensions that 'continued to bedevil the self conception of the more modern proletarian and socialist movements'. She concludes that 'he was rather the artist-intellectual-politician's image of the people for the people's edification. Hercules, like the goddess of Liberty who preceded him, was a classical figure, whose meaning was most available to the educated' (111).

What are we to make of a British nineteenth-century Hercules who is shown as a champion of the workforce in struggle but is also distinctly sacralized by the accompanying text as a Christian and possibly humanist symbol with attendant virtues? The Hercules of the French Revolution had been stripped of the regal and religious layers he had acquired through the centuries, but he still did not endure as a symbol for the sans-culottes. This pagan hero famous for eating, drinking and fornicating to excess had paradoxically become a moral exemplar and martyr by Christian late antiquity, which would appeal to Victorian sensibilities. It seems to be a god-fearing Hercules who becomes fit for purpose in the celebration of a British strike that had the support of the Catholic Church. This figure will sweep away not just destitution but prostitution. One of Hercules' labours was the cleansing of the Augean stables and he poured a torrent through the filth by rerouting the river.

However, the ideological and art historical plot thickens. The muscle man modelled on a classical and Herculean concept of heroic and athletic masculinity was already an established high-cultural icon in Victorian Britain. He was not simply the strong man familiar to the masses from fairground and circus canvases. Jarlath Killeen's fascinating Radio 3 essay on Bram Stoker (20 April 2012) focuses upon the muscular Christianity that was part and parcel of the British Empire's message of superiority.[22] An almost supernaturally strong and toned physique symbolized profound moral and psychological goodness. Art critics and upper-class viewers of the Leighton sculpture were troubled by the fact that the athlete was entwined into a kind of impasse of struggle with the python and not necessarily gaining the upper hand. Both the bronze and the banner hero have lowered their heads, but, on closer inspection, their eyes look up and they are locked into a gaze with the serpent.

The banner with its floral surround is like a staged tableau (the foliage evokes patterning from the Arts and Crafts Movement pioneered by William Morris and in which Walter Crane played a leading role). We might expect a mythical scene. Of course, the most famous fighter of a python was the god Apollo, who had liberated the area of Delphi by slaughtering this immense colonizing snake. However, the most immediate evocation has to be Hercules, famous for his tussles with snake or snake-like creatures. Juno (Greek: Hera) sent snakes to kill him in his cradle, and in his Labours he confronted and defeated the many-headed Hydra at Lake Lerna.

There is also bound to be a biblical resonance in this conflict with a subtext of the Garden of Eden and the temptation that took place in Paradise. The strong-minded man as opposed to the weak-willed woman knows that the serpent must always be held at arm's length and no engagement must be made with what is in reality the devil in disguise. The gorgon Medusa who had snaky coils as tresses could petrify at a glance, so her myth (she was defeated by Perseus) might form an oppositional subtext to the depiction of a hero who survives making eye contact with his monstrous adversary. Paradoxically, whether a biblical or mythical man, or even perhaps a romanticized version of a heroic coal heaver, the muscleman who wrestles the snake on the banner is confronted by a creature that also evokes the Irish Sea Serpent.

The serpent was employed by the establishment press as a negative symbol of a pagan past (Christian legend had St Patrick ridding Ireland of snakes), of the folklore and nationalist aspirations of a colonized country, reinforcing a perception of the Emerald Isle as a place of superstition and subversion. And yet many of the unskilled dock labourers were Irish, hence the involvement of the Catholic Church in negotiating a triumphant, if temporary, victory for the strikers. The snake entwined about the muscular man might represent a feminizing and sinuous sexuality subverting a bright future of British technology, industry, prosperity and expansion. It could almost be a conflation of Eve and the very creature that subverted and corrupted her – but this may be fanciful in so far as the serpent seems a predominantly phallic symbol in this artistic context.

Whatever the sex (in biological terms) of the snake, a choice has clearly been made to take up the serpent as a symbol of evil and exploitation. It was not always so; the classical snake also had positive connotations, as Fontenrose's definitive work of 1959

(*Python: A Study of the Delphic Myth and Its Origins*) demonstrates. We could recall the framing coils of the Ouroboros in the Sharples certificate that represented eternity and immortality (without implications of gender?). The decorative or ornamental serpent could be apotropaic in Western culture, but in this time of strife and struggle during the late nineteenth century it becomes firmly fixed as the strangling and crushing force of capitalism. It is significant that Crane's illustrations replace the empowered labourer as conqueror with the female figure of Liberty (see Annie Ravenhill-Johnson's discussion in Chapter 9). Hercules' hydra lasts longer in labour movement iconography than the hero himself. He has been replaced by the iconic woman warrior.

If those in struggle were to resurrect the images on the Dockers' banner to fight neocapitalist exploitation, they could be faced with an ideological conundrum. This nineteenth-century Herculean worker is an ambiguous adversary of the serpent of exploitation, servant of the ruling class. A classicist might point out that Hercules had a huge appetite and could easily symbolize the greed of global capitalism. The hero's labours sent him on a kind of clearance programme across the Mediterranean, but philanthropic Hercules cannot avoid identification with an allegedly paternalistic imperialism bent on 'civilizing' the world. Hercules and the serpent share insatiable appetites and both are equally capable of symbolizing capitalism, constantly driven to excessive accumulation. Their eyes do meet and this could be a reflective gaze.

The hero may wrestle with the monster of exploitation but he is also its reflection, and perhaps the shame of realization ensures that he always lowers his head, even if he engages his eyes. The British working classes frequently produce leaders who cannot let go nor definitively defeat the system that has so utterly encircled them. The Dockers' banner is in some ways a watershed in the history of labour movement art but is it really a sea change ideologically from the collaborative discourse of earlier emblem designs? It replaces a reassurance about a culture shared with the ruling class (the monumental, sanitized and intricate certificates and banners of Bricklayers, Carpenters, Stone Masons, etc.) with a confrontational statement about the exploitation of labour; but, as we have seen, contemporaneous banners sought to promote a partnership between workers and employers throughout the Commonwealth.

After all, the masses in struggle and the owners of the means of production (who rapidly reversed the gains made by striking gas workers and dockers) both borrowed Roman insignia of power and hegemony.[23] Hercules' cultural trajectory in union and socialist art shows how a classical symbol becomes a two-edged sword in the development of revolutionary consciousness. The emblems of the London Dock Strike taken as a whole suggest that the British working class has a long history of being at the same time anticapitalist and proimperialist.

Where Next?

I prefaced Annie Ravenhill-Johnson's chapters with a quote from Joan Bellamy, taken from a 1980s Open University arts module, in which she refers to the dominant ideology that was embedded in the trade union emblem. This remains a good working

tool for the purposes of analysing the nature of the iconography of the banners and certificates. It is also a blunt instrument. On the other hand, the emblems can still be viewed as the 'voices and texts' of the working people and 'read' as such. In the Open University module Voices and Texts in Dialogue by historian Donna Loftus (2010), the third study book is devoted to 'the age of equipoise' and focuses on nineteenth-century Lancashire in the 1840s and 1850s.

In 'Politics and the People', Loftus gives the example of the banners as statements on the importance of work to social identity and concludes that 'despite the shared culture that was promoted, workers saw themselves as having to defend their own interests in the workplaces' (158). She also makes the astute distinction that 'a shared language does not imply a shared meaning. Categories such as independence and respectability could be interpreted in different ways' (178). These artefacts or texts of labour can be opaque and problematic sources for understanding the class-consciousness of the Victorian and Edwardian working classes. It also has to be remembered that the art of the trade unions in the period under scrutiny is largely a study of artefacts that were produced as a commercial enterprise. Gorman (1986, 17) wryly observes that Tutill set up his premises at City Road in 1859 'to exploit the high skills and low wages of the East End silkweavers'. Tutill did not countenance union organization in his banner workshops!

This book has paved the way for future research with its tracing of the cultural trajectory of British worker representation across centuries of trade emblems from the Greek and Roman world up to the early twentieth century. The end date of 1925 has left the last 90 years free for scholarly investigation. It is a little puzzling that books on the art of revolutionary Russia do not engage with Victorian trade union emblems and explore the presence of British labour movement motifs in the proletarian culture of the Soviet Union. On the other hand, the subject of working-class visual culture is indeed a vast one. Continental and Commonwealth banners could be brought into the equation as well, as could the traditions of agitational art in the labour movements of the USA and Canada. Diego Rivera's Detroit murals would also be significant in such a study, especially as he was very much aware of the tensions between technology for the creation of plenty and its use for destructive military means.

For scholars in classical reception the twentieth- and twenty-first century art of the labour movement is up for grabs. After all, the myths of Greece and Rome continue to thrive in all kinds of cultural currents and there is an expanding research area exploring the presence of classical motifs in the modern media and the ways in which reconfigured gods and heroes from the ancient past are perceived by modern viewers.[24] Those of us studying the persistence of Greco-Roman motifs in the realm of mass and popular culture may find that famous and infamous historical figures from the twentieth century have supplanted classical and legendary characters as convenient images for heroizing or demonizing the political players of the present day. Struggles for self-determination across the world have also brought forth new signs and symbols, influencing labour movement art in the UK and giving its emblems a progressive (rather than imperialist) international dimension. Women workers also find their rightful place in the depictions of factories, agriculture and the service industry.

Trade union art of the twenty-first century might present only lean pickings for those of us working in classical reception, but I would be surprised if a version of Hercules or of Hephaistos or any of the Olympian pantheon did not make an occasional guest appearance. Hercules has to share his kudos as slayer of capitalist evils with other more home-grown mythological characters such as St George, who, complete with bloated dragon, appears occasionally in twentieth-century banners. Gorman (1986, 186) includes a plate of the Manchester branch banner of the General and Municipal Workers' Union, produced in 1979 by Andrew Turner. The central figure is a worker (top half only) whose huge hands are foregrounded, parting the chains. This super-strong champion smashing everything in the way of the working class was nicknamed 'The Incredible Hulk', a graphic novel Hercules nonetheless. On the other hand, we might also discover that the classical symbol, whether architectural or figurative, has been reappropriated by the ruling classes and has lost its admittedly contested potential for radical resignification.

Our Banners are Still Bright

Over half a million people demonstrated against the coalition cuts on Saturday 26 March 2011 and other forms of direct action have since gone forward across the globe. At the time of writing, another mass protest is planned for 20 October 2012 against the austerity strategy. We live on a conflicted planet, and given the erosion of the welfare state in the UK and the widening gap between rich and poor, James Connelly's phrase 'carnival of reaction' springs to mind. However, the wit and rhetoric of masses on the march can raise the spirit. Solidarity and the strength of like-mindedness are vividly expressed through chants, songs and banners. Even the costumes can be confrontational. We see hard-hitting and satirical slogans, angry, funny and poignant placards, but also the artistry and imagination of the more elaborate banners still festoon the flanks, weaving together tradition and modernity.

Public protest is where the working classes and their allies continue to flirt their colours. If you have ever participated in or sold your political wares at the Tolpuddle Martyrs' March or witnessed the parades at the Durham Miners' Gala then you have some notion about the pictorial and picturesque past and present of women and men in struggle. Nowadays our banners are ever broader in compass and our trade union 'flags' celebrate the ethnic and gender diversity of our workforces. Progressive and agitational groups are gathering together with organized labour and anticapitalist sentiment is by no means monopolized by militant trade unionism. We all have a song to sing and a picture to paint. When it comes to the art of the people, collective and conscious creativity can only strengthen spontaneous and individual inspiration.

There are, of course, plenty of other emblems, past and present, to study. The People's History Museum has an ever-growing database (400 in their own collection and around 2000 from other museums). Popular protests of today attract tangible artefacts (banners and placards, for instance, though the latter are ephemeral and mostly discarded after each demonstration) and their traditions of performance (street

theatre and marching bands). A study of more recent and contemporary iconography in the trade union movement would take up hours of viewing television footage and whatever YouTube might yield as visual evidence.

As ever, there is always a mix of the old and new. A cursory look through my Durham Miners' Gala souvenir booklet of 2009 reveals some splendid examples of emblems, all of which sport the styles and motifs discussed in the preceding chapters of this book. The Bearpark Artists' Co-op has been producing new commemorative banners from original designs by Barrie Ormsby, as well as weaving replicas of older banners using the Jacquard loom techniques. Ed Hall, a modern banner maker, has run workshops with Nick Mansfield on the history and manufacture of the artefacts. In 2010, Annie Ravenhill-Johnson led a banner-making workshop held in the Herbert Museum and Art Gallery, Coventry, which was heralded as a great experience by the participants.

According to an article in the *Morning Star* that marked the 127th Durham Miners' Gala of 2011: 'Despite the closure of our collieries, our communities still stand proud. We are witnessing a great resurgence in the number of new banners' (David Hopper, General Secretary of the Association of Durham Miners, 'Digging the Festivities', *Morning Star*, 9–10 July 2011, 11). Tellingly, to accompany the sound socialist sentiments expressed in Hopper's report, which calls for action against the capitalist crisis at home and military adventures abroad (but also displays a misplaced faith that there might yet be a change in the attitudes of the class-collaborative labour leadership), the picture at the top right of the page is of a beautiful but unidentified emblem.

It is in fact a colour photo of the restored obverse side of the Esh Winning Colliery banner from the 1940s, shaped in the form of a splendid scrolled ribbon attached to a medallion (Plate 90). The banner's conservation is documented by Caroline Rendell, Norman Emery, Chris Scott and Jim Devenport in Lennard and Hillyer's *Textual Conservation* (2010). It was blessed in the cathedral by the Bishop of Durham at the 2006 Miners' Gala. The Esh Winning Colliery moved from private ownership (the Pease family) to the National Coal Board in the postwar nationalization programme (it was permanently closed down in 1968). In the photo of the banner, a miner clasps the hand of a carefully painted gentleman in a suit who sports a poppy in his lapel. This figure is arguably identified as 'the owner', but the central scene very probably represents the transfer of the mine from private to public ownership.

Although it is a 'modern' mid-twentieth-century banner, it is packed with familiar Victorian iconography from a central, winged victory figure to the (Methodist) motto 'ALL MEN ARE BRETHREN' and the beehive of industry on the grassy foreground.[25] The whole design has wonderful balance and symmetry and the scene behind the two men depicts a healthy, happy mining environment. For readers of this volume, the Esh Winning banner (and of course so many other extant emblems) surely demonstrates the persistent power of these artefacts in the cultural and ideological life of the working classes.

Much more could be said about the message and meaning of this image and why the *Morning Star* chose to select it from the parade without comment or key![26] It is

aesthetically pleasing and celebrates the cultural creativity of the mining unions and the folk art of the community. A significant number of Durham banners contain images of socialist and communist figures and symbols (Marx, Lenin and the hammer and sickle). As David Wray observes (in his excellent article 'The Place of Imagery in the Transmission of Culture: The Banners of the Durham Coalfield', *International Labor and Working Class History* 76 (2009): 147–63):

> Several categories [of banners] can be identified, from the 'conciliation and arbitration' and 'anti-capitalist' Banners outlined above, to others that are concerned with: politics; social welfare; pride in the industry; occupation, and mine; and conflict and struggle.

It is interesting to re-view the Esh Winning banner with its message 'All men are brethren' and 'Let us work together', when it is so prominently selected by a socialist newspaper in 2011 to embellish an article crying out against the horrors and deprivations of twenty-first century moribund (though still-surviving) capitalism. We could see it as a commentary upon cynical coalition government rhetoric, which, amongst other strategies for retaining a consensus for its rule, spins the sentence 'We are all in it together' as part of the picture of 'the big society'. The adoption by the Labour Party leader of a nineteenth-century notion of 'one nation' at the annual conference in October 2012 is also designed to play down class conflict. It is ironic but also politically poignant that the Esh Winning banner recalls working-class optimism under a postwar Labour government – this really was once an emblem of hope (emblems of hope being an apt way of characterizing the whole genre).

We clearly must keep reading as well as viewing the emblems of the labour movement in each new context of display, identifying consensus politics through its manifold cultural expressions as well as its revisionist statements and strategies. But a more positive and creative agenda has emerged and was flagged up in the feature published by the *Morning Star* (8 August 2012) in which this book was promoted.

Annie Ravenhill-Johnson and I would be delighted if this work inspired future volumes on the significance of the banners and certificates in the history of the working classes and in the field of classical reception studies. Even better if the book encourages those involved in progressive action to theorize about existing forms of cultural expression in the labour movement and to play a part in producing an appropriate aesthetics for the struggles of our time. The point, after all, is not just to interpret the world but to change it.

NOTES

Chapter 1 The Genre

1 Joan Bellamy, 'Trade Union Imagery', Open University module A102, An Arts Foundation Course: Units 23–4, Popular Culture and the Labouring Classes (Milton Keynes: Open University Press, 1986), 50–58.

2 Examples of these keys are numerous, and can be found in archives such as the People's History Museum, Manchester.

3 Plutarch, *Numa*, 17.

4 Ovid, *Fasti*, 819.

5 Francis Klingender, *Art and the Industrial Revolution*, ed. Arthur Elton (Chatham: Evelyn, Adams & MacKay, 1968), 56.

6 Victoria Solt Dennis, *Discovering Friendly and Fraternal Societies: Their Badges and Regalia* (Buckinghamshire: Shire Publications, 2005).

7 See Tom Paine, *Rights of Man* (1791) and *Common Sense* (1776).

8 R. W. Postgate, *The Builders' History* (London: The National Federation of Building Trade Operatives, 1923), 11.

9 Rodney Mace, *British Trade Union Posters* (Stroud: Sutton Publishing, 1999), 16.

10 The Doxology is a Christian hymn of praise. In the Anglican tradition it is usually 'Glory be to the Father, and to the Son, and to the Holy Ghost. As it was in the beginning is now and ever shall be, world without end, Amen.' In the Protestant tradition it is usually 'Praise God from whom all blessings flow/Praise Him all creatures here below/Praise Him above ye Heavenly Hosts/Praise Father, Son and Holy Ghost.' There are other doxologies, but unfortunately Postgate is not specific as to which he refers.

11 A prayer of Moses, it speaks of human frailty and ends with an entreaty to God to prosper the work of one's hands.

12 Postgate, *The Builders' History*, 64–6.

13 Working Class Movement Library, TU/BOIL/1/2.

14 J. E. Mortimer, *History of the Boilermakers' Society, Volume 1, 1834–1906* (London: George Allen & Unwin, 1973), 23.

15 E. J. Hobsbawm, 'The Tramping Artisan', *The Economic History Review* 3, no. 3 (1951): 299–320.

16 H. Broadhurst, *Henry Broadhurst, MP* (1901; New York: Garland, 1984), 11–12.

17 R. A. Leeson, *Travelling Brothers* (St Albans: Granada Publishing 1980).

18 Mortimer, *Boilermakers' Society*, 25.

19 Leeson, *United We Stand* (Bath: Adams & Dart, 1971), 7–8.

20 George Tutill's Catalogue of 1912 claims that the company has been in business for 'more than seventy-five years' (42).

21 Roger Logan, *East Riding to East End: A Life of George Tutill – Regalia Manufacturer*, 6. Online: http://www.flags-tutill.co.uk/george-tutill-monograph.php (accessed 12 February 2013).

22 John Gorman, *Banner Bright: An Illustrated History of Trade Union Banners* (London: Scorpion, 1986), 47–8.

23 Logan, *East Riding to East End*, 6.

24 Mace, *British Trade Union Posters*, 25.

25 Elizabeth McGrath, 'Rubens's *Arch of the Mint*', *Journal of the Warburg and Courtauld Institutes* 37 (1974): 193–205.

26 Giorgio Vasari, *Lives of the Artists*, vol. 2 (1568), trans. George Bull (London: Penguin, 1987), 317–18.

27 Cornelius Scribonius Grapheus, *Spectaculorvm in svsceptione Philippi Hisp. Prin. Antverpiae aeditorvm, mirificvs apparatvs* (Antwerp, 1550), quoted in Margery Corbett and Ronald W. Lightbown, *The Comeley Frontispiece: The Emblematic Title-Page in England, 1550–1660* (London: Routledge & Kegan Paul, 1979), 7.

28 McGrath, 'Rubens's *Arch of the Mint*', 193–205.

29 Ibid.

30 Arts Council of Great Britain, *French Popular Imagery, Five Centuries of Prints*, exhibition catalogue, Hayward Gallery, London, 26 March–27 May 1974 (Uxbridge: Hillingdon Press, 1974), 85.

31 Lynda Nead, *Victorian Babylon* (New Haven and London: Yale University Press, 2000), 204–5.

32 Corbett and Lightbown, *The Comlely Frontispiece*, 2.

33 Hazel Edwards, *Follow the Banner: An Illustrated Catalogue of the Northumberland Miners' Banners* (Manchester: Mid-Northumberland Arts Group in association with Carcanet Press, 1997), 14.

34 Ibid., 16.

35 Algernon Graves, *The British Institution 1806–1867: A Complete Directory of Contributors and Their Work from the Foundation of the Institution* (1875; Bath: Kingsmead Reprints, 1969).

36 Jane Johnson, *Works Exhibited at The Royal Society of British Artists 1824–1983 and the New English Art Club, 1888–1917*, vol. 2 (Woodbridge: Antique Collectors Club, 1975).

37 Roger Logan, *East Riding to East End*, 11–13.

38 George Tutill, Catalogue of 1912, 43.

39 Theatrical backdrops were painted in this way, and established artists such as Rossetti and Burne-Jones undertook such commissions.

40 Gwyn A. Williams, in Gorman, *Banner Bright*, 17.

41 *Beehive*, 16 April 1864; *Pioneer*, 7 December 1833.

42 *Morning Star*, 15 August 1986 (banner of the National Graphical Association being blessed by the Reverend John Oates).

43 Erasmus Darwin, *The Botanic Garden* (Part 1, 'The Economy of Vegetation', published 1791 and Part 2, 'The Loves of the Plants', published in 1789, i.e. before Part 1) (London, J. Johnson, 1791).

44 Klingender, *Art and the Industrial Revolution*, 35.

45 Karl Marx and Friedrich Engels, *On Literature and Art*, ed. Lee Baxandall and Stefan Morawski (St Louis, Milwaukee: Telos Press, 1973), 134–5.

Chapter 2 The Emblem within the Emblem

1 Andrea Alciati, *A Book of Emblems: the Emblematum Liber in Latin and English by Andrea Alciati (1492–1550)*, trans. and ed. John F. Moffitt (Jefferson and London: McFarland & Co., 2004), 7.

2 Margery Corbett and R. W. Lightbown, *The Comeley Frontispiece: The Emblematic Title-Page in England 1550–1660* (London: Routledge & Kegan Paul, 1979), 11.

3 Charles Moseley, *A Century of Emblems* (Aldershot: Scholar Press, 1989), 29. Note: the images mentioned here are from the Bernadino Daza Pinciano text, published 1549.

4 Alciati, *Book of Emblems*, 11.

5 Ibid., 12.

6 Ibid., 5.

7 1500, 1508, 1515, 1518 and 1533.

8 Brant also begins with a motto, then a woodcut and finally a discursive poem ending with a moral injunction. Published in German, Latin, French, English, Flemish and Dutch, 1494–1548.

9 The 1543 edition by Christian Wechel, published in Paris, had nine more emblems. Aldus Manutius issued a second volume of Alciati's emblems, adding a further 86 new ones.

10 Alciati, *Book of Emblems*, 6.

11 Alciati's emblems eventually totalled 212, grouped according to subject.

12 Geoffrey Whitney, *A Choice of Emblemes and Other Deuices* (Leyden: Plantyn and Raphelengius, 1586).

13 Quoted in translation by John F. Moffitt in Alciati, *Book of Emblems*, 8.

14 The Roman fasces, sticks bound together, is a symbol of strength through unity.

15 R. A. Leeson, *United We Stand: An Illustrated Account of Trade Union Emblems* (Bath: Adams & Dart, 1971), 10. Note: Leeson does not give a source for this quotation.

16 According to Corbett and Lightbown, *Comeley Frontispiece*, 2, the English frontispiece has its origins in the Renaissance title pages of the late fifteenth century and is rooted in international Northern Mannerism.

17 Corbett and Lightbown, *Comeley Frontispiece*, 6.

18 See Chapter 4, 'James Sharples and His Legacy', for a fuller discussion of this subject.

19 Karl Marx, speech on the anniversary of *The People's Paper*, no. 207 (19 April 1856), *Surveys from Exile*, vol. 2, ed. D. Fernbach (1973), 299–300.

20 The depiction of the piston engine is part of a tradition of technical illustration, which goes back to early printed editions of Vitruvius.

21 It is very different from depictions of this industry at the time by artists such as de Loutherbourg.

22 This emblem depicts Triton as trumpeter of Neptune (the inspiration for Bernini's *Triton Fountain*).

23 Daniel Beresniak, *Symbols of Freemasonry* (Paris: Editions Assouline, 1997), 82.

24 Ibid., 84.

25 Alexander Piatigorsky, *Freemasonry: The Study of a Phenomenon* (London: The Harvill Press, 1997), 251. This text was first published in 1997 under the title *Who's Afraid of Freemasons?*.

26 Bro. A. E. Fair identifies her as 'the goddess of Fame [who] crowns the engineer and smith for the part they have to play in implementing the plan prepared for them'. See Bro. A. E. Fair, 'The Emblem of the Society', *AEU Monthly Journal* (October 1952): 7.

27 Karl Marx and Friedrich Engels, *On Literature and Art*, ed. Lee Baxandall and Stefan Morawski (St Louis: Telos Press, 1973), 134–5.

28 The most famous narrative of this myth can be found in Ovid, *Metamorphoses*, Book One.

29 Fair, 'Emblem of the Society', 7.

30 Leeson, *United We Stand*, 13.

31 George Wither, *A Collection of Emblemes, Ancient and Moderne* (London, 1635), Book 3, Emblem IX (Glasgow University Library, SM 1903).

32 Thomas Jenner, *The Soules Solace or Thirtie and One Spirituall Emblems* (New York: Delmar, Scholars' Facsimiles & Reprints, 1983), 41.

33 Leeson, *United We Stand*, 37.

34 John Gorman, *Banner Bright: An Illustrated History of Trade Union Banners* (London: Scorpion, 1986), 153.

35 Gwyn A. Williams, in Gorman, *Banner Bright*, 15.



36 Jonathan Rose, *The Intellectual Life of the British Working Classes* (New Haven and London: Yale University Press, 2002), 116.

Chapter 3 Depicting the Worker

1 John Barrell, *Dark Side of the Landscape* (Cambridge: Cambridge University Press, 1980), 4.
2 Edward Said, *Nationalism, Colonialism and Literature* (Derry: Field Day Theatre Co., Pamphlet no. 15, 1988), 5–22.
3 Comte, in *System of Positive Polity* (1854), suggested a system of artificial insemination as a means of keeping middle-class women as close to the ideal Madonna as possible – virginal, but still able to fulfil their 'natural destiny' as mothers.
4 John Barrell, *Dark Side*, 15.
5 Ibid., 16.
6 Ibid., 164.
7 Peter Lord, *The Visual Culture of Wales: Industrial Society* (Cardiff: University of Wales Press, 1998), 81.
8 Trade Reports of the Boilermakers' and Shipbuilders' Society, 1859–68 (Working Class Movement Library, Salford, TU/BOIL/6/1).
9 Trade Reports of the Boilermakers' and Shipbuilders' Society, 1872 (Working Class Movement Library, Salford, TU/BOIL/1/1).
10 Trade Reports of the Boilermakers' and Shipbuilders' Society, 1873 (Working Class Movement Library, Salford, TU/BOIL/1/2).
11 The writing for this entry on the census form (Public Record Office reference R.G. 10 1335) is difficult to read and the word 'Grower' is open to interpretation.
12 Fitschen is noted as exhibiting one painting in an exhibition of 1887, where his address is given as 'The Hollies', Broadgreen Avenue, Croydon.
13 A subtle convex tapering of a column to correct the optical illusion of concavity created by tapering.
14 *Poor Richard's Almanack* was a yearly publication by Benjamin Franklin, writing under the pseudonym of Richard Saunders. Published in Philadelphia, it was a source of astrological information, weather information, a calendar and contained proverbs and aphorisms. This particular motto appeared in the edition of 1757.
15 R. A. Leeson, *United We Stand: An Illustrated Account of Trade Union Emblems* (Bath: Adams & Dart, 1971), 32.

Chapter 4 James Sharples and His Legacy

1 J. E. Mortimer, *History of the Boilermakers' Society, Volume 1, 1834–1906* (London: George Allen & Unwin, 1973), 17–19.
2 R. A. Leeson, *United We Stand, An Illustrated Account of Trade Union Emblems* (Bath: Adams & Dart, 1971), 18.
3 I.e. Moorish, interlacing arabesque patterning.
4 This upper section of the emblem is repeated on their blank book of 1845.
5 Leeson, *United We Stand*, 8.
6 Bishop Blaise is also the patron of those suffering from diseases of the throat, as he is said to have miraculously healed a boy who was choking on a fishbone. The 'Blessing of St Blaise', originating in the sixteenth century, is said to be still practised today, and involves the placing of two candles on the throat of the patient. Blaise died circa 316.
7 Benjamin A. Rifkin, *The Book of Trades (Ständebuch) of Jost Amman and Hans Sachs* (New York: Dover Publications, 1973), xv.

8 Joseph Baron, *James Sharples: Blacksmith and Artist* (London: Jarrold & Sons, 1893), 12.

9 Francis G. Klingender, *Art and the Industrial Revolution*, ed. Arthur Elton (Chatham: Evelyn, Adams & MacKay, 1968), 152.

10 Tim Barringer, *Men at Work, Art and Labour in Victorian Britain* (New Haven and London: Yale University Press, 2005), 138.

11 Plate 13 illustrates the oil painting from which the engraving was taken.

12 Baron, *James Sharples*, 8.

13 Klingender, *Art and the Industrial Revolution*, 153.

14 For a comprehensive discussion of the life and work of James Sharples, see Chapter 3, 'Blacksmith and Artist', of Tim Barringer's excellent *Men at Work, Art and Labour in Victorian Britain* (New Haven and London: Yale University Press, 2005).

15 Latin, beak or prow of a ship, deriving from an actors' stage near the Forum in ancient Rome, which was decorated with prows of ships captured at Antium in 338 BC.

16 Engraving, 1572.

17 For a discussion of this topic, see Klingender, *Art and the Industrial Revolution*, 73.

18 The Hartlepool branch, for example, in a banner made in the latter part of the nineteenth century or early twentieth century has portraits of John Burnett and Rob Austin on the reverse.

19 *The Bundle of Sticks* and *The Four Oxen and the Tiger*.

20 Diodorus Siculus, *Library of Greek History*, first century BCE.

21 *Bakers' Union – Our History, 1849–1977* (Leicester and London: Leicester Printers, Church Gate Press, 1977), 7.

22 Sarah Butler, 'Ancient Rome and the Town and Country Debate from the 1850s to the 1920s', *New Voices in Classical Reception Studies* 6 (2011): 13–31.

23 *Bakers' Union – Our History, 1849–1977*, 7.

24 Wheat, oil and wine are also used in the consecration of Masonic lodges.

25 John Gorman erroneously refers to him as 'Stanley' – *Images of Labour* (London: Scorpion Publishing, 1985), 81.

26 Gorman, *Banner Bright: An Illustrated History of Trade Union Banners* (London: Scorpion, 1986), 130.

27 In medieval and Renaissance sculpture and painting, money bags are symbolic of the sin of avarice and greed.

28 Gorman, *Banner Bright*, 130.

Chapter 5 The Development of the Architecture of the Emblem

1 R. A. Leeson, *Travelling Brothers* (St Albans: Granada Publishing, 1980), 105.

2 John Ruskin, *The Stones of Venice* (Orpington: George Allen, 1893).

3 Owen Jones and Jules Goury, *Plans, Elevations, Sections and Details of the Alhambra* (London: Owen Jones, 1842–45).

4 The *Beehive* was a weekly paper run by George Potter, head of the London Trades Council, and the veteran Chartist, Robert Hartwell.

5 S. Higenbottam, *Our Society's History* (Manchester: Amalgamated Society of Woodworkers, 1939), 341.

6 Alfred, Lord Tennyson, *Lady of Shalott*, part 1, line 5 (1833 and 1842).

7 R. A. Leeson, *United We Stand, An Illustrated Account of Trade Union Emblems* (Bath: Adams & Dart, 1971), 25.

8 Higenbottam, *Our Society's History*, 341–2. Higenbottam in quoting here and in the following quotes from the key and pamphlet entitled 'A Full *Explanation* of the *Emblem* of the General Union of *House Carpenters* and *Joiners* of Great Britain and Ireland', which was sent out with the certificates.

9 'Plane, hammer, chisel, turnscrew, compass and awl'.

10 R. W. Postgate, *The Builders' History* (London: National Federation of Building Trade Operatives, 1923), 308–9.

11 The Working Class Movement Library in Salford holds a copy of this certificate.

12 Leeson, *United We Stand*, 27.

13 1486–1570 (his own tombstone gives an incorrect age).

14 Leeson names one as William Crawford, General Secretary and Member of Parliament, who died in 1890 (*United We Stand*, 62).

15 Leeson illustrates the earlier National Amalgamated Tin Plate Workers of Great Britain emblem of circa 1892 of the same design (*United We Stand*, 17).

16 Anne J. Kershen, *Uniting the Tailors: Trade Unionism amongst the Tailoring Workers of London and Leeds, 1870–1939* (Ilford: Frank Cass, 1995), 18.

17 *Amalgamated Society of Tailors, Twenty-Seventh Yearly and Financial Report, January 1st to December 31st 1892, inclusive* (Manchester: Co-operative Printing Society, 1893), 414.

18 Genesis 3:7.

19 Benjamin A. Rifkin, introduction to *The Book of Trades (Ständebuch)*, by Jost Amman and Hans Sachs (New York: Dover Publications, 1973), xv–xvi.

20 Friedrich Nietzsche, *Daybreak: Thoughts on the Prejudices of Morality*, trans. R. J. Hollingdale (Cambridge: Cambridge University Press, 1982), Section 523, 208. cf. Pierre Macherey, *A Theory of Literary Production*, trans. G. Wall (London: Routledge & Kegan Paul, 1978), 90.

21 Kershen, *Uniting the Tailors*, 8.

22 Ibid., 11.

23 E. Thompson and E. Yeo, eds, *The Unknown Mayhew: Selections from the Morning Chronicle* (1971, 147–9) in *Culture & Society in Britain, 1850–1890*, ed. J. M. Golby (Oxford: Oxford University Press, 1986), 9.

24 Kershen, *Uniting the Tailors*, 113.

25 Genesis 3:16.

26 John Gorman, *Banner Bright: An Illustrated History of Trade Union Banners* (London: Scorpion 1986), 101.

27 Andrew August, *The British Working Class 1832–1940* (Harlow: Longman, 2007), 39–40.

28 Hope's anchor stems from Paul's Epistle to the Hebrews 6:19: 'Hope we have as an anchor of the soul'.

29 Leeson, *United We Stand*, 39.

30 Corn, the growing of which freed mankind to pursue craft works, is embodied in a Masonic password relating to the abundance of the fruits of the earth. See Robert Lomas, *Turning the Hiram Key Making Darkness Visible* (Surrey and Kent: Lewis Masonic, 2007), 127.

31 In the 1840s, building regulations began to be introduced, but they were patchy and often lacked enforcement, and by the end of the century, when they were more tightly enforced, they covered new construction only, and most workers continued to live in the older properties. Cholera epidemics were brought about by a lack of clean water and poor sanitation, and in 1866 the Sanitary Act began the reforms that gradually lead to improved conditions.

32 Friedrich Engels, *The Condition of the Working Class in England*, trans. and ed. W. O. Henderson and W. H. Chaloner (Oxford: Blackwell, 1958), 54–69.

33 Postgate, *The Builders' History*, 192

34 Ibid., 205

35 Friedrich Engels, *Arbeiter Zeitung*, 23 May 1890, first published in *Articles on Britain* (Progress Publishers, 1871), as quoted in *Marx and Engels on the Trade Unions*, ed. Kenneth Lapides (New York and London: Praeger, 1987).

36 Leeson, *United We Stand*, 52.

37 Engels, *Arbeiter Zeitung*.

38 Ben Tillett, *Memories and Reflections* (London: John Long, 1931), 75.

39 Sir Hubert Llewellyn Smith and Vaughan Nash, *The Story of the Dockers' Strike, Told by Two East Londoners* (London: Unwin, T. Fisher, 1889), in Norman Longmate, *Milestones in Working-Class History* (London: BBC Publications, 1975), 68.

40 Later, in 1922, it joined with the South Side Labour Protection League, becoming the Transport and General Workers' Union.

41 Glyn A. Williams, in Gorman, *Banner Bright*, 18.

42 Quoted in Postgate, *The Builders' History*, 343–4.

43 Engels, *Arbeiter Zeitung*.

Chapter 6 Arthur John Waudby and the Symbols of Freemasonry

1 Jean Gimpel, *The Cathedral Builders*, trans. Teresa Waugh (London, Sydney, Auckland, Bergvlei, Pimlico: Random House, 1993), 77.

2 Ibid., 111.

3 Ibid., 102.

4 R. W. Postgate, *The Builders' History* (London: The National Federation of Building Trade Operatives, 1923), 354.

5 Daniel Beresniak, *Symbols of Freemasonry* (Paris: Editions Assouline, 1997), 16.

6 D. Knoop and G. Jones, *The Genesis of Freemasonry* (Manchester: Manchester University Press, 1949), 14.

7 T. O. Haunch, 'English Craft Certificates', *Ars Quatuor Coronatorum* 82 (1996): 169–253.

8 Algernon Graves, *The Royal Academy of Arts: a complete dictionary of contributors and their work from its foundation in 1769 to 1904* (Wakefield, Bath: S. R. Publishers, Kingsmead Reprints, 1970), vol. IV.

9 Jane Johnson, *Works Exhibited at The Royal Society of British Artists 1824–1983 and the New English Art Club, 1888–1917*, vol. 2 (Suffolk, Woodbridge: Antique Collectors Club, 1975).

10 Cited in Knoop and Jones, *Genesis of Freemasonry*, 290.

11 This chapter builds on the groundbreaking work of Joan Bellamy, 'Trade Union Imagery', Open University module A102, An Arts Foundation Course: Units 23–4, Popular Culture and the Labouring Classes (Milton Keynes: Open University Press, 1986), 50–58.

12 Robert Lomas, *Turning the Hiram Key Making Darkness Visible* (Surrey and Kent: Lewis Masonic, 2007), 69–70.

13 Ursula Terner, 'A Brief Look at Masonic Images: Secret Meanings in Freemasonry?', *Ars Quatuor Coronatorum* 109 (1996): 231.

14 Charles Moseley, *A Century of Emblems* (Aldershot: Scholar Press 1989), 66.

15 Bodleian Library, Oxford. Douce S.35.

16 Ninety copies of the regulations (e.g. Regius and Cooke, circa 1400) exist in manuscript form (see Knoop and Jones, *Genesis of Freemasonry*, 62).

17 Knoop and Jones, *Genesis of Freemasonry*, 277.

18 Alexander Piatigorsky, *Freemasonry: The Study of a Phenomenon* (London: The Harvill Press, 1997), 46–7.

19 Terner, 'A Brief Look at Masonic Images', 231.

20 Beresniak, *Symbols of Freemasonry*, 6.

21 Lomas, *Turning the Hiram Key*, 98, 119.

22 Ibid., 148.

23 Ibid., 175.

24 Beresniak, *Symbols of Freemasonry*, 12.

25 Piatigorsky, *Freemasonry*, 245.

26 Postgate, *The Builders History*, 220.

27 Amos 7:7–15.

28 Lomas, *Turning the Hiram Key*, 70.

29 Beresniak, *Symbols of Freemasonry*, 16.

30 Ibid., 20.

31 Knoop and Jones, *Genesis of Freemasonry*, 237.

32 Lomas, *Turning the Hiram Key*, 71.

33 Beresniak, *Symbols of Freemasonry*, 8.

34 He also gave them eight Admonitions.

35 Piatigorsky, *Freemasonry*, 46–7.

36 Lomas, *Turning the Hiram Key*, 103, 108.

37 Terner, 'A Brief Look at Masonic Images', 228.

38 Aubrey's *Natural History of Wiltshire* (1847), quoted in Knoop and Jones, *Genesis of Freemasonry*, 170.

39 Terner, 'A Brief Look at Masonic Images', 229.

40 Albert G. Mackey, *Encyclopedia of Freemasonry* (Virginia: Macoy Publishing, 1966), 129–30.

41 Virgil, *Georgics*, 4.170–78.

42 Lomas, *Turning the Hiram Key*, 114.

43 E. Hobsbawm, 'Man and Woman in Socialist Iconography', *History Workshop* 6 (1978): 125.

44 Beresniak, *Symbols of Freemasonry*, 16.

45 Postgate, *The Builders' History*, 164.

46 Ibid., 245, quoting from *Knott v. Hinckley*, February 1866.

47 Ibid., 245–50.

48 It is thought that Waudby died in 1872.

49 I am grateful for Grace Gillham for this photograph.

50 F. Chandler, *Amalgamated Society of Carpenters and Joiners: History of the Society 1860–1910* (Manchester: Co–operative Printing Society Limited, 1910), 26–7.

51 Item 169 records that, on completion, each member of the order would be given a copy free of charge, but that all subsequent impressions be paid for by the members. A. Robinson, *A Concise History of the Independent United Order of Mechanics Friendly Society from 1847 to 1870* (Newcastle on Tyne: Bro. John B. Barnes, 1880), 39.

52 R. A. Leeson, *United We Stand, An Illustrated Account of Trade Union Emblems* (Bath: Adams & Dart, 1971), 27.

53 Lomas, *Turning the Hiram Key*, 128, 176.

54 Ibid., 170.

55 Chandler, *History of the Society 1860–1910*, 20, 21, 24.

56 Gorman, *Banner Bright*, 81

57 Warwick Modern Records Centre, SCJ. MSS.78.

58 Chandler, *History of the Society 1860–1910*, 27.

59 See discussion on page 68.

60 Ibid., 27.

61 'Faraday Giving His Card To Father Thames', *Punch*, 21 July 1855.

62 The artist, John Martin, had published similar plans in 1834.

63 Leeson, *United We Stand*, 46.

64 Postgate, *The Builders History*, 254.

65 Postgate records that in September 1878 the City of Glasgow Bank collapsed owing £12 million. Over £17,000 of the union's money was in the bank, rendering them almost penniless, and the entire Scottish building trade was paralysed for years. Ibid., 326–7.

66 Leeson, *United We Stand* 28.

67 'The square and compasses are only opened and overlaid to form two chevrons when the immediate Past Master places them on the volume of the sacred law, as the Lodge is open.' Lomas, *Turning the Hiram Key*, 223.

68 Leeson, *United We Stand*, 27.

69 Piatigorsky, *Freemasonry*, 262.

70 Ibid, 83.

71 Lomas, *Turning the Hiram Key*, 124–5.

72 Leeson, *United We Stand*, 27–8; Gorman, *Images of Labour* (London: Scorpion Publishing, 1985), 78–9.

73 Leeson, *United We Stand*, 27–8.

74 Lomas, *Turning the Hiram Key*, 88–9.

75 Ibid., 94.

76 Piatigorsky, *Freemasonry*, 246, 292.

77 Postgate, *The Builders' History*, 354.

78 Leeson, *United We Stand*, 30–31.

79 Postgate, *The Builders' History*, 265–6.

80 Piatigorsky, *Freemasonry*, 243.

81 Lomas, *Turning the Hiram Key*, 174.

82 Abbé Dubos, *Réflexions critiques sur la poésie et sur la peinture* (1719), quoted in Moshe Barasch, *Modern Theories of Art 1: From Winckelmann to Baudelaire* (New York: New York University Press, 1990), 29.

83 Gwyn A. Williams, in Gorman, *Banner Bright*, 20.

84 Diane Clements (director, the Library and Museum of Freemasonry, Freemason's Hall, London), e-mails to author, 10 March 2010 and 28 March 2011.

Chapter 7 Men, Myths and Machines

1 Lynn Hunt, 'Hercules and the Radical Image in the French Revolution', *Representations* 1, no. 2 (1983): 95–117.

2 R. W. Postgate, *The Builders' History* (London: The National Federation of Building Trade Operatives, 1923), 2.

3 Walter Mosses, *The History of the United Pattern Makers' Association, 1872–1922* (London: Co-operative Printing Society, 1922), 5.

4 *Ovide Moralisé* (meaning Ovid moralized), was an immense allegorical project.

5 Pindar, *The Odes*, trans. Sir J. E. Sandys (Cambridge, MA and London: Loeb Classical Library, Harvard University Press, 1915), 195.

6 Vitruvius, in the preface to his second book, compared the Emperor Augustus to Hercules as a philanthropic donor to his conquered peoples of the benefits of civilization.

7 Hunt, 'Hercules and the Radical Image', 99.

8 Henry Slatter, *The Typographical Association: A Fifty Years' Record, 1849–1899* (Manchester: The Labour Press, 1899), 136.

9 J. Johnson and A. Greutzner, *Dictionary of British Artists 1880–1940* (Woodbridge, Suffolk: Baron Publishing, 1976).

10 Algernon Graves, *Dictionary of artists who have exhibited work in the principal London exhibitions from 1760 to 1893* (Bath: Kingsmead Reprints, 1969).

11 Graves, *The Royal Academy of Arts: a complete dictionary of contributors and their work from its foundation in 1769 to 1904, vol. 1* (London: Henry Graves; George Bell & Sons, 1905).

12 Slatter, *Typographical Association*, 84.

13 Ibid., 84.

14 *Evolving English: One Language, Many Voices*, British Library (exhibition), 12 November 2010–3 April 2011.

15 According to Slatter's description, the words are 'Ye worde of God. Deo. 1474'.

16 Owen Jones, *The Grammar of Ornament* (London: Day & Son, 1865).

17 R. A. Leeson, *United We Stand, An Illustrated Account of Trade Union Emblems* (Bath: Adams & Dart, 1971), 65.

18 'For all flesh is as grass, and all the glory of man as the flower of grass. The grass withereth, and the flower thereof falleth away: But the word of the Lord endureth for ever. And this is the word which by the gospel is preached unto you.'

19 See John Barnes, *Vade Mecum*. Online: http://barneshistorian.com/vm-blades.php (accessed 24 January 2013).

20 I am indebted to Chris J. Ludlow, fine art tutor at Loughborough University, specializing in cast metals, for this information.

21 Photograph of James Sharples, studio of R. A. Grigson, Blackburn, 1860 (People's History Museum, Manchester).

22 Henry Wadsworth Longfellow, 'The Village Blacksmith' in *Yale Book of American Verse*, ed. Thomas Raynesford Lounsbury (New Haven: Yale University Press, 1912), no. 59. Online: http://www.bartleby.com/102/59.html (accessed 12 February 2013).

Chapter 8 The Classical Woman

1 Sarah Boston, *Women Workers and the Trade Unions* (London: Lawrence Wishart, 1980), 13, 17.

2 E. Hobsbawm, *Industry & Empire* (Harmondsworth: Penguin, 1969), 68.

3 Boston, *Women Workers and the Trade Unions*, 58.

4 Lise Vogel, *Marxism and the Oppression of Women: Toward a Unitary Theory* (London: Pluto, 1983), 44.

5 Boston, *Women Workers and the Trade Unions*, 11.

6 Ibid. (quoting from *The Women's Trade Union Review* of October 1891), 58.

7 Ibid., 58.

8 Ibid., 9–10.

9 Sarah Stickney Ellis published several. For example: *The Women of England: Their Social Duties and Domestic Habits* (1839).

10 John Ruskin, *Sesame and Lilies, Of Queens' Gardens*, lecture of 1865 (Orpington, Kent: George Allen, 1886), 136–8.

11 Ibid., 149, 152–3.

12 Norman Emery, *Banners of the Durham Coalfield* (Gloucestershire: Sutton Publishing, 1998), 33.

13 Quoted in Andrew Marr, *The Making of Modern Britain: From Queen Victoria to V.E. Day* (London: Macmillan, 2009), 50.

14 Cited in Vogel, *Marxism and Women's Oppression*, 44.

15 R. A. Leeson, *United We Stand: An Illustrated Account of Trade Union Emblems* (Bath: Adams & Dart, 1971), 59.

16 L. Birch, ed., *The History of the TUC 1868–1968* (London: General Congress of the TUC, 1968), 22.

17 R. H. Franks, evidence recorded in *The Report on Mines and Collieries* (1842), cited in Alan Bennett, *A Working Life: Child Labour Through the Nineteenth Century* (Poole: Waterfront Publications, 1991), 36–8.

18 John Gorman, *To Build Jerusalem* (Ipswich: Scorpion Publications, 1980), 40.

19 Marina Warner, *Monuments and Maidens: The Allegory of the Female Form* (London: Weidenfeld & Nicholson, 1985), 67–8.

20 George Eliot, 'Margaret Fuller & Mary Wollstonecraft', *Leader*, 13 October 1855, cited in B. Dijkstra, *Idols of Perversity* (Oxford: Oxford University Press, 1986), 24.

21 Caroline McGhie, 'Great Feats of Clay', *Independent on Sunday*, 10 July 1994, 66.

22 Cited in Bennett, *A Working Life*, 51.

23 Ibid., 50–51.

24 The 'Modest Venus' who attempts to cover herself with her hand.

25 Karl Marx and Friedrich Engels, *On Literature and Art*, ed. Lee Baxandall and Stefan Morawski (St Louis, Milwaukee: Telos Press, 1973), 134–5.

26 Not until the 1880s would employers become liable for compensating industrial accidents.

27 J. L. Newton, M. P. Ryan and J. R. Walkowitz, eds, *Sex and Class in Women's History* (London: Routledge & Kegan Paul, 1983), 28–9.

28 Homer, *Iliad*, 5.736–42. (Lucan, in *De Bello Civili* IX, describes them as vipers.)

29 Apollodorus, 2.4.3, 3.10.3.

30 Marina Warner, *Monuments and Maidens: The Allegory of the Female Form* (London: Weidenfeld & Nicholson 1985), 200.

31 However, in the nineteenth century, the Medusa also became a symbol of suffering and hope, and a political symbol for corruption in post-Revolutionary France. In July 1816, the French frigate, Medusa, was part of an expedition sent to repossess the colony of Senegal from the British. It foundered, its captain and officers leaving the ship in well-provisioned lifeboats, whilst 146 men and one woman were herded onto a makeshift raft with just a little wine and biscuits. The raft was towed behind the captain's lifeboat but was soon cut adrift from it without food or even a compass. At first, those on the raft ate their clothing and leather, after which they resorted to cannibalism. Only 15 of the 147 survived, but 5 more died later. The two survivors, Correard and Savigny, refused to be bullied by the captain and officers into signing reports to exonerate them. Their ensuing book became a bestseller in France and Britain and exposed the incompetence of the royalists still running France. When the French regime attempted to suppress the story, the *Times* was paid F10,000 to keep it alive. This may be a reason why, in this certificate, Justice bears the head of Medusa in order to indicate the British stand against corruption.

32 John Ruskin, *The Queen of the Air: Being a Study of the Greek Myths of Cloud and Storm* (lecture given in University College, London, 9 March 1869) (New York: Hurst & Co., 1907), 56.

33 According to emblem 19 of Alciati, 'More Prudent than Loquacious', the barn owl is the attribute of Athens founded by Cecrops, for this bird belongs among the birds of good counsel. It was consecrated to serve armed Minerva so displacing the chattering crow.

34 Leeson, *United We Stand*, 19.

35 Ibid., 49.

36 'O, sweet content, O, sweet, O, sweet content! Work apace, apace, apace, apace; Honest labour bears a lovely face' (from 'The Pleasant Comedy of Patient Grissel' in *Life-lights of Song: Songs of Life and Labour*, ed. David Page (Edinburgh: William P. Nimmo, 1864), page 111).

37 William Shakespeare, *Henry V*, 2.2.671, spoken by Lord Scroop.

38 This emblem is discussed more fully in Chapter 2, 'The Emblem within the Emblem'.

39 Isaiah 1:18.

40 Warner, *Monuments and Maidens*, xix.

41 Hesiod, *Theogony*, 924.

42 Jane Ellen Harrison, *Epilegomena to the Study of the Greek Religion and Themis* (New York: University Books, 1962), 500.

43 See Chapter 5 herein.

44 According to Giambattista Vico, *Principi di scienza nuova di Giambattista Vico d'intorno alla commune natura delle Nazioni*, (edition 3, 1744) trans. Thomas Goddard Bergin and Max Harold Fisch (Ithaca, NY and London: Cornell University Press, 1970), 159. The first shields were round because the cleared and cultivated lands were the first *orbes terrarum*.

45 Giambattista Vico, *Principi di Scienza Nuova*, 142.

46 Homer, *Iliad*, Book 17.

47 Ovid, *Metamorphoses* 13.289–95. See also Virgil, *Aeneid* 8.620–30 in which the shield Vulcan makes for Aeneas is explicitly heralding the rise of Rome and the triumphs of empire.

48 The key is also a Masonic symbol: 'Those Secrets [of the Freemason] I keep under my left breast [...]. The Key to those Secrets I keep [...] in a bone box that neither opens nor shuts but with Ivory Keys. That Key [...] hangs by a Tow-Line [...] and is made of [...] no metal at all.' Quoted as part of the Masonic initiation ceremony in Alexander Piatigorsky, *Freemasonry: The Study of a Phenomenon* (London: The Harvill Press, 1997), 82.

49 According to Norman Emery, this banner is post-1947 as the gate is the gate of nationalization. Norman Emery, *Banners of the Durham Coalfield* (Gloucestershire: Sutton Publishing, 1998), 101.

50 The composition of the cluster of six men on the far right of the group is similar to those on the right of Erin on the *O'Connell Monument*, Foley and Brock, Dublin (1863), where Erin, holding the Act of Emancipation, points upward to the statue of the Liberator.

51 Hesiod, *Works and Days*, I.52.

52 R. Johnson, 'The Promethean Commonplace', *Journal of the Warburg and Courtauld Institutes* 25 (1962): 10.

53 Unfortunately this banner is in a poor state of repair in this reproduction.

54 Quoted in Boston, *Women Workers and the Trade Unions*, 16.

55 Robert Owen, *The Book of the New Moral World*, Sixth Part (London: J. Watson, 1836–44).

56 Lisa Tickner, *The Spectacle of Women: Imagery of the Suffrage Campaign 1907–14* (Chicago: University of Chicago Press, 1988).

57 Ibid., 248.

58 Walter Crane, *Illustrations and Ornamentation from The Faerie Queene, Arranged by Carol Belanger Grafton* (Mineola, NY: Dover Publications, 1999), 100.

59 At the time they were known as 'suffragists'.

60 Jane Beckett and Deborah Cherry, *The Edwardian Era* (Oxford: Phaidon Press, 1987), 110.

61 F. Fordham, *An Introduction to Jung's Psychology* (London: Penguin, 1957), 54.

62 Eric Hobsbawm, 'Man and Woman in Socialist Iconography', *History Workshop* 6 (1978): 135.

63 Warner, *Monuments and Maidens*, 153.

64 Ibid., 241.

65 R. Parker and G. Pollock, *Old Mistresses* (London: Pandora Press, 1981), 132.

Chapter 9 Walter Crane

1 Lynn Hunt, 'Hercules and the Radical Image in the French Revolution', *Representations* 2 (1983): 95–117.

2 Walter Crane, *William Morris to Whistler: Papers and Addresses on Art and Craft and the Commonweal* (London: G. Bell & Sons, 1911), 39.

3 Stanley Pierson, *Marxism and the Origins of British Socialism: The Struggle for a New Consciousness* (Ithaca, NY: Cornell University Press, 1973), 22–38, 75–80.

4 George Bernard Shaw, preface to *Major Barbara* (1905), in *Collected Prefaces* (London: Odhams, 1938), 121–2.

5 Ibid., xii.

6 Crane, *William Morris to Whistler*, 10.

7 Ibid., 214–15.

8 Crane, *The Claims of Decorative Art* (London: Lawrence & Bullen, 1892), 50.

9 Crane, *William Morris to Whistler*, 86–7.

10 Crane's 'Freedom' was inspired by Swinburne's poem 'The Era of Revolution' in which a winged figure wearing the bonnet rouge rescues humanity.

11 Morna O'Neill, 'Art and Labour's Cause is One': Walter Crane and Manchester, 1880–1915 (Manchester: Whitworth Art Gallery, University of Manchester, 2008), 101. O'Neill dates this banner 'circa 1890' yet the union was not formed until 1898.

12 Greg Smith and Sarah Hyde, eds, Walter Crane 1845–1915: Artist, Designer, Socialist (London: Lund Humphries, 1989), 17.

13 Edward Said, Nationalism, Colonialism and Literature (Derry: Field Day Theatre, 1988), 5–22.

14 Crane, William Morris to Whistler, 213.

15 Apollodorus 3.18.6.

16 'The people's flag is deepest red/It shrouded oft our martyred dead.'

17 John Gorman, Banner Bright: An Illustrated History of Trade Union Banners (London: Scorpion 1986), 89.

18 Ovid, Metamorphoses, 8.183–235.

19 Walter Mosses, The History of the United Pattern Makers' Association, 1872–1922 (London: Co-operative Printing Society, 1922), 130.

20 Ibid., 49.

21 Ibid., 58.

22 Ibid., 107.

23 Ibid., 141.

24 R. A. Leeson illustrates a membership certificate in United We Stand: An Illustrated Account of Trade Union Emblems (Bath: Adams & Dart, 1971), 68.

25 Illustrated London News, 6 March 1872.

26 Thought to be a second-century Roman copy of a lost original by the Greek sculptor Leochares.

27 Leeson, United We Stand, 66.

28 Mosses, History of the United Pattern Makers' Association, 141.

29 Isobel Spencer, Walter Crane (London: Cassell & Collier Macmillan, 1975), 148.

30 Pickles' correspondence, Labour Party archive.

31 John Barrell, Dark Side of the Landscape (Cambridge: Cambridge University Press 1980), 164.

32 Karl Marx, speech on the fourth anniversary of the People's Paper, London, 14 April 1856, quoted in J. M. Golby, ed., Culture and Society in Britain 1850–1890 (Oxford: Oxford University Press, 1986).

33 Anne J. Kershen, Uniting the Tailors: Trade Unionism amongst the Tailoring Workers of London and Leeds, 1870–1939 (Ilford: Frank Cass, 1995), 107.

34 Crane, An Artist's Reminiscences (1907; Detroit: Singing Tree Press, 1969), 267.

35 Smith and Hyde, Walter Crane 1845–1915, 21.

36 G. B. Shaw, 'Early History of the Fabian Society' in The Fabian Conference, 1886, quoted in Edward R. Pease, The History of the Fabian Society (London: A. C. Fifield, 1916), 56.

37 Crane, William Morris to Whistler, 14–15.

38 Friedrich Nietzsche, Daybreak: Thoughts on the Prejudices of Morality, trans. R. J. Hollingdale (Cambridge: Cambridge University Press, 1982), 208.

39 Gorman, Banner Bright, 131.

40 Spencer, Walter Crane, 157.

41 Art Journal (1870): 87, quoted in Andrew Wilton and Robert Upstone, eds, The Age of Rossetti, Burne-Jones and Watts (London: Tate Gallery Publishing, 1997), 134.

42 Rev. Charles Kingsley was a Christian socialist and builders' union leaders such as Applegarth were strong liberals.

43 Letter from E. S. Beesley in O.B.S. Monthly, December 1862, quoted in R. W. Postgate, The Builders' History (London: The National Federation of Building Trade Operatives, 1923), 204.

44 J. Proudhon, *Du principe de l'art, et de sa destination social* (1865), trans. Elizabeth Fraser, in Stewart Edwards, ed., *Selected Writings of Pierre-Joseph Proudhon* (London: Macmillan, 1970), 214ff.

45 Crane, *William Morris to Whistler*, 254.

46 Ibid., 3.

47 Proudhon, *Du principe de l'art*, 310.

Chapter 10 The Art of Copying

1 Chantrey made several, including one presented in 1830 by Watt's son to the Hunterian Museum, Glasgow, and also a bronze on a granite pedestal in 1832, in George Square, Glasgow.

2 H. Spencer, *Principles of Sociology* (London: Williams & Norgate, 1876, 1882 and 1896 – 3 volumes).

3 In the same way, middle-class women looked after their own children's intellectual needs but working-class servants were assigned to look after their physical needs.

4 *Scythian Knife Grinder*, Hellenistic period (copy), Uffizi Gallery, Florence.

5 R. W. Postgate, *The Builders' History* (London: The National Federation of Building Trade Operatives, 1923), 198–9.

6 F. Chandler, *Amalgamated Society of Carpenters and Joiners: History of the Society 1860–1910* (Manchester: Co-operative Printing Society Limited, 1910), 26.

7 Postgate, *The Builders' History*, 220.

8 See Chapter 6 of this volume.

9 The Free Trade Hall replaced a wooden hall of 1838 that had been used to hold meetings protesting against the Corn Laws and bourgeois profiteering.

10 R. A. Leeson, *United We Stand: An Illustrated Account of Trade Union Emblems* (Bath: Adams & Dart 1971), 16.

11 Hesiod, *The Homeric Hymns and Homerica*, trans. Hugh G. Evelyn-White (London: William Heinemann, 1914), 446 (translation modified).

12 In Homer's *Iliad* 1.580–600, he recounts how Zeus caught him by the foot and threw him from the heavens. He fell all day and at sunset landed on Lemnos with little life left in him.

13 John F. Moffitt, 'Velázquez's "Forge of Vulcan" – The Cuckold, the Poets, and the Painter', *Pantheon-Internationale Jahreszeitschrift* 41, no. 4 (1983): 322, note 8.

14 Sebastiano Serlio, *Architettura* (1537), xxiv (quoted here in the English version of 1611, book IV, folio 24). *The Five Books of Architecture: An Unabridged Reprint of the English Edition of 1611* (Toronto and London: Dover Publications, 1982).

15 Thomas Jenner, *The Soules Solace or Thirtie and One Spirituall Emblems* (New York: Delmar, Scholars' Facsimiles & Reprints, 1983), 41.

16 George Tutill, Catalogue of 1912, 35. People's History Museum, Manchester.

17 Ibid., 27 and 46.

18 Lord Byron, *Childe Harold's Pilgrimage*, Canto ii, Stanza 76 ('Hereditary bondsmen! Know ye not, Who would be free, themselves must strike the blow?').

19 According to Gorman, it was quite probably copied from an earlier banner. See *Banner Bright: An Illustrated History of Trade Union Banners* (London: Scorpion 1986), 93.

20 Hesiod, *Theogony*, 310–12, 770–73.

21 Some authors (e.g. Richard Ormond in *Sir Edwin Landseer* (London, Thames & Hudson, 1981), 97) refer to the dog as 'Bashaw', but the Victoria and Albert Museum, London, exhibit Wyatt's sculpture under the title 'Brashaw'.

22 I am most grateful to the staff of the National Railway Museum for their help in providing these facts, notably the transcription of 'Railway Dogs, Dedication of "Carlo" Cot' from the *Southern Railway Magazine*, by Beverley Cole, curator of Pictorial Collections (20 May

2002), and National Railway Museum, Object no. 1990–7629, 'Railway Collecting Dog: "Laddie"', by Helen Ashby, registrar (26 June 2002).

23 The marble of the original sculpture deteriorated and in 1956 it was replaced by a bronze statue.

24 Walter Crane, *William Morris to Whistler: Papers and Addresses on Art and Craft and the Commonweal* (London: G. Bell & Sons, 1911), 8.

25 Sarah Boston, *Women Workers and the Trade Unions* (London: Lawrence Wishart, 1980), 47.

26 Naval History and Heritage Command, 'Admiral David Glasgow Farragut, US Navy, 1801–1870', *Biographies of Naval History*. Online: www.history.navy.mil/bios/farragut_davidg.htm (accessed 24 January 2012).

27 John Ruskin, *The Queen of the Air, Being a Study of the Greek Myths of Cloud and Storm* (New York: Hurst & Co., 1907), 56.

28 Lynn Hunt, 'Hercules and the Radical Image in the French Revolution', *Representations* 2 (1983): 99.

29 Gorman, *Banner Bright*, 127.

30 Leighton himself never married and his sexual orientation is still being debated.

31 Ford Madox Brown, *On Work* (1865), as quoted in Julian Treuherz, *Pre-Raphaelite Paintings for the Manchester City Art Gallery* (London: Lund Humphries, 1980), 53–9.

Conclusion Reprise and Review

1 In the late nineteenth century, Cyrenus Osborne Ward produced the sociologically eccentric but remarkable volume *A History of the Ancient Working People* (later published as *The Ancient Lowly*), expressly to give the American labour movements a history and 'a classical solidity and grandeur' (see Malamud, *Ancient Rome and Modern America* (Chichester: Wiley-Blackwell, 2009), 104–5 for the content, context and influence of the book). Ward characterized dissent from slave revolts to unrest amongst the organized crafts as early examples of strikes and saw the *collegia* and *sodalicia* (trade guilds, clubs and fraternities) as early labour associations, forerunners of the producer and consumer co-operatives. He also lists (*passim*) a huge range of crafts and their subdivisions, some of which Morel discusses in his chapter. See also Aldrete (2009, 191) for jobs and professions listed on tombstones.

2 Morel also cites Haterius, the builder whose family tomb gives an illustrated account of his accomplishments in the trade (including the Colosseum) and inscribes the information that he held priestly office in the imperial cult.

3 See the opening salvo re the social realities of Victorian working-class women in the critique of Hobsbawm by Alexander, Davin and Hostettler (1979, 174). Davis' introduction to the 2011 edited essays in *Class and Gender in British Labour History* (Pontypool: Merlin Press, 2011) notes that the female workforce of the Victorian period has been sidelined by progressive and reactionary scholars alike.

4 Eumachia from Pompeii is a famous female factory owner whose family became rich through vineyards, brickmaking, pottery and textiles. She erected a building in the local forum and decorated it with lofty imperial images and a portrait sculpture of herself donated by the fullers' corporation.

5 Engels wrote in *Anti-Dühring*, Part Two, that slavery first made possible the division of agriculture and industry on a large scale. Ellen Wood argued in 1981 that Marx and Engels had overemphasized the numbers of slaves in Greece, writing that 'the majority of Athenians citizens earned their livelihoods by labour'. Elitist aristocratic perceptions (whether in ancient Athens or Victorian England) about 'banausic – base, menial and mechanical classes', whose souls were in spiritual bondage through the necessity of doing productive work or slavish service, tend to occlude the real tensions between the privileged and the (working)

populace. However, 'the presence of independent producers does not characterise a specific mode of production'. This observation from S. H. Rigby (1997, 224–9) is part of a valuable excursus on the problems of seeing antiquity as one unvaried social formation, but also on the importance of identifying from whose labour surplus value was extracted and for whose benefit.

6 Marx himself wrote that Greek art presupposed Greek mythology, that natural and social phenomena were already assimilated in an unintentionally artistic manner by the imagination of the people (in his introduction to *Contribution to the Critique of Political Economy*, 1859). These and other pronouncements have proved impenetrable for many theorists. Heinrich von Staden (in the 1975 edition of the classical journal *Arethusa*, devoted to Marxism and classical antiquity) introduces a helpful diagram (122) to clarify Marx's more dynamic schema of the dialectic between material productive relations and a work of art. Greek art and literature proved to have transhistoric aesthetic value. If, as von Staden argues, mythology is for Marx 'the basis and material of Greek *Kunst*' (126), then a subjective and superstitious conception of nature and of social relations in the ancient Greek psyche becomes an objective material force in the form of cultural products with a universal and timeless appeal.

7 Siobhan McElduff makes some pertinent introductory remarks in her chapter on the reception of classical literature in eighteenth- and nineteenth-century Ireland (Martindale and Thomas 2006, 180–91). She is concerned that studies of the movement of Greek and Latin texts amongst the non-elite has been neglected, leading to the creation of a false history of reception and of classics. Edith Hall suggests that a crucial question is 'to which cultural media containing information about the Greeks and Romans would the people under investigation be most likely to have experienced systematic exposure?' (Hardwick and Stray 2008, 392).

8 Malamud, in her 2009 book *Ancient Rome and Modern America*, devotes a chapter to working men's heroes. The Caledonian Calgacus, rebel against the Romans, was a role model in the American Revolution. The Gracchi brothers of the Roman republican era were heralded as democratic land reformers and frequently cited by the rhetoricians of the nineteenth-century Free Soil Movement.

9 Hunt (1983, 97) reprises the fascinating debate on the need for visual symbols or seals in the representation of the French Revolution, and the view of deputy Grégoire that the insignia of the new Republic had to dispense with 'the ridiculous hieroglyphics of heraldry', which were 'now for us only historical curiosities'.

10 I borrow this phrase from the Autumn 2011 Ostrovsky article in *Royal Academy Magazine* (58). The exhibition *Building the Revolution* (2011) had a relatively modest collection of paintings and photographs, but Arkady Ostrovsky puts these into an ideological context. Of particular interest are his observations on the use of biblical imagery by the Soviet artists of the 1920s and his description of Shchusev's second version of Lenin's Mausoleum as inspired by the step pyramid form of the ancient ziggurat: 'A sacred structure built by Babylonians, who believed it connected heaven and earth' (60). Ostrovsky argues that, 'empowered by the spirit of Lenin, the Bolshevik leaders could now ascend invisibly to the top of the Mausoleum and observe the crowds bearing their portraits' (60).

11 Reid (1992, 23) claims that there was still a heavy reliance upon independent groups of highly skilled workers, that not all new industries were characterized by intensive mechanics and the division of labour.

12 In recent decades important research has opened up on the militancy of women workers who were capable of committing spontaneous acts of defiance, whether or not they had formed their own labour associations. In Davis' 2011 edited essays on *Class and Gender in British Labour History* (significantly subtitled *Renewing the Debate or Starting It?*), a body of persuasive evidence has been collated across the spectrum of women at work. A key case study in the significance of

women leading industrial action in the nineteenth century is Louise Raw's 2009 *Striking a Light: The Bryant and May Matchwomen and their Place in History*. Raw has discovered the real heroines from amongst the workforce who led the action. The conduct of this struggle was inspirational for the striking Gasworkers and the Dockers shortly after them. Unsurprisingly but shamefully, Eleanor Marx (who did so much to educate and assist the union leaders and to organize relief in both these strikes) was never honoured in a roundel on any of their banners.

13 Von Staden (1975, 139) tentatively proposes that: 'Marx's vision of Communist man, especially the free aesthetic praxis of reintegrated communal man, is at least subconsciously inspired by his view of the Greeks', although he prefaces this with a more general observation that 'visions and views are not infrequently interrelated in this manner'.

14 The campaigners for women's suffrage and their distinct iconography figure briefly in Chapter 8. Their emblems were usually home-made and relied a great deal on pattern and colour along with well-designed and prominent lettering. Rozsika Parker's 1984 book, *The Subversive Stitch* (197–210), discusses the stark simplicity of their iconography: 'Whereas trades union banners were largely produced by a professional banner-making firm, the women of the suffrage movement employed their considerable personal skills previously reserved for such objects as portieres and mantel draperies. Within the suffrage movement there was an arts and crafts society called the Suffrage Atelier.'

15 The significance of Mary Lowndes and the range of her artistic contributions (she is primarily known as a designer of stained-glass windows) are discussed by Lisa Tickner in 'Banners and Banner Making' (*The Nineteenth-Century Visual Cultural Reader*, 2004).

16 Ravenhill-Johnson's examination of prevailing nineteenth-century notions about the idealized female form as signifier comes with a nineteenth-century historical context. Labour organizations and radical movements were not and are not immune to patriarchal portrayals of women. Scholars in gender studies continue to uncover stereotypical representations of the nurturing woman in all kinds of visual contexts. In paintings like G. E. Hicks' *Women's Mission: Companion to Manhood* (1863), the wife is positioned as a flying buttress. The concept of masculine and feminine styles and orders of architecture (which was also given class distinctions) is borne out in the writings of Christopher Wren. For this and discussions of class and sexuality in Victorian art, see G. Perry's *Gender and Art* (1999) and K. McLelland's 'Some Thoughts on Masculinity' (1989).

17 Lummis, like Reid before him, challenges assumptions about the 'aristocracy of labour', comprising the highly skilled or specialized workers. Lummis presents a picture of regional variation across occupations. He also demonstrates the militancy of the skilled stratum in struggle even when they were sought after for their specialist know-how. He suggests that by the later eighteenth century they could very easily be laid low by seasonal downturns in employment. At times their very specialism meant they lost out to the more flexible labourer, and those in industries with job security and inherited rights to a placement had greater security regardless of whether they were skilled or unskilled workers.

18 Mayhew noted the pitiable state of health and short life expectancy of the coal backer or coal porter (alternative titles), quoting the words of a 45-year-old man employed in coal heaving, and commenting that they these workers were usually spent by the age of 40 (Quennell 1987, 557).

19 A static and statuesque Hercules (accompanied by presumably the Nemean lion, although it looks more like a tame pet than the ferocious enemy of one of his most famous labours) is included in the 1926 certificate of the Associated Society of Locomotive Engineers and Firemen (Plate 25), featured in Chapter 7, 'Men, Myth and Machines'. Annie Ravenhill-Johnson wonders if this is an allusion to the philanthropic Hercules given a lofty position as the hero who brings civilization to conquered peoples. One of the earliest recorded examples of a nascent general union was called the Philanthropic Hercules: 'a parliament of working

men'. (Thanks to Malcolm Chase, professor of social history at the University of Leeds, for this information.)

20 Other emblems of this period continued to flaunt a Victorian love of elaboration. Tom Lewery (1986, 130–34) celebrates their touching naivety whilst accepting that the painters were better craftsmen than artists. A reporter at the 1887 Northampton Shoemakers' Strike was horrified by processions with banners 'of more than Chinese gorgeousness and hideousness, fit for the ragshop' and pronounced himself distressed by the utter lack of art education in the working classes. On the other hand, the *Manchester Guardian* of 17 September 1877, on the occasion of the trades procession marking the opening of the new town hall, had heaped praise upon the banners of the Tailors, the Bootmakers and the Cabinet Makers, describing the latter as 'highly satisfactory as a work of art, and does infinite credit to the taste of the members of the Society' (Lewery, 134).

21 Workers as figures with Herculean strength appear in Soviet posters and banners. In Callow, Pooke and Powell (*The Art of Revolution*, 2011, 33), they suggest that an actual hero of labour, Alexei Stakhanov, solidified the image of the shock worker who could lift many tonnes of coal over his quota in one shift. Of course the historical context is quite different from the period of British banner production. The art of the French Revolution is highly influential but there are visual echoes of the later trade union emblems in the Soviet depiction of labour in action. In *The Art of Revolution* (23), the popularity of the heroic blacksmith is highlighted, complete with hammer and anvil forging the new Soviet future. Industrial and agricultural workers could identify with this figure, but is there any hint of Hephaistos/Vulcan in the mind of the artists or the viewers?

22 Dr Jarlath Killeen (Trinity College, Dublin) kindly sent me his transcript and I am indebted to his insights here.

23 Gorman (1986, 40) comments: 'For illustrations to enliven the banners, the combined imagination of the dockers and the banner painters knew no bounds. While one group depicted its members as Roman centurions, another embellished their banner with the figure of King John.'

24 See Classics for All (Shahabudin and Lowe, 2009). Annie Ravenhill-Johnson's identification of the ziggurat as an important architectural motif in the emblems was first presented at Professor Edith Hall's 'Classics and Class' conference (British Academy, 2010).

25 As a classicist who has learnt so much from Ravenhill-Johnson's research, I was intrigued by the figure of the miner and wondered (fancifully) if the feathery embrace of the Nike around his head, the caduceus shape of his jack hammer and his laced knee-high work boots invoked the winged Mercury.

26 To be fair, the banner featured as part of the photo on the adjacent page has a more assertive message, with a miner (naked from the torso up and evoking the Herculean muscle man) rising out of a demonstration of workers. Proclaimed on their scroll is the sentence 'OUR FIGHT IS FOR THE RIGHT TO WORK'. This is the banner of the North-East area of the National Union of Mineworkers.

GLOSSARY

Annie Ravenhill-Johnson

abacus
: The flat top of a capital or column supporting the entablature.

architrave
: The lowest part of the entablature, resting on the capitals of the supporting columns, or a moulding surrounding or framing a door or window opening.

arcuated
: From Latin *arcus*, a bow. A style of architecture in which the structure is supported on arches.

arts mécaniques
: The mechanical arts (such as metallurgy, architecture, agriculture) as opposed to the liberal arts.

attic storey
: A stage above the principal entablature.

avant-garde
: Favouring an ultramodern style.

banderole
: A small streamer, ribbon or flag, sometimes containing speech.

bonnet rouge
: The Phrygian or Liberty cap. A soft cap with the top pulled forward. Worn by revolutionaries in France from 1790 and by Marianne, France's national emblem.

caduceus
: A winged staff around which two snakes are entwined. Everything Hermes touched with it turned to gold.

capitals
: The upper part of a column or pier.

cartes de visite
: Available from 1854, small photographs mounted on card the size of visiting cards.

cartouche
: A carved or printed panel like a sheet of paper with the edges turned over usually in an ornate ornamental frame.

caryatid	The sculpture of a female figure used as a pillar to support a building.
chaplet	A Roman circular wreath as headdress or crown, made of flowers and leaves, and usually on a metal base.
chiaroscuro	The contrasting of light and shade in a work of art.
clipeus	A round shield of wicker or wood covered in oxhide and edged with metal with a sharp central projection, itself a weapon. Large enough to cover a person. Forerunner of the scutum.
codex	An ancient manuscript not in a roll but in book form.
collegium	A legal association or council.
colonnade	A row of columns supporting an entablature.
colophon	A decorative symbol or imprint on a printed work giving the writer's or printer's name.
columbarium	From Latin, *columba*, a dove or pigeon. Dovecote. In ancient Rome the name also given to chambers containing niches for cinerary urns.
Corinthian	An order of architecture with the capital decorated with carved leaves of acanthus.
cornice	The topmost member of the entablature.
cornucopia	A horn containing fruit and flowers to indicate plenty.
corolla	In ancient Rome, a crown of branches and twigs later with added flowers or a horn base, worn by victors in sacred contests. Names from the resemblance to the corolla or petals of a flower.
cowan	Builder of drystone walls; an uninitiated person.
crepidoma	A three-level platform supporting a Greek temple.
deification	The process of supposedly transforming a mortal into a god.
Doric	The oldest and simplest of the three orders of architecture.
engaged columns	Stone columns built into a wall usually for half its diameter.
entablature	From Latin *in tabula*. The horizontal superstructure resting on the capitals in classic architecture, comprising frieze (the central space) and cornice (the upper projecting mouldings).

entasis	The subtle bulge of a column to correct the optical illusion of concavity created by tapering.
escutcheon	A heraldic shield displaying armorial bearings.
Fabian	A member of the Fabian Society, founded 1884, for social change through cautious reform.
fasces	A bundle of sticks or rods, usually with the blade of an axe protruding from it, carried by Roman lictors as a symbol of authority when escorting eminent figures such as governors, army leaders, magistrates, etc. Fasces could be crowned in laurel to celebrate victories or covered as a sign of mourning.
finials	Foliage that tops pinnacles, canopies, etc., in Gothic architecture.
frieze	The middle section of the entablature.
gavel	A type of hammer used by a chairman, auctioneer or judge to call for order.
gravitas	A Roman virtue implying dignity or importance.
grisaille	A painting executed in shades of grey or neutral greyish colour, usually to imitate the effect of sculpture.
hatchment	A funerary tribute to the deceased usually in the form of a black lozenge-shaped plaque bearing their heraldic arms, crest, etc.
humanitas	A Roman virtue denoting a cultivated, courteous, decent man.
iconography	The illustration in art of a subject.
Ionic	One of the orders of architecture with its capital having spiral volutes beneath its abacus.
keystone	The wedge-shaped central voussoir of an arch.
lancet arches	Tall, narrow, pointed arches.
lapis lazuli	A bright blue, semiprecious stone.
lictor	From the Latin *ligare*, to bind. A Roman citizen chosen as a bodyguard for officials.
lunette	A half-moon-shaped space.
mandorla	Oval shape derived from the intersection of two circles.

monogram	A design comprising a person's initials.
nouveau riche	From French, new rich. A person who has acquired wealth only recently, especially one who flaunts it.
ogee arch	A pointed arch formed each side by two contrasting 'S' shaped curves.
omphalos	From Greek, navel. Omphalos stones were erected (e.g. at Delphi) and indicated the centre or navel of the world, and were said to allow direct communication with the gods.
pediment	The triangular gable of a classical temple or portico.
pegma	A type of staging scaffolding.
Phrygian cap	A soft, conical cap with top pulled forward. From Phrygia. In the Roman Empire it signified freedom and liberty; often conflated with the pileus.
pilaster	A flat column and capital against a wall, usually built into it and projecting not more than one third its surface breadth.
Pileus	The felt cap of the Roman freed slave.
pince-nez	Spectacles without arms that literally 'pinched the nose'.
piscina	From Latin *piscis*, a fish. In Christian churches, a perforated stone basin, usually in a niche, for the washing by the priest of his hands and sacred vessels.
praedella	A series of small paintings at the bottom of an altarpiece.
pre-Raphaelite	A short-lived brotherhood of young Royal Academy student and artists who, from 1848, rebelled against current British artistic practice and attempted to recapture the innocence of early Italian art before Raphael, using clear bright colours and a detailed observation of nature.
putto	From the Italian for 'little boy'. Small naked child, sometimes winged, in a work of art. Plural putti.
quadrivium	Four subjects taught in the Renaissance.
rebus	The representation of a name or word by means of a picture suggesting its syllabus.
rostrum	A small platform, usually for a public speaker.
rustication	The working of stone, especially at the base of buildings to imply great strength, producing a rough surface, usually with

	the margins of each block chiselled smooth. In later usage, smooth blocks with carefully recessed margins to accentuate the joints.
rutellae	Roman grain storage measures or jars.
schola	Confraternity.
scraffito	The technique of overlaying one pigment with another and then scratching or scraping away the top pigment to reveal the underlying one. Especially effective with the use of gold leaf.
scriptorium	Writing room in the medieval monastery where monastic scribes copied manuscripts.
scutum	Typically a rectangular, semicylindrical body shield with central boss, light in weight but big enough to protect the whole body.
socle	A high plinth or pedestal supporting a sculpture.
spiritelli	Little spirits.
status quo	From Latin, the state in which. The state of affairs as it is at present.
strapwork	Ornamentation resembling leather cut into pieces that slot together.
stylobate	The top level of a crepidoma.
tabula rasa	From the Latin, a wax writing tablet, heated and smoothed to give a renewed, smooth writing surface. A blank slate. The theory that human perception comes from experience.
Terra Mater	Roman goddess Terra Mater, Terra or Tellus, Mother Earth.
tessera	A small pebble, cut stone or glass mosaic tile. Plural tesserae.
thorn	Þ, a letter in common use in the English alphabet until the fourteenth century, indicating the 'th' sound.
thrutch	To climb or push into a small space.
trabeated	From Latin *trabes*, a beam. As in vertical post and horizontal-beam architecture.
triglyph	A projecting block in a frieze with three grooves or channels incised into its face.
vesica piscis	See mandorla.

vignette A small picture or tableau.

volute The spirals scroll which forms the distinctive feature in an
 Ionic order capital.

voussoir The wedge-shaped stone forming part of an arch.

ziggurat A flat-topped pyramid.

BIBLIOGRAPHY

Agulhon, M. 'On Political Allegory: A Reply to Eric Hobsbawm'. *History Workshop* 8 (1979): 167–73.

Alciati, A. *A Book of Emblems, the Emblematum Liber in Latin and English by Andrea Alciati (1492–1550)*. Edited and translated by John F. Moffitt. Jefferson, NC and London: McFarland & Co., 2004.

Aldrete, G. S. *Daily Life in the Ancient City: Rome, Pompeii, and Ostia*. Oklahoma: University of Oklahoma Press, 2004.

Alexander, S., A. Davin and E. Hostettler. 'Labouring Women: A Reply to Eric Hobsbawm'. *History Workshop* 8 (1979): 174–82.

Amalgamated Society of Tailors, Twenty-Seventh Yearly and Financial Report, January 1st to December 31st 1892, inclusive. Manchester: Co-operative Printing Society, 1893.

Apollodorus. 2.4.3. and 3.10.3.

Arts Council of Great Britain. *French Popular Imagery, Five Centuries of Prints* (exhibition catalogue, Hayward Gallery, London, 26 March–27 May 1974). Uxbridge: Hillingdon Press, 1974.

Wilton, A. and R. Upstone, eds. *The Age of Rossetti, Burne-Jones and Watts*. London: Tate Gallery Publishing, 1997.

August, A. *The British Working Class 1832–1940*. Harlow: Longman, 2007.

Bakers' Union. *Bakers' Union – Our History, 1849–1977*. Leicester and London: Church Gate Press, 1977.

Beckett, J. and D. Cherry. *The Edwardian Era*. Oxford: Phaidon Press, 1987.

Barasch, Moshe. *Modern Theories of Art 1: From Winckelmann to Baudelaire*. New York: New York University Press, 1990.

Baron, J. *James Sharples: Blacksmith and Artist*. London: Jarrold & Sons, 1893.

Barrell, J. *Dark Side of the Landscape*. Cambridge: Cambridge University Press, 1980.

Barringer, T. *Men at Work, Art and Labour in Victorian Britain*. New Haven and London: Yale University Press, 2005.

Bellamy, J. 'Trade Union Imagery'. Open University module A102, An Arts Foundation Course. Milton Keynes: Open University Press, 1986, 50–58.

Bennett, A. *A Working Life: Child Labour through the Nineteenth Century*. Poole, Dorset: Waterfront Publications, 1991.

Beresniak, D. *Symbols of Freemasonry*. Paris: Editions Assouline, 1997.

Birch, L., ed. *The History of the TUC 1868–1968*. London: General Congress of the TUC, 1968.

Boston, S. *Women Workers and the Trade Unions*. London: Lawrence Wishart, 1980.

Boden, H. *Symbolism in Trade Union Emblems*. Salford: Working Class Movement Library, 2010.

Broadhurst, H. *Henry Broadhurst, M.P.* New York: Garland, 1984.

Bradley, M., ed. *Classics and Imperialism in the British Empire*. Oxford: Oxford University Press, 2009.

Brown, L. 'Liberty Caps and Other Symbols: The Politics of Visual Culture in Revolutionary France' (unpublished lecture delivered at Open University research seminar, 23 July 2003).

Butler, S. 'Ancient Rome and the Town and Country Debate from the 1850s to the 1920s'. *New Voices in Classical Reception Studies* 6 (2011): 13–31.

Callow, J., G. Pooke and J. Powell. *The Art of Revolution*. London: Evans Mitchell, 2011.

Chase, M. *Early Trade Unionism: Fraternity, Skills and the Politics of Labour*. London: Breviary Stuff, 2012.

Colley, L. *Britons – Forging the Nation: 1709–1837*. Yale: Yale University Press, 2009.

Corbett, M. and R. W. Lightbown. *The Comeley Frontispiece: The Emblematic Title-Page in England, 1550–1660*. London: Routledge & Kegan Paul, 1979.

Crane, W. *The Claims of Decorative Art*. London: Lawrence & Bullen, 1892.

———. *William Morris to Whistler, Papers and Addresses on Art and Craft and the Commonweal*. London: G. Bell & Sons, 1911.

———. *An Artist's Reminiscences* (1907). Detroit: Singing Tree Press, 1969.

———. *Illustrations and Ornamentation from the Faerie Queene, Arranged by Carol Belanger Grafton*. Mineola, NY: Dover Publications, 1999.

Darwin, E. *The Botanic Garden*. London: J. Johnson, 1791.

Davis, M., ed. *Class and Gender in British Labour History: Renewing the Debate (Or Starting It?)*. Pontypool: Merlin Press, 2011.

Dennis, V. S. *Discovering Friendly and Fraternal Societies: Their Badges and Regalia*. Buckinghamshire: Shire Publications, 2005.

Dijkstra, B. *Idols of Perversity*. Oxford: Oxford University Press, 1986.

Diodorus Siculus. *Library of Greek History*.

Edwards, H. *Follow the Banner: An Illustrated Catalogue of the Northumberland Miners' Banners*. Manchester: Mid Northumberland Arts Group in association with Carcanet Press, 1997.

Edwards, S., ed. *Selected Writings of Pierre-Joseph Proudhon*. London: Macmillan, 1970.

Emery, N. *Banners of the Durham Coalfield*. Gloucestershire: Sutton Publishing, 1998.

Englander, D. and R. O'Day, eds. *Retrieved Riches: Social Investigation in Britain 1840–1914*. Aldershot: Ashgate, 1998.

Engels, F. *The Condition of the Working Class in England* (1845) in *The Collected Works of Karl Marx and Friedrich Engels*, vol. 4. London: Lawrence and Wishart, 1975.

Fair, A. E. 'The Emblem of the Society'. *Amalgamated Engineering Union Monthly Journal* (October 1952).

Fordham, F. *An Introduction to Jung's Psychology*. London: Penguin, 1957.

Frank, B., C. Horner and D. Stewart, eds. *The British Labour Movement and Imperialism 1800–1982*. Cambridge: Cambridge Scholars Publishing, 2010.

Giardina, A. *The Romans*. Edited and translated by Lydia G. Cochrane. Chicago: Chicago University Press, 1993.

Gimpel, J. *The Cathedral Builders*. Translated by Teresa Waugh. London, Sydney, Auckland, Bergvlei: Random House, 1993.

Golby J. M., ed. *Culture and Society in Britain 1850 – 1890*. Oxford: Oxford University Press, 1986.

Graves, A. *The British Institution 1806–1867: A Complete Directory of Contributors and Their Work from the Foundation of the Institution*. Bath: Kingsmead Reprints, 1969.

———. *Dictionary of artists who have exhibited work in the principal london exhibitions from 1760 to 1893*. Bath: Kingsmead Reprints, 1969.

———. *The Royal Academy of Arts: a complete dictionary of contributors and their work from its foundation in 1769 to 1904*, vol. 1. London: Henry Graves; George Bell & Sons, 1905.

Gorman, J. *To Build Jerusalem*. Ipswich: W. S. Cowell, Scorpion, 1980.

———. *Images of Labour*. London: Scorpion, 1985.

———. *Banner Bright: An Illustrated History of Trade Union Banners*. London: Scorpion, 1986.

Gorky, M. 'Soviet Literature'. In *Soviet Writers' Congress 1934: The Debate on Socialist Realism and Modernism*. London: Lawrence and Wishart, 1977: 27–62. (Reprinted from *Problems of Soviet Literature*, edited by H. G. Scott, 1935.)

Hardwick, L. P. and C. Stray, eds. *A Companion to Classical Receptions*. London: Wiley-Blackwell, 2008.

Harrison, J. E. *Epilegomena to the Study of the Greek Religion and Themis*. New York: University Books, 1962.

Haunch, T. O. 'English Craft Certificates'. *Ars Quatuor Coronatorum* 82 (1969): 169–253.

Hemingway, A., ed. *Marxism and the History of Art: From William Morris to the New Left*. London: Pluto Press, 2006.

Hesiod. *Theogony*.

———. *Works and Days*.

Higenbottam, S. *Our Society's History*. Manchester: Amalgamated Society of Woodworkers, 1939.

Hobsbawm, E. 'The Tramping Artisan'. *Economic History Review* 3, no. 3 (1951): 299–320.

———. 'Man and Woman in Socialist Iconography'. *History Workshop* 6 (1978): 121–38.

———. *Industry and Empire*. Harmondsworth: Penguin, 1969.

Homer. *Iliad*.

Hunt, L. 'Hercules and the Radical Image in the French Revolution'. *Representations* 2 (Spring 1983): 95–117.

Jenner, T. *The Soules Solace or Thirtie and One Spirituall Emblems*. New York: Delmar, Scholars' Facsimiles & Reprints, 1983.

Johnson, J. *Works Exhibited at The Royal Society of British Artists 1824–1983 and the New English Art Club, 1888–1917*, vol. 2. Woodbridge, Suffolk: Antique Collectors Club, 1975.

Johnson, J. and A. Greutzner. *Dictionary of British Artists 1880–1940*. Suffolk, Woodbridge: Antique Collectors Club, Baron Publishing, 1976.

Johnson, R. 'The Promethean Commonplace'. *Journal of the Warburg and Courtauld Institutes* 25 (1962): 9–17.

Jones, O. *The Grammar of Ornament*. London: Day & Son, 1865.

Jones, O. and J. Goury. *Plans, Elevations, Sections and Details of the Alhambra*. London: Owen Jones, 1842–45.

Kershen, A. J. *Uniting the Tailors: Trade Unionism amongst the Tailoring Workers of London and Leeds, 1870–1939*. Ilford: Frank Cass & Co., 1995.

Killeen, J. *The Essay: Bram Stoker* (broadcast on BBC Radio 3, 20 April 2012).

Klingender, Francis G. *Art and the Industrial Revolution*. Edited by Arthur Elton. Chatham: Evelyn, Adams & MacKay, 1968.

Lapides, K., ed. *Marx and Engels on the Trade Unions*. New York and London: Praeger, 1987.

Layton-Jones, K. 'Visual Quotations: Referencing Visual Sources as Historical Evidence'. *Visual Resources* 24, no. 2 (2008): 189–99.

Leeson, R. A. *United We Stand: An Illustrated Account of Trade Union Emblems*. Bath: Adams & Dart, 1971.

———. *Travelling Brothers*. St Albans: Granada Publishing, 1980.

Lewery, A. J. *Popular Art – Past and Present*. London: Trafalgar Publishing, 1991.

Loftus, D., ed. 'Voices and Texts in Dialogue'. Open University module A150, Voices and Texts. Milton Keynes: Open University Press, 2010.

Logan, R. *East Riding to East End: A Life of George Tutill – Regalia Manufacturer* http://www.flags-tutill.co.uk/george-tutill-monograph.php (accessed 26 February 2013).

Lomas, R. *Turning the Hiram Key: Making Darkness Visible*. Surrey and Kent: Lewis Masonic, 2007.

Longmate, N. *Milestones in Working Class History*. London: BBC Publications, 1975.

Lord, P. *The Visual Culture of Wales: Industrial Society*. Cardiff: University of Wales Press, 1998.

Lucan. *De Bello Civili*, IX.

Lummis, T. *The Labour Aristocracy 1851–1914*. Aldershot: Ashgate and Vermont: Scolar Press, 1994.

Mace, R. *British Trade Union Posters*. Stroud: Sutton Publishing, 1999.

Malamud, M. *Ancient Rome and Modern America*. Chichester: Wiley-Blackwell, 2009.

Mansfield, N. 'The Contribution of the National Banner Survey to Debates on 19th century Popular Politics'. *Visual Resources* 24, no. 2 (2008): 133–43.

————. 'Radical Banners as Sites of Memory: the National Banner Survey'. In *Contested Sites: Commemoration, Memorial and Popular Politics in Nineteenth-Century Britain*. Edited by P. A. Pickering and A. Tyrrell. Surrey: Ashgate, 2004, 81–100.

Mansfield, N. and K. Uhl. 'Banners: An Annotated Bibliography'. *Journal of Social History Curators' Group* 27 (2002): 43–54.

March, J. *Cassell Dictionary of Classical Mythology*. London: Cassell, 1998.

Marr, A. *The Making of Modern Britain: From Queen Victoria to V.E. Day*. London: Macmillan, 2009.

Martindale, C. and R. F. Thomas. *Classics and the Use of Reception*. London: Blackwell, 2006.

Marx, K. Introduction to *Critique of Hegel's 'Philosophy of Right'* (1843). Edited by J. O'Malley. Cambridge: Cambridge University Press, 1970.

Marx, K. and F. Engels. *The German Ideology* (1845). Translated by S. W. Ryazanska. London: Lawrence and Wishart, 1965.

————. *On Literature and Art*. Edited by Lee Baxandall and Stefan Morawski. St Louis, MO: Telos Press, 1973.

McGrath, E. 'Ruben's *Arch of the Mint*'. *Journal of the Warburg and Courtauld Institutes* 37 (1974): 193–205.

McCarthy, T. *The Great Dock Strike of 1889*. London: George Weidenfeld Publishing, 1988.

McClelland, K. 'Some Thoughts on Masculinity and the Representative Artisan in Britain, 1850–1880'. *Gender and History* 1, issue 2 (1989): 164–177.

Mortimer, J. E. *History of the Boilermakers' Society, Volume 1, 1834–1906*. London: George Allen & Unwin, 1973.

Moseley, C. *A Century of Emblems*. Aldershot: Scholar Press, 1989.

Mosses, W. *The History of the United Pattern Makers' Association, 1872–1922*. London: Co-operative Printing Society, 1922.

National Fairground Archive. 'Painted Work'. University of Sheffield, 2009. http:/www.nfa. dept.shef.ac.uk/history/art/painting.html (accessed 28 March 2012).

Nead, L. *Victorian Babylon*. New Haven and London: Yale University Press, 2000.

Newton, J. L., M. P. Ryan and J. R. Walkowitz, eds. *Sex and Class in Women's History*. London: Routledge & Kegan Paul, 1983.

Nietzsche, F. *Daybreak: Thoughts on the Prejudices of Morality*. Translated by R. J. Hollingdale. Cambridge: Cambridge University Press, 1982.

O'Neill, M. *'Art and Labour's Cause is One': Walter Crane and Manchester, 1880–1915*. Manchester: Whitworth Art Gallery, University of Manchester, 2008.

————. *Walter Crane: The Arts and Crafts, Painting and Politics 1875–1890*. New Haven and London: Yale University Press, 2010.

Ostrovsky, A. 'Building Blocks' ('Building the Revolution'). *Royal Academy Magazine* (Autumn 2011): 58–62.

Ovid. *Fasti*.

————. *Metamorphoses*.

Padover, S. K., ed. *The Karl Marx Library*, vol. 1. New York: McGraw-Hill, 1971.

Parker, R. *The Subversive Stitch: Embroidery and the Making of the Feminine*. London: I.B. Tauris, 1984.

Parker. R. and G. Pollock. *Old Mistresses*. London: Pandora Press, 1981.

Paxman, J. *The Victorians: Britain through the Paintings of the Age*. London: BBC Books, 2009.

Pease, E. R. *The History of the Fabian Society*. London: A. C. Fifield, 1916.

Pelling, H. *A History of British Trade Unionism*. London: Penguin, 1963.

Perry, G., ed. *Gender and Art*. New Haven and London: Yale University Press, 1999.

Phillips, A. and B. Taylor. 'Sex and Skill: Notes towards a Feminist Economics'. *Feminist Review* 6 (1980): 79–86.

Piatigorsky, A. *Freemasonry: The Study of a Phenomenon* (first published in 1997 under the title *Who's Afraid of Freemasons?*). London: Harvill Press, 1997.

Pickering, P. A. and A. Tyrrell, eds. *Commemoration, Memorial and Popular Politics in Nineteenth Century Britain: Studies in Labour History Series*. Aldershot: Ashgate, 2004.

Pierson, S. *Marxism and the Origins of British Socialism: The Struggle for a New Consciousness*. Ithaca, NY: Cornell University Press, 1973.

Pindar. *The Odes*. Translated by Sir J. E. Sandys. Cambridge, MA and London: Loeb Classical Library, Harvard University Press, 1915.

Plutarch. *Numa*.

Postgate, R. W. *The Builders' History*. London: The National Federation of Building Trade Operatives, 1923.

Quennell, P., ed. *Mayhew's London*. London: Bracken Books, 1987.

Raw, L. *Striking A Light: The Bryant and May Matchwomen and their Place in History*. London: Continuum, 2009.

Reid, A. J. *Social Classes and Social Relations in Britain 1850–1914* (Economic History Society Series). London: Macmillan, 1992.

Richardson, R. 'In the Posture of a Whore? A Reply to Eric Hobsbawm'. *History Workshop* 14 (Autumn 1982): 132–7.

Rifkin, B. A. *The Book of Trades (Ständebuch) of Jost Amman and Hans Sachs*. New York: Dover Publications, 1973.

Rigby, S. H. *Marxism and History*. Manchester: Manchester University Press, 1998.

Rose, J. *The Intellectual Life of the British Working Classes*. New Haven and London: Nota Bene Yale University Press, 2002.

Ruskin, J. *Sesame and Lilies, Of Queens' Gardens*. Orpington, Kent: George Allen, 1886.

———. *The Stones of Venice*. Orpington, Kent: George Allen, 1893.

———. *The Queen of the Air: Being a Study of the Greek Myths of Cloud and Storm*. New York: Hurst & Co., 1907.

Said, E. *Nationalism, Colonialism and Literature*. Derry: Field Day Theatre Co., Pamphlet no. 15, 1988.

Schwartz, V. R. and J. M. Pryzblyski, eds. *The Nineteenth Century Visual Cultural Reader*. London and New York: Routledge, 2004.

Serlio, S. *The Five Books of Architecture: An Unabridged Reprint of the English Edition of 1611* Toronto and London: Dover Publications, 1982.

Shaw, G. B. Preface to *Major Barbara* (1905). In *Collected Prefaces*. London: Odhams, 1938.

Slatter, H. *The Typographical Association: A Fifty Years' Record, 1849–1899*. Edited by Richard Hackett. Manchester: The Labour Press, 1899.

Smith, G. and S. Hyde, eds. *Walter Crane 1845–1915: Artist, Designer, Socialist*. London: Lund Humphries, 1989.

Spencer, I. *Walter Crane*. London: Cassell & Collier Macmillan, 1975.

Staden, H. von. 'Greek Art and Literature in Marx's Aesthetics'. *Arethusa* 8, no. 1 (1975): 119–144.

Tennyson, A. 'The Lady of Shalott', 1833 and 1842.

Terner, U. 'A Brief Look at Masonic Images: Secret Meanings in Freemasonry?' *Ars Quatuor Coronatorum* 109 (1996): 224–32.

Thompson, D. *The Chartists: Popular Politics in the Industrial Revolution*. New York: Pantheon, 1984.

Thompson, E. P. *The Making of the English Working Class.* London: Penguin, 1963.

———. *Customs in Common.* London: Penguin, 1991.

Thompson, F. M. L. *The Rise of Respectable Society: A Social History of Victorian Britain, 1830–1900.* London: Fontana Press, 1988.

Tickner, L. *The Spectacle of Women: Imagery of the Suffrage Campaign 1907–14.* Chicago: University of Chicago Press, 1988.

Tillett, B. *Memories and Reflections.* London: John Long, 1931.

Vasari, G. *Lives of the Artists*, vol. 2 (1568). Translated by George Bull. London: Penguin Books, 1987.

Vico, G. *Principi di scienza nuova di Giambattista Vico d'intorno alla commune natura delle Nazioni*, edition 3, 1744. Translated by T. G. Bergin and M. H. Fisch. Ithaca, NY and London: Cornell University Press, 1970.

Vogel, L. *Marxism and the Oppression of Women: Toward a Unitary Theory.* London: Pluto, 1983.

Warner, M. *Monuments and Maidens: The Allegory of the Female Form.* London: Weidenfeld & Nicholson, 1985.

Weinbren, D. 'The Good Samaritan: Friendly Societies and the Gift Economy'. *Social History* 31, no. 3 (2006): 319–36.

———. 'Beneath the All-Seeing Eye: Fraternal Order and Friendly Societies' Banners in Nineteenth- and Twentieth-Century Britain'. *Cultural and Social History* 3, no. 2 (2006): 167–91.

Whinney, M. *Sculpture in Britain 1530–1830.* New Haven and London: Yale University Press, 1992.

Whitney, G. *A Choice of Emblems and Other Deuices.* Leyden: Plantyn and Raphelengius, 1586.

Wither, G. *A Collection of Emblemes, Ancient and Moderne.* Glasgow: Glasgow University Library SM, 1903.

Wood, E. 'Marxism and Ancient Greece'. *History Workshop* 11 (Spring 1981): 3–22.

Woods, K. W. Introduction to Open University module A226, Exploring Art and Visual Culture. London: Tate Publishing, 2012, 1–15.

INDEX

The index covers only the text. The plates are listed after the acknowledgements at the front of the book.